WISE GALS

WISE GALS

THE SPIES WHO BUILT THE CIA
AND CHANGED THE FUTURE OF ESPIONAGE

BY NATHALIA HOLT

G. P. PUTNAM'S SONS
NEW YORK

PUTNAM
— EST. 1838 —

G. P. Putnam's Sons
Publishers Since 1838
An imprint of Penguin Random House LLC
penguinrandomhouse.com

Library of Congress Cataloging-in-Publication Data
Names: Holt, Nathalia, 1980- author.
Title: Wise gals: the spies who built the CIA and changed the future of espionage / by Nathalia Holt.
Other titles: Spies who built the CIA and changed the future of espionage
Description: New York: G. P. Putnam's Sons, [2022] | Includes bibliographical references and index. |
Identifiers: LCCN 2022019091 (print) | LCCN 2022019092 (ebook) |
ISBN 9780593328484 (hardcover) | ISBN 9780593328491 (ebook)
Subjects: LCSH: United States. Central Intelligence Agency—History. |
Women intelligence officers—United States—Biography. |
Intelligence officers—United States—Biography. | Women spies—United States—Biography. |
Spies—United States—Biography. | Intelligence service—United States—History—20th century. |
United States. Central Intelligence Agency—Officials and employees. |
Discrimination in employment—United States—History—20th century.
Classification: LCC JK468.I6 H63 2022 (print) | LCC JK468.I6 (ebook) |
DDC 327.1273009—dc23/eng/20220518
LC record available at https://lccn.loc.gov/2022019091
LC ebook record available at https://lccn.loc.gov/2022019092

Trade Paperback ISBN: 9780593328507

Interior art: World map © Oleksandr Molotkovych/Shutterstock.com

BOOK DESIGN BY KRISTIN DEL ROSARIO

147532949

For the women who toil,
invisible,
invaluable,
for Laurie

Put yourself behind my eyes
and see me as I see myself,
for I have chosen to dwell in a place you cannot see.

—JALĀL AL-DĪN MUḤAMMAD RŪMĪ

CONTENTS

AUTHOR'S NOTE

The Wise Gals are no longer with us to tell their stories, and yet they still speak. This work of nonfiction was researched thanks to the materials they left behind, which include diaries, letters, interviews, reports, memos, scrapbooks, and photographs. In addition to these sources, the Central Intelligence Agency has released primary documents about the careers of these women and the challenges they faced. All the work published in this book is declassified and was obtained through the Freedom of Information Act.

A large portion of this book is credited to the CIA officers, both retired and active, who contributed their stories and memories. Just like the work these men and women perform, their contributions to the book remain anonymous. For this reason, their names appear as redacted in the source notes, and their own stories, while worthy of telling, have mostly been left out.

Firsthand accounts of historical events are often slanted by those who have lived through them. To limit this, I have used material from archival sources, acquired from multiple countries, to ensure that the material I obtained through these interviews is factual. Occasionally, material obtained from an interview was unable to be supported through outside sources. In these instances, I've weighed other evidence, and

carefully checked dates and timing, when deciding whether to include these portions within the book. When I've chosen to include these first-hand histories without supporting documentation, I've noted the instance in the endnotes.

The thoughts and feelings of individuals in the book were obtained through their personal materials and author interviews with those who knew them. All quoted material is obtained directly from primary sources and credited in the endnotes.

This is the kind of book the Wise Gals could not have anticipated would ever be written. In their later years, they watched as their male colleagues became the subjects of multiple biographies, while their lives and accomplishments remained undocumented. Sadly, their stories could not have been told while the women were still with us. If living, neither the identities of the women, nor their work within the agency, would have been disclosed by the CIA. It is only in death that the full measure of their accomplishments can be revealed.

WISE GALS

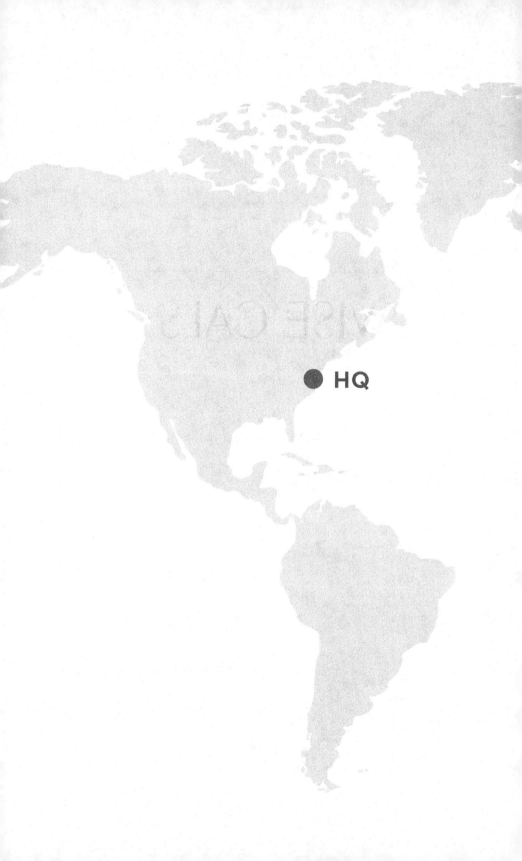

● HQ

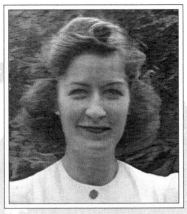

ADDY HAWKINS

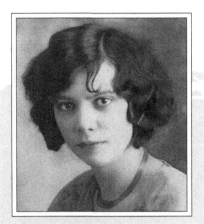

LIZ SUDMEIER

MARY HUTCHISON

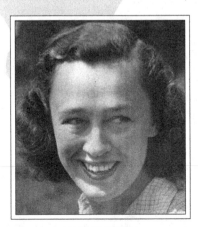

JANE BURRELL

ELOISE PAGE

NOVEMBER 1953

A small group of women gathered together just a few blocks from the White House to contemplate the dismal future of American intelligence. They had spent the past decade forming the fledgling American espionage enterprise known as the Central Intelligence Agency, breaking new ground for women in the workplace by working alongside men in dangerous, important operations. They'd played an integral part in gathering the intelligence that had won World War II for the Allies, and now they were on the front lines of the Cold War, spreading their network of spies across the world. But at this moment, these female founders were taking a rare opportunity to look inward.

And what they saw made them angry.

Eloise Page wasn't the kind of woman who was prone to emotional outbursts. Her friends would tell you that when she was upset, her demeanor was usually icy rather than explosive. She had a firm sense of right and wrong, and she never hesitated to reprimand those who crossed a line. Yet on this unusually balmy day in Washington, D.C., her temper was fiery.

For the past few months, Eloise and a group of twenty-two of her female colleagues at the CIA had tackled a seemingly impossible goal: to strip away the inherent sexism that plagued the institution they loved. Women were doing the same work as their male counterparts, Eloise

and her colleagues argued, but they weren't getting the same pay or recognition as the men they worked alongside each day. That had to change. To accomplish this, they had carefully documented the experiences of women at the agency over the course of years. The daring missions. The enormous responsibility. These women had given everything to safeguard America's security. In fact, some of their colleagues had even given their lives.

Eloise and the other women knew that achieving their aim of equal pay and recognition for their work would not be easy. They met in the evenings, after their regular workday was over, gathering statistics and stories that would prove their case to the higher-ups at the CIA. While the group was officially named the Committee on Professional Women, everyone at the agency jokingly called them the Petticoat Panel. It became a nickname they loathed but adopted nevertheless, as a reminder of exactly what they were up against.

For Eloise, who had spent years overseas working in complex CIA operations, the task before them was rather mundane. They compiled numbers from each department of the agency, took into account the education and work experience of every employee, combined the dry statistics with personal anecdotes, and then prepared their reports. Yet their training in covert operations was aiding their progress in ways their male managers could not have predicted. As they interviewed female employees, they peeled off the niceties that people naturally coated their experiences in and exposed what a career in government service truly looked like if you were a woman.

What they found wasn't pretty.

Repeatedly they heard frustration in their colleagues' voices. The number one reason that women were leaving the CIA was not marriage or pregnancy, as so many executives claimed. Instead, their interviews revealed a deep dissatisfaction among women, specifically concerning their promotion within the agency. Although 40 percent of the CIA's workforce in 1952 was made up of women, only 20 percent had reached

a mid-range salary level (about $7,514 a year). This was compared with 70 percent of their male colleagues who were paid at that level.

The problem wasn't that the women weren't being given responsibility, either; it was that they weren't being paid for it. Many female employees had advanced degrees and were directing the activities of large teams. They had worked on successful operations and had years of experience in the field. In many cases, they even had the support of male colleagues and the recommendations of their bosses.

Yet they couldn't get a raise.

As she looked around the room, Eloise realized that she had never worked so closely with a group of women before. No matter whether she was in London, Brussels, Paris, or Washington, D.C., it seemed she was always in a room of men. Nor had she ever known her fellow CIA officers so well. After all, they were (by nature and by profession) a secretive bunch, often scattered around the world in various sensitive locales. But the Petticoat Panel was a chance for her and the other women in the CIA to meet and open up to one another in a way they weren't usually able to when on the job. While delving into the experiences of the women of their agency, it was only natural for them to share their own backgrounds. When one of her colleagues asked Eloise how she'd managed to secure a promotion from secretary to officer from General William Donovan, the father of American intelligence, after the war, she responded, "Oh, I had the goods on Donovan," a wicked smile on her lips.

Everyone loved the lively Elizabeth Sudmeier, whom they called Liz. She had grown up on a reservation in South Dakota and liked to tease her friends in the Lakota Sioux language. She had recently completed Junior Officer Training, also called JOT, and was the only woman in her class, so she could report directly on gender discrepancies in CIA instruction and mentoring. "Women in the JOT program need to be more highly qualified than most of the men," she said.

Then there was Mary Hutchison, a woman who had first been

dismissed by the agency as a "contract wife." The term referred to a woman married to a CIA officer, who was assumed to be trained and employed by the agency merely because of her marriage. Such roles were often entry points for women into the CIA, but Mary—with her proficiency in several languages, her doctorate in archaeology, and her string of fiery comebacks—was uniquely suited for a career in espionage. If only she could get the higher-ups at the CIA to notice her exemplary work.

Eloise had grown closest to the chairwoman of their group, Adelaide Hawkins, whom she called Addy. They were the same age, they both hailed from small towns in the South, and they each had joined the CIA during World War II, before it even officially existed (when it had gone by the moniker OSS, or Office of Strategic Services). Friendly as they were, Eloise sensed Addy's envy of her overseas assignments. While Eloise had spent years in Europe, Addy, a divorced mom with three children, had been bound stateside. It didn't matter that Addy's children were grown, that fathers were allowed to work overseas, or even that she was highly qualified for such positions. Addy was a mother, so she would never be sent overseas; that was that. Annoyed by the inconsistency of the agency, Addy hoped that her work with the Petticoat Panel might spur an overseas assignment for herself.

There were dangers overseas. A few members of the panel knew about another woman, one who wasn't there that day. Jane Burrell was the model of a tough, successful CIA officer. Working across France and Germany, Jane had wrestled with difficult double agents, charmed deadly assassins, and sent dozens of Nazis to their doom.

With Jane's example to lead the way, how could the Petticoat Panel not succeed? They had a cadre of smart women who had picked this moment, in 1953, to transform the intelligence agency they had built a decade earlier. It wasn't just their colleagues who were counting on them; it was the CIA itself. Talented women were leaving the agency,

and each dissatisfied officer was fragmenting the future of American espionage.

The panel represented both their opportunity and their legacy, and the senior male administrators felt the crushing pressure of their historic expectations. The stakes were high, and their opponent was unrelenting. "I think it is important to remember how it came into being," said one of the men, referring to the Petticoat Panel, "because [of] a couple of wise gals."

"ISN'T THAT A STRANGE PROFESSION?"

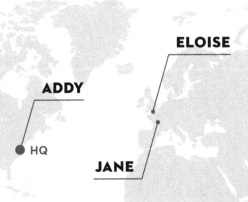

JESSICA

1934-1944

The message could kill someone. It moved from Berlin to Lisbon to Normandy. Then it was stolen off the coast and sent to Bletchley. Twisted around until nearly unrecognizable, it was shipped off to America. In Washington, D.C., it was jumbled once more before being sent to London and then back to France. The paper swam in a sea of secret messages that formed a flood of intelligence during World War II. Finally, in Normandy, on December 20, 1943, X-2 counterintelligence agent Jane Burrell caught it and read the name that had been hidden between the mixed-up letters.

The name: *Carl Eitel.*

.

Carl Eitel had other names. Ten years earlier, when he worked as a waiter on the SS *Bremen*, moving between Germany and New York, he had been known as Charles Rene Gross. The waiter had spent long hours detailing the ports of New York in his notebook, with an emphasis on their fortifications and aircraft support. Once in the city, he slipped off to the Roxy cinema and then got a beer at Café Vaterland on the corner of Eighty-Sixth Street and Second Avenue. Relaxed and happy, he casually wandered the streets, stopping at every bookstall he could find. He didn't look for reading material. Instead, he purchased technical magazines by the dozen. No matter the subject, Eitel wanted them. Although his

behavior had been unusual, he'd passed unnoticed at the time. It was 1934, after all, and the borders of America were then wide open for Western Europeans . . . even those with an odd penchant for technical detail.

In his hotel in New York, Eitel took a tube of what looked like modeling clay, working it through his fingers until the material was soft and supple. Squeezing a little into a glass partially filled with water, he stirred the substance until it turned a mustardy yellow color. He dipped a toothpick into the thick liquid and dragged it across a sheet of rough paper, writing sentences that quickly faded as the fluid dried on the page. The rugged bond obscured any imperfections caused by writing with a crude toothpick, and soon the sheet of paper appeared blank again. Eitel then used that same piece of seemingly blank paper to write an innocuous letter to Germany, sharing mundane details of life in Manhattan and how much he missed his homeland. But underneath these pleasantries, the contents of his missive were anything but harmless.

Eitel was in fact working for Abwehr, the German intelligence agency, scouting details about the technological capabilities of the country his homeland would soon be at war with. Of all his various duties in the US in that precarious inter-war period, however, none was more important than recruiting new agents. Earlier in 1934, he had introduced a young Spaniard named Juan Frutos to the world of German espionage. Frutos was at the time a baggage handler who also worked on the SS *Bremen*. An ocean liner was a wonderful place for a spy like Eitel to enlist new agents: it was full of young people who spoke multiple languages, were accustomed to travel, and were in need of money. Frutos was enthusiastic about working for Eitel, no matter how seemingly inconsequential the mission. On one trip he had extravagantly handed Eitel an envelope, as proud as if it contained Winston Churchill's darkest secrets. Instead it was packed with the modest request made by Eitel: dozens of postcards, each one depicting a different French warship. Simple, yes—but these sorts of details would inform crucial intelligence for the years and conflicts that followed.

The two men had kept in contact over the years, as Eitel moved from New York to Germany and then on to Brest, France. The location had the strategic advantage as the closest French port city to the Americas. There Eitel's life had become increasingly luxurious, as World War II had begun and Eitel enjoyed the fruits of his years of intelligence work. During the day he worked inside the charming surroundings of an ancient stone castle, the Château de Brest, which was seized during Germany's occupation of France. He was building an intelligence service using the port's fishing boats. Every day was profitable: even if the boats didn't turn up information about the suspicious travel habits of French citizens, the daily catch made a healthy addition to his bank balance.

His hair had started thinning and his potbelly ballooned, but Eitel was happy. In the evenings he took his girlfriend, Marie Cann, to the bistro he purchased from the profits of Abwehr and the fish market. The rest of his money he blew on extravagant gold jewelry, not for Cann but for himself. His small, round glasses often reflected the glinting light from his gold chains and rings.

The good life was about to end for Eitel. In the summer of 1943, he left France for Lisbon, pulling behind him a web of intelligence agents

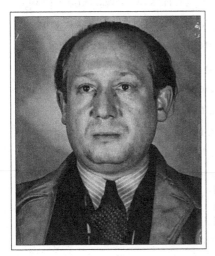

Carl Eitel.
Credit: The National Archives of the United Kingdom

that stretched across Germany, France, and now Portugal. In his pockets were papers that identified him as a French citizen named Charles Grey. If arrested, he would show those papers to the authorities and pledge his allegiance to the Allies. Yet hidden deep in his belongings, where he hoped they would never be found, were a German passport, a gun, and a vial of cyanide.

.

The message that would lead to Eitel's downfall seemed harmless at first glance. It was only a few lines long and was one of thousands of transmissions moving through Bletchley Park, Britain's premier cryptanalysis operation. While America's fledgling spy agency was just starting to take baby steps, Britain's MI6 intelligence service was already at a full gallop, and Bletchley Park was the beating heart of the whole operation. And it was a surprisingly equitable one as well—through a combination of availability (most men were off at war, after all) and smarts (specifically in mathematics, where many of the women shined), 75 percent of the team at Bletchley was female, and together they received encrypted messages that had been intercepted over the radio.

In 1940, the team at Bletchley had broken Germany's intensely difficult cipher, Enigma. Codes and ciphers, terms often used interchangeably, are in fact distinct. A code replaces the word or phrase entirely, while a cipher only rearranges the letters. Both codes and ciphers make a message secret and comprise encryption. There were thousands of Enigma ciphers being sent by the Germans, and Bletchley Park was swimming in data, only able to decipher a percentage of the transmissions. But as the Allies were finding, breaking the cipher (as huge of a feat as that had been) wasn't going to be enough.

Even after the jumble of letters and numbers were deciphered, they still didn't make sense. There were too many acronyms to understand the cryptic transmissions, and then all the individual snatches of conversation needed to be pieced together to comprehend the larger message. The

codebreakers analyzed the material, fitting together the pieces of information like a puzzle. When they were done, the intelligence they had gathered, deciphered, decoded, and reassembled was called Ultra.

The group at Bletchley did not decide what to do with Ultra. Instead, the messages were disseminated to a select group of high-level agents at British intelligence and in the newly developed US spy services, who would use the hard-won intelligence to their advantage. These messages were precious and seen only by a small number of operatives. They were code-named Ultra because this prized wartime intelligence was considered elevated above even the highest British security clearance—it was the most secret, most valuable commodity the Allies had.

Meanwhile, half a world away from the front lines in Europe, another Wise Gal was struggling with her own sea of secret messages.

.

In Washington, D.C., months before Eitel moved to Portugal, his name was revealed in a coded message. It was winter, with air so cold and dry it could make your skin crack, but inside her office, Adelaide Hawkins was dripping with sweat. You might think the trouble was the stress of her job. As chief of the cryptanalysis section, she hired, trained, and organized her team of dozens of men and women. The center prepared messages, encrypting and transmitting them across the globe, before decrypting the replies and routing the messages to the appropriate individuals. Her office was nothing like the Bletchley Park complex across the Atlantic. Instead, the majority of American codebreaking during World War II was handled by the US Army Signal Corps and the US Navy Signal Intelligence Group. Addy's work was starkly different, yet it would wield a critical and lasting impact. She was on the forefront of an American experiment that would later be called central intelligence.

Addy was a founding member of a group that was fumbling for recognition: the fledgling American intelligence organization called the Office of Strategic Services, or OSS. The OSS was the world's newest

intelligence agency . . . and by far its least talented. The inexperienced US agency could hardly be compared to the well-established British intelligence service, a massive organization broken into MI5 for domestic spying and MI6 for international espionage. Yet the need for an American system of organizing, evaluating, and communicating intelligence operations across the globe was pressing.

On this Saturday morning in February 1943, inside the headquarters of the OSS, the problem was not the gravity of her work. Instead it was the stuffy basement in which she and her team were confined. There was no air circulation, and the room was packed with young people working elbow to elbow, dancing around the room during moments of success, and even occasionally breaking out into song. But no one was singing now. It was too hot. Then the door swung open loudly and General William Donovan walked in.

Donovan was known by the fun-loving nickname Wild Bill, although there was little crazy about his personality. The man who once planned to become a Catholic priest did not smoke or drink to excess. He was sixty years old and spoke in a reserved voice. He had a round face, a head full of gray hair, and blue eyes that, when narrowed at you, reflected the sagacity of his years of experience. All that experience and gravity was put to the test in his current role as head of the OSS.

As he barged into the room, he remarked, "It's awfully warm in here."

"I know," Addy replied mournfully. "The windows are closed and they've gone away without working on the air conditioning and I don't know what we can do." She gestured toward the small windows above their heads—they were at street level and didn't appear to open.

Although uncomfortable in the hot basement, Addy rarely complained. She was thirty years old, married with three young children, and she adored her job. She had initially joined the OSS in 1941 as a way to escape her annoying mother-in-law, a prickly woman who had come to live with the family after Addy's husband was deployed overseas. But she'd grown to love the work and the way it made her feel irreplaceable.

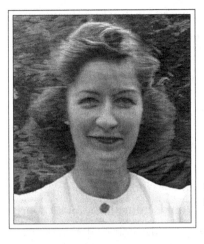

Adelaide Hawkins, 1941.
Courtesy of the estate of Adelaide Hawkins

She sat at her desk and pondered the stacks of paperwork in front of her. *We're fighting for our lives*, she thought to herself. *I can do this.* Yet when her thoughts turned to the men and women suffering overseas, she felt a sharp pang of guilt. If she was being truly honest with herself, she had to admit that she had never been so happy as she was right then, during World War II.

Like the work of everyone on her team, Addy's work was secret; she could tell no one in her household how she spent her days at the agency. To the outside world, even to her in-laws, she was merely a clerk. Addy found that people rarely questioned her. "Oh, is that so?" they would say, before losing interest in her unimpressive job. It wasn't difficult for her to keep quiet. Addy felt special, and she knew she was going to hold on to her secrets, no matter what.

The work represented far more than a retreat to her. She couldn't imagine her life without it. Still, she knew that she was considered a placeholder. Her position as chief was too critical to entrust to a woman, and certainly not one like her, a mere high school graduate from a small town in West Virginia. All around her were men who had graduated from Ivy League institutions, who were lawyers, professors, and journalists. It was only a matter of time before administrators hired a man to fill her position. She would then have to work under him, as a deputy.

Whispers about possible replacements were already circulating, and Addy knew that she needed to make herself indispensable if she wanted to keep her job. Right then, however, she was too hot to think.

"Why, you young people can't work like this," Donovan said as he looked around and then headed back to his office upstairs. Addy assumed he was getting on the phone to maintenance. Instead, a brown shoe suddenly kicked through one of the windows from the outside and her desk was covered in shards of glass. She stood, openmouthed.

"And a good thing I wasn't sitting down," she said.

The solution was pure Wild Bill—bold, immediate, and a touch reckless. Despite Donovan's age, there were moments when the years rolled right off his back. "Anyone could do it," he'd say, the excitement spreading across his face as he spoke of an operation's potential success. In reality, few were as skilled as Addy.

At the moment, Donovan was as animated as a teenager. Addy had decrypted a new message, deciphered its meaning, and then had rewritten its contents, jumbling its letters once more according to their code, so that it could travel secretly to Donovan's London office and then to Jane Burrell in France. The new intelligence would draw Donovan back across the ocean to London, where he would spend most of the next few years establishing a new group of spies, ones bent on penetration and deception.

.

Before President Franklin D. Roosevelt appointed Donovan to create from scratch the OSS (and its elite unit, X-2) in 1942, the United States had no spy agency. Even the remnants of the Black Chamber, a World War I–era codebreaking group, had been shut down decades earlier. What remained were isolated intelligence units serving the army, navy, and Treasury and State Departments, but which did not coordinate with one another. All that would have to change as the US joined the Allied forces in Europe to defeat the Axis powers. But how?

Donovan was a military man, but one who didn't stand on ceremony or even hierarchy in the manner of many career soldiers. For one thing, medals and awards were unimportant to him. Everyone knew that in World War I he had been awarded the prestigious Croix de Guerre, a French military honor. What was less well known was that Donovan initially refused to accept it. He would not take the accolade until it was also given to a young Jewish man equally as deserving.

Donovan also had a weakness for passionate eccentrics. He often observed that you could teach an operative strategy, but you couldn't make him care. He was looking for the people who cared fervently . . . and he found them in sometimes surprising places. With little value placed on social pedigree or military rank, Donovan selected a mix of artists, military men, scientists, movie stars, and, surprisingly, a multitude of women, to build the OSS. This first espionage force was instructed in languages and cloak-and-dagger techniques, and trained to kill. One observer described the ideal candidate as "a Ph.D. who can win a bar fight."

At Donovan's side was a young woman named Eloise Page. Her friends called her Weezy, but with her boss she was always Miss Page. Where the general was stocky and imposing, Eloise was petite, with high, delicate cheekbones and bright, intense eyes. She was twenty-one years old but moved through the world with the poise of a much older woman. Part of her graceful manner came from her upbringing in Richmond, Virginia, where she grew up in what was called a "first family," a prominent and wealthy social group that traced their heritage to early colonial settlers.

The last name Page raised certain expectations within her community. Her friends and family in Richmond expected her to marry well, start a family, live in the right neighborhood, and move in the proper social circles. Had World War II not intervened, it's possible that Eloise might have fulfilled those hopes, although not likely. She did not care much for others' expectations, often telling her mother, "I know my own mind."

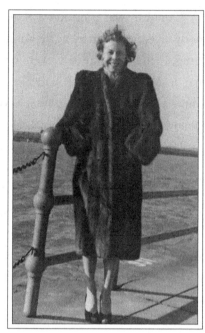

Eloise Page.
Courtesy of the estate of Eloise Page

Her friends would say she was "born to be a leader." A fresh college gradu-ate with idealistic ambition, Eloise was searching for purpose, and she found one while living in London and working a low-paying job under difficult wartime conditions. She was General Donovan's secretary.

The position was more akin to an aide-de-camp. Eloise not only organized and typed Donovan's correspondence, but she also helped write its content, as well as discuss strategy, organize Donovan's travel, and arrange meetings. It was a mountain of responsibility for a young woman who was habitually late for her own appointments. Still, Dono-van leaned on her: a year earlier, she had played a pivotal role in Opera-tion Torch, the invasion of French North Africa, and the first jointly planned operation between the United Kingdom and the United States. Hunched over reports and maps, carefully labeled with potential land-ing sites, Donovan and Eloise spent late nights together organizing the intelligence OSS had collected.

She had not always been so bold with Donovan. Initially she'd stood in awe of the general, but soon she learned to withstand the variabilities of her boss's hot temper and realized that he actually *wanted* her opinions. He loved to debate military and espionage strategy as much as she loved shaping his decisions. Although Donovan was known for his extramarital affairs, his relationship with Eloise was professional.

Donovan was accomplished at identifying young, talented individuals. In Eloise he recognized exactly the kind of woman he needed. With her Southern accent and diminutive size, she appeared a pampered socialite. Yet inside the tailored dresses and white gloves, Eloise never flinched. She was surprisingly tough and capable. While her family and friends saw her as a secretary, likely to return to the social set of Virginia after World War II, in reality she was already on her way to becoming a bona fide spy.

By 1943, Eloise was passionate about developing their X-2 network, the elite group of counterintelligence agents who acted as liaisons between British and American intelligence. Admission into X-2 was highly selective. Not only were its officers privy to the secrets behind wartime intelligence, but they also had the power to veto military operations without disclosing their reasons for doing so. It was the vision of this group of agents that dominated American counterintelligence operations in the final years of World War II. Eloise's strength lay in fostering relationships with British intelligence. As the name Carl Eitel passed back and forth between American and British intelligence, it was clear to both her and Donovan that this was a key opening for their new X-2 agents in Normandy.

.

Jane Wallis never expected to be living in France. When she'd applied for a government job back in 1941, she remembered seeing a line on her job application that read, "If you are willing to travel, specify: occasionally,

frequently, or constantly." Jane had marked an *X* next to "occasionally," hoping for the least amount of travel. It didn't work out that way.

Born and raised in Iowa, Jane found escape in the study of language. Fluent in French, she studied abroad, in Montreal and Paris, and traveled throughout Germany, Italy, and Spain. She had intellectual potency, graduating with a joint degree in French and English literature from Smith College in 1933. Her family would describe her as "witty and pretty" with dark brown hair, bright blue eyes, and an exceptional mind.

Immediately after graduation she eloped, marrying a man named David Burrell. She assumed her travels were over, and she settled into a life focused not on her love of language and words but instead filled with the expectations of a housewife and mother.

The children Jane hoped for never came, and instead of a house filled with babies, she found herself alone after her husband was deployed. Like so many women, Jane was determined to find her own role in World War II. The female labor force grew by 50 percent between 1940 and 1945, with 25 percent of all married women working outside the home. In 1942, Jane would become one of them, joining the OSS as

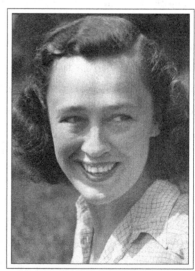

Jane Burrell, Bois de Boulogne,
Paris, 1945.
Courtesy of the estate of Jane Wallis Burrell

a junior clerk, at an annual salary of $1,440. Men in her position, with the same education and experience, were starting at an annual salary of $4,600.

She first worked in the Pictorial Records Section of the OSS, where bundles of photographs of various sites in now-Axis-occupied Europe were dumped on her desk, sorted by region. Her department's task was enormous—there were more than a million pictures to analyze—and in those confusing early days of World War II, the work was critical. Almost all the pictures of Europe had been taken years before, during the peaceful prewar days. Now, those same images allowed the Allies to re-create detailed and (more) current maps of the landscape where their soldiers would soon be fighting. The US government was placing advertisements in magazines and on the radio, asking citizens to mail in their pictures of European vacations. Pleas for more photographs regularly circulated throughout government agencies. "Possibly some of you possess a photograph," read one such request, "which, if properly used, could be a more deadly weapon than ten torpedoes or twenty tanks."

The pictures were used to identify targets and coordinate strategy. With a magnifying glass in hand, Jane went through the images, looking for clues. She often found herself in familiar territory, identifying streets in France that she had strolled down in real life. The work was tiresome, requiring an eye for detail and a patience to go back over the same images repeatedly. The results, however, were sometimes spectacular. Just by piecing together the blocks of a street in a small town in Germany from the snapshots of an American tourist, Jane helped lead to the destruction of a Nazi asset.

It wasn't long before the quality of her work brought her to the attention of her supervisors. James R. Murphy, chief of OSS counterintelligence, was impressed with Jane's analysis and her proficiency in languages. He decided that she was ready for more. In July 1943, she received a letter that would alter the course of her life. It said that she was being transferred overseas, stating with typical bureaucratic

terseness: "This transfer is not for your convenience, but in the best interests of the Government." The letter had been sent from the OSS.

The OSS was composed of novice American agents who were untested and very green. At first, the British wanted little to do with their American counterparts, who were more likely to bungle their plans than to actually assist in operations. They made an exception for one elite section of the OSS called X-2.

X-2 was made up of the best spies and communication officers the United States had at that time. These officers were specifically working in counterintelligence, which was related to (but distinct from) intelligence. Whereas espionage acquired information through clandestine operations, counterintelligence destroyed it. And in the case of X-2 counterintelligence, they were working hard to destroy the network of spies sent to infiltrate the Allies' efforts during World War II.

Instead of looking at photographs of vacations gone by, Jane was now firmly in the present. She traveled through the towns and countryside she had studied in detail, rarely getting lost. The intelligence she was receiving in X-2 was very different than mere photographs. It was the only division to receive raw Ultra material. As Jane sat at her desk in Normandy and held the German intercept that named Eitel, she felt fortunate for the convoluted path that had brought it to her—from Bletchley in the UK, through Donovan's situation room in Washington, D.C., to her small room in France. Little did she realize that the intelligence had passed through the hands of many hardworking women, just like her, who were doing vital work to win the war. Working as an intelligence officer was a career that hadn't existed a few years earlier, but now Jane valued it above all else—even her marriage.

Thanks to Donovan, X-2 was bustling with female officers, and Jane developed a diverse group of friends and colleagues overseas. They bonded over the urgency of their work, even as they kept the details of their operations confidential from one another. Their positions were

critical, as officers had to recruit, develop, and handle their own spies. It was late 1943, and Jane was ready to initiate contact with Eitel.

British intelligence was wary of working with newcomers like Jane; they eyed her and the X-2 unit with suspicion. While the Americans were struggling to start a spy organization, the British foreign secret intelligence service, MI6, had been operating in Western Europe for decades. Even as they were helping to establish X-2 as their American counterparts, they were hesitant to hand off responsibility to new agents.

However, Jane was not just any agent. She spoke French like a native, wore her hair and makeup like a Parisian, and made friends wherever she went. Ever since she was young, Jane blended seamlessly into situations. She had spent her life playing a series of roles expected of her: that of Midwestern daughter, then student, and finally housewife on a dairy farm. However, it was only now, as an American spy in France, that she felt she could be her genuine self.

The OSS station in Normandy where Jane worked was a villa with whitewashed walls and purple climbing wisteria vines. Inside, agents sat in a living room scattered with newspapers from multiple countries or moved quietly downstairs to a basement converted into a code room. From this base of operations, Jane plotted her strategy.

Meeting with Carl Eitel was simple. Selecting a time when she knew no one would be home, Jane and another agent entered his apartment building at 14 rue Victor Hugo unseen. They picked the lock at his door, ignored his belongings (which had already been searched by British agents), and then waited for him to come home. They weren't waiting for long.

It turned out the difficulty in this operation wasn't finding Eitel (he was hiding in plain sight); it was turning the German intelligence agent to work for them. At first Eitel was willing to admit to almost nothing. According to him, he had worked for Abwehr for only two years. He said nothing of ocean liners, espionage in the United States, or his

recruitment of agents. Jane began pressuring him, with threats of turning him over to the British or possibly to the Soviet Union. Most German intelligence agents would do *anything* to avoid the Soviet Union, whose treatment of enemy agents was rumored to be painful and deadly. The threat worked. Eitel, the son of a French mother and a German father, with close ties to his Jewish sister-in-law, had no real loyalty to anyone but himself, and so he agreed to work for the Allies.

Eitel would become a key part of a sensitive operation that Jane was part of: Operation Double Cross. MI5, the domestic British secret service, and MI6, the foreign branch, had been amassing a network of turned German spies who could be used against the Nazi intelligence service. Now, X-2 was joining the operation, recruiting and handling their own agents. Jane was working closely with British agents whose backgrounds appeared unblemished and whose loyalties seemed clear.

Working with another X-2 officer, Lieutenant Edward R. Weismiller, a Rhodes scholar with degrees from Cornell and Harvard, Jane began extracting information from Eitel.

"Who is John Eikins?" Jane asked.

Eitel was surprised. "How did you get that name?" he sputtered. But Jane refused to reveal that their source came from an Ultra communication. They couldn't risk the Germans finding out that the Allies had cracked the Enigma cipher.

Instead, Weismiller laid a heavy gold ring on the table. It was the perfect bribe for a man who loved to sparkle. With his new jewelry, Eitel revealed the name of the man he had spent the past nine years working with: Juan Frutos. He described him as a young Spaniard, a man who sometimes went by the pseudonym John Eikins, one of many agents Abwehr had sprinkled across the French countryside.

As soon as Jane and her team of X-2 agents had Juan Frutos's name, they began monitoring him. He was based in the French port city of Cherbourg. When he and his girlfriend left their apartment, the American agents broke in and combed the place. A cache of letters proved to

be a treasure. They found some from Eitel, corroborating their relationship, and others that seemed suspicious—a network of spies for them to track down, although they couldn't be sure the names were real. It was time to make contact.

Frutos had a lot to lose. He had two young sons, a wife . . . and a girlfriend. Even with these incentives, he didn't want to tell Jane anything. She knew Eitel had recruited him, but Frutos wouldn't tell her how long he had worked for him. He wouldn't even admit that he knew Eitel was a spy, instead only saying vaguely that he had suspected it. He certainly was not ready to reveal that he was a "stay-behind agent" in France, one of a number of men and women spying on Allied positions and troop movements along the coast.

As Jane questioned Frutos, her frustration grew. The man was pretending that he couldn't remember names or dates. He stumbled in his speech, refusing to give details and rambling on about Spain. Jane knew that while getting information from Frutos was important, the most crucial task was recruiting him to work for her and the Allies. It was clear that Frutos was not an idealist; certainly he was not devoted to Germany or that country's ideals. Rather, he was merely a man trying to save his own skin. She wouldn't even need a gold ring to pull him to their side.

Jane reasoned with Frutos, acting as his friend and working on his confidence. She promised him some money and told him it would be in his best interests to come over to her side. Other agents stressed that they knew he was lying and that the consequences would be bleak unless he cooperated. They kept up the pressure, holding Frutos for five long days until they were able to turn him. The real exertion, however, was still ahead.

Jane pondered the value of her newest spy. To some, it might have seemed that he was just one unimportant man, a mere underling in the vast army of Allied operations. His loyalties were hazy and his intelligence limited. Yet in the distance, Jane, along with a select group of her colleagues, was preparing for an invasion of staggering proportions. A

future was emerging where this one man, buried deep behind enemy lines, would play an essential role. This glimpse of victory, however, could emerge only if Jane was able to control him.

.

Running agents was dangerous, complex work. It required intimate knowledge of the operation, the enemy's position, and the Allies' immediate and long-term goals. It was also frequently deadly. A quarter of all espionage agents in France were killed, and those numbers were even higher for women operatives. Female couriers were a common target for the Gestapo, and even the possession of a wireless radio was a crime that carried a death sentence.

Jane was responsible for a handful of agents. She met with them covertly, assessed their abilities, and clearly defined their roles in an operation. She monitored Ultra transmissions to ensure that information was being passed appropriately and that her agents were acting on the counterintelligence as X-2 predicted. They called it a "closed loop" system because they could feed the information to the Germans and then watch it come out the other end in Nazi communications. With sophistication and caution, Jane constantly tested her agents' new loyalties.

In May 1944, with speculation of an imminent Allied invasion at a fever pitch, Abwehr sent Frutos two radio sets and strict instructions to report on the arrival of ships, numbers of soldiers, their weaponry, tanks, and artillery. Here was an ideal opportunity for Allied intelligence operations, but the intrigue proved too much for Frutos. In fear for his life, he hid both radio sets in the attic.

Frutos had gone dark.

With British intelligence struggling to control the wayward spy, X-2 agents took command. By July 1944, they had convinced Frutos to continue. He was too far in to back out now. That summer, Jane began calling Frutos a new name. They had played with the code name Pancho before finally deciding on Dragoman. With German intelligence

focused on Dragoman and his suspicious, intermittent reporting, Jane was imperiling both their lives with every contact.

Jane knew that time was crucial to their operations. Every day that Dragoman was quiet would inflame the Germans' suspicions. With nail-biting anxiety, Jane checked the Ultra messages incoming from Bletchley, searching for clues. She suspected Dragoman was being watched, although she didn't know who among the modest countryfolk living alongside him might, in reality, be a German spy. X-2 was reporting there were at least two Abwehr agents living in Dragoman's neighborhood. They might sniff out the truth at any moment. If he was even suspected of working with the Allies, the game was over.

Meanwhile, X-2 was losing control of Dragoman/Frutos's other contact, Eitel. He was bragging to his friends that he was secretly working for the Americans, showing no discretion whatsoever, while simultaneously missing liaisons arranged in Paris with X-2. Even worse, in early 1944, he traveled to Berlin. *What is he doing there?* Jane and the X-2 spies wondered. The Americans did not know the purpose of his trip, but they certainly had their suspicions. Arresting Eitel upon his return, they found his responses contradictory and unhelpful. Something needed to be done about this potentially rogue double agent.

One line in an X-2 agent's report underlined the danger Eitel was in if they couldn't match his accounts: "If such [a] story is not proved, he should be executed."

Eitel might have been faltering, but Dragoman was finally beginning to prove his worth. His secrecy was critical, as Jane knew he would play an important role in X-2's next, most vital mission: Operation Jessica. The plan was part of a larger deception run by the Allies.

If Allied forces were going to successfully invade Western Europe following the D-Day landing in France on June 6, 1944, they needed to overtake strategic French port cities. These key locations could supply the invading army with reinforcements and supplies, assisting Allied troops as they moved through France and into new combat zones. The

operation was delicate: the Germans needed to believe the Allies were present in large enough numbers along the border between France and Italy so that they would hold the position of Nazi troops and U-boats, but not so large that they would preemptively attack. Meanwhile, the Allies were focused on France's Brittany coast, a region located west of the D-Day landing sites that would be critical for the invasion of the continent. As luck would have it, it was here that Dragoman resided as a stay-behind German agent and spy for X-2.

The port city of Brest, France, Eitel's stomping grounds, was now considered vital for the Allies to overtake. To fool the Germans, the Allied forces employed life-size imitation ships, tanks, and aircraft in decoy locations surrounding Brest. But this ruse had a flaw: by itself, the inflatable equipment was comical. It looked real only from a distance, and to give the ploy credibility, the Allies needed the corroboration of their double agents. In a coordinated effort, the British secret service and X-2 instructed their spies to flood Abwehr with misinformation.

As Jane and the X-2 team readied Dragoman to be a trusted source of (false) information for the upcoming invasion of Brest, they first gave him real intelligence on Allied operations to prove his worth to the Germans. It was a nail-biting moment. They hated giving the Germans any genuine information on their troop movements or locations. Yet Jane knew it was a necessary evil if Dragoman was to gain the trust of Abwehr. They planned to give the Germans just enough credible intelligence for them to believe Dragoman, and then they would begin their true mission of misdirection. This proved challenging, as Dragoman's previous messages to Abwehr were brief and lacking in detail, and an abrupt change would prompt suspicions. They raised the character count slowly, from eighty words up to ninety, until they stretched the reports into pages. The messages worked. The Germans were impressed with Dragoman's more detailed reporting, little suspecting that X-2 agents had written the transmissions.

The inflatable army was a success. Allied forces soon overtook Brest and Dragoman's spying gained critical importance. In December 1944, the German offensive campaign in the Ardennes Forest between Belgium and Luxembourg forced Allied forces into the Battle of the Bulge. Under the direction of Jane and X-2, Frutos responded by obtaining technical details on anti-torpedo nets used to protect ships from German U-boats. Frutos gave considerable data not only on the anti-torpedo nets but also detailing convoy routes and describing the vast damage caused by the German V-bombs. Every word was false. X-2 agents crafted each transmission, working together to edit the text until it meshed perfectly with all the information they and MI6 had fed the Germans.

In the last days of 1944, Allied troops were able to reinforce and resupply their forces in the Battle of the Bulge from crucial French port city locations, while the fearsome German U-boats sped toward the sites X-2 had directed them to, far from resupply lines. Speaking of Dragoman, one report read, "[x] might have had a decisive influence on the whole German U-boat campaign in American and British waters."

Jane—and the network of X-2, OSS, and MI6 spies across the world—had saved countless Allied troops' lives.

.

Multiple (secret) reports written in 1945 heaped praise on Frutos and his role in tricking the Germans. The same cannot be said for Eitel.

Following his arrest in France, Eitel was brought, unwillingly, to England. No longer needed by X-2, he was interrogated by the British secret service and was treated as one of many German agents being questioned following World War II. Despite the key role he played in leading the Allies to Frutos, Eitel's allegiance was murky at best. No one could be sure if he had been under X-2 control, or really an agent of Abwehr, or some perverted combination of the two. The investigators carefully lined up his stories, trying to ferret out the truth. They showed

him dozens of photographs, testing his knowledge of German agents but also hoping to gain his collaboration. He detailed his early history in espionage, but the end of his career was poorly defined. "He appears to be three different men," read one report, connecting Eitel with two other names he used: Gross and Eberle.

At the end of 1945, reports made from Camp 020, the interrogation center in London where Eitel was held, describe his health as good. No one knows what happened to him after that. He never returned to his bistro or to his girlfriend. One cryptic line is found in his files: "A sad end for a double agent." A list of his personal belongings, which appear to have been unclaimed, included cash, clothes, and a large collection of gold jewelry.

While the fall of 1944 was the beginning of Eitel's end, as both a spy and possibly as a man, the Wise Gals basked in its glory. By early 1945, the momentum was building in their work. Yet even as they came tantalizingly close to what they hoped would be Germany's surrender, they could see the long tail of the Third Reich following them.

Both Eloise and Jane were troubled with one particularly frightening intelligence report. It concerned a meeting that took place on August 10, 1944, at the Maison Rouge hotel in Strasbourg, France. In attendance were the titans of German industry: the leaders of IG Farben, Krupp, Leica, Messerschmitt, and Zeiss, among others.

The events of 1944 had brought clarity, even to members of the Nazi Party, that Adolf Hitler's regime was coming to an end. In response, the men who had massively profited off the Nazis gathered to protect the enormous wealth they'd accumulated. Their plan was clear: transfer the money to Swiss bank accounts, then divert the money to shell companies in neutral countries. They knew the Swiss would be amenable to the proposal, especially if they gave them 5 percent of the profits. Once the world cooled off, the money could be used to fund the Fourth Reich. An underground movement to hide Nazi treasure, gold, jewels, and artwork was spreading across Europe.

The Wise Gals were sharply aware that the Nazi Party would not go quietly; they would merely blend in with their surroundings. Like cicadas, they would remain hidden underground, waiting years if necessary, until the world was ripe for their resurrection.

It was time to get digging.

SAFEHAVEN
1944-1945

He's impossible, Eloise thought, her frustration mounting. *Unreasonable, and totally thoughtless.* She had been up until three in the morning with her boss, General Bill Donovan. It was early May 1945, and they had spread their operations across an entire floor of Claridge's, a swanky five-star hotel in central London. The hotel was perhaps too polished for the Americans' endeavors. In rooms considered worthy of royalty, they plotted strategy, bribery, and even deadly retribution.

Eloise was accustomed to the long hours—after all, she'd been working for the brilliant, mercurial Wild Bill for three years by now—but her irritation intensified when, upon returning to the makeshift office four hours later, Donovan asked, "Is the dictation done?" She wanted to scream. Instead she merely replied, "No," and drew up her chair to the typewriter. Donovan's unreasonable expectations rattled her.

One might have thought that the end of the war would mean *less* exertion and pressure for Eloise. Instead, the burdens were building. Donovan wanted to build a permanent American organization that echoed the sophisticated success of British intelligence operations, but he found support wavering in Washington. The OSS was fragile, an organization that could be easily crushed by politicians who saw the end of World War II as the termination of big government.

Victory was a temptress, potent to those who would prefer to leave

Europe and the costly rebuilding of the continent to others. To do so was to close one's eyes to the threat of potential conflict as well as the punishment of prior evil. Even as they fought the war, Donovan was preparing for the eventual prosecution of Nazi war criminals. As early as 1943, he suggested holding the trials in Nuremberg; he wanted the Third Reich to symbolically fall in the place in which it had originated.

In order to try them in court, however, the criminals had to be caught. After four years of training with Donovan, Eloise was ready. As she typed up his dictation in London, connected his phone calls, and responded to his mail, she knew that each administrative act was nearly her last. Soon she would immerse herself in the world of spycraft and leave the secretarial drudgery behind. She would not mourn the change. Being a secretary for Donovan was demanding, and she yearned for the next phase of her life to begin.

While Eloise relished what lay ahead, her parents fretted over her future back in Richmond, Virginia. As the rolling hills of the Shenandoah Valley turned from brown to bright green with the warm rains of spring, so was life returning to what it had once been. Even before Germany formally surrendered, men were returning to their jobs, women were leaving the workforce, and the rations on food, gas, and even toothpaste were lifted. Yet Eloise still didn't come home.

When their daughter did return, late as usual, she was home only briefly, to pack up a few of her things before leaving for good. She wasn't telling her family many details about her new career. They understood that she wasn't a secretary anymore, but in Eloise's vague job description they couldn't piece together exactly what she would be doing.

Her mother could still remember what it felt like to see her eleven-year-old daughter cross the stage at the Peabody Conservatory of Music in Baltimore. The young girl, in her best white dress and with her hair curled, had fearlessly sat at the piano and begun to play. After her fingers touched the last keys of the piece, she stood up and curtsied in front of the audience. As she clapped at her daughter's performance, it seemed she was seeing

into the future. She pictured Eloise grown into a musician, her talent in the arts unparalleled. When Eloise was accepted into Hollins College in Roanoke, an exclusive women's college, and majored in music, she was certain this vision would be realized. Now her world had been shaken off its axis with a single sentence from Eloise: "I'm moving to Brussels," she said.

"Working for that general?" her mother asked.

"Yes, and I'm working for the government . . . ," Eloise said, keeping her phrasing ambiguous. "In intelligence."

"Isn't that a strange profession?" asked her mother. Eloise just shook her head; she had nothing to say.

During the war, Eloise had understood who her allies were and which countries they were fighting against. Now, in 1945, nothing was clear. She was entering a country tangled with loyalties she did not fully comprehend—with consequences she couldn't yet fathom.

What would happen if the former "good guys" became the enemy?

.

It started with a gunshot.

The year before, in the dark morning hours of September 1, 1944, an assassin moved up rue Defacqz, a quiet street in the wealthy Saint-Gilles community just outside Brussels. The avenue was lined with leafy, green trees bordering an elegant row of brick townhomes. Gunfire suddenly split the air in front of house number 71. The city itself was in upheaval, on the precipice of liberation by Allied forces, and the streets had become chaotic as German troops withdrew from the city into the countryside. The sound of commotion and even gunfire in the street was not uncommon. When the shots were heard on that September morning, however, neighbors peered out their windows cautiously. They saw a man running down the road, dressed in the drab green fatigues of the Russian Liberation Army.

In the street below lay two bodies.

Killed by machine gun, in front of his home, was Jurij Vojcehovskij,

along with his bodyguard, Aleksej Litvinov. Vojcehovskij was the leader of the Russian community in Belgium. Appointed by the Nazi Party, he was part of a scheme by the Gestapo to seize control over Russian citizens in exile. Vojcehovskij had ruled over his community mercilessly, slicing through the ethnic divisions of his fellow Russians living in Brussels and abroad and segregating them as "good" (i.e., loyal to the Nazis) or else "too Jewy" or "Freemasonry." The latter two designations were a death sentence. (Of course, the real rub was that the leaders in Berlin to whom he was so loyal didn't even see those distinctions. Rather, Hitler called all Russians "*untermenschen*," or subhuman.)

Despite the Nazi party line against Russians, Vojcehovskij idolized Hitler. Following an attempt on Hitler's life in July 1944, he wrote a letter to Berlin, which read, "A miracle happened, there is no other way to describe it. The Führer remained alive. Providence not only saved him, but all of us, too, our families, our peoples." The bomb, placed in a conference room by those in the German resistance, had punctured the dictator's eardrum but left him otherwise unharmed.

Vojcehovskij's loyalties exposed the complexity American intelligence was wading into. Where the Russian leader in Belgium would once have been viewed as an enemy, the growing divide with the Soviets meant that men like Vojcehovskij now had more in common with American interests than with their ostensible allies. The world's two most powerful nations had very different visions for the future of the European continent and the world. Distrust and hostility swelled.

As Vojcehovskij lay dying in the street, he perhaps prayed for the same divine mercy to spare his life that had wielded its cryptic wonder on the Führer.

Fate, however, had other plans.

.

Adelaide had spent her entire adult life chasing Ed Hawkins, but now she was ready for him to disappear.

Unlike Eloise (whose employment with General Donovan meant she was usually outnumbered by men in any situation), *women* were the only constant in Addy's life. In her office in Washington, D.C.—the one where Donovan had once kicked out the window on a hot winter day—she watched the men move through the workplace like a mountain brook, their training typically rocky and difficult at first, before they flowed smoothly into field positions. At home, men were just as transient.

Addy and Ed met when Addy was eighteen years old. She was a West Virginia girl, raised in Wheeling, a small steel mill town on the Ohio River. Her father had never finished the fourth grade, and so he took whatever odd jobs he could find, sometimes sweeping floors in a factory to make ends meet. With the bills piling up, her mother sent Addy to live with her aunt in order to ease the financial burden on her family.

Addy was not the kind of girl anyone expected much of. Unlike the social climbers she would hire in the years ahead, she was a country girl with little education, who at nineteen found herself unexpectedly pregnant. While Addy came from a family of nobodies, the same could not be said of Ed Hawkins, the father of her unborn baby. His parents were college graduates who inherited a pawnshop and lived in a majestic three-story mansion.

When it became clear that her daughter and Ed would have to get married, Addy's mother decided to forge a relationship between the families. Afraid that the Hawkins family would be repulsed by their modest home, they invited their future in-laws to a picnic in the park. They laid out a blanket and spread out a mix of Southern cooking for their guests. When the Hawkinses arrived, their chauffeur pulled a folding table and two chairs out of the trunk of their car. Addy and her family watched in astonishment as Ed's parents took their seats, literally looking down on them.

Addy's mom whispered to her daughter, "Have they ever been to a picnic before?"

The picnic would foreshadow the family tensions that lay ahead. After their baby was born, a daughter they named Sheila, Ed left for

Colorado. He was running a sandwich shop, delivering BLTs for a nickel apiece, when Addy showed up on his doorstep. It would become a pattern for them: Ed running off, wallowing in childish fantasies, while Addy tried to hold the family together.

By 1939, the couple had three young children and were living in Washington, D.C. World War II was the event that finally took Ed beyond Addy's reach once and for all. He enlisted in the army and was shipped off first to New Guinea and then to Australia, spending mere days out of every month at home. Even when he was at home, it was obvious to Addy that he wished he were somewhere else. He would caress his dog, a Doberman named Kurt, with more love and affection than he ever bestowed on her. The children withdrew from him. When he walked in the door, there were no cheers of "Daddy," and not one of them threw their arms around him. Instead, they looked upon their father as a stranger, which, sadly, he had become to them all.

Ed's mother, meanwhile, was living with Addy and the children in

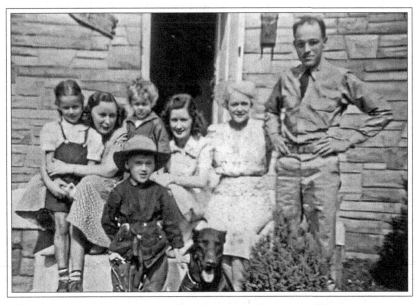

Adelaide Hawkins (center) with family and Doberman Kurt, 1941.
Courtesy of the estate of Adelaide Hawkins

their house in Silver Spring, Maryland. Her attitude had changed little in the decade since Addy first met her. She was selfish, demanding, and often cruel. When Addy's youngest son lost a rubber band, she slapped him hard across the face, causing the four-year-old to sob in confusion and anguish. Showing no remorse, the woman complained that her grandchildren were "awful, horrible creatures" and promptly moved out. Addy was not sorry to see her go, but she was suddenly left without any child care—a necessity for her work in the OSS secret basement to continue. For a time, Addy's mom came to help, but the solution was short-lived.

With mixed feelings, Addy placed her three elementary-school-age children—Sheila, in fourth grade; Eddie, in second; and Don, in first—into nearby boarding schools. For herself, she rented a room on Butterworth Place in the American University Park neighborhood of D.C. It was 1944, and for the first time in her life, the thirty-year-old had roommates: two young women who worked for her. Without regret, she shipped off Ed's dog to a kennel, perhaps the only creature in the house that would truly miss her husband.

The freedom opened up a door in Addy's career. She could work late, travel freely as needed, and immerse herself in the ciphers of war. She felt like the men she worked alongside: unburdened by the daily expectations of womanhood. There were twenty men and only three women in her department. The men were all similar: mostly from the Northeast, educated in Ivy League schools, and often from society families. Among this set they flippantly called the OSS "Oh, So Social." Yet it wasn't their spot on the social register that had earned them a place in Donovan's message center.

It was Addy who influenced who got into the sensitive department (and who didn't) with a battery of clever tests and assessments.

When making hiring decisions, Addy gave the applicants a standardized test but then asked, "Do you like crossword puzzles? How about bridge? Do you play chess?" She couldn't talk about their work

directly, and she couldn't share the operations the team was part of, but she could pull out a chessboard and try to assess their mental ability. Their work decrypting communications, generating ciphers, and transmitting messages across the world sometimes felt like a maze. Progress could be slow and frustrating, with each letter requiring multiple permutations, but if you found your way through to the other side, the win was gratifying. Every cipher that came through was a challenge, a puzzle to decipher, transmit, and encrypt in a war that relied on secret messages. The men and women she hired were going behind enemy lines and needed to communicate securely with her back in Washington.

While she was adept at creating ciphers, breaking codes was not part of Addy's work. In fact, the majority of American codebreaking during World War II was handled by the US Army Signal Corps and the US Navy Signal Intelligence Group. During the war, both groups employed hundreds of cryptologists, from a diverse array of backgrounds. Addy's accomplishments lay not in the number of messages she translated but in the form of centralized intelligence she organized. In addition to training the agents going into the field, she devised a system where their communications were securely sent to all officers plotting strategy in the region. Using a tiered system of cryptonyms linked to an officer's clearance level, she could ensure that messages went precisely where they were needed, both at headquarters and in the theater of war. She was creating a network that would prove as critical after the war as it had been during.

Addy had been taught directly by William and Elizebeth Friedman, pioneers in the world of codes and ciphers. Elizebeth in particular had spent months with Addy in 1942, teaching her not only how to break and make ciphers but also providing her mentorship.

Addy was struck by the fact that Elizebeth was just "as famous" as her husband. She'd met so few women with prominent careers. She reached up on her bookshelf and grabbed a slim volume, *The Shakespearean Ciphers Examined*, by William and Elizebeth Friedman. It was

a gift from Elizebeth and was extremely precious to her. She'd wrapped up the book in plastic and swore that she'd never let anyone borrow it. Now, however, she brought the book down gently, caressing its cover as she flipped to an inscription on an inside page. "To a dear friend," it read, and below was Elizebeth's scrawled signature. Addy clutched the book to her chest.

Elizebeth had enormous influence on Addy, and they respected each other greatly, but Addy could also sense something else from the famous codebreaker. Was it . . . pity? Addy was sharply aware of how others, particularly those brought up in privilege, viewed her because of her humble background and soft Southern accent. She shook her head. She didn't care; she was seizing an opportunity that would not be granted to her back home in West Virginia. This was her moment, and she was going to grab it.

With Addy's job came newfound freedom and a fierce sense of independence, but also sadness and guilt. She worried about her children and the increasing fragmentation of her family. At times she felt fortunate; she knew that the war was dividing families across the globe, with many separated permanently. She *should* be happy. Grateful, even.

Still, in moments of reflection, she wondered if she would ever truly be settled again. Who, she wondered, was on her side?

.

During the war, while working at the side of Bill Donovan, Eloise had become strangely accustomed to the rubble of London. At night she fell asleep to the sounds of gunfire and sometimes explosions. "London can take it!" was a phrase Eloise knew well, from the 1940 British propaganda film of the same name, a stand of defiance for a city that had lost tens of thousands of lives and more than a million buildings in German aerial attacks.

By contrast, Brussels was an alien landscape for Eloise. The city had been largely untouched by the bombings that had rained down on its

neighbors. Seventeenth-century bronze statues still lined the streets leading to the city center, while the Grote Markt, the city's grand square, glistened in opulence and beauty. The cobblestone streets of the capital were barely even scuffed. The city had been occupied by Nazi forces since May 28, 1940, when the Belgian army surrendered to Germany, its soldiers becoming prisoners of war and its leaders in exile in Britain. Four years of German occupation had left the country of Belgium intact but decimated its Jewish citizens. Of the approximately fifty thousand Jews who lived in Belgium prior to 1940, half were killed in German concentration camps.

Eloise had recently been transferred to Brussels, and she wondered what was ahead for her. What secrets this still-beautiful city held. And if she was up for the task.

What Eloise did not tell anyone, not even her parents, about her new government job was that she was not going to Brussels as a clerk (though that was her cover story). No longer Donovan's secretary, she had been promoted by her boss and mentor to lead one of America's first postwar intelligence stations in Europe.

Eloise Page had gone from Southern belle to spy.

Her orders in Brussels were to hunt down Nazi agents. However, the city itself was akin to a living, metamorphizing animal. In addition to the infusion of hidden German agents, Brussels had become a hub of Soviet activity in the last year of World War II. One reason for this was as clear as a corpse lying in the street: Jurij Vojcehovskij.

Before his assassination in 1944, Vojcehovskij harbored a deep hatred of communism. The emotion was sown from the death of his father, an officer in the Russian Liberation Army, who had been killed by the Bolsheviks two decades earlier. Born into wealth and privilege, he considered himself above much of the Russian community he controlled in Belgium and so used his position as a vehicle for personal retribution and economic gain.

Vojcehovskij was part of a first wave of Russian emigrants to flee

their homeland after the country's civil war. A second waves of exiles, prompted by World War II, was composed of an incongruous mix of Red Army soldiers turned Nazi sympathizers, escaped prisoners of war, and forced laborers. Belgium was unique among Western European nations for being the only country with an *increase* in Russian immigration in the late 1930s. As the numbers of newcomers swelled to at least eight thousand, those who opposed Soviet rule clashed fiercely with its communist ideologues.

American and British intelligence viewed the aftermath of Vojcehovskij's death warily. In ideology, he was not markedly different than many of their new anti-communist collaborators. His murder ripped open the divisions inherent in Russian communities in Europe at the end of World War II. Newspapers debated whether Vojcehovskij was targeted by the Russian resistance movement or killed by his German collaborators. The unsolved murder undoubtedly weighed on Eloise's mind as she mounted her intelligence operations in Brussels, particularly as she received numerous reports from the Belgian police about the assassination, and its fallout, upon her arrival.

No matter who had killed Vojcehovskij, Eloise was certain to be working with those who had plotted his downfall. American intelligence was playing all sides, meeting with the myriad anti-communist Russian resistance groups in Belgium whom the Soviets demanded be extradited, Nazi collaborators, as well as Soviet and Polish intelligence agents. Every week, Eloise's reports uncovered new connections her station had formed in the city. She was there to hunt Nazis, but the rising tensions between American and Soviet interests could not go unnoticed.

The alliance between the two nations had been forged in a collective need for the defeat of Nazi Germany, but the partnership was fraying. The oppressive nature of the Soviet regime and Joseph Stalin's aggressive pursuit of Eastern Europe had sparked a layered interplay of sociopolitical and socioeconomic influences.

Simply put: America's partner was about to become its biggest foe.

And into this already shaky situation, new influence was about to upend the destiny of the two nations. In the summer of 1945, while Eloise was setting up her postwar station, a mushroom cloud formed over the Jornada del Muerto desert in New Mexico. Shortly thereafter, in a meeting in Potsdam, a suburb of Berlin, US president Harry Truman hinted to Stalin about the weapon whose destructive power was nearly ready for its unveiling. If Truman expected a dramatic reaction from the man he privately called "Uncle Joe," he was disappointed. Soviet intelligence had already debriefed Stalin on the American development of atomic weapons. It was the first time the atomic bomb was openly discussed between the Soviets and the Americans, a weapon that was about to wield enormous influence. "A complex weapon makes the strong stronger," George Orwell wrote in 1945, "while a simple weapon—so long as there is no answer to it—gives claws to the weak."

The Nazis were attempting to claw their way up without armaments. A hidden river ran through Germany, one whose dirty waters could propel them into power years after their surrender. The money flowed swiftly, curving through the countryside, threatening to destroy every innocent person in its path.

WERWOLF
1945

A howl wailed across radios in Germany throughout April and May 1945. Every broadcast of Radio Werwolf started the same way: the plaintive cry of a lone wolf. Then a high-pitched female voice sang in German, "I am so savage . . . Lily the werewolf is my name . . . I bite, I eat, I am not tame . . . My werewolf teeth bite the enemy, and then he's done, and then he's gone . . ."

After the music finished, the program began. "Hatred is our prayer, and revenge is our war cry," the host said, instructing his listeners to "fight on even if we suffer military defeat."

What began a year earlier as Unternehmen Werwolf, or Operation Werwolf, a covert operation that dropped trained German forces behind Allied lines, had grown in the waning days of World War II into an expanded propaganda program encompassing both SS officers and civilians. The end of the war was not going to mean the end of the fight.

And the Allied forces had taken notice.

"Every friendly German civilian is a disguised soldier of hate," warned a series of radio spots on the Armed Forces Network. "In heart, body, and spirit every German is Hitler. Hitler is the one man who stands for the beliefs of Germans. Don't make friends with Hitler. Don't fraternize!"

The advice continued: "If in a German town you bow to a pretty girl

or pat a blond child, you bow to Hitler and his reign of blood. You caress the ideology that means death and persecution. Don't fraternize!"

A year earlier, in 1944, Allen Dulles, chief of the OSS in Bern, had reported similar fears to Donovan. "Upon the German collapse," he warned, "hundreds of thousands of Nazis and SS will attempt to hide themselves in the German community. There are various conflicting stories as to the extent to which they are already preparing an underground movement." The threat was clear: even after the official end of World War II, German agents weren't going to disappear.

And neither were OSS agents—especially the elite X-2 division.

It was a warning that Jane Burrell heard loud and clear. As a counterintelligence agent in X-2 in the waning days of the war, her aim was to gain information from captured German officers. If threats didn't work, she tried bribes. A heady mix of fear and friendship was necessary to produce and control the agents. And with the end of the war upon them, her attention had been drawn to the mountainous regions of southern Germany and Austria.

American intelligence had recently confirmed the presence of German fortifications in the Bavarian and Austrian Alps. For Jane and the other agents of X-2, Operation Werwolf and the resulting resistance of the German forces (even after the official end of hostilities) came as no surprise. SS officers were fading into their communities, hoping to escape punishment while hiding the spoils of war.

They couldn't allow that to happen.

.

Arriving in Munich on May 17, 1945, Jane Burrell found the city around her completely altered from her memory. Gone were half the city's homes, now unsteady mounds of lumber and stone. It seemed like a lifetime ago that Jane had traveled through the city as a naive twenty-year-old college student, a woman who knew nothing about fascism or Nazis. She could have no idea that fifteen years later she would become

unrecognizable, an entirely different person both in character and in purpose. She was as changed as the city that lay in ruins around her.

Munich was full of danger. The werewolves were active in the once-glorious city that the Nazi Party had called the "Hauptstadt der Bewegung," or the capital of their movement. Now Munich was broken but not destroyed—a strong undercurrent of German resistance remained in the city, and Jane was there for one purpose: to hunt Nazi spies and seize their treasure.

It was treacherous work, and Jane never forgot the stakes. Kept on her person at all times were two supplies of pills. The first was called the K-pill. The *K* stood for "knockout." The pill contained a large dose of hydrocodone that could be given to a target Jane needed to incapacitate.

A sheet of instructions that came with the vial of K-pills read, "For a small man, use 3 tablets; for a large man, use 4 tablets . . . Crush the tablets and add to drink or liquid food. It is better, if possible, first to

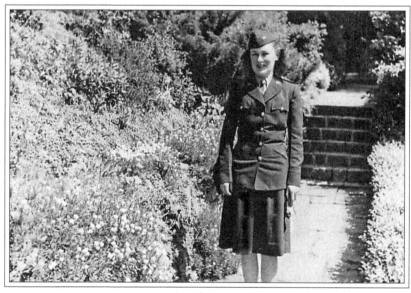

Jane Burrell in uniform, Heidelberg, Germany, 1945.
Courtesy of the estate of Jane Wallis Burrell

dissolve the crushed tablets in a little water (up to four will dissolve in a teaspoonful) and add this solution to the drink or liquid food. The crushed tablets will not dissolve easily in a strong alcoholic drink." The tablets were meant to work quickly, within half an hour, but Jane's instructions also warned that they might work too well. "Death is most likely to occur," the instructions read, "if the victim is left exposed to cold or wet while he is asleep."

The second supply Jane carried was the L-pill. The *L* stood for "lethal." Made from potassium cyanide, the pill was meant for her. No instructions came with it, as none were necessary. If she was captured and it was clear that her interrogation would lead to torture and death, she was to kill herself with it.

Alongside Jane was a man she called the Ostrich. With his receding widow's peak, thin mustache, and short stature, he appeared insignificant. However, in reality he was a prized agent—a man whose allegiance had proved exceptionally difficult to obtain. When first arrested by American soldiers in France in 1944, where he and another man had been caught attempting to blow up gas lines, he'd refused to answer any questions or give up a shred of usable information. The truth had been pounded out of him violently by British intelligence. Stubbornness in the face of violence was a sign that Jane recognized: it meant he was thoroughly committed to the Nazi Party.

The Ostrich was not German. Before he assumed the label of a flightless bird, he was born Ludwig Nebel in Switzerland. After he had crossed illegally into Germany in 1942, he had volunteered for the Waffen-SS, the military branch of the Nazi Party, but was soon shuttled over to the intelligence agency given his extreme loyalty to the Germans. Nebel hunkered on the Swiss border, where he spied on radical right-wing political parties that the Third Reich considered as possible allies, such as Volksbund, Front, and the Swiss Fascists. After his commanding officer was sent to Berlin, Nebel followed and learned that his work spying on the radicalized youth of Switzerland was no longer of interest.

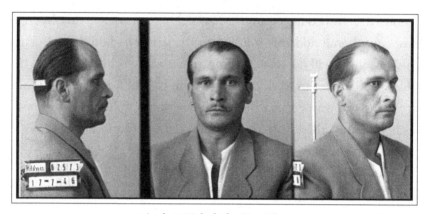

Ludwig Nebel, the Ostrich.
Credit: National Archives and Records Administration

Instead, he was receiving a rare opportunity: A-Schule West (Agent School West), which was operating out of a country house near The Hague.

The school focused on sabotage, and Nebel was trained in detonating gas lines, the chemical effects of various bombs, and how to charm those he crossed paths with in enemy territory. He was also trained in the ways of the Allies. "I was particularly interested in the enemy's training and instruction methods," said Otto Skorzeny, the German commanding officer of the school. "I asked our interrogators to devote special attention to that aspect." Far too many German intelligence agents were being turned by the English and the Americans, and Skorzeny was looking for "dedicated, idealistic volunteers," such as Nebel. "If a man wants paying before he will risk his life," Skorzeny said, "one cannot expect much force of character."

This was the Nebel Jane had first met back in 1944. She knew him then as a saboteur and a man who snuck both counterfeit bills and information across enemy borders. But even under pressure, the information he provided to X-2 and MI5 was limited. His dates were confused, and the names he sputtered out were worthless. She knew there had to be more. Nebel must be convinced to talk.

As isolation and psychological distress were getting them only so far, Jane and her fellow agents tried another tact: bribery. His gold watch was returned to him, and he was promised 1,000 marks, a considerable sum, for his cooperation. It worked: Nebel accepted the gifts and wrote out a full confession of his childhood, Nazi recruitment, training, and criminal activities. He left out only what he felt certain X-2 couldn't ascertain from any other source.

Jane was becoming known as a particularly skilled interrogator, but it wasn't every agent that X-2 was willing to spend so much time and money wooing. Nebel was special. Jane's supervisor and the director of X-2 in Paris, Major Franklin P. Holcomb, described Nebel, aka the Ostrich, as an "agent of rare importance, fully trained in sabotage, well acquainted with both officials and operations of the SD [German intelligence], and also briefed to contact a large stay-behind network in France." He would, they hoped, be the key to unlocking the network of high-level Nazi officials who were attempting to hide among the rest of the populace during the confusing postwar period.

Yet even with a confession in hand, X-2 knew it would be impossible to rely upon the man to identify all the hidden tricks of the retreating Germans—especially one as wily as the Ostrich. One X-2 agent was so certain that Nebel would betray them that he wrote to OSS station chief Allen Dulles and told him, "Shoot him at sight; he's bad."

There was only one way to be certain that Nebel would submit to them and continue his work as an agent for the Allies. They led the Ostrich into an interrogation room and threw down a picture on the table in front of him. Nebel reached for the portrait, his hands visibly trembling.

"We have her" was all the X-2 agents had to say. Nebel looked at the image again. It was his two-year-old daughter.

With Nebel's allegiance secured, he was returned to Germany and resumed his high-level post in the government during the final days of the Third Reich. X-2 agents watched Nebel's rise in the military from afar, the information trickling in from captured Germans with

knowledge of Nebel's work in the SS, while awaiting further communication. They could not contact him directly. Instead, the messages were coded through his regular correspondence with his family. In early February 1945, when his father received a letter from his son stating that he was in good health and had recently returned from the front on leave, X-2 agents relaxed slightly. All was well.

If Nebel expected that the end of the war would mean his release from his work with the Allies, he was sadly mistaken. His rise in German intelligence made him extremely valuable to Jane—and that value continued, even after the conflict ended. For now, the work of X-2 and the OSS had shifted to Nazi hunting.

Nebel's work in the Third Reich had extended into many areas— from overseeing the racist control of the population, to directing the Gestapo, to administering the brutal death camps. The Reich Security Main Office was also Hitler's treasure box. Created by Heinrich Himmler in 1939 and headed by Reinhard Heydrich, the organization was a hub of theft, plundering billions of dollars of gold and jewels from its occupied countries and concentration camp victims, as well as the looting of priceless works of art, including paintings, books, furniture, and sculpture.

All of this was going to prove vital when tracking down the high-ranking Nazi officers who were starting to melt back into the countryside after the end of World War II. This was Operation Safehaven. Follow the money; find the Nazis.

But Jane and her colleagues working on Operation Safehaven soon realized that the Nazis were not content with their stolen treasure, as vast as it was. They also decided to make their own, running a large counterfeit operation that Nebel described to Jane as Project Bernhard (named, in aggrandizing fashion, after its director, one Bernhard Krueger). But this mission had a diabolical twist: while most counterfeiters merely committed fraud with their products, the Nazis were hoping to induce havoc.

Their plan: flooding American and English markets with convincing-looking fake dollars and pounds, thereby plunging the economies of both

Allied nations into chaos and tanking their currencies. In their secret factory, buried underneath the Dead Mountains of Austria, the Nazis made millions of counterfeit notes. The Bank of England £5 note, known as the "white fiver," was a favorite target of the swindlers thanks to its simple black-and-white coloring, a design that had remained largely unchanged since 1793. Along with the currency, Nebel concocted fantastic schemes, such as dropping the money from airplanes and watching the bills rain down on the streets of London.

Jane knew there were hundreds of millions of dollars floating around, the bills so well produced that they could even hoodwink experts. The problem was widespread enough that the Bank of England decided to cut ties with the £5 note altogether, declaring that every bill would have to be evaluated carefully and traded in for notes of an entirely new design. They concealed a slim metallic thread in the rag of the paper currency as added protection.

The phony bills themselves were of value, although of a different kind, to Jane. She was hunting the counterfeit money as one followed a trail of bread crumbs, expecting it to lead her to her prey. Jane knew that counterfeit bills were merely one facet of the immense treasure hiding across Europe. If she and her fellow X-2 secret agents didn't find the valuables before they were concealed—and arrest the men responsible—the Allies risked the escape of war criminals and the possible return of the Nazi Party to power.

Follow the money; find the Nazis.

The sprawling interagency program encompassed both the State and Treasury Departments, but it was the involvement of the OSS and specifically X-2 that brought critical intelligence and data collection to the bureaucratic muddle. Their goal was to ferret out German financial assets—currency, gold, jewels, art, and other valuables—and block their concealment in foreign countries, a practice that was occurring in Switzerland, Spain, Portugal, and Argentina.

The Ostrich—Jane's key agent back in Munich—was the key to all of it.

Jane spent long hours with the Ostrich, squeezing out every drop of information possible about Nazi intelligence and their caches of looted goods. Jane had come to Munich with three men: the Ostrich; another former Nazi code-named Jigger; and her colleague Lieutenant Charley Michaelis. Jane felt comfortable with Michaelis; the two had previously worked together in France in the double-agent section of a unit of X-2 called Special Counter Intelligence, and they'd forged a close bond in Normandy during the events leading up to the D-Day invasion, and then during Operation Jessica. They would need every bit of that mutual trust for the mission that was to follow.

Like the infamous Nebel, aka the Ostrich, Jigger had also been an officer in German intelligence—his real name was Herbert Berthold. And like the Ostrich, Jigger had also been turned to work with the Americans. Both Germans were placed in an apartment in Munich, where Jane and Michaelis questioned them meticulously and monitored them closely. The Americans' task was daunting: without warning the enemy of their approach, they needed to track down the hidden financial assets scattered across the former Third Reich and arrest the Nazis responsible.

Jane knew she had one secret weapon: the fact that X-2 had custody of Nebel's daughter, along with the girl's mother. Even as she traveled with the Ostrich, knowing as she did his dark history, she never worried about his betrayal. The man had too much to lose.

But in addition to threats, Jane also made promises. X-2 unequivocally told Nebel that they would work to pardon him of criminal charges if he continued to cooperate with them.

As thoroughly as Jane *thought* she knew the Ostrich, she had no idea yet how deeply evil the man she worked alongside was.

.

Back in Washington, D.C., Addy Hawkins could feel the pressure coming at her from all sides. The end of World War II was not relieving the anxious grasp that clutched at her chest at night. In fact, it was partly the

cause of her worry. Now that the war was over, the OSS, once composed of thirteen thousand members, was being hollowed out from the inside. Only a few thousand employees were left, and the pressure in Washington, D.C., to scrap the entire agency was building momentum. The FBI, army, navy, and State Department wanted the departments broken up and spread around.

While the OSS was under assault in 1945, it wasn't just her work that was stressful. Back home, Addy also felt her family ripping apart. Her kids were still in boarding school, but they were struggling without her. A call came in from the Longfellow School for Boys in Bethesda, Maryland. Her elder son, Eddie, was in trouble. He had become so nervous that he could barely function in school. Crippling anxiety was preventing him from making friends, leaving him lonely and miserable. Addy could not watch her son suffer. She explained the situation to Major Delafield, at that time her commanding officer in the message center, and then scooped up both her boys and took them on vacation.

Addy rented a small beach house in Sarasota, Florida. They spent each day on the sand of Lido Key beach, playing in the waves, going fishing, and letting the salt water heal their wounds. Addy's daughter, Sheila, wasn't with them. She had wanted to stay in school. But for her sons, the vacation was everything they needed. Finally reunited with his mom, Eddie could feel the anger that had built up within him finally release. For Addy, too, the time in Florida was restorative. She knew she couldn't keep her kids in boarding school. Yet she also couldn't quit her job. She needed the income. She had to find a way to be a single working mother in a world made for wives.

Returning to D.C. in June 1945, Addy decided to purchase a home big enough for her, her children, and her parents. She cared little for her husband's opinion; she knew he would stay overseas as long as possible. She also knew if she lived with her parents, her mom, the matriarch she had always depended on, could hold the family together.

The large house in South Arlington was the first place that truly felt

like home to Addy. The commute to D.C. was easy, just a fifteen-minute drive, and while she was at work, she knew her mother would be sitting in her chair by the living room window, watching the kids play in the yard after school. Her father was there as well, able to give her children the attention of a father figure.

From this happy, relaxed setting, however, Addy noted that the messages coming into the OSS from their X-2 agents in Germany were becoming increasingly urgent. Even with outside political pressures, the message center had to continue pulling in intelligence and making sense of their communications from their agents stationed across the world. Messages from Eloise Page in Brussels, Allen Dulles in Switzerland, Jane Burrell in Germany, and others stationed across Europe formed the bulk of Addy's work in the summer of 1945.

From the cryptic lines that Addy deciphered, it seemed that Jane and Lieutenant Michaelis were on the verge of a massive discovery. "We may be close," read one transmission sent on June 15, 1945. Yet what they were hunting was obscured by a string of code names.

All Addy knew was that it had something to do with a man known as Tarbaby.

.

The road wound sharply from Germany into the Italian Alps. Jane was traveling between jagged, snow-covered peaks when the castle appeared suddenly, its bloodred tile roof peeking through the rich pine tree forests. Known as Schloss Labers, the enigmatic estate had long been a target of X-2 agents who wanted to peel back its fifteenth-century stone layers and uncover its secrets. Now Jane was going inside.

Back in March 1945, a Hungarian chauffeur named Bela Tar had been sent to the castle in Merano, Italy. Passing through its dramatically peaked, ominous entrance, Tar had met a man named Fritz Wendig. The halls housed a vast communication system, radios littered the halls, and Tar had even spied crates full of suspiciously new Italian lire. Tar

said that Wendig had offered him some of the counterfeit money to sell on the Swiss black market, in exchange for information on the Americans. As soon as he crossed the Swiss border, however, Tar had driven to an OSS station, where he described the incident to X-2 agents, even drawing them a detailed map of the castle.

It was thanks to Bela Tar that Jane had first heard about the Italian castle and the rumors of the criminal operation ongoing within. Now, later in 1945, as the war drew to its seemingly inevitable conclusion, the stories were getting new substantiation. One of the men she interrogated in those confusing days in mid-1945 was a man named George Spitz.

Spitz was an Austrian art dealer who, Jane was told by a young German officer, used counterfeit money on the black market to purchase artwork for the Nazis. Spitz had been seen receiving gold and jewels from SS officers. Jane and Michaelis seemed to have stumbled onto a gold mine.

They took Spitz into custody and performed their interrogation in a small, windowless room. Spitz was made to wait for hours, in complete isolation, until anyone talked to him. Once the questioning began, however, there was no holding back. The agents ripped into him. Yet as fierce as their words and threats could be, there was little actual violence.

Harsh interrogations, where men and women were physically

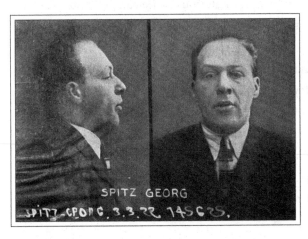

George Spitz.
Credit: CIA/CREST

beaten and even tortured, were seen by the American intelligence service as the work of "uncivilized and ruthless combatants." "In the hands of the Soviets," read one report, "interrogation is not only a means of gathering information but a political weapon." X-2, in contrast, relied on rapport-based interrogations, a psychologically manipulative tactic where prisoners were encouraged to give extensive narratives about themselves, ultimately promoting cooperation between subject and interrogator. "If you make life for certain prisoners fairly easy, they will relax," one interrogator explained.

Armed with psychological training in the practice of interrogation, a skill considered critical for X-2 agents, Jane was well equipped to question Spitz on the nature of his work for the Nazis. Although female spies are often portrayed as using their sexuality to obtain secrets, nothing could have been further from the truth for Jane. Still, her gender did confer a distinct advantage. She was seen as less threatening during her interrogations than her male counterparts, inducing her subjects to view her as a friend, and thus cooperate.

"I go on trips for them," Spitz pleaded in an accent that, now strained from fear, betrayed his Brooklyn roots. He explained to the agents that he was being exploited by the Nazis and that they had threatened to kill him. "I'm Jewish," he pleaded with her. Then he mentioned the name Wendig and the vast, mysterious castle called Schloss Labers.

According to Spitz, Wendig was merely an alias for a man named Friedrich Schwend, a longtime member of the Nazi Party. In 1943, Wendig, aka Schwend, had sent Spitz on six trips to Belgium in order to purchase gold, jewelry, and artwork. Spitz acted as a banker, but he was not sent with legitimate money, instead carrying tens of thousands of counterfeit English pounds. Returning to the castle, Spitz had seen the swindling operation at work. It was here that Schwend sent their counterfeit bills across Europe, shrewdly culling one-third of the profits for himself. In addition to the phony bills, he filled his castle with luxury

items purchased with the proceeds of concentration camp victims and the looting of occupied regions.

It was clear to everyone at X-2 that Schwend was the man who would lead them to Nazi gold.

Spitz first brought Jane and the other X-2 agents to the small town of Prien, Germany, but upon their arrival they found only Schwend's luggage. The Nazi had gotten a whiff of their intentions and run off, leaving his bags behind. X-2 knew they had to act quickly before he left the country altogether, possibly bound for Latin America, where so many of his co-conspirators had chosen to flee. Finally, just a week later, Jane and Michaelis caught him in Wiesbaden, Germany. X-2 sent him to their interrogation center in Munich, where they hoped to be able to pry the whereabouts of the vast amounts of gold, counterfeit bills, jewels, and priceless artwork they knew had run through his network.

Sitting in his cell, Schwend could feel his anxiety intensify as the lock slid open, but then his taut muscles relaxed. It was only Spitz, his former employee. He had little idea that Spitz had been prepared as a "penetration agent" by the Americans, whom he was now working for. Schwend was just glad to see a familiar face. The technique was as old as espionage itself and had been refined by British intelligence before they passed it on to X-2.

After weeks of being held alone, perhaps Schwend should have been wary of the sudden presence of his old colleague, but loneliness had eaten away his natural suspicions and instead he felt only intense relief. Finally, he had someone to talk to. When the guard walked away, Schwend vented his frustration, releasing a tumult of emotion. Spitz listened patiently, as he'd been taught. Then he told Schwend how he was in the same position, with many of the same feelings. Schwend was moved—a traumatic bond formed between them.

One week became two, and then three. Spitz was finally ready to mention his captors. In the manner that only a friend could, Spitz

assured Schwend that Jane and Michaelis could help. In fact, they might even be able to save their skin. Without realizing that he'd been manipulated, Schwend finally agreed to talk to the Americans.

Spitz had impressed X-2 with his ability to deliver, but that didn't mean they were ready to trust everything Schwend had to say, particularly because they were able to verify only portions of his statements and accusations. The promises they made, on the other hand, were as empty as Dachau in the summer of 1945. Newly liberated of its prisoners thirteen miles to the north, the atrocities committed were a reminder to Jane and X-2 that they owed these members of the Nazi Party nothing.

Freedom was what Spitz promised, and that prospect (combined with the hope of avoiding the Nuremberg trials, scheduled to begin in just a few months' time) was what finally convinced Schwend to cooperate with X-2. Now, he needed a code name. A list was kept in a binder in the Munich station so that each agent could receive a moniker that was unique and untraceable to their source. Their names would never be used in correspondence and were supposed to be avoided even in conversation.

The code name conferred a new identity, mutating the German intelligence agents into Allied collaborators. The name was part obfuscation and part salvation, a symbol of the redemption of a sinner. Code names were supposed to be chosen at random, but with Schwend, the agents at X-2 couldn't help themselves. They gave him the code name that fit his experience and their ambitions: Flush.

In the quiet, windowless room, Flush began talking. He communicated the sordid truth about Operation Bernhard, describing a moneymaking plant in the Sachsenhausen concentration camp in Germany, its panicked move into the Dead Mountains of Austria as Allied troops got closer, and finally the frenzied dumping of counterfeit money into the deep, cold waters of Lake Toplitz. Even as the operation met its final hours in Austria, the SS officers pressured their concentration camp victims. "Soon you'll be liberated," one Nazi warned, "but do not breathe a word to anyone about what you have been doing or you will pay with your lives."

While X-2 knew it would take considerable resources and trained divers to search the depths of the alpine lake, they could scan the countryside, with Jane and Michaelis led by Flush and Tarbaby. Together the foursome began a treasure hunt whose success transcended the value of the gold. If Jane and Michaelis accomplished this mission—if they were able to get Flush to find that missing money and keep it out of the fleeing Nazis' hands—then they could get valuable evidence that would help bring countless German officials to justice.

Driving the curving roads that led out of Germany and into Italy, the X-2 agents were nervous. They were headed to Schloss Labers, the castle that had concealed Nazi secrets so thoroughly that Allied troops had found no evidence of their wrongdoing within. Now, with Flush leading the way, the Americans had to consider how thoroughly they trusted Friedrich Schwend. Were they heading into a trap?

They skirted the woods that led away from the castle, the pine trees enclosing around them until the peaked roof disappeared entirely. It was

Schloss Labers.
Credit: Dr. János Korom

there, right where Flush pointed, that they saw the sacks lying on the ground. It was obviously the work of hurried men; the bags were not even buried. Instead they had been dumped in this remote spot at the base of a tree. On the ground a few golden coins gleamed in the dirt, having fallen out of rips in the sacks. The SS officers who had stashed the money had been in such a rush that they hadn't bothered to pick up the loose change.

Without counting it, the agents bundled up the bags and brought them to the car. They drove back to Munich and in the station began to unload the loot. As they dumped the bags, the sheer mass of gold shocked the Americans. They had never seen such a treasure in their lives. They counted the coins carefully, the process taking hours as they each confirmed the amount. Jane ran the gold through her fingers; she had counted 7,139 coins. She had come across millions in counterfeit currency during her short time working out of the Munich station, but she knew that there was nothing fake about the fortune in front of her.

Altogether, they had pulled 103 pounds of treasure from the woods. It was worth an unimaginable fortune—$200,000 in American currency, ten times the average annual wage in the US. Yet it was just a fraction of the total gold the Nazis had stolen during World War II, some $600 million in bullion, plundered from European central banks, family fortunes, and even the gold fillings extracted from Holocaust victims.

"The money constituted a possible threat to Allied security," wrote Michaelis in his report, "as it could have been used to finance anti-Allied activities." The truth, Jane knew, was significantly more treacherous. At this point in Germany, riches were more dangerous than weaponry. A bomb might kill instantly, but gold could keep hope alive in the hearts of Hitler's followers for years. Jane saw Flush as her golden compass, guiding her to the vast treasure hidden across the countryside. It may have been dumped in woods, caves, alpine lakes, and even hastily thrown

into a river on one occasion, yet no matter where it flowed, Jane was sure to follow.

.

While the OSS was triumphing abroad, trouble was afoot back home in Washington, D.C. Bill Donovan certainly felt it. Wherever he traveled, either at home or abroad, he was surrounded by his enemies. The influence he'd once held in the White House had perished along with President Franklin D. Roosevelt, when the president had suddenly died in April 1945, just months after winning his fourth term as president.

"Mr. Truman was very quiet," Donovan said after meeting with the new president, "and when I left, there was no question in my mind that the OSS would be dissolved at the end of the war."

President Truman had been clear with the spymaster, calling the OSS "a threat to the liberties of the American people," and saying that "an all-powerful intelligence apparatus in the hands of an unprincipled president can be a dangerous instrument. I would never use such a tool against my own people, but there is always the risk." With the war ending, it seemed the country could return to the status quo—that was, a future without an intelligence service.

Now in Germany, Donovan found himself at odds with another powerful superior: chief US prosecutor for the Nuremberg trials, Robert H. Jackson. Jackson, also an associate justice of the US Supreme Court, had asked Donovan to be his number two in charge of the trials, tasked with prosecuting the leaders of the Third Reich. The two men needed each other, even as they argued bitterly.

Donovan was responsible for the visual presentation of Nazi atrocities, as well as collecting the evidence and analyses prepared by his X-2 agents. Reading on his feet, a habit he'd picked up in the trenches of World War I, he pored through documents, reports, photographs, and law books, consumed by his task. His passion began to betray itself.

"You are walking on the edge of the grave," Donovan told Nazi leader Hermann Göring during one of their interviews in 1946, "and the question is only how you will go in."

With Jackson he argued for the presence of witnesses, those individuals who had actually been in the room when arguably the most horrendous acts in human history occurred. He wanted the victims present because he believed the world needed to hear their experiences directly. Jackson, however, was wary of this approach. He asserted that written documentation would show overwhelmingly the guilt of the men involved. Testimony from witnesses could be twisted in cross examination, potentially putting the convictions they needed at risk.

"It so happens that I have the responsibility," Jackson said, "and I am going to run this case according to my best judgment."

Ultimately there was a deep philosophical difference between the two. Jackson wanted to be sure the criminals were punished, while Donovan wanted to guarantee the world grasped the extent of the atrocities committed. Finally, the arguments broke down with Donovan declaring, "I believe you are wrong. If that is your final decision, I shall return to the States and withdraw from the prosecution."

Yet back home things were no better for Donovan. Those in the War and State Departments looked upon the OSS as a spoiled younger sibling. Unlike their congressionally mandated budgets, the OSS, as a wartime agency, enjoyed unrestricted emergency funds. Now that the war was over, the purse strings were starting to tighten.

The FBI, on the other hand, saw the OSS as a direct threat, impeding on their counterintelligence turf. In reality, the opposite was true. J. Edgar Hoover, the director of the FBI, expanded his agency's jurisdiction into South America, while simultaneously banning the OSS from the Western Hemisphere entirely. The arrangement would have consequences: the FBI had no network of officers skilled in double-agent operations, and so a dearth of intelligence in Latin America left the continent open for escaped Nazi war criminals.

While the FBI was focused on the detection of criminals, Donovan dreamed of the OSS morphing into a very different kind of agency. He saw his web of agents spread across the globe, gathering intelligence and sending it home, where it could be soberly weighed and assessed by men and women who, unlike military intelligence, had no stake in future conflict. He spoke often of a "modern intelligence system" and lamented that "we should go back to the eighteenth century." Donovan believed that a central intelligence organization, run by civilians, could prevent war in a world that was still anything but peaceful.

By the summer of 1945, Donovan knew the OSS was at the mercy of the new president and held little hope for his intelligence service. Donovan's rivals in Washington had been working craftily against him. A series of newspaper articles, which Donovan believed originated from the top levels of the FBI, labeled Donovan's plans for a peacetime intelligence service as an "American Gestapo," claiming the new agency would "take over the FBI, Secret Service, ONI, and G2." It didn't matter that Jane had uncovered a small fortune in gold, or that Eloise was preparing for their inevitable conflict with the Soviets, or even that Addy was shrewdly able to coordinate all their worldwide intelligence efforts. Their successes overseas were numerous and ongoing, but their ability to battle bureaucrats in the nation's capital was . . . well, inconsistent at best.

By September 20, 1945, it was all over. With a single stroke, President Harry S. Truman signed executive order 9621, abolishing the OSS. Thanks to an oversight when drafting the resolution, Donovan had just ten days to demolish the agency he had spent years building. Overlooking the Potomac on a warm Friday evening, Addy watched her boss speak to the staff in a resigned voice.

"We have come to the end of an unusual experiment," he said. "This experiment was to determine whether a group of Americans constituting a cross section of racial origins, of abilities, temperaments and talents could meet and risk an encounter with the long-established and

well-trained enemy organizations. . . . Within a few days each one of us will be going on to new tasks, whether in civilian life or in government service. You can go with the assurance that you have made a beginning in showing the people of America that only by decisions of national policy based upon accurate information can we have the chance of a peace that will endure."

The Japanese had surrendered a little more than a month earlier, and headlines in San Francisco, Detroit, Charlotte, and New York were all screaming "PEACE!" in bold font. Yet for Jane, Eloise, and Addy, the conflict that would define their life's work was just beginning to erupt.

"UNSAVORY ACTS"

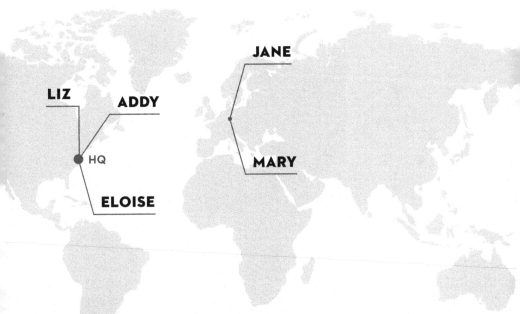

RUSTY
1946

Mary Hutchison was squirming. She had never felt more uncomfortable in a job interview in her life. It was 1946, and she was thirty-five years old. She'd applied to many things before, including graduate school, jobs in libraries and schools, and even the military, but this interview was by far the most contentious.

"He doesn't seem to *like* me," Mary later wrote. The man she was speaking of was Richard Helms.

Helms was part shadow, a man who slipped into rooms and situations unnoticed, and part luminary, able to captivate nearly anyone, but particularly journalists and politicians, with his sparkling conversation. The sides of his personality screamed duplicity—a character trait ideal for espionage, but less so as a hiring manager.

As it happened, he was both.

In the wake of World War II, as a young officer, he was part of the team forming a transitional, postwar intelligence agency. Truman might not have liked the idea of an espionage agency, but he could not deny its necessity, particularly as tensions rose with the Soviets. He had in mind "a different kind of intelligence service from what this country has had in the past," describing a "broad intelligence service attached to the President's office." In his memoirs, Truman reflected, "If there had been

something like coordination of information in the government it would have been more difficult, if not impossible, for the Japanese to succeed in their sneak attack at Pearl Harbor."

Now, the most critical task before Helms in early 1946 was choosing the founding members to help him build what was about to be called the CIA. He hired mostly applicants who were "male, pale, and Yale" . . . but occasionally an unusual candidate came his way.

Mary was certainly unusual.

.

Helms was thirty-three and working out of what had once been the OSS Berlin office. The past two years had seen him traveling from Maryland, to London, to Paris, to Luxembourg, to Germany, with multiple trips to Washington in between. He could hardly expect his future to bring greater stability; no agency in the US government was in greater flux than its intelligence service in 1946. Yet there was also a sense, palpable to all, that they were at the beginning of building something necessary and that the people Helms employed would be the forefathers of this enterprise.

Helms was not particularly excited when he first met Mary Hutchison. Perhaps if her name had been Matthew, he would have summoned greater enthusiasm, as her credentials on paper were certainly impressive. As it was, he spoke in a tired voice, saying, "I'm pleased to offer you a secretary position."

This offer of employment sparked a sharp reaction from Mary. While Helms moved through the ranks of government with ease, finding promotions around each corner, she had clawed her way up, from a reserve officer in the Women Accepted for Volunteer Emergency Service (WAVES) unit to a lieutenant commander (working as an intelligence officer). She had hoped that this new job would be a stepping-stone to something greater. Something substantial. Certainly something more than a secretarial job.

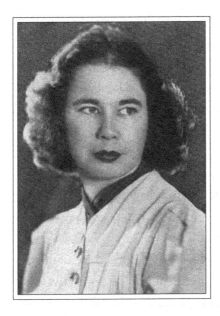

Mary Folse (Hutchison).
Credit: The State Historical Society of Missouri, manuscript collection

"That's a waste of my abilities," Mary said to her potential new boss. Her tone was sharp, yet her points were persuasive. Mary held a PhD in archaeology and was fluent in Greek, Spanish, French, and German. Well-mannered and comfortable moving in polite circles, Mary didn't relish speaking back to anyone—especially to a potential boss during a job interview—but she knew it had to be done. She wasn't going to be stuck typing letters and fetching coffee for men with less education and experience than herself. She knew what she had to offer.

The longer Helms listened to the young woman, the more he was convinced by her intelligence and abilities. He decided to hire Mary as a reports officer. While working as an operations officer was a prized position, a reports officer, although a critical role, was looked down upon by some at the CIA. "There is a general feeling that handling reports is women's work," read one document, "to be avoided like the plague by any promising and ambitious young man who wants to get ahead in operations."

Given these prejudices, women were often initially hired as reports officers but then promoted to work in operations, maintaining the

nominative title despite their expanded role. This was the fate that awaited Mary, just as it had for Jane Burrell, also a reports officer, although clearly working in operations. As Mary reviewed field data, plotted missions, and managed intelligence agents in the field, she knew her new position was merely a starting point.

.

The intelligence agency was as unformed as the ambitions of its employees. Before the OSS was even in the ground, its agents were plotting their next move. No matter the sinking pit of bureaucracy they had become mired in, despite Donovan's speech that the experiment was over: those in government knew that an intelligence agency capable of operating worldwide was critical to American interests. The Soviets were already spying on them, and they would need to organize if they wanted to return the favor.

Just four months after the OSS met its demise, on January 26, 1946, President Truman invited a small group to lunch at the White House. In a mock ceremony, Truman presented two men with black cloaks, black hats, and crude wooden daggers. Once adorned in the dark, humorous outfits, he pasted a fake mustache on one of the men and formally decreed in a mocking tone, "By virtue of the authority vested in me as Top Dog, I require and charge that Front Admiral William D. Leahy and Rear Admiral Sidney W. Souers receive and accept the vestments and appurtenances of their respective positions, namely as Personal Snooper and as Director of Centralized Snooping." From this ignominious beginning a new intelligence service was born: the Central Intelligence Group, or CIG. The organization would serve as the forerunner to the CIA.

The satirical pageantry was not intended for any working spies, of course, who would have been more likely offended rather than amused by its humor. Donovan mocked the stereotype directly in his speeches, saying, "Intelligence work is held in peculiar opinion in the United States. Most

people think of it as a cloak and dagger business. In reality, it is detailed and minute work. Intelligence is that service of information used by all nations to determine the politics and intents of other nations." Donovan would go on to severely criticize Truman's new agency, calling it "phony."

Yet there was nothing spurious about the missions the new American intelligence agency was undertaking. They were dealing with both the aftermath of World War II and the new, growing Soviet threat. Even as the agency's interests expanded, their numbers kept shrinking. Those working overseas were stretched incredibly thin. In September 1945, when the OSS was dissolved, they were down to just seventy-nine members in Germany. By the end of the year, there were thirty-one agents. Now, in early 1946, there were only eight. Jane was no longer one of them; she had been transferred back to Washington.

Most of those dismissed from government service could return to the lives they had enjoyed prewar. For Jane, however, there was no going back. Returning to D.C. at the end of 1945, she met with her husband. They had both departed Syracuse, New York, in 1943, David giving up his family's dairy machine business to join the US Navy as a lieutenant, and Jane leaving behind a sheaf of unpublished stories for a far different role in Europe. The reunion was not a happy one: The stress and separation of the past few years had drained their affections.

The truth was, Jane was no longer the person she had been just four years earlier. Being a spy had fundamentally changed how she viewed herself and the world around her. In their years apart, fragmented by war, she had grown past his reach, and the idea of going back to her old life, becoming a housewife on a dairy farm, was outlandish. They separated and a year later divorced. Without her husband, it was now the US government that Jane wedded herself to.

.

Like Jane, Eloise was awarded no ceremonial cloak and dagger, but she did still have her job. In 1946, Brussels was a city of allies and enemies

that American counterintelligence was struggling to unravel. The coded directives coming from Washington, marked SAINT to indicate that they dealt with security and counterintelligence, were clear. Germany was no longer the target. Instead, resources were being shifted to the Soviet Union.

For Eloise, this was no surprise. Privy to Donovan's communications as she had been throughout the war, she had recently witnessed a critical turning point in the US-Soviet relationship. In early 1945, Western allies had met with Nazi negotiators in Switzerland, purposely leaving out the Soviets, in order to negotiate a surrender of German forces in northern Italy. The reason for this was clear: there was a growing distrust between the Soviet leaders and those of Britain and the US, who opposed the USSR's aggressive and antidemocratic occupation of Eastern Europe. When Vyacheslav Molotov, the Soviet minister of foreign affairs, learned of the surreptitious meeting, his letter to the American ambassador was icy: "For two weeks, in Bern, behind the back of the Soviet Union, negotiations between representatives of the German Military Command on one side and representatives of American and British Command on the other side are conducted. The Soviet government considers this absolutely inadmissible."

If Molotov found these secret meetings reprehensible, what would he have thought of the true intentions of his supposed allies? A new plan was emerging from Winston Churchill and his chiefs of staff: codenamed Operation Unthinkable, the mission's goals were to "impose upon Russia the will of the British Empire and the United States. Even if the will of these two countries may be defined as no more than a square deal for Poland." In other words, now that the war was nearly over, the tenuous alliance between Western forces and the Russians was fracturing.

The date for "opening of hostilities" against the Russians was initially planned for July 1, 1945. Conceived by Churchill, the military action had British, American, Polish, and even German troops set to push

Stalin's Red Army out of eastern Germany and Poland. The operation itself was too brash and dangerous to be realized, but even its conception served to shape American and British intelligence, indelibly printing the idea that war with the Soviets was becoming inevitable.

It was no secret that the fragile peace that existed between the powerful nations was fracturing. On March 5, 1946, Churchill had pointed to the Soviets as the greatest threat to peace and declared that "an iron curtain has descended across the continent." In the fraught political climate, it was perhaps unsurprising that swindlers were taking advantage of the tensions.

As part of counterintelligence operations in Brussels, Eloise was working to identify Soviet intelligence agents who were already plotting against the United States. The number of individuals coming forward with information, however, was astronomical, a veritable haystack of information . . . and Eloise was charged with finding that all-important needle of vital information amid all the false leads and phony intel. Some of her sources identified Nazi Abwehr networks that were scheming against the Allies, while others fingered the Soviet intelligence agency as a potential threat. The reports Eloise was asked to investigate were often ridiculous, the obvious result of petty grievances or the work of fantastic storytellers. The fraudulent informants insisted on being paid for their allegiance, and in their naïveté, American intelligence was willing to hand over francs far too often.

In hopes of not repeating the same mistakes, Eloise characterized her intelligence sources under two labels. There were the "paper mills"—hostile agents whose aim was to spread their false reports as far and wide as possible. The paper mills used a mix of real and fake intelligence to confuse and complicate the truth, obscuring the origins of everything, so that American intelligence could not discern the difference between what was real and what was complete fiction. Eloise saw this technique most commonly employed by the Russian émigré populations in Brussels, who were trying to draw attention and money to their

political causes. One man came in with secret knowledge of a tailor shop where the measurements written down for custom suits were all code for American targets (a great story, but sadly not verifiable).

There were also the "fabricators." These were men and women who "without genuine agent resources, invent their information or inflate it . . . for personal gain or a political purpose." One young woman came in with an elaborate tale of her cheating husband and his sordid rendezvous in Moscow (it turns out the Russian woman he was seeing wasn't a spy, and his spurned wife was looking for retribution).

While the lines between the two descriptions often blurred, it was critical for Eloise to categorize not just when but also *how* American intelligence was being bamboozled. She recognized that the problem was not just that they were wasting money—though they certainly were doing that—but that there could be real-world, dangerous consequences to relying on faulty information. As it operated at that moment, American intelligence was extraordinarily vulnerable. "The Soviet government," read one report, "possesses a tremendous capability of planting deception and provocation material in U.S. intelligence channels at the moment of its choice." As the Cold War was ramping up, the stakes couldn't have been higher.

The American intelligence operation was still in its infancy, and its mistakes were glaring. Eloise must have felt discomfited as she admitted the station's shortcomings in her reports—"subject found to be corrupt," read one—yet her experience was not isolated. Similar blunders in intelligence gathering were occurring across Europe, as she would soon learn. Wartime, by its nature, had led to chaos in the intelligence community, and Eloise was striving to bring order to the disarray. Her time with Donovan and British intelligence in London had taught her the foundation, but there was nothing like boots on the ground to give her the experience.

Eloise was modeling the Brussels postwar station off Britain's MI6. However, the dwindling number of personnel she was given to do the

work threatened their mission. Eloise called the situation "vexing" to a colleague, a description that could hardly fully describe her frustration in not having enough officers to follow through in their operations. There was a growing fear that all their work was fleeting. She could not be insensible to the fact that the British suspected their fragility and were pulling back.

"We're floundering," she said to her colleague. "There's just not enough of us."

Eloise may have felt helpless, but others were taking notice of her work, and the impression she was making in those early postwar days would be positive and lasting. Prominent among her admirers were James Jesus Angleton and Allen Dulles. Angleton was a twenty-nine-year-old former X-2 agent who, after the war, had risen to become chief of all intelligence activities in Italy. Dulles was even more well known in the intelligence community; the former Swiss director for the OSS was now acting as a station chief in Bern, Switzerland, and he had the opportunity to observe Eloise's work and read her reports firsthand.

When Dulles later said that women make "fine spies," he may have had Eloise in mind. Although Eloise's position was unusual for a woman, especially one her age, just twenty-six, they were both struck by her competence and professionalism. It seemed Eloise was born to be a spy.

The European station chiefs were also all in agreement about the threat to their operations stemming from indecisive action in Washington. "For months we have been 'hanging on' with an indefinite status, changing our organization's name and generally lacking a fixed place in the intelligence picture," wrote Lieutenant Commander W. M. Scott in 1946 from his post as chief in the American intelligence station in London. "Our friends here have been exceedingly patient and we, by dodging issues and slightly 'coloring' our status, have been able to hold our own in practically all phases of liaison with the British . . . in all conversations with British intelligence personnel they have repeatedly stressed

the need for more coordination of our intelligence services . . . for the good of the American government the question of the status of our organization must soon be settled one way or the other; relations which are of extreme importance to American intelligence are not going to be possible to maintain unless we have a definite status soon."

It wasn't surprising that the British viewed American intelligence as transient. "I am completely opposed to international spying on the part of the United States," President Truman said in 1945. "It is un-American." Truman's concerns about creating a centralized American intelligence service were founded on valid apprehensions. He worried that giving considerable power to a group of spies would inevitably lead to surveillance of the American public. Yet even in his idealism, Truman recognized a fundamental truth: the Soviets were working on the bomb, and they needed watching.

By 1946, British intelligence considered whether they should continue openly sharing their intelligence reports with the Americans. Without their assistance, Eloise knew all was lost; her station, already slimmed down considerably, would have to completely shutter its doors. Such was the extent to which they depended on their allies. The British were particularly hesitant to share reports on Soviet intelligence, as they worried that they "would reveal to the Americans the extent of our concentration in that particular field." The Americans, however, already knew.

.

Back in Washington, D.C., Addy looked at the Soviet cipher in front of her. It was five digits with no alphanumeric letters. Admittedly, there was something elegant about its design. The numbers seemed trim and sleek in comparison to the bulky mix of letters and numbers she was accustomed to. The simple beauty of the numbers presented a distinct problem: she had no idea what they meant.

Addy could be forgiven for admiring the work of the Soviets; after

all, their ciphers had proved seemingly impossible to break. Multiple teams of codebreakers were hard at work deciphering the strings of numbers that were starkly different than those of the German Engima or the Japanese Purple. At Bletchley Park in Britain, the team now focused its attention on the Soviets, while at Arlington Hall in Virginia (a hub of cryptanalysis in the US), experts had been working on breaking the Soviet ciphers since at least 1943. This group, part of the Army Signal Corps, was part of a secret project called Venona.

While the numbers of most military groups were shrinking, the men and women working on Venona had grown from a mere twenty-five in 1944 to seventy-five after the Japanese surrender. The work was backbreakingly tedious, with dozens of men and women hunched over their desks, wrestling with more than five thousand messages of Soviet origin lifted from diplomatic cables in New York and Washington and throughout Europe. Each one was thought to be encrypted by a random code, used only once before being discarded. Hints about the code had come in from defected Soviet agents, British intelligence, and even burned scraps of paper rescued from Soviet intelligence offices in Europe, but they still hadn't found the key to unlock its meaning. And still they toiled.

Addy, privy to their progress, knew that they were getting close. And time was of the essence. Credible Soviet intelligence coming into her group had slowed to a mere trickle, and the vast web of US agents, politicians, and operatives who relied on this intelligence were becoming desperate. But despite the importance of this information, Addy couldn't help but notice (like Eloise in Brussels) that the resources allotted to her team were much smaller. In contrast to the twenty-four-thousand-person OSS during the war, the newly re-formed CIG was small—just four hundred individuals overseas, plus another two hundred sixty in Washington by 1946. And because many of the OSS personnel had taken jobs in the new CIG, Addy seemed to know everyone. After all, she'd been working there five years by that point. But like the British allies, Addy

also worried about the permanence of American intelligence. It seemed likely that their work would not survive the political tumult of the postwar years.

Against this backdrop, the struggle to obtain Soviet intelligence was reaching critical levels. Messages coming in from Army G2 (the military intelligence service, a parallel intelligence service to the former OSS / new CIG) reeked of desperation. The army knew that their CIG counterparts had, as one report wrote, "the needed communications organization"—after five years, the group founded by Bill Donovan was running like a well-oiled machine, despite its diminished force. The G2 military intelligence, on the other hand, was struggling to preserve a disastrous and underhanded operation they had initiated in secret the year before. Code name: Rusty.

When Rusty had been initiated in 1945 by the army's G2 forces, the OSS had been purposefully left out. This was not surprising given the mix of jealousy and rivalry between the military and civilian intelligence services. What was unexpected, however, was the scope of the G2's operation—and how quickly Operation Rusty got out of control. It started in a POW camp in 1945, when a German intelligence officer named Reinhard Gehlen approached his captors with a tempting offer. He described it as nothing less than a plot to "rescue Western civilization."

Gehlen had held a prominent role in the Nazi Reich as *Generalmajor*, and his job was to gather intelligence on the Soviet Union. In effect, he was a German spy, overseeing the same detailed intelligence network as senior-level officials at the OSS in the US or MI6 in Britain had. However, what he and his men found enraged Hitler. The Soviet military forces, they told him, were much stronger than Germany had originally assumed. Each report was worse than the last, detailing the strength and wide capabilities of the Red Army. While it was accurate, it wasn't what the Führer wanted to hear. Finally, Hitler became so

incensed that in April 1945, he dismissed Gehlen entirely, preferring to reach the end of his reign as uninformed as possible.

But Gehlen could see the writing on the wall . . . and he wasn't about to be caught unprepared. He knew that his only hope to get through the aftermath of the war alive was to make himself as invaluable as possible. In preparation for what was to come, Gehlen gathered his paperwork, taking care to include the files with the most important communications and detailed information about the Red Army's capabilities, and he ordered the documents sent to secret locations in Bavaria. Then he gathered a select group of his intelligence agents, hunkered down in Berlin, and waited (like so many other Nazis) to be captured by the Americans.

Unlike most German soldiers, however, he was substantially better informed about details of the Soviet Union—details that were now particularly prized by the US as their relationship with their former ally was growing ever cooler. Gehlen's ace in the hole was his intel on Soviet prisoners of war—particularly documentation he had about how poorly the Soviets treated their POWs. This, Gehlen realized, was leverage. He wanted to survive, and he saw his files, his still-active agent network in Russia, and the contents of his skull, as a way out.

Gehlen and his men were brought to Wiesbaden, Germany, in June 1945. Jane also spent time in that same interrogation center that summer, debriefing German officials, although it's unlikely she ever laid eyes on Gehlen. Army military intelligence took great care to keep him hidden. Gehlen knew the value of his information, and so, it seemed, did the US military. With Gehlen's intel as its foundation, G2 hatched an audacious plan to "resurrect his Abwehr network against the Soviets."

By the end of August 1945, Gehlen and his men had accomplished the seemingly impossible: they escaped prosecution as Nazi war criminals and were flown out of Wiesbaden to a classified building in Fort Hunt, Virginia, known only as PO Box 1142. And the G2 team began an ambitious, if foolhardy, plan. Code name: Rusty.

It wasn't long, however, before the operation began to falter. The scale of Rusty—setting up what was essentially a stand-alone German intelligence service, one made up of former Nazi officers and their contacts throughout Europe—was a massive undertaking. The Americans knew the identities of only a fraction of the German agents, making their reports unverifiable and their motives questionable.

Soon realizing that they were in over their heads, G2 tried to pawn Gehlen off on the already overburdened American intelligence service in late 1945, but the organization rejected the idea outright, with one officer calling the operation "rather grandiose and vague." Central intelligence advised G2 to drop it entirely.

Instead, G2 decided to double down, pumping more money and resources into Gehlen's organization, setting up what was essentially a shadow intelligence network working alongside (but largely hidden from) the existing one. By October 1946, the group had grown to an unbelievable six hundred agents, moving throughout Germany's Soviet zone and comprising mostly the scattered remnants of Gehlen's former spy squad, including SS officers such as Karl Josef Silberbauer, the man who had arrested Anne Frank and her family in Amsterdam in 1944. But while Operation Rusty had the manpower, the men and women were lacking in nearly every prerequisite for the job: proper training, adequate supervision, and steadfast loyalty. The agents also were not directly controlled by American officers, unlike Jane's relationships with her agents. To top it all off, many of them were former (or perhaps even current) Nazis.

Perhaps the most dangerous aspect to the situation was the fact that the Soviets had been tipped off to Operation Rusty. They were now demanding that Gehlen and the others in his group be turned over to them immediately. In Washington, Addy and the CIG team were certain that Rusty communications were being breached. While Addy had carefully trained her OSS officers in how to communicate securely behind enemy lines, no such precautions or instructions were given to the

German agents employed by Operation Rusty. They were in desperate need of her expertise. By 1946, letters from army intelligence to the CIG pleaded for central intelligence to "be given complete control of the operation, and that all current activities of this group be immediately stopped before further security breaches nullify the future usefulness of any of the members of the group."

In addition to communications, money was dragging Rusty down. While every intelligence operation wasted money on uncorroborated sources from time to time, it seemed that the G2 officers running Rusty relied on no other tactic besides bribery. And as Jane and Eloise knew all too well, paying sources often led to inaccurate intelligence.

"It seems a shame that anyone is willing to pay so much for very low grade and mostly unverifiable information," read one memo. By one estimate, the Rusty operation alone cost two to three times the entire budget of the CIG—an extraordinary number considering that the number of Germans employed by Rusty was roughly equal to that of the entire civilian intelligence agency.

The entire operation was being run so haphazardly that it was no wonder that central intelligence wanted no part in it. They responded with a detached superiority in October 1946: "One of the greatest assets available to US intelligence has always been the extent to which the United States as a nation is trusted and looked up to by democratic-minded people throughout the world. Experience has proven that the best motivation for intelligence work is ideology followed by common interests and favors. The Germans, the Russians, their satellites, and to a lesser extent, the British, have employed fear, direct pressure of other types, and lastly, money. With most of these factors lacking to it, Operation RUSTY would appear to be dependent largely upon the last and least desirable."

Yet it didn't matter how much they protested, this unsavory and thus far unprofitable operation was about to be foisted on the Wise Gals . . . with dire consequences.

· · · · · · · · · · · · ·

Just when American intelligence needed a solid, steady hand, tragedy struck. On New Year's Eve 1946, Bill Donovan arrived at his son's home, a sprawling estate called Chapel Hill Farm, outside Winchester, Virginia. As soon as his car pulled up, his five grandchildren came running out the door, pulling at the illustrious war hero and leading him by the hand to the stables to look at the ponies before heading into the house. The hard-driving general softened around his family, transforming into a man that Eloise had only ever seen glimpses of. The price of two world wars had undeniably aged him, but he was not giving up on public service. He had already opened his headquarters to run for a US Senate seat from New York and had amassed a passionate flock of supporters, including Eleanor Roosevelt.

That evening he was preparing to celebrate his sixty-fourth birthday at the Blue Ridge Hunt Club and its annual ball. As she prepared for the festivities, Donovan's wife dropped her jewelry into a glass of liquid silver polish sitting on the kitchen counter. Sheila, Donovan's five-year-old granddaughter, came running inside, hot and thirsty from her play on the farm. In a flash, Sheila picked up the tumbler and drank what she thought was a simple glass of water. Immediately she fell down in convulsions. Panicked, her parents rushed her to the hospital, but by the time they got there, Sheila was already dead. The culprit was potassium cyanide, a lethal poison commonly used in silver polish.

Donovan never recovered. It seemed to Eloise that he became merely a shadow of the energetic, workaholic man she'd known. Sheila's death radically changed him. No longer did he engage in political wrangling over his intelligence service or harbor aspirations for his own candidacy. Instead, the father of American intelligence turned inward, choosing to turn over the reins of his leadership to his protégés.

The Wise Gals were ready to accept.

BELLADONNA
1946

In a small room in Munich, Mary Hutchison sat with a man of many names. He was known as Crabbe, or Sarazen, or Kilkenny, or Carryall. Occasionally he was known as Malcolm W. Stevens. More often, he was called nothing at all, his words and actions described without attribution to their source. Yet nearly every word that left his mouth was of importance to American intelligence.

The man's real name was Zsolt Aradi. He was thirty-six, with wavy brown hair, a large dome of a forehead, and hunched shoulders. As he spoke to Mary, he responded in rapid-fire Hungarian to her questions. She listened avidly. She knew how important this operation was. The stakes couldn't have been higher.

For Mary, the assignment was everything. Since she'd convinced Richard Helms to hire her (*not* as a secretary) earlier that year, she'd had a steep learning curve. After all, the ostensible reason she had joined American intelligence was because she was following her husband, and everyone at the station in Munich knew it. There was absolutely no reason for anyone to take her seriously. But she knew this was work she was meant to do. Work she could be good at. This operation with Aradi was her opportunity to prove that she belonged there.

The problem was that she wasn't sure she could trust the man across from her.

Aradi was spying on church officials in the Vatican in order to gain intelligence on the Soviets. It was Mary's job to delve deeper into his connections. Together, they were trying to build a network of collaborators to pry into Russian affairs.

In his files, Mary learned that the modest family man sitting across from her had chosen to become a spy at the Vatican, in the heart of Rome. It was the holiest site on earth for him, both physically and spiritually. The walls of the Vatican had been his fortress during the war, protecting him from the destruction of his native Hungary. Because Pope Pius XII maintained neutrality throughout the war, bombs had only grazed the surface of Vatican City, without lasting damage.

Aradi knew how privileged he was to have made it through the war unscathed, particularly when he compared himself to the fortunes of his close personal friend, a Hungarian bishop named Vilmos Apor. Unlike many Catholic priests, Apor was unafraid to speak out publicly against fascism, and he had risked his own safety to shield Jewish citizens who lived in his parish. As horrible as the German occupation had been in Budapest, the invasion of Soviet troops provided no relief. The Red Army stormed through towns, seizing control though intimidation, murder, pillaging, and rape. In April 1945, Soviet troops came into the bishop's seminary and hunted down several women Apor had hidden in a cellar. As they dragged the women out, the fifty-three-year-old bishop yelled at them to leave and then grabbed their arms, attempting to wrestle the men off their victims. He was shot immediately.

The news shattered Aradi. Vilmos Apor had been his closest friend, the nearest thing he had to family. From that moment on, Aradi identified himself as "stateless," a man who belonged to no nation. The Soviet Union had stolen his country and his friends and torn apart his family. The Soviet Union was now his enemy. And Aradi was prepared to devote himself to his enemy's destruction.

Mary looked at this man across from her. She knew what a powerful motivation revenge could be. The question she had to ask herself was

this: Was it enough to trust him to work with her on Project Belladonna? Was the enemy of her enemy in fact her friend?

Aradi occupied that elusive middle ground that was exactly what American intelligence needed. He was a man who identified himself as partial to the Allied forces, but he was not rabidly anti-communist. This was an important distinction, as central intelligence had found that open antagonism "amounted to a strong desire to see an early war between Russia and the US."

Mary was working with Aradi on identifying collaborators who could be trusted, and in these early years of the Cold War, the European continent was bursting with men and women who wanted to work with the Americans. Yet identifying spies capable of providing Soviet intelligence was a sticky enterprise. The Germans had managed to recruit dozens of nationalities willing to fight for the Third Reich, including Poles, Czechoslovakians, Hungarians, Russians, and Ukrainians. Many were recruited because of their fiercely anti-communist beliefs, which now, in late 1946, made them natural enemies of the Soviet Union in the postwar era. Yet how could American intelligence reasonably test the loyalties of those they had just been fighting against? Many of them resembled Jurij Vojcehovskij, the Russian assassinated in Brussels, in both their multifaceted ideology and their exploits. One CIG agent had described the problem aptly: "The German Intelligence Service background of many of them becomes an asset, however distasteful."

Aradi had the answer. With his connections through the Catholic Church, he was able to pry into the allegiances of groups the Americans could not investigate openly without giving away their interest—for example, Aradi used his popularity in what central intelligence labeled as "influential Vatican circles" to obtain intelligence from a variety of Central European countries. Countries where, say, a priest could travel freely but an American could not. Aradi's most critical contribution, though, was in an area that was increasingly difficult to penetrate—and one that would be vital for generations: Ukraine.

.

Mary's interviews with Aradi intensified during the last days of December 1946. Her life had been a whirlwind of travel and new assignments since she joined central intelligence. The holidays passed in a blur, a mere distraction in the mountain of intelligence work that lay before her. She might be separated from her family in Missouri, but unlike most other agents, she had her husband by her side.

Mary and Gregory, whom she affectionately called Hutch, had been married for three years. They met as graduate students at the University of Missouri, where Greg was earning his master's degree in English and Mary was working on her PhD in archaeology. They bonded over a love of books, music, and language, their dates as intellectual as they were passionate. They often spent time on the sunny east lawn outside the library. On one afternoon the ants bothered them in the grass and so they decided to move inside. Greg handed Mary a tall stack of books as he held the door open, when a sudden gust of wind blew through.

Young Mary Folse (Hutchison).
Credit: The State Historical Society of Missouri, manuscript collection

"Did you ever try to pull a dress down with both hands full of books?" Mary asked in a letter to her friend. "It's simpler to leave it up."

While Greg immersed himself in obscure Renaissance literary criticism, with a particular interest in Spenser, Mary was off exploring. For her doctoral thesis, she traveled to Greece and took part in excavations at Corinth, an ancient city-state that had once been one of the country's glories, hosting two ports and a vibrant commercial center. It was not a simple matter to conduct research overseas, and Mary had to stand firm against the heads of her department who questioned whether an unmarried woman should be allowed to travel abroad as part of their program. There were no other women in her classes, and few working in archaeology in general. However, for Mary the feeling of digging into the dirt and unearthing what had lain undisturbed for thousands of years was worth every condescension, ill-timed jest, and unwanted advance. She was twenty-five and saw archaeology as a means to travel the world, picturing her future self on a Grecian necropolis, mapping the mysteries of the past and preserving every shred of pottery.

While her parents, particularly her father, a police officer in Kansas City, struggled to understand why their daughter was obsessed with ancient history, Greg was different. With him, she didn't have to conform to anyone else's expectations of what a young woman should be. They married in 1943 but, like so many other newlyweds of the era, were separated by war. Mary was still in the Navy WAVES, while Gregory joined the army. Now, in 1946, they were finally together again in Germany, building a nascent intelligence agency along with their new life together.

Yet as doggedly as Mary worked, and as much as she had overcome to become an officer, it seemed that she was fated to relive old fights. She was constantly having to justify why her career was as worthwhile as her husband's.

With Aradi, Mary had her chance. Here, her fluency in multiple languages and her aptitude for analyzing historical context was vital.

She interviewed Aradi closely in both Hungarian and English, compared reports written in Ukrainian and German, scrutinized their potential, and then spent hours writing up the material for Washington. Her reports identified organizations within Ukraine as potential allies for the United States, initiating what would become a critical and long-lasting alliance between the two nations.

Aradi's information pointed to one particular group of Ukrainians, referred to as Referat-33 or R-33, as potential Soviet spies. Through his connections at the Vatican, he had met with several of its leaders, none of whom were aware of his connection to the Americans. With Mary he discussed what these principals were like, describing them as "determined and able men, but with the psychology of the hunted. They are ready to sacrifice their lives or to commit suicide at any time to further their cause or to prevent security violations, and they are equally ready to kill if they must." Aradi believed that the R-33 could be a useful source of intelligence from behind the Iron Curtain in Ukraine, but at the same time he cautioned that any hint of connection to the Americans needed to be shielded because "they have an almost religious worship of their nation and distrust anything foreign."

Despite these concerns, the Ukrainians seemed an ideal match for the needs of the Americans. Their animosity of the Soviets was ripe for manipulation. Working under Aradi's cover, they began to send Ukrainian agents into the Soviet Union, where they would focus on gaining military intelligence. Operation Belladonna, as the program was titled, was in full force.

In Washington they marveled over Mary's work, exclaiming that she "had done wonders" with Aradi. Yet at the same time they noted her marital status. She was frequently identified as "the wife of Capt. Gregory L. Hutchison" in her reports, and never as Dr. Hutchison, a distinction markedly different than that of the male officers she worked alongside.

The relegation of her status on a project was a matter that Mary

couldn't simply brush off. Graduate school had taught her that if she wanted to be taken seriously, she had to be willing to assert herself.

.

Mary was an exception among women applying for work at the new intelligence agency. While she scoffed at Richard Helms when he tried to hire her as a secretary, most women were not able to leverage their education and experience as adroitly.

Elizabeth Sudmeier, another fiercely intelligent woman who made her way into the Central Intelligence Group directly after World War II, was thirty-four years old. She had spent the past few years in Alaska serving first in the Women's Army Auxiliary Corps (WAAC) and then in the Women's Army Corps (WAC). Like many of the Wise Gals drawn to the CIG in the early days of the Cold War, she had a particular set of talents and skills that made her uniquely qualified to work at the agency . . . even if she didn't fully appreciate those skills yet in herself.

Liz grew up in Timber Lake, South Dakota, on the Cheyenne River Reservation. Her father ran a lumberyard and then, when that business failed, he traded horses with the Sioux Nation. She grew up with two brothers and a Sioux nanny named Eudora Traversie, whom she adored and who, by all accounts, loved the Sudmeier family. Traversie was Liz's first friend, cradling the infant in her arms as she sang traditional Lakota songs. The school in Timber Lake was small, with only a handful of students enrolled in each grade. Yet it was also reflective of its western community, housing both Sioux children and those of European immigrants whose parents had been lured to settle in the region thanks to the Homestead Act.

No one quite knew how Liz's parents scraped together enough money to send her to college, but in 1933, she graduated with her BA in English literature from the College of St. Catherine in St. Paul, Minnesota. From this promising start, however, the future was murky. The

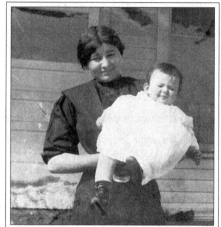

Elizabeth Sudmeier with nanny
Eudora Traversie, South Dakota,
1913.
*Courtesy of the estate of
Elizabeth Sudmeier*

Depression had cast its glare on the economy, and Liz, while she loathed going back to South Dakota, felt extremely fortunate to find employment as a teacher in the village of Eagle Butte.

For a young woman longing for city life, the role of rural schoolmarm was stifling. The town comprised just six houses loosely grouped together, with most residents living on nearby farms. The plains were so flat that Liz could see for miles in every direction. At night the sky would overwhelm the earth, the stars stunning in their beauty. Liz, however, still longed for the twinkling of streetlights and the glow of tall buildings. She found solace in the town's poky one-room library, a luxury in the Great Depression era and her lifeline to a world bigger than the state.

"It's beyond the pale," Liz would say when she described Eagle Butte. When she found a job as a bank teller in Minneapolis, she jumped at the chance to leave.

It was World War II that broke Liz out of her staid life in the Midwest, although Fairbanks would seem a poor substitute for a woman bent on city life. The WAAC marked the first time women were allowed to serve in the US Army, with the exception of nurses, and in an era when everyone was yearning to serve their country, more than thirty-five thousand women applied to join the WAAC in its first year.

Of these, only 570 women were chosen. While they technically received the same base pay as the male enlisted ranks, the compensation was quite different. The WAACs did not receive overseas pay or life insurance, nor were they even eligible for a military funeral. These restrictions were lifted in 1943, though, when women were allowed to "receive all the ranks, privileges, and benefits of their male counterparts."

The Alaskan territory was not yet a state, and for most Americans it was barely thought of at all. The wild, snowy tundra was considered an overseas assignment in the Pacific theater of the war. It was here that Liz first proved herself. Just six months after Pearl Harbor, the Japanese had bombed a naval base and an army fort in the American territory, highlighting the vulnerability of the region.

"I believe in the future he who holds Alaska will hold the world," said Brigadier General William Mitchell to Congress, as he described the strategic advantages of the North Pacific waterway. Liz's assignment had gone from snowy backwater to a seat on the front lines.

Liz was stationed first in Canada and then sent to Alaska. The territory was considered highly dangerous, particularly as it held the distinction of being the only plot of US soil where a World War II battle took place when, in 1942, a thousand Japanese troops invaded the Alaskan town of Attu, overwhelming its small number of residents and holding them captive. It took nearly a year for the US Army to arrive, comprising 12,500 soldiers, on May 11, 1943. They initially believed that retaking Attu would be a simple operation, but the land battle that ensued was one of the deadliest of the war. American soldiers found themselves on uneven terrain, the permafrost making the tundra spongy and creating natural foxholes for the enemy. After eighteen days of fighting, there were 549 American and 2,351 Japanese casualties. Only twenty-eight Japanese survived the prolonged attack.

It was to this Alaska that Liz was moving: glacial, isolated, and perilous. In 1943, the WACs shipped off to the territory, fearing all the risks inherent in an overseas assignment. Liz was assigned to Ladd Field

in Fairbanks as a control tower operator. While most women were as-
signed clerical positions, Liz received this post thanks to her college edu-
cation and steady nerves. Ladd Field was being used by Russian pilots
who were training under challenging weather conditions and ferry-
ing planes across the northern waterway. It was an intriguing position
for the young woman who loved languages and absorbing other
cultures.

The barracks Liz moved into in Fairbanks were "famed as the most
attractive living quarters on any post," but they would not remain stand-
ing for long. One June afternoon, a group working in headquarters
looked out their window and saw flames consuming the modern build-
ing. "Hey, the WAC shack's on fire!" one yelled, as they rushed to get
help. As the flames grew, women began jumping out of the upper two
stories, crushing their feet and fracturing their fibulas as they landed.
Liz rushed out of the building, barely escaping in time. The barracks
burned so hot and fast that the building was soon reduced to a smoking
heap of wood on the ground. The women were left with only the clothes

Ladd Field. Photo by Elizabeth Sudmeier.
Courtesy of the estate of Elizabeth Sudmeier

on their backs. Still, it could have been worse: one of their own had died in the flames. They would never learn what started the fire.

The WACs were moved to the cold-weather testing barracks, a site as uncomfortable as the name implied. Instead of toilets, it hosted a long row of open holes without privacy. The men shared what possessions they could, lending pairs of pajamas, soap, and toothpaste. Despite these conditions, Liz never complained in her letters back home.

"I like Alaska," she wrote to her mother, "but not so much as being with all of you."

She mixed with the pilots and watched their planes take off out of the Alaskan wilderness with little idea that the future of Soviet aircraft would one day be linked to her own.

After the war she had little idea where her career would lead her. She knew she didn't want to go back to South Dakota, nor did she want to teach. Washington, with its promise of government jobs, lured her. Despite her rank as corporal, and her medals for service during World

Russian pilots at Ladd Field. Photo by Elizabeth Sudmeier.
Courtesy of the estate of Elizabeth Sudmeier

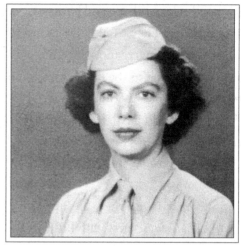

Elizabeth Sudmeier in her
WAAC uniform, 1942.
*Courtesy of the estate of
Elizabeth Sudmeier*

War II, Liz was hired as a shorthand stenographer in the central intelligence Office of Reports and Estimates in March 1947. It was the very position that Mary had eschewed a year earlier, but Liz felt an overwhelming pressure common among women in the postwar years. Although more than 70 percent of women employed in 1945 desired to keep their careers following World War II, four and a half million women lost their jobs when the men returned. Similar to the rest of the army, the vast majority of the WACs were demobilized following World War II.

By these odds, Liz counted herself as lucky. She was living in Washington, D.C., a city far larger than any the small-town South Dakotan girl had ever laid eyes on. Her work, while secretarial, was part of a cause larger than herself, and in the ambitions of the new agency, she saw reflected her own aspirations.

.

While Liz was starting at the agency, Jane was shifting her focus from France (where she'd been stationed throughout the war) to the Middle East. Back in Washington now, she was working as an analyst studying the region from afar. Truman could end the OSS, but he could not dispense with the need for intelligence. Departments and agencies would

shift, but ultimately Jane's position with American intelligence did not end. Her talents were needed.

While her work at the new CIG continued, Jane was about to receive some unexpected news about another man, one she knew well, one who would not so easily escape his war crimes. The crime in question was particularly shocking as it concerned a man beloved in Denmark: Kaj Munk.

Kaj Munk was a Lutheran pastor and playwright in the small Danish village of Vedersø. In the 1930s, he watched the rise of fascism across the continent with unease. Most Christian leaders remained silent, but Munk, like Vilmos Apor, felt morally impelled to speak out against the tyranny growing in Germany and Italy. In 1938, he published an open letter to Italian prime minister Benito Mussolini, condemning the persecution of the Jewish community. There were many who cringed at his outspokenness, including the Danish ministry of ecclesiastical affairs, which sent around a letter asking its clergy to "abstain from any comment, spoken or written."

Two years later, during the occupation of Denmark, Munk continued to voice his opposition to fascism, despite the risk to himself and his young family. His plays, writings, and sermons combined the elegance of his thinking with his strong sense of morality, as demonstrated in one sermon:

> There are people who imagine the truth can be pickled. One can salt it down, they think, have it in the salting barrel, and then take it up and use some of it when it is convenient. They are mistaken. Truth cannot be preserved. It exists only when it is alive. And it has to be used exactly at the moment when it offers itself. If it is not used, truth dies and rots and quickly spoils. The worst of all lies is the dead truth . . . Truth has words at its disposal; lying has the sword and chains.

By late 1943, Munk felt a sense of urgency. "I must go to Copenhagen," he told his wife. "For the last time I must go over there and preach,

and tell them the truth to their faces. Nobody else does it!" While the Germans had expressly forbidden his sermons, Munk chose to defy their orders on December 5, 1943, giving a sermon titled "New Year's Day." As he stood at the National Cathedral in Copenhagen he preached, "To stay silent in the face of sin is to speak the language of the devil."

On January 4, 1944, Munk was seized from his home, shot in the head, and left in a nearby ditch. While the Nazis hoped that this murder would dampen the Danish resistance, a rebellion was sparked instead. Munk's funeral was overwhelmingly moving for the four thousand people who attended, and the preacher became, in his death, a larger-than-life figure. American intelligence would label him a "national martyr-hero," noting that "emotion is connected with the mere mention of his name." Munk's assassination ignited outrage and hastened the fall of Nazi Germany.

After the war, the Danes did not forget Kaj Munk. The hunger to find and punish the men responsible for his death gained momentum in 1947. What Jane did not expect was that the man she had known for years, one whom she had spent countless hours in Germany with, was one of Munk's killers.

It was the Ostrich: Ludwig Nebel.

While Ludwig Nebel's files indicated that he was involved in many "unsavory acts," he had carefully concealed the most horrific act of his career as a Nazi. Jane could not ignore the fact that this was the man they had chosen, even courted, as an agent.

For Mary, Liz, and Jane, the importance of recruiting foreign agents who were trustworthy, and whose objectives they clearly understood, was about to emerge as a turning point in each of their careers. The men they chose harbored their own motivations, which were often at odds with the aims of American espionage. With each interaction, they were putting their lives in peril. For Jane, it was the past that would haunt her. Another collaborator was about to come back into her life, and not in a positive light.

TRIDENT

1947

Jane had wispy brown hair, bright blue eyes, and eyebrows that arched dramatically, lending her an engaged, inquisitive expression. It wasn't just her brows; Jane radiated curiosity. So much of her life had been spent chasing the unknown. She had sought the thrill of new experiences at three universities, on a dairy farm in upstate New York, and in too many European cities to name.

But the years had changed Jane. She was no longer the carefree girl that her two younger brothers remembered—the one who'd teased them, played tennis with her family, and shot air rifles into the woods. By 1947, she had emerged in her mid-thirties as independent, capable of cutting through deception, and fiercely loyal to a country that she had no plans of residing in, at least not anytime soon.

Paris in the postwar era was an intelligence officer's dream. While every officer returned to DC at regular intervals (to discuss operations, file reports, and complete physicals), most of the men and women working at central intelligence aspired to work overseas. Paris was where the action was, as well as the opportunity. It was where an officer could significantly influence spy recruitment and operations, which was seen as pivotal to career advancement. If Jane wanted to continue to rise in her profession (which she most certainly did), she needed to establish herself in Paris.

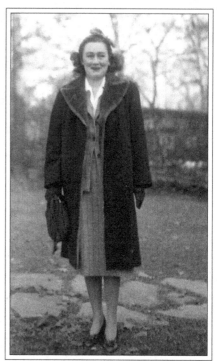

Jane Burrell, 1946.
*Courtesy of the estate of
Jane Wallis Burrell*

Jane adjusted to her new Parisian lifestyle seamlessly. The city itself was awash in newcomers, as the postwar displacement of people all across Europe packed hotels and apartments with new, temporary citizens. Many of these transient residents couldn't speak French or did so with strained accents. Jane's French, on the other hand, was impeccable. Her particular skill of blending in wherever she went was as keen as ever, and those she encountered casually never suspected that she was an American.

The world of overseas postwar intelligence was fast-paced and never boring, and Jane found herself working with a mix of officers from all across the globe, most of them French and American, but with many other nationalities represented as well. Everyone knew it was likely that spies moved among them. Jane was a lively part of it all, with a vibrant

group of friends and colleagues. But she was always cautious and a bit circumspect. After all, you never knew who might be watching . . . and what they might be looking for.

It might be expected that Jane's Parisian apartment would reflect the diversity and color of her surroundings—filled with mementos, photographs, and books. After all, this was a woman who had traveled extensively over the past four years and had friends in far-off corners of the world. Yet, similar to most intelligence officers, Jane's decor was decidedly bland, the type of nondescript dwelling that could belong to any humble American clerk. Among the humdrum belongings was only one relic that betrayed Jane's past, present, and future: a handwritten letter on two sheets of thin, onionskin paper. But the letter was not addressed to her.

The letter was dated December 31, 1934—almost thirteen years earlier—and it was filled with greetings for the New Year from Reinhard Heydrich, the central architect of the Holocaust, to Henrich Himmler, the leader of the German SS. Heydrich wrote in an old German dialect that even those fluent in the modern language struggled to comprehend. The skinny, slanted handwriting declared that the Third Reich would "thwart those enemy elements without losing strength." Jane smiled to herself, filled with satisfaction as she reviewed the old letter. This missive represented everything she'd been fighting against as a young intelligence officer. Himmler and Heydrich were her sworn enemies, and now, in 1947, both men had been dead for years. And here was Jane: resolute as always . . . and still gaining strength.

Jane would never reveal how the trophy came into her possession. The secret of the letter was, like so much of her work, impenetrable. Yet for the modest American officer who lived a life of necessary duplicity—unable to share her accomplishments with those she loved, and powerless to even decorate her apartment with keepsakes of her many adventures—the humble item was one of her most precious belongings.

Jane knew what it was like to live two lives. Perhaps that was why

she was able to work so effectively with George Spitz. Back in 1945, her interrogations of Spitz had led to the uncovering of a Nazi counterfeit plot and the recovery of a fortune in gold coins. Those intelligence officers who'd come after her were not faring quite as well. Although now based in Paris, Jane was kept updated on her old assignments, just in case her involvement might be deemed necessary again—and the Spitz case was one of the thorniest . . . and the most important.

On the outside, George Spitz appeared to come through the war unscathed—a carefree man who threw lavish parties at his home in Munich, drank late into the night, and bragged to his friends that he was an American spy. But beneath his flamboyant shell, Spitz was an anxious crook who increasingly feared that his past was about to catch up with him.

From his earliest conversations with Jane back in 1945, his story had been a study in contrasts. He had told her he was an American Jew, but with the Germans he claimed he was Austrian and a devout Catholic. The truth lay somewhere in between. Reviewing his records, Jane learned that Spitz had been born in Vienna, but his family moved to Brooklyn when he was a child. His religious affiliation was more difficult to pin down, as he used whatever identity conferred an advantage in the moment. This much was certain: he crammed multiple lifetimes of experience into one deceitful existence.

Spitz was once fabulously wealthy. His family had owned a successful banking house in New York City called Spitz & Co. As a young man, Spitz chose to dissolve the partnership between himself and his brother, pocketing half a million dollars in 1928—a fortune. With the money he ran off to Europe, chasing a sultry movie star named Fern Andra, whom he'd fallen for. He trailed after her to Monte Carlo, where the movie star "gambled his fortune away on the roulette table." Spitz left the city empty-handed, with neither his riches nor his girlfriend.

Exactly what kind of work Spitz had done during the war and whom he'd worked for was still unclear, though it seemed increasingly

obvious he hadn't been on the right side of history. Jane knew that Spitz was being reinterrogated by Allied officers in Munich in the spring of 1947, but she wasn't sure what it was about or what kind of intelligence he had to offer. While all intelligence officers were by necessity skeptical, Jane had learned the hard way that Spitz was especially prone to fits of make-believe. As more time passed, she could clearly perceive the extent of his deception. She had already let one murderer, Nebel, aka the Ostrich, slip through her hands, and now it was evident that Spitz still had a few surprises up his sleeve.

Even though she wasn't Spitz's handler any longer, the case still troubled Jane. As an officer, she was supposed to have control over her network of spies. Yet the current mess of tangled allegiances and lies among their spies seemed nearly impossible to clean up.

"Spies do not have any shelf life," Richard Helms once said. "They cannot be warehoused . . . As a rule, a spy who had lost the insights for which he was hired is soon to become an ex-spy." The indiscreet Spitz embodied this warning. He had become more of a liability, bragging of his spying for the Americans, than the asset American intelligence needed.

Despite his failings, American officers weren't ready to cut him loose—or perhaps they didn't know how. They had gifted Spitz a car, along with some assorted furniture. However, chief among their presents was the shield they offered from prosecution. Cradled in the arms of American protection, George Spitz appeared as content in the postwar period as he had been during the height of World War II while working for German intelligence.

While Spitz reveled in the luxuries that few could afford in postwar Munich, the Americans were considering what tangible benefit the man provided. Certainly, he had helped Jane identify and turn Friedrich Schwend, code name Flush, leading to the retrieval of a hoard of golden treasure. But what else was his information good for? As agents reinterrogated Spitz, they found little of value, and soon the tide of opinion turned against him.

"Spitz is one of the greatest swindlers," read one report. Later analyses would declare him an "opportunist who made most connections with American officials to further personal positions."

Jane considered this as she reviewed and received updates on Spitz's case. His failures were inevitably her own. She, along with other X-2 agents, had once assured Spitz that she would keep him out of the courtroom. Now, she was not certain she could deliver on that promise. Central intelligence preferred not to intrude, particularly in prosecutions undertaken by foreign governments in which they had little control.

Jane had seen this play out firsthand with Nebel, the Ostrich. At first, officers doubted the charges being made by the Danish government. It seemed ludicrous that the man they thought they knew intimately could conceal such a gruesome crime. Despite the hours spent together, Jane had never suspected the horrific past of her spy. "The organization feels itself obligated to protect and aid him as much as possible," read one internal American memo. "For this reason we are very anxious to determine whether the charges made by the Danish mission are substantiated by sufficient evidence so that any element of doubt as to [Nebel's] guilt is removed . . . we would be very loath to allow him to be transferred to Denmark to stand trial for some denunciation which had no basis of actual fact."

The Americans could not fool themselves for long. The Danish became "insistent" that Nebel be arrested, producing evidence that the man was not merely a member of the Nazi gang that murdered Kaj Munk but its leader. Even after Nebel was extradited, his case continued to tug at intelligence officers. "Although this man was undoubtedly a criminal thug and a wholehearted Nazi," said one British MI6 agent, "the fact remains that he gave us a considerable amount of information . . . and worked loyally for the Allies at considerable danger to himself." Jane was prepared to testify on his behalf and waited some months in suspense, wondering if she would be sent to Copenhagen.

After some back and forth, the administrators in Washington

ultimately decided not to make the Danes aware of Nebel's work as a spy. His crimes were simply too grave; the Americans wanted to avoid any association with him. They were particularly concerned that their involvement might result in "unfavorable publicity."

Now in Copenhagen, Nebel continued to squirm. He named Jane specifically, desperate for the mercy of her testimony and afraid that he would be sentenced to death. Jane, however, had gone deaf to his pleas. She was relinquishing a promise made to a murderer. When his lawyers told him that American intelligence had discarded him, he sat in his jail cell, alone and hopeless. There would be no redemption. Nebel, whose name in German meant fog or haze, would live both sides of his double life shrouded in secrets.

Spitz, on the other hand, would be bathed in the light of Jane's beneficence.

.

American intelligence often promised money, material goods, or protection, either physical or legal, to foreign contacts to persuade them to provide critical information. Yet there was another favor frequently requested by prospective spies: they wanted to live in the United States. This prize, while often assured, was not so easily granted. "As happens so frequently," reads one central intelligence report, "promises that are made during the stress of war are often forgotten because the emergency has passed."

In Munich, Mary Hutchison heard many appeals for American citizenship from the spies she worked with, but none so loudly as the pleas coming from Zsolt Aradi. Mary wrote recommendations for Aradi, but she knew that her opinion, by itself, would count for little. Although by 1947 she had strong-armed her boss, Richard Helms, into making her an officer, she was still trying to prove to those at the Munich station that she was more than a "contract wife," a woman hired merely because she was married to an intelligence officer.

The truth was, Mary Hutchison was born to be a spy. She was the kind of woman who could spend a wild weekend with friends on West Eighty-Second Street in New York, staying up at all hours, drinking beer, and cursing, and then visit conservative relatives on a farm in Kansas, where she would sip her tea modestly, discuss embroidery, and keep her legs perfectly crossed. She was an expert at duplicating her friends' handwriting, her scrawl nearly indistinguishable from the original. Archaeology and military service had given Mary a wide network of friends living across the world, all of whom seemed to call her a different nickname. She was Macushla, Esmeralda, or Mary-girl, each relationship forged in a different language. In her letters she was by turns thoughtful and teasing, maintaining close relationships no matter where she was sent.

Yet when her intelligence colleagues looked at her, they could not perceive her advanced degrees or her skill at crafting intelligence reports. Instead, they saw a pretty woman with a wide smile. She was thirty-six, but her smooth skin and plump cheeks made her look like a teenager. While many women might revel in a youthful appearance, Mary turned to cosmetics. She wore deep red lipstick in an attempt to look older and more sophisticated.

The term "contract wife" weighed on Mary. It was maddening to have her work demeaned. In the 1930s, back when she was still a single university grad looking to pursue a graduate degree, she found that many schools were not eager to accept women into their doctoral programs—after all, it was assumed, a woman would "take the place of a man" who rightly deserved the spot. But Mary was vocal. "I'll work harder than any man," she had boasted to her advisor. She then proceeded to do so, receiving a competitive scholarship in archaeology and comparative philology, the field of comparing languages to ascertain their relation in history.

Yet even this auspicious beginning had not led to tangible success. After writing her thesis, then earning her PhD at the University of

Missouri, she found jobs in her chosen field scarce. She watched as her fellow (male) students went off to work for universities across the country, from California to Illinois to Florida, but none of these institutions were willing to hire Mary as a faculty member or even as a lecturer.

Meanwhile, Mary had attended no fewer than thirty weddings between 1936 and 1940. Every female friend she had seemed to be married, and every letter she received teased her about "being next." She was twenty-nine years old, decidedly late to the party in a culture where most women were wed by twenty-one. Yet she knew what would happen to her if she were to marry: her degree would crumble in the dust of broken dreams. A popular girl, she'd dated a lot of men in college and graduate school, but she wasn't ready to settle down. No one in her family was surprised by Mary's independence. "I can't quite picture you in mother's wedding dress," wrote her sister, "with a veil coming down the stairs."

To make ends meet, she worked as a proofreader and editor at a newspaper in Kansas City before switching over to education, finding a job in curriculum planning for the Houston public school system. She saw the jobs as temporary, stopgaps on the road to working at archaeological digs overseas. Then World War II began.

Volunteering for the WAVES, she was sent to Miami in 1942. Before joining, she signed a document promising not to marry during her training. Mary was unconcerned. She was single and hopeful that an overseas assignment might be in her future, even hinting to her parents that they might not be seeing her for a while.

The military, however, had other ideas. Recognizing her talent and her capacity for language, the navy made her an intelligence and liaison officer, stationed stateside. In the Miami offices she sat with Jews and dissident Germans who had escaped Hitler and now sought refuge in the United States. Her job was to interview and debrief these exiles, with the aim of collecting relevant intelligence, yet these interviews were poignant and often wrenching. She spoke with men and women who had

watched their entire families killed in front of their eyes, who had escaped certain death themselves, yet who still held on to hope for a new life in the United States. No matter how stirring and emotional she found her interrogations, she had work to do. Speaking in German or French, she asked a stream of questions about their experience. Her tone was sympathetic, but her role was to extract as much intelligence as possible from each encounter.

What she was doing now in 1947 Munich was similar in many respects. She was there to obtain usable intelligence from her network of spies. Zsolt Aradi was, by that definition, a mere cog in the wheel, and his ultimate fate should not have influenced her work. Yet it did. Just as in Miami, where she sometimes cried in front of her roommate at night, trying to comprehend the terror and misery that was spreading across the globe, she felt deep empathy for the man she had worked alongside.

Recognizing her own limited influence, she asked her colleagues, who had long relied on Aradi's valuable intelligence, to recommend him to the higher-ups for US immigration. This was done readily, with one officer saying that Aradi was responsible for "some of its best central European reports." Still, the spy's visa request kept getting shuffled from one department to another.

One difficulty may have been an item hidden in his file that questioned his sexuality. This memo labeled Aradi as a "homosexual" who "shares an apartment with a man." When made aware of this accusation, Aradi denied it, pointing out that he lived in an army billet, with no control over his roommate.

While rumors may have hampered Aradi's entry into the United States, it's entirely possible that bureaucracy alone was responsible. In 1924, a national quota system limiting immigration visas per nationality was instituted in the United States. According to the law, only one thousand Hungarians were allowed to immigrate yearly. This meant that the waiting period for a Hungarian applicant in 1947 was approximately forty years. "In all candor, the subject of immigration to the United States

is one of the most confusing problems that any of us have ever had to deal with," Richard Helms, Mary's boss, explained in reference to Aradi.

In a poll taken at the end of 1945, only 5 percent of Americans felt that immigration from Europe should be increased. The issue became highly politicized, with Congress refusing to take action. Frustrated by partisan dithering, the president issued the "Truman doctrine," admitting up to forty thousand displaced persons, many of whom were Jewish, into the country. Yet even with this bold executive action, American immigration remained low.

While they wrangled to find Aradi a way into the country, his value as an undercover agent suddenly vanished. Aradi was walking through the Vatican one day when he saw a man he recognized from the CIG headquarters in Rome. It was a Jesuit priest, a Hungarian like himself. The two locked eyes for only a moment, but in that instant Aradi realized his cover had been blown. The man was not just another priest, but instead an agent like himself, working between the Americans and the Soviets, whose reports had been so poorly executed that American intelligence had dropped him. Now this priest knew where he worked, and that he worked with a foreign intelligence agency, and so could reveal to his Soviet colleagues that Aradi was in actuality an American spy.

With his connections potentially exposed, Aradi lived in fear of being sent back to Hungary. He knew that a brutal fate awaited him there—his spying would undoubtedly yield swift, fierce retribution from the Soviets. Yet Italy was in many ways just as dangerous. The country's communist-socialist party was gaining a toehold leading up to the 1948 election, which would leave Aradi defenseless. The American zone of Germany seemed the safest place for the agent, at least temporarily.

So Aradi was removed to West Berlin, where, for the time being, the fractured city would serve as his home. While Aradi was desperately looking for a homeland, his handler Mary was merely homesick. She missed her parents, her friends, and archaeology. At night, after work, she would sit with Greg in their apartment and write long letters home.

"I've been thinking of you ever since I left," she wrote to a close friend living in New York City. "I wander and I eat magnificently . . . yet still I wish for you."

She told her friends she was still working for the navy, but she avoided the details of her job in her letters. Instead she talked about food, her marriage, and her future travels. Even if permitted, she didn't *want* to discuss her struggles at work. Despite her efforts, she could not be oblivious to the fact that her country's undercover operations were not going particularly well.

Perhaps this was not surprising. After all, both the British and Soviet intelligence services had been operating for decades, with wide experience in managing elaborate, covert operations. The Americans, by contrast, were brand-new to the spy game, with even their name—the Central Intelligence Group—lacking permanency.

Mary was working on Operation Trident, an offshoot of Belladonna, which utilized Aradi's contacts in the Ukrainian liberation group called the Referat-33. In the spring of 1947, Mary and the central intelligence officers in Munich were struggling to build a foreign intelligence network from the ground up. Their goal was to penetrate Soviet intelligence, but to do so indirectly, primarily through four members of the Ukrainian resistance, code-named Canaan, Capaneus, Caparison, and Capelin. In return, they offered the men protection in the American zone of Germany and a modest cache of supplies.

As they worked closely with Aradi, their immediate goal was to protect their agents. Mary and her fellow CIG officers had become caretakers for the men, and they knew that their four lives (as well as Aradi's) rested in their decisions. It was an overwhelming responsibility, and Mary was acutely aware of the risk they were taking. The Soviets were actively searching for the very men they were collaborating with, and if word got out that the wanted men were at the heart of an American operation, the consequences for all involved would be severe. Mary knew that open hostility had to be avoided at all costs.

To protect the secrecy of Trident, Aradi identified a man named Myron Matvieyko, a former German intelligence agent whom the Nazis had previously sent behind Soviet lines. He was now a leader in the organization of Ukrainian nationalists. Together, the CIG determined Matvieyko would be their main contact in Munich. All of their Ukrainian spies working under Operation Trident (Canaan, Capaneus, Caparison, and Capelin) would report through Matvieyko to limit contact with the Americans. They were trusting the former German agent explicitly with an operation that would shape the future of spying in the Cold War. Their trust in Matvieyko, as it would turn out, was misplaced.

.

While Mary worked companionably with her agents, Jane's former spies were a thorn in the side of central intelligence. Mary and her husband were invited to the home of Friedrich Schwend, aka Flush, in the spring of 1947. She managed to beg off, but other American intelligence officers were less finicky, and the party was crowded with a mix of Americans, Europeans, officers, and spies. Among the attendees was Spitz, who was always eager for a good time. In the middle of the revelry, Schwend stated he was going to be leaving town for a while to visit his family in Italy. The announcement struck no one as remarkable. Perhaps it should have.

Mary had been hearing rumors about Schwend for the past month, ever since the Italians raided the castle at Schloss Labers yet again and found, hidden in walls and under floorboards, a vast treasure. Although he had never mentioned it to Jane in 1945, a hoard of counterfeit money remained behind: pounds, dollars, and even Allied military currency, or AMC. AMC were bills that were given to troops entering newly liberated countries. The AMC was used as a measure of currency control, ensuring that American dollars did not circulate next to weaker foreign currencies, which could risk inflation.

Given how new the AMC bills were, their presence in a counterfeiting operation was suspicious. Central intelligence officers feared that the

Allied military currency.
Courtesy of the author

Nazis were quietly continuing their criminal enterprise of printing and circulating fake money, their factory now buried somewhere underground in Italy. What did Flush know about all this, and when did he know it? After all, he was the castle's inhabitant and a leader in Operation Bernhard. Distrust now blemished Flush's (already spotty) reputation. It seemed that if he was truly under Jane's control as an agent, he would have led her and Lieutenant Michaelis to the stash of counterfeit money, along with the sacks of gold.

What neither Mary, Jane, nor any of the other central intelligence officers realized, however, was that Flush was keeping secret not an ongoing counterfeit plot but instead his own thievery. He had been stealing money and treasure for years, first from the Nazis, and then from the US Army German intelligence service, the Gehlen Organization. He hoarded these riches in holes across Germany and Italy, each one offering a combined retirement plan and escape route.

Now, with attention centered on him, Flush decided it was time to leave Europe. After his going-away party in Munich, he traveled with his wife to Italy. Like so many other Nazi collaborators, he was fleeing on a "ratline," an escape route for Nazis, to South America. He pretended to be a Yugoslavian agricultural technician and traveled under a forged Red Cross passport. He wasn't leaving empty-handed, instead carrying two briefcases packed with counterfeit bills onto the transatlantic steamship. In April 1947, he reached his destination, Peru, and rechristened himself Federico. Cheekily, he wrote two letters to his officers back at central intelligence in Munich, saying he would "always remember the Americans for the kind treatment he received." Jane could hardly return the sentiment.

.

When Eloise looked out the window at the central intelligence headquarters in Washington, she saw three lines of army-green tanks rolling down Pennsylvania Avenue. It was the Army Day parade, held annually since 1928 to draw attention to the importance of national defense. That April day in 1947, the sky was a bright blue, the weather was mild, and the cherry trees were just starting to bud. The headquarters of American intelligence was located just seven blocks down Pennsylvania Avenue from the White House, a location that facilitated their daily briefings to the president. On this day, however, no one was getting around the city easily; the streets were too packed with veterans and their families.

Eloise often got lost in crowds due to her small stature; she was just a smidge over five feet, but she made up for her lack in height by always wearing heels. Even while stationed overseas she wore dresses, stockings, and her beloved Ferragamo pumps. The Italian designer shoes were a perfect blend of style and comfort for an officer who was often on her feet. In Brussels, Paris, and London, the men she worked alongside often rolled up their sleeves and loosened their ties, but Eloise never lapsed in her wardrobe. Her Southern upbringing had taught her that her dress

was her armor; it created a shell of professionalism that ensured those around her took her seriously.

As Mary and Jane knew only too well, many of the agents recruited by American intelligence in Europe following World War II had proved problematic, and in Washington, Eloise and the other officers were trying to learn from their mistakes. Recruiting men whose pasts had not been sufficiently investigated, such as Flush, the Ostrich, and Spitz, had seemed a temporary solution to a desperate problem in 1945, but two years later, the men were a source of headaches for the group. Their entanglements had put stress on diplomatic relationships across Europe as central intelligence grappled with whether to protect agents who had proven useful and what details they could reasonably share with foreign prosecutors.

In Washington, a new report was stirring up the intelligence community. It was written by one of their own, a former X-2 agent named Samuel Brossard, now an officer in central intelligence. He had just assessed Operation Rusty and his recommendations were not at all what Eloise expected. Central intelligence had been keeping its distance from Rusty, the troubled operation that used former Nazi intelligence officers to gather information on the Soviets. Now, Brossard advised central intelligence to take over the group but fire those whose "past records, previous connections, or actions constitute potential sources of political embarrassment or are actual threats to our security."

For many central intelligence agents, including Eloise, the prospect of working with former Nazi intelligence officers—even the "good" ones—was questionable. "It's going to get us in trouble," she confided to another officer. She did not speak out against the action officially—that was for others—but in private conversations she expressed concerns. Considering the hassle their foreign agents were causing in Europe, Eloise was hardly alone.

Central intelligence itself was struggling. Eloise watched as the leaders of her organization were rapidly replaced: three men served as

director of central intelligence in its first two years of existence. In her eyes, none were comparable to the man who remained her measure of excellence: William Donovan. The problems they were facing were more than mediocre leadership. They had neither permanence nor a budget. Yet for Eloise, mingled together with the worry about the future of their operations was also the excitement of being at the start of a new enterprise. In the course of one humid, capital-city summer, Eloise was about to join in the dramatic rise of American intelligence.

OPERA
1947-1948

Jane held the letter firmly. She was intimately aware how powerful a single letter could be. In her hands, letters had maimed and even killed men. They were the beginning of a chain that, once started, proved impossible to break. The paper she held felt innocuous, a mere bureaucratic detail within the greater purpose of her work. Yet in the end, it would prove to be her downfall.

.

On July 26, 1947, President Truman received devastating news: his mother was dying. Mrs. Martha Ellen Truman was ninety-four years old and in declining health. Just two months earlier, the president had rushed to her bedside after she'd fainted, and he had then spent twelve days with the woman he still called "Mamma." Now, the news from Missouri was grim. Truman hopped on the presidential plane and flew out to Grandview.

The airplane he flew in was unlike any other in existence. Before Air Force One, the first plane constructed for the presidency was a Douglas VC-54C Skymaster. Everyone called the plane the *Sacred Cow*, a nickname that played upon the aircraft's high security and bloated size. Truman was sitting in the plane's executive stateroom at a large table, the seal of the president of the United States emblazoned on its

surface. Recessed, built-in ashtrays were placed at each corner. A large map formed the backdrop, while light slanted in through a rectangular pane of bulletproof glass.

Truman had left Washington in a hurry, leaving behind most of his work for the day, but he had brought with him the one task that he could not bear to delay. The paperwork lay on the table, and as he reached to sign it, there were no photographers, no crowd of advisors, and not one woman in the room. On that summer afternoon, in the presence of just two enlisted men who were stewards on the *Sacred Cow*, Truman signed the National Security Act of 1947. When he was finished, he turned to the men and said, "We now have a separate Air Force."

What Truman didn't mention was that along with the air force, the country had also gained something else: the Central Intelligence Agency, or CIA. It had been just two years since Truman had abolished the OSS, and now he was creating an agency that looked remarkably like the one he had discarded. The Americans had modeled the style of their intelligence agency on the British, creating a civilian service, independent from military influence, rooted in espionage and counterintelligence strategy. The CIA would report directly to the president.

Truman's change of heart, going from abolishing the OSS in 1945, to reinstating the group as the CIG in 1946, and now to expanding its powers as the CIA in 1947, grew from desperation. His concern was not that the agency would become too controlling, as he had previously expressed, but that it wouldn't become powerful enough. He needed a single report that could make sense of the whirlwind of intelligence activities happening across the globe. In just a few months, however, he would begin to think about other needs.

By December 1947, Truman and his National Security Council authorized the CIA to use covert operations to prevent a communist takeover in Italy. It was the beginning of an increased dependence on covert operations at the agency. Eloise, Mary, Liz, and Jane worked in

clandestine operations, those activities that were meant to run unseen and unnoticed. Covert operations, on the other hand, were a step further—they were operations intended to be not necessarily hidden, but deniable. In fact, they included operations that could not fail to be noticed, such as the overthrow of a foreign government, but were designed never to be traced back to the US government.

The CIA's covert operations started as a mere sprinkle among the more classic espionage activities, but this portion of the agency's work would soon grow, taking on a life of its own. In 1963, Truman would write that the "quiet intelligence arm of the president has been so removed from its intended role that it is being interpreted as a symbol of sinister and mysterious foreign intrigue."

While Americans had borrowed strategy from the British secret intelligence service, they deviated when organizing the structure of American intelligence. The CIA was envisioned as independent but without controlling interest. It could gather the intelligence needed to inform policy but lacked the power to enact it. Even more unusual, the CIA was designed to compete with other government agencies. This duplication of efforts was intended to create a healthy rivalry, producing a variety of opinions derived from both civilian and military intelligence.

Although the CIA would not be officially christened until September, on July 28 (just two days after Truman signed the bill), Adelaide Hawkins stood in the headquarters of American intelligence. The old building on E Street, in the Foggy Bottom neighborhood of Washington, was as familiar to her as her own home in Silver Spring. Now, she was swearing her loyalty to her country in a wordy pledge:

"I, Adelaide Hawkins," she promised, "do hereby swear that I am not engaged in any strike against the government of the United States and that I will not so engage while an employee of the government of the United States, that I am not a member of an organization of government employees that asserts the right to strike against the government

of the United States, and that I will not while a government employee become a member of such an organization."

Addy was given a physical and declared fit for service. She was officially one of the first agents in the brand-new CIA. Addy was working in the Office of Special Operations, or OSO, the division of the agency responsible for all espionage and counterespionage. She was based in the communications division. The department's name was deliberately made to sound bland and uninteresting, but the work Addy was undertaking was anything but. In the years ahead, most agents would call the department covcom, short for covert communications. Armed with her World War II cryptanalyst training, she was embarking on the next phase of her career: developing spy gear to assist communications.

As Addy surveyed her new team, she couldn't help but notice how different it was from the haphazard group Donovan had assembled during World War II. There were no society men, fresh from their exclusive Manhattan bridge clubs, for her to quiz with puzzles; no chess champions in which she could indulge in an afternoon game; and there was certainly no choir of Dartmouth glee club singers, relieving the stress of their day with the stirring beauty of "Ave Maria." Instead, Addy's unit was a mix of scientists, technicians, and other intelligence specialists like herself. The once young and frivolous attitudes of her fellow employees working in a musty basement had shifted into a resolute staff in a permanent workplace.

Addy brought the practical experience of how to structure a communications network from her time running the message center, combined with her scientific expertise from working in cryptanalysis. But she also felt strangely alone in the new workplace, despite her excellent experience. While women had once made up less than 20 percent of employees in the message center, now their absence in the new CIA halls was even more striking. Addy was working with nearly all men. The few other women on her team occupied administrative roles.

Newly divorced Adelaide
Hawkins with her three
children, Sheila, Eddie, and
Don, and dog Mickey, 1947.
*Courtesy of the estate of
Adelaide Hawkins*

Addy, on the other hand, was hired as deputy chief of the department, a position that underscored her value to the newly formed CIA. She found the men easy to work with, free of resentment at working alongside, or even beneath, a woman, and yet despite this, feelings of inadequacy tugged at her. "I'm just a West Virginia girl," she told a colleague who had congratulated her on her promotion. She was a single mother and sharply aware that every professional advancement she hoped to achieve was weighed down by how administrators viewed her personal life. Still, she remained optimistic; after all, she had gotten this far.

She had little to regret—certainly not Ed. She was glad he was long gone. "I'd like to have a divorce," he'd said to her, on one of his sporadic visits. Addy had spent her life chasing that man across the country, even showing up on his doorstep after he'd abandoned her and Sheila. Yet when she heard those words come out of his mouth, she felt nothing but relief. She didn't need him anymore, and she was done fighting for a marriage that had died years earlier. By 1947, at the same time she was emerging as a professional woman and building a new government

agency, her divorce was finalized. The CIA would always be as old as her freedom from an unhappy union.

It was the death of her old life, but what emerged was a woman that her nineteen-year-old self could never have even conceived of. Strong. Assured. Confident. And there was still so much to do. Her work, always a source of stimulation, was now becoming exceptionally thrilling.

Addy relished one of her earliest projects in the department, a microdot camera. The Cold War lent itself to spy gadgets in a way few previous conflicts had. Without outward hostility, suspicion and distrust were growing as fast across the European continent as the Eastern bloc. The Soviets were swallowing up Eastern European countries along their borders and installing communist regimes. It was clear that Eastern Europe was just the beginning of their grasp for global power. Stalin was at the helm of a totalitarian government that was repressing and killing its own people.

As Addy spoke with CIA officers stationed in capitals across the globe, she noted how tensions with Russia had shifted their espionage. Unlike in years past, they were gathering massive amounts of documents, often obtained surreptitiously from foreign governments. Yet how, Addy wondered, could such a bulk of material be secretly transmitted from the source to the agent and back to Washington? Running files across foreign capitals would attract attention. They needed to be able to transfer a large amount of information in a tiny space.

The microdot camera fit this need perfectly. An agent could take the device and photograph a document. The camera reduced the image until it fit on a disc the size of the period at the end of this sentence. That tiny dot could be concealed in anything, even glued onto the punctuation of a letter, where it would remain indistinguishable until retrieved by its recipient. Once placed under a microscope, the document could be read normally.

The concept of a microdot is akin to making shadow puppets. As you draw your hand closer to the lamp, the shadow on the wall grows.

Microdot camera circa 1949.
Credit: CIA/CREST

As you draw your hand away, the shadow shrinks. Photographers had been utilizing this basic concept since the nineteenth century, when enlargers for film photography were first developed.

The CIA was building on the research of a Frenchman named René Dagron. While most photographers want to make their images bigger, Dagron had the opposite effect in mind. In 1859, he patented the first microfilm technique. By increasing the distance during exposure on his silvered plates, as well as adding in special lenses, he was able to create tiny images that were just two square millimeters. He even constructed elegant jeweled viewers so that a microscope would not be needed to see his mini-creations. He sold his "photo micro jewels" as a novelty at the 1859 International Fair in Paris. A decade later, during the Franco-Prussian War in the 1870s, Dagron's technology allowed news and messages between families separated by the siege to be reduced in size and tied onto the tail feathers of carrier pigeons.

The microfilm technique was improved over the years, notably by a scientist named Emanuel Goldberg. Goldberg was born in Moscow but moved to Germany as a young man. His field was photography, and he had been recruited to work at the world's largest camera firm: Zeiss Ikon. In 1925, he published his work on the *Mikrat*, German for "microdot." His *Mikrat* worked along a similar principle to those who came before him. If you look through a microscope, you can observe tiny

things that look remarkably large. However, if you flip over the objective on a microscope and look the other way, it can make big things appear incredibly small. Goldberg's lens was more convenient than his predecessors'. He cleverly housed the developer for his negatives inside a thirty-five-millimeter camera of his own invention. His design greatly compressed an image, taking an entire page of text and reducing it to a minuscule 0.1-square millimeter.

Goldberg viewed the technology as a gift to humankind, and he harbored lofty dreams of squeezing down entire libraries, making the world's knowledge accessible to anyone, anywhere. The Nazis, however, had other plans for his work. In 1933, after Hitler came to power, stormtroopers invaded the Zeiss offices and arrested the Jewish scientist. Goldberg was held for three years while SS officers tried to pry every bit of *Mikrat* knowledge from his head.

Despite kidnapping Goldberg, German intelligence agents found the practicality of microdots lacking. The size and legibility of the images needed to be improved, and the bulky camera itself was difficult to conceal. Such an innovative device couldn't stay a secret for long, and soon word of the *Mikrat* reached the Allies. British intelligence experimented with the microdot format toward the end of World War II, but without the technology to make the images even smaller (and the camera itself less obtrusive), the applications were limited, and innovation of the microphotography lagged.

Addy and the team at the new CIA saw the potential of this device immediately, and they were determined to make it work for their needs. Soon, they were redesigning the microdot camera so that it fit snugly into the palm of a spy's hand, with lenses so powerful that pages of documents could now be squeezed into the tiny dots without losing their clarity. Their camera was roughly the size of a quarter, with a raised lens fitted on top. In addition, they were playing with the composition of the microdot itself, bleaching it with drops of diluted iodine so that it blended imperceptibly behind postage stamps or secreted in jewelry.

This soon became not just an engineering problem but also a chemistry one. Addy and her colleagues became experts in an obscure-sounding specialty: emulsions.

Emulsions are liquids that can never fully combine, like oil and water. In the 1920s, Goldberg had used the same elements in his *Mikrat* emulsion that most photographers used to create gorgeous studio photographs: a mixture of silver chloride and silver bromide. This offered a rich, beautiful photograph, gorgeously capturing the tones of light and shadow across the black-and-white spectrum. But it was rubbish at creating the kind of crisp, tiny photos that intelligence agencies needed.

In contrast, the CIA's wish list for an emulsion was far less complicated than that of most professional photographers. They didn't care about portraying a velvety skin tone; they needed to develop an emulsion that could capture images in low light, be fixed to a minuscule dot, and provide crisp black-and-white images, all while looking like nothing at all.

In the building on E Street, Addy and the team began to assess the possibilities of new, tantalizing emulsions in their compact camera. Addy carefully considered how ciphers could be used in microdot communications, freeing up even more space. Technology would come and go—microdot cameras were just the latest trend—but the challenge of communications would persist. Yet even as she labored in the building that she knew so well, she also pined for an assignment outside the country. She was hardly alone; the desire was common among her colleagues.

Overseas operations were prized jewels, a way to prove oneself in the field and a critical stepping-stone on the path to obtaining career advancement. Sitting at a desk in Washington could never hold the same allure. If Addy had been a man, it was likely that she would have already been operating out of a foreign capital. Both her years at the OSS and the quality of her work would have garnered her a coveted position. Instead, Addy was hampered by the fact that she was divorced and, even

worse, a mother. She could file her requests and dream of foreign lo-cales, but if she wanted to prove her worth to the new CIA administra-tors, she would have to do it from Washington.

.

Not every woman found it difficult to get an overseas position at the CIA. The acronyms might change, but the need for intelligence had never halted. Truman may have abolished the OSS before bringing it back to life as the CIA, but Jane had never stopped. Her work was too impor-tant. By January 1948, Jane had been living in Paris for nearly two years, working out of the CIA station there. Her cover job was as a courier at the US embassy, but she, too, was actually a founding member of the CIA.

Each CIA station was run by a chief who employed operations officers—those individuals who would go out in the field, recruiting, developing, and handling their network of spies. The intelligence they collected was then dumped in the lap of a reports officer at the station, who was responsible for sifting through the information, figuring out which of the slurry of reports was vital for headquarters to know about, and then writing them up in a clear, concise manner.

On paper, Jane's role was a reports officer in France . . . but in reality, she was working as an operations officer. After all, it was a natural off-shoot of the work she'd been doing for the OSS and CIG for years dur-ing World War II and its immediate aftermath. This double dealing would be a common theme for the agency, particularly in regards to its talented female officers. Jane's training in espionage and counterintelli-gence made her ideal at spotting potential spies, winning them over, and gaining their cooperation.

One of Jane's key strengths was working with foreign intelligence services. Part of this was borne from struggle. It was not easy to be an American working with British intelligence during World War II; an officer was required to prove herself. Doing so had also made Jane irrepressible.

Jane had formed a liaison with the French intelligence service, nick-named *la piscine*, or the swimming pool, as their headquarters were located next to a large public pool. Similarly, agents dubbed the CIA station *the opera*, a nod to its location at 11 rue Scribe, an ornate, honey-colored building across the street from the stunning Palais Garnier, Paris's opera house.

It was her years in espionage that had garnered Jane this prime position working directly with the French intelligence service. Similar to Addy, she was now divorced, but unlike her, she had no children. She was just thirty-four years old, still at the beginning of her career, and poised to take on bigger responsibilities. Her work at this critical time had the potential to influence decades of foreign policy. Yet some mundane tasks still required her attention.

It had started with a letter delivered to her at the end of 1947: a piece of correspondence that, while it might have appeared harmless, would change her fate. It was about George Spitz, the important (yet always frustrating) intelligence source Jane had cultivated and "handled" during wartime. The CIA had decided to cut ties completely with Spitz. He had become useless as a covert agent, and, of increasing concern, a spotlight was starting to illuminate his once-murky past. Like so many other agents Jane had recruited and controlled, the extent of his activities during the war had never been fully clarified. There were some crimes that men would try to hide no matter what. For the Ostrich, that crime had been murder. For Spitz, it was his role in the Nazi Party.

Although he pretended to be an innocent art dealer swept into German hands, it soon became clear that his role within Abwehr, the German intelligence agency, was far greater than he let on. A recent report leaked a secret that any American collaborator would be desperate to hide: he had worked for the Gestapo, the secret police. Spitz had spent years pointing the finger at others, desperate to take the focus off himself, shifting his identity to appear innocent, but it was all for naught.

Meanwhile, a separate group of art historians and museum directors

was after George Spitz. They worked for the Allied forces' Monuments, Fine Arts, and Archives section and were known as the Monuments Men. They were not only men, of course, but instead a diverse 350-member force dedicated to tracking down artwork looted by the Nazis. They were not related to the CIA, or even to the military, but instead comprised an independent group of global experts commissioned by President Roosevelt in 1943. These men and women worked alongside the army and American intelligence, but that did not mean that secrets were shared freely. Often they had to be pried loose, especially from the CIA, who would take months to decide on each case, going back and forth in correspondence that weighed the risks and benefits of revealing their intelligence.

Some of the art the Nazis stole as a way to make money, but the majority of the pieces were never meant to be sold. Instead, Hitler planned to build a museum in Linz, Austria, with a collection unrivaled on the world stage. He was not the only Nazi obsessed with art. Hermann Göring, one of the most powerful figures in the Nazi Party, was infatuated. He amassed a personal collection of more than a thousand pieces, worth an estimated $200 million. Some of those paintings had been acquired by Spitz, who had crossed borders with briefcases of counterfeit bills to purchase Rembrandts and Rubens that would hang on Göring's crowded, sloppy walls. The Nazi had acquired so much art that the frames of his paintings overlapped. To obtain a collection of this size required unrestrained travel, and so in his pocket Spitz carried a pass, signed by Heinrich Himmler, that allowed him to move freely across Germany and the occupied territories.

While Hitler coveted works from Vermeer, Titian, Raphael, Canaletto, and Van Dyck, he was just as fanatical about ridding the world of "degenerate art." His targets were not only Jewish artists, but entire artistic movements, such as Cubism, Dadaism, Futurism, and Impressionism. Hitler destroyed over half a million works of art from artists such as Paul Klee, Joan Miró, Pablo Picasso, and Salvador Dalí, incinerating thousands of masterpieces in bonfires.

Ultimately, the Monuments Men saved more than five million pieces of artwork. By 1948, the group had been investigating for five years and was hitting its stride. Their interrogations had uncovered masterpieces, such as Michelangelo's *Madonna in Bruges* sculpture, buried underground in an ancient salt mine deep in the Austrian Alps.

There was an urgency to their work. They knew the Soviets were pursuing the same artwork that they were seeking, but with one important difference. While the Monuments Men were committed to returning the priceless treasures to their respective countries and museums, the Soviets were stealing the artwork for themselves. They saw the seizures as justified restitution for the Nazis' destruction of Russian museums and books.

Millions of pieces were taken from German museums and galleries by Soviet "trophy brigades" who specifically sought artwork. Their thievery was broad, encompassing Old Master paintings, Gutenberg Bibles, archaeological treasures from the Bronze Age, and paintings slated for destruction by Edgar Degas, Claude Monet, Paul Gauguin, and Paul Cézanne. One thing was certain: after the Red Army took possession of the paintings, rugs, textiles, furniture, sculptures, and jewelry, the Monuments Men knew they would never see them again.

In October 1947, one of these Monuments Men, a Dutch art dealer named Joachem Stach, was investigating George Spitz. Stach was identifying cultural objects and artwork that had been looted from Dutch and Belgian collections, and his inquiry was leading him closer and closer to Spitz. While interrogating Heinrich Hoffmann, who had been Hitler's photographer and close personal friend, Spitz's name kept coming up. Hoffmann claimed that Spitz had managed large shipments for the SS, had removed paintings from Holland, and was particularly active in Belgium. Spitz denied the accusations, saying he was just a run-of-the-mill art dealer who had been entrapped by the Nazis. Spitz claimed he knew nothing about counterfeit bills, large shipments, or how the fraudulent operation ran. It was obvious that someone was lying.

When Stach questioned Hoffmann's driver, he heard a compelling

story. According to that man, Spitz had made a trip to Belgium in May 1944. When he'd returned, he'd brought with him two ornate trunks that were each "so heavy that one person could not carry them." The driver guessed that they were filled with jewels or gold. Stach postulated which priceless artworks had been traded away for the treasure—he suspected a painting named *Peasant Dance* by Peter Paul Rubens—but knew that only Spitz could reveal the answer.

To make matters worse for Spitz, a Belgian woman named Jane Inchler, the widow of a man Spitz had once conducted business with, described his activities in detail, claiming that he had made more than twenty trips to Brussels, each time reporting to the Devisenschutzkommando, or DSK, a special looting unit of SS soldiers that tore through France, Belgium, and the Netherlands, stealing whatever they thought might be of value. Further inquiries supported this accusation, with several SS officers stating that Spitz was not just a middling art dealer for the Third Reich but was instead a protégé of Hermann Göring. The "Jewish boy from Brooklyn" had proved remarkably adept at playing both sides of the war.

The Spitz investigation was gaining momentum in late 1947, as the Belgian government prepared to bring charges against him. When George Spitz was brought in for an interrogation on October 28, he became enraged.

"I'm a Jew!" Spitz roared, before angrily defending his behavior, wildly claiming he was part of an underground movement during the war, a common excuse for German collaborators, who knew that the tangle of resistance organizations was spread across Europe and impossible to trace, and touting his activities with Jane and American intelligence post-1945. Spitz was upset that he was being questioned at all. He had thought his time working with X-2 agents would wipe his records clean.

As he described the ways in which he had aided the Allies, a few names were repeated. One of them was newly minted CIA agent (and

longtime US intelligence officer) Jane Burrell. The investigators, however, had trouble believing Spitz's story. Part of their suspicions centered around his association with Flush, who had so recently disappeared.

"Why, when he has been so helpful for the allies," the Belgian investigator asked in a report, "did Schwend emigrate to Peru?" Clearly, the Monuments Men needed to speak with American intelligence officers to better understand what had occurred. However, it was not at all certain that the CIA would help them. It depended on Jane.

By December, a letter with the subject "Request for Information" reached Jane in Paris. "It is necessary that Belgian, Dutch, French, and Swiss intelligence and war crime services work together with American investigators," the letter read, "to clear the whole business in a widespread combined section." The request was similar to the one she had received previously for the Ostrich. For that crime, American intelligence had chosen not to intervene. Now, however, Belgian investigators were asking to talk with Jane directly. She needed to fly to Brussels to speak with the unit investigating George Spitz. The information she shared would directly impact the man's future.

For Jane, the task could hardly have been thrilling. She wrote a letter to Spitz telling him she would cooperate with the Monuments Men in Belgium, but the task was uncomfortable. It required her to wallow in memories of 1945, when she had worked with liars, traitors, and murderers. She had learned so much since then, and she was putting it to use now in her counterintelligence work in France.

However distasteful she may have found Spitz, she felt honor-bound to fulfill a promise she'd made during the war to help Spitz in exchange for the intelligence he had provided years before. And so with the CIA's permission, she shared Spitz's contributions in an unrecorded conversation in Brussels. Her testimony appears to have helped the agent: George Spitz was not charged. His future, however, would always be hampered by his Nazi past. In a far cry from the lavish parties he once held, Spitz went on to run a hot dog cart in Munich.

As Jane returned to Paris on January 7, 1948, the skies were dark and rain splattered against the windows of the Air France Douglas DC-3 aircraft. A thick fog nestled itself along the Parisian boulevards, clinging to the buildings so thickly that only the beacons at the peak of the Eiffel Tower were visible as they passed overhead. As the pilot and crew approached Le Bourget Airport, they could barely distinguish the runway lights ahead. With landing gear in place, they nosed the plane down. Immediately, the crew sensed their error; they were coming in too close to a stand of trees south of their runway. A piercingly loud crash split the air as the passengers felt a jolt against the plane's belly, almost as if the aircraft were being punched in the gut. The plane was careening wildly now, tipping onto its side before rolling across the tarmac. When it finally came to a stop, flames were already building inside the cabin. Jane Burrell, along with sixteen other people, was trapped inside. No one would make it out alive.

Reports of the incident listed the names and occupations of the victims of the plane crash. However, one record was false. In the newspapers, they reported that Jane Burrell was traveling from Brussels as an American clerk or courier. Of course, she was neither. Instead, she was the first CIA officer to be killed in the line of service.

The tragedy of losing Jane was as poignant as the stirring librettos that issued from the opera house across from her empty office. There was so much the young officer had left to accomplish. Every aspect of

Document from the US Department of State declaring Jane Burrell was "on official travel when the accident occurred."

Courtesy of the estate of Jane Wallis Burrell

her life was shaped by her deep loyalty to American intelligence, and the path ahead had seemed clear. Instead, all the promise and potential her life had held vanished in an instant.

Philip Horton, a former English professor at Harvard who was serving as chief of the Paris CIA station, wrote a heartfelt letter of condolence to Jane's father, expressing how deeply he valued her. "The organization was sorry not to have a representative present at the funeral ceremony," he wrote, "as witness to our deep esteem for Jane as well as gratitude for the brilliant work she did for her government; but we of course understood your family's desire to have present only the nearest relatives."

As time passed, Jane's memory faded. The fledgling agency forgot her. Her death was erased from records and even left off memorials dedicated to CIA officers lost in the line of duty. Yet Jane's work had a lasting impact on the future of American intelligence. From her network of agents, a foundation was formed on which all anti-Soviet counterintelligence would be based. Her accomplishments, and particularly her errors, had established a system for recruiting and handling spies, the techniques of which would guide the activities of the CIA over the next four decades. For the Wise Gals, Eloise, Addy, Mary, and Liz, Jane's legacy defined their entire careers.

"SHE GETS INTO YOUR DREAMS"

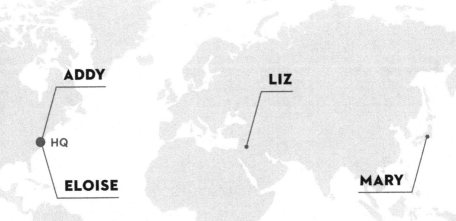

VERMONT
1949

In July 1949, Eloise read an unusual poem. It was published in a literary Russian magazine and contained the line "At the prearranged hour / the explosion occurred / the granite was blown asunder to dust." A colleague whispered to her, "Is this how they're taking credit?"

Although it seemed far-fetched, even Soviet poetry reeked of deception. At CIA headquarters, the poem seemed to offer a hint as to what was to come: the atomic age was upon the United States, and it was only a matter of time until the Soviet Union had the same devastating capability. At least that was how some officers at the CIA perceived it. While the Office of Reports and Estimates believed a Soviet atomic weapon was still years away, many agents were dubious of this assessment. One of them was Eloise Page.

The Soviets can't possibly have an atomic weapon yet went the refrain from the higher-ups. *They simply don't have the resources.* One shortcoming that Eloise perceived in that assessment was that the estimates made by American scientists were based on their knowledge of Soviet laboratories, their stocks of uranium, and the capabilities of their researchers. All good data points.

What the nuclear physicists failed to properly consider, however, was the role of intelligence. While the Russian scientific community was

depleted in the aftermath of World War II, the Soviets had other resources in the form of spies, searching for shortcuts.

For those with experience in counterintelligence, like Eloise, the situation was clear: the abilities of Soviet scientists were not nearly as important as the work of their spies.

.

September 3, 1949, was the kind of mild day that Alaskans dreamed of all year long. It was sixty degrees Fahrenheit, with a light breeze rustling through the fall colors of the tundra. Denali, the highest peak in North America, was often a disappointment for tourists, as it spent its summer shrouded in clouds, barely visible. Yet on this Saturday morning, the mountain emerged resplendent, the snowy white slopes glistening against the blue canvas of the sky.

But just north of the mountain, the service members at the Eielson Air Force Base in Fairbanks were frustrated by the sunny Labor Day weekend. It was ruining their plans. They were trying to organize a field exercise under arctic conditions, and the warm weather was getting in their way. Their training had a specific and deadly aim: they wanted to ready their airmen to assemble and deliver a uranium-enriched weapon in frigid, subzero temperatures. Alaska, with its close proximity to Russia, was an ideal staging ground for such an activity.

The training event had already been postponed once, as no one in Washington viewed it as particularly urgent. Americans reigned alone in the field of atomic weaponry, and even in the remote northern territory of Alaska, just across the Bering Sea from America's enemy, the threat of a Soviet bomb felt . . . distant. In one of the daily briefings given to President Truman that summer, the CIA reiterated this perception, reporting that "the capability of the USSR to develop weapons based on atomic energy will be limited to the possible development of an atomic bomb to the stage of production at some time between 1950 and 1953."

This forecast was so influential that when a plane landed in Alaska

that fateful September day, no one imagined what would happen next. The aircraft was a Boeing B-29, nicknamed the "superfortress," as it was able to deliver the largest payload of air-to-ground bombs at the time. It was this same model, a B-29 named the *Enola Gay*, that had dropped a ten-thousand-pound atomic bomb on Hiroshima, Japan, four years earlier, in 1945.

The plane that touched down at the Eielson base was technically a WB-29, with the *W* standing for "weather reconnaissance"—the plane had been modified to incorporate a weather observation unit above its fuselage. The WB-29s had a wild history, serving first in World War II, and then, after the war, joining the "hurricane hunters" out of the Keesler Air Force Base in Mississippi. The squadron had swooped into tropical storms and cyclones, fearlessly collecting weather data. But in 1947, the funding went dry and the WB-29s settled into a sedentary lifestyle.

The quiet life wasn't to last. Two years later, one of these WB-29s, weather-beaten and war-worn, was traveling along a route that the air force nicknamed Loon Charlie. The three-thousand-mile route from Mississippi to Alaska was long but habitual for the pilots: a WB-29 flew its course every other day. The eleven-person crew expected nothing unusual besides a tremendous amount of work. Every three hours the plane was depressurized and the weather officer removed two filters from what they called the "bug catcher," a simple filtration device, and placed them in separate envelopes. After they landed, each filter paper would be assessed for the presence of radioactive particles. The flight itself was thirteen and a half hours, making for a neat stack of ten envelopes by the time they reached Alaska.

That day, as usual, the envelopes were handed to the debriefing officer as the crew left the plane, who in turn handed the stack over to base security. From there they were brought to a run-down trailer, nicknamed the "shack," that housed a collection of scientific instruments, including an extremely heavy lead cylinder that enclosed a wraparound Geiger counter.

Every element in the universe is made of atoms, but those that make up enriched uranium or plutonium are particularly unstable. These radioactive elements are prone to breaking into bits, a quality that gives them powerful explosive energy but also enables them to be readily detected, even in the filter of a plane traveling at an altitude of eighteen thousand feet, thousands of miles from the site of detonation.

When a Geiger counter is exposed to radioactive molecules, those particles enter the tube of the device and collide with the gas inside, creating an explosion of charged subatomic particles. The positively charged protons can escape, but the negatively charged electrons become trapped around the Geiger counter's positively charged core. When enough electrons build up around the core, an electrical current is produced. This pulse closes a switch in the mechanism, which is then registered on the meter of the counter as a click. The more radiation particles that are present in a sample, the faster the counter will click.

In New Mexico, scientists had been trying to determine how many clicks per minute, or cpm, signaled the turning point that America and its allies dreaded: the detonation of a Soviet atomic weapon. To do this, a group of Los Alamos researchers considered how far radioactive particles were likely to travel through the air and what way the winds would blow from probable test sites in the Soviet Union, taking into account the natural level of radioactivity that exists in the air. After debating their models, they settled on a cut-off of 100 cpm. A glut of false alarms followed, but despite this, in July 1949, the scientists decided to lower the cut-off even further, to 50 cpm. They couldn't risk missing the bomb.

On September 3, after the WB-29 had landed and its filters were analyzed as usual, something different was detected: the Geiger counter started clicking at a fast rate. The officer on duty recorded 85 cpm from the filter collected during the second segment of the trip. No other portion of the flight registered on the Geiger counter. This was unusual, but initially the positive test didn't spark panic or even worry among the officers. After all, the threshold had just been lowered two months

earlier. Even after a second filter paper tested at 153 cpm, calm pervaded. They had experienced a total of 111 false alarms over the years, and so it seemed likely that this was just 112. Like the boy who cried wolf, an airman could be excused for remaining skeptical when a positive radiation test came his way.

A report was immediately sent to a data analysis center in Washington and a sample of the filter paper shipped to an independent lab. No one expected an immediate response. It was Saturday night of Labor Day weekend, with lawmakers on recess and most officials on holiday. The nation's capital was as quiet as a vaporized city.

.

In 1949, Eloise returned to CIA headquarters after years in the field in London, Brussels, and Paris. She was coming back at the right time (American intelligence was ready to flourish), at the right age (twenty-nine, seasoned but still young), and with the right marital status (single). She was bursting with ambition and knew that if she aspired to become a leader at the new agency, she needed to remain unmarried. The stark truth was that married women rarely got promoted. Everyone expected they would start having babies and then quit.

She didn't share this conviction with her parents, who were thrilled she was finally coming home to the States. They were pleased at the easy distance between Virginia and Washington, but her job still perplexed them. They knew their daughter loved to travel, but to persevere in a lowly government clerk position hardly seemed like a worthwhile career. Four years had passed since Eloise had announced her intention to remain in government service, but to their unwitting eyes, she'd received neither promotion nor acclaim for her work.

The Randolph Page family was as proud as it was prominent. They could claim both Thomas Jefferson and Robert E. Lee in their family tree, an ancestry akin to royalty among some in the South. Historic homes and plantations, still associated with their family, dotted the

Virginia countryside. If Eloise chose, this was the life she could embrace. A well-connected debutante would only have to wish herself married for it to be so. Certainly, the effort would be less. Yet Eloise desired neither money nor comfort. Instead she was looking for meaning.

While to some, it might have seemed that by choosing the CIA she was defying her family, Eloise saw her choice as embracing her legacy and heritage. She idolized her father, and it was his dogged example she was emulating. The truth was that while her family had the pedigree associated with wealth, they had little actual money. Her father, Randolph Rosewell Page, despite his historic name, was a civil engineer working for the railroad. There was no grand estate, family trust, or servants on the payroll. Instead, he and his wife, Lillian, lived modestly, either renting homes or living as boarders with others, and always laboring for a living wage.

It was these sides of her personality, the combination of socialite and blue-collar, that made her such an excellent spy. Eloise could not tell her parents that she was part of the CIA's clandestine service, but she felt that if he had known, her father would have approved of her career choice.

Like Adelaide Hawkins, Eloise was working in the Office of Special Operations. While Addy was focused on developing spy gear and communications, Eloise was working in counterintelligence. Her supervisor was a man she knew well from her time in X-2 in Europe: James Jesus Angleton. Angleton had a reputation as a workhorse. He was the kind of man who kept a cot in his office, using it at least a few nights a week after spending long nights at work. He expected the same dedication from his officers, and Eloise was no exception. She might have been the only woman in his group, but Angleton demanded no less of her. As he assessed her work as an agent, Eloise was watching him just as closely. She was comparing him to her former mentor, William Donovan, and while he seemed to match the father of American intelligence in

determination, it was still unclear how he would measure up when it came to results.

Eloise was focused on Soviet activity in Europe, and she was particularly adept at sifting through scientific and technical intelligence. The bomb weighed heavily in her thoughts and plans. She knew there was no secret behind the fission reaction that made atomic energy possible. Instead, determination and a few details on American operations and material composition would likely bring the devastating weapon right into their enemy's hands. "She gets into your dreams," one of Eloise's colleagues said of the bomb in 1949. It was about to become a nightmare.

By the late 1940s, the reports coming from East Germany were increasingly worrisome. At an old manufacturing plant in Bitterfeld, East Germany, the Soviets were purifying metallic calcium. A spy, working at the plant as a chemical engineer, was providing intelligence officers on both sides of the pond with regular updates.

Calcium production on its own was harmless. During the war, the Bitterfeld plant had produced five tons of calcium metal a month to clean radio tubes, twenty tons for railroad bearings, and a small fraction for inflating weather balloons. Despite these precedents, Eloise suspected a more sinister purpose behind the Soviet calcium plant.

Part of America's success in atomic weaponry was due to the whims of geography. The United States had a monopoly on high-grade uranium ore, which just happened to be concentrated in North America. The Soviets, on the other hand, were stuck with ore that was often composed of just 1 to 2 percent uranium.

Yet even with high-grade ore, there were challenges. Uranium can be found in almost every rock on earth, but the vast majority of it has an atomic weight of 238 and is unusable in nuclear weapons by itself. Just 1 percent of mined uranium has an atomic weight of 235. That small discrepancy—a few protons and neutrons swirling around the nucleus

of an atom's core—means the difference between an explosive atomic bomb and a dud.

In the Y-12 plant in Oak Ridge, Tennessee, they took ore containing both types of uranium, also called isotopes, and placed them in a device named a calutron. The large metal tank was heated, exciting the ions inside and sending the molecules racing around the device, set up like a miniature racetrack. When the isotopes passed through two poles of magnets, the force pulled them off the track. Like a bowling ball headed for the gutter, the molecules began veering off, curving outward from the poles. Although they started at the same point, the heavier uranium, 238, was able to travel farther in its arc. This was because its heftier atomic weight gave it greater momentum, whereas the lighter uranium, 235, fell on a tighter, shorter curve. As they landed in the same spot every time, trays placed at each location were able to separate the two isotopes, yielding enriched uranium. It was uranium enriched by this method that was employed in the "Little Boy" nuclear weapon dropped on Hiroshima, Japan.

The effort and equipment required to enrich uranium, even for Americans with a ready supply of the ore, was substantial. Plutonium, on the other hand, is less picky; any combination of its isotopes can be weaponized. It requires less energy to produce and is often made as a by-product of uranium reactors. When uranium-235 decays, pieces of the molecule will fuse with uranium-238, producing uranium-239. This will decay further, yielding plutonium-239. Plutonium-239 can then be purified into metallic plutonium. One way to accomplish this is by adding calcium metal, which steals away the oxygen ions, producing weapons-grade plutonium. This is called a redox chemical reaction, and it looks like this, where Pu is plutonium, Ca is calcium, and O is oxygen: $PuO_2 + 2\ CA \rightarrow Pu + 2\ CaO$.

Given their limited access to uranium ore, CIA officers conjectured that the Soviets were likely designing a plutonium-based nuclear bomb. It had taken years of experimentation for scientists in North America to

produce weapons-grade plutonium, an effort that resulted in the "Fat Man" bomb dropped on Nagasaki, Japan, in 1945. It was unlikely, however, that the Soviets would have to wait so long. The basic science of fission reactions was known worldwide, and while spies within the US government, passing along their closely guarded formulas and techniques, were at first merely a fear, they were now seemingly a certainty, as Soviet spies in the US were increasingly being identified by the FBI.

One of them was Elizabeth Bentley, who in 1949 appeared on the first televised broadcast of NBC's *Meet the Press*. With her light brown hair and blue-gray eyes, the Connecticut native appeared to be a harmless American girl. She was well educated, having studied English, Italian, and French at Vassar and then Columbia University, a background not unlike Jane's. Bentley, however, chose a starkly different path. At twenty-two she joined the American Communist Party and chose to dedicate her life to its purpose.

For intelligence officers of all affiliations, Bentley's appearance caused a stir. Not only was a Soviet spy openly defecting, but she was willing to name names on TV. The Soviets had code-named her Umnitsa, Russian for "wise girl," a nod to her effective leadership. Now she was turning on the communists that she had served for over a decade.

Bentley revealed to investigators the widespread nature of Soviet espionage, naming more than a hundred undercover agents in a spy ring so massive it far surpassed the suspicions of the American intelligence community. While the government had been tailing Soviet diplomats, listening in on their conversations and even intercepting their cables, Bentley divulged that most working spies in the United States were not Russian, but instead Americans. Her actions had unintended consequences; the notion that spies were everywhere, acting in a massive conspiracy, sparked Senator Joseph McCarthy's irresponsible campaign against communism.

As shocking as Bentley's accusations were, the FBI struggled to obtain direct evidence of these misdeeds. It was clear that espionage agents

in the United States were far more pervasive than they had realized, but it was uncertain what secrets they had compromised. Behind the scenes, Soviet intelligence officers urged their network to lay low in the United States. They had obviously anticipated this moment and wanted to leave no trail for the Americans to follow.

Eloise kept a careful eye on developments. While the CIA and FBI were sharply divided by geography, concern over atomic weaponry united them. They viewed their work as bigger than nationalism or base ideology; preventing the spread of nuclear technology could save the human race. While the FBI focused on the spies that lived among Americans, Eloise knew that a group of German scientists living abroad posed a potentially larger threat.

Following World War II, the US military collected German scientists the way a child accumulates toys, selfishly gathering as many as his hands will hold. These scientists were brought to the United States as part of Operation Paperclip, and the American government put them to use working on a wide range of projects, from rocketry to medicine to weaponry. As critical as the research they were developing was, keeping their distinctive talents out of Soviet hands was an even higher priority.

In 1947, the CIA had confirmed that at least seven scientists, including Nikolaus Riehl, who had worked for a German uranium enrichment plant, had eluded the Americans and been recruited by the USSR. Unverified intelligence reports indicated that the group of men was working in the Soviet atomic energy program, based on the coast of the Black Sea. As usual, the expertise of former Germans, whether scientists or spies, allies or enemies, was causing trouble.

While scientists and policymakers still assumed a Soviet nuclear weapon was years away, for intelligence officers, the calcium plant in East Germany was a warning. The scale of its operation alone was massive. Thirty tons of metallic calcium were leaving Bitterfeld plant every month, bound for Zaporozhye, a Ukrainian city roughly two hundred miles from its border with the Soviet Union. By contrast, the United

States produced only three to five tons of calcium metal every year for non-atomic purposes.

Combined with other intelligence, the pieces were slowly coming together. British intelligence had tracked down three carloads of uranium ore leaving the Jáchymov mines in Czechoslovakia, reportedly bound for the Soviet Union. Another report described the construction of two plutonium reactors, supposedly built in a mysterious closed city, appearing on no maps but instead buried deep in the Russian wilderness.

Getting direct intelligence from within the Soviet Union was nearly impossible. The borders were closed up tight, and the CIA lacked the spy network necessary to penetrate them. The calcium plant, however, was temptingly close. Because it was located in East Germany, spies could still slip between the country's blockades. Both MI6 and the CIA saw Bitterfeld as the answer to a lack of intelligence inside the USSR. They perceived that the amount of calcium produced by the plant, if accurate numbers could be obtained, would indicate how far along Soviet nuclear weapons had advanced. In Washington, they calculated what these numbers would look like. They estimated that it would take roughly 1,360 tons of calcium to yield the approximately six kilograms of plutonium. This was how much the "Fat Boy" bomb had contained. Of course, even a fraction of that amount had the potential to be incredibly destructive.

But the old prejudices and rivalries between British and American intelligence persisted, even after World War II. The seasoned British officers were worried that American "clumsiness" would ruin the operation, and they requested that only British agents be permitted to penetrate the calcium plant. They could hardly be blamed for their skepticism of the young CIA's capabilities—after all, the agency was still new and impermanent. The Americans, however, were not so easily sidelined. Eventually the two agreed to work together, with MI6 sending in the majority of spies and in effect taking the lead on the operation.

By early 1949, Eloise Page knew practically as much about the operation at Bitterfeld as the Soviets did. Weekly reports kept her and her

CIA colleagues up to date on the plant's productivity, purity rate, and shipping records. Not only that, but one of their spies had even managed to smuggle a vial of the stuff past the border into West Germany. From there it was sneaked across the Atlantic and into the nation's capital. The silvery substance, contained in its glass vial, gleamed in the light of their Washington offices, a portion having been sent out for analysis. The gemlike crystals inflamed Eloise's suspicions; it was exactly what they had been afraid of: calcium metal with a purity of over 90 percent. No industrial process on earth required such highly purified calcium. None, that was, except bomb-making.

Neither the scale nor the purity of the calcium seemed to impress the CIA's Office of Reports and Estimates. They left their predictions for the development of Soviet nuclear weapons unchanged. Yet Eloise knew that decisive action was needed. If they couldn't convince the higher-ups that the Bitterfeld plant should be taken into greater consideration, it was essential they take part in a sabotage effort alongside their British colleagues.

Eric Welsh, a former chemist who was now the head of atomic intelligence for the British, hatched a plan. It was code-named Operation Spanner, and all it required was a pinch of boron, a trace mineral found in soil. Boron, because it absorbed neutrons, completely stopped nuclear reactions. It was an ideal additive for the metallic calcium if it could be added furtively . . . by one of the agents the CIA had on the ground in the East German plant. No matter what, the operation would be risky. If batch testing found that more than one part per million of boron was in the sample, the chemist working undercover would be immediately identified and the consequences would be severe. The only hope to protect their agent and sabotage the Soviet bomb would be to introduce a tiny sample of boron so pure that even a minuscule amount would be destructive to the atomic chain reaction and yet undetectable to routine tests.

There was only one country in the world where such a substance could be found: the United States.

As it happened, an ultra-pure quantity of boron-10, an isotope adept at taking up the neutrons, had been made as part of the Manhattan Project. This boric acid was considered a "last resort," made in case an emergency shutdown was required. It currently sat unused in a laboratory. Here was the opportunity the CIA was waiting for: a chance to not just gather intelligence but actively sabotage the threat from the inside.

After the upper levels of the Atomic Energy Commission approved the operation, Eloise spoke with a number of trusted American nuclear scientists, explaining the need for complete secrecy about the boric acid's use. With Soviet agents potentially in American laboratories, they agreed to write nothing about the top secret operation on paper. The boric acid was handed over to the CIA without a single record that it had ever existed. Eloise ensured it was sent on to their British counterparts, and then she waited.

It was 1949, and just when sabotage was finally within their reach, the operation stalled. The only way the British could assure the agent in East Germany that excess boron wouldn't be detected in his batch was to clearly state how much boron was already present in the Bitterfeld calcium. This was critical, as they needed to know exactly how much of the purified American boric acid to add. Yet no one could agree on this vital point. American analyses disagreed with the British, and no standard for measuring boron in this capacity existed.

To settle this, Eloise and her team reached out to University of Chicago physicist Arthur Dempster, the man who had discovered the uranium-235 isotope. Coincidentally, he had just received a new scientific instrument called a mass spectrometer. The machine could identify unknown compounds by knocking about its molecules, subjecting them to a magnetic field, and then measuring how they bounced around. He told Eloise that it should be able to decisively measure exactly how much boron existed in the Bitterfeld sample. Concerns remained, particularly over which test the Soviets were likely to employ on the batch of calcium at Bitterfeld, but they decided, after weeks of uncertainty, to move

forward. They had the boron; they knew how much to add; and now was their moment.

Then calcium production abruptly stopped at Bitterfeld. There was no warning, and no inkling when it might start up again. It was an agonizing moment for the intelligence officers. After years of carefully watching the comings and goings of the plant, finally concocting a plan, and then getting ready to execute it, the collapse of their hopes was profoundly demoralizing. The British tried to convince their spy at the plant to go ahead anyway, to add the boric acid to the raw calcium, but he refused, saying fearfully, "I'll be caught."

For some at the CIA, the halt of calcium production was deeply disturbing. It indicated that the Soviets were no longer simply experimenting with how to make weapons-grade plutonium but had already done so. No more calcium would be needed if their experiments had been successful. When a year passed, and still the plant remained quiet, Eloise knew they were too late.

.

The data incoming from Alaska on that momentous Labor Day holiday in 1949 was code-named Vermont. At first no one believed the numbers coming in. It was Saturday night in Washington, and CIA officers had every reason to be skeptical. Just a day earlier, in an intelligence briefing sent to the Joint Chiefs of Staff, the Joint Nuclear Energy Intelligence Committee had presented a clear timetable for the first Soviet nuclear test. It read:

Earliest possible .. 1951
Most likely.. 1953
Possibly. ... 1955

After the report came in from Alaska, Eloise and the other CIA officers had no choice but to wait and see what would happen next.

Samples of the filter paper had been sent to an independent testing site, Traeger Labs in California, but it would take three days for the package to arrive. At the same time, they were also testing the decay rate of the radioactivity measured in the Labor Day samples.

Radioactive samples hold such a massive amount of energy that they are in a constant state of decay, breaking into smaller and smaller bits. All radioactive particles decay at a specific rate. This is often called a half-life, which is equal to the time it takes a sample to decay to half its original concentration. Testing the decay of the samples in Alaska would not only confirm that the measurements were real, they would also reveal which radioactive element, and even which isotope, they were dealing with. The half-life of plutonium-239 is 29,100 years, uranium-235 700 million years, and the half-life of uranium-238 is a shocking 4.5 billion years, as old as Earth itself.

The Vermont data revealed the event that Eloise had long dreaded. This was not a fluke, nor was it a false alarm. The sample was decaying at a rate that indicated plutonium-239 contamination. It was precisely what the data from Bitterfeld had predicted. The air force immediately sent out WB-29s to the spot on the Loon Charlie route that had yielded the contaminated filter sample and then headed south to follow the still-hypothetical radioactive cloud. Altogether, the US Air Force would undertake ninety-two flights, with additional flights performed by the British air force after the Americans had alerted their allies to the danger. Combined with independent lab testing, their worst fears were confirmed. The Soviets had the bomb. Back in Washington they named this first Soviet nuclear test Joe-1, a nod to President Truman's nickname for Stalin.

In Washington, Truman wrestled with the data, still unwilling to accept the implications of this significant development. Even as more evidence poured in, identifying a likely testing site on the banks of the Irtysh River in the USSR, he remained uncertain. Truman had accepted the timeline presented by the atomic committee but couldn't help but

believe, or perhaps hope, that this was all a terrible mistake. CIA officers made their arguments emphatic, particularly as Hoyt Vandenberg, a former director of central intelligence, now the chief of staff of the air force, felt it was critical that the United States announce their detection of the test. The Soviets had taken them by surprise, and this was their one chance to return the favor. Because they had no hint that the United States was monitoring for radioactive particles, the USSR would be caught unawares by America's unexplained knowledge of the event.

Still cautious about accepting the news, Truman insisted that Vandenberg sign a document attesting that he believed a Soviet nuclear test had occurred between August 27 and 29, 1949. Only after it was done, on September 23, did Truman release a statement that read, "I believe the American people, to the fullest extent consistent with national security, are entitled to be informed of all developments in the field of atomic energy. That is my reason for making public the following information. We have evidence that within recent weeks an atomic explosion occurred in the U.S.S.R."

What the Soviets would do next was still unknown. Yet for Eloise, it was clear that the CIA had reached a turning point. Their scheme to sabotage Soviet calcium might have been at an end, but the contacts she had built within the scientific community emerged as vital to their future. Now that the United States no longer held an atomic advantage, the stakes were higher. Eloise was prying deeper into the technology, and the intentions, of their enemies. One lesson was clear: they needed spies with inside knowledge of Soviet weaponry. Unfortunately, the one woman capable of getting her the intelligence she desperately needed was still a secretary.

KUBARK

1950

To become a spy, you do not merely fill out a job application. The decision will override all other life choices, can never be altered, and is occasionally deadly. You are signing up not merely for a job but a way of life. No family member or friend will ever again have your complete confidence. You will surrender the comforts of your home and live abroad, likely for years. Your work and accomplishments are unlikely to ever be acknowledged outside your own intimate circle. Even death may not lift this shroud of secrecy.

And if you are a woman, these sacrifices will be far greater, as Elizabeth Sudmeier was about to discover.

In 1950, Liz Sudmeier had been a typist at the CIA headquarters in D.C. for three years with little hope for advancement. Female officers directly involved in operations were few and far between, with the exception of Eloise, Mary, and Addy. And not one of them occupied a senior administrative role. While Mary had been able to force her way into her job as an officer after a contentious interview, both Eloise and Addy had taken advantage of what some at the CIA call a "side door" for women. Both women worked their way up from clerical positions, struggling to demonstrate their competence and diligence in their daily work. Some of their male colleagues, on the other hand, had had their senior-level jobs virtually handed to them. The CIA contacted many

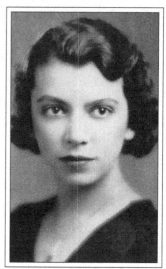

Elizabeth Sudmeier.
Courtesy of the estate of Elizabeth Sudmeier

male recruits directly, often identifying candidates through military connections or professional networks. The agency was still in its infancy, only three years old, and in desperate need of qualified staff.

"I'm trying to build up a corps of well qualified men here," wrote Lieutenant General Walter Bedell Smith, who in 1950 was the newly appointed director of central intelligence. To train these new recruits, Smith directed the agency to initiate a new program called career corps candidate training. This was where Liz's ambitions lay, a side door that would sneak her into officer training.

There were seventeen people admitted into the first candidate training class. Sixteen of them were the kind of people you might expect to be recruited into the CIA in 1950: young white men who graduated from prestigious universities like Harvard, Yale, and Princeton. Most of them had studied political science or economics, and all of them had some proficiency in a foreign language. Yet among this homogenous group was a black sheep: Liz.

Liz was overjoyed when she learned that her supervisor had recommended her for the career corps program. She wasn't a graduate of an Ivy League school or a member of a prominent East Coast family, and

she had no special connections within the agency. She was also thirty-eight years old, past what administrators would consider a prime recruitment age. Yet her boss had recognized her passion for intelligence and, despite the odds, propped open the side door for her.

To embark on such a perilous career path, a person had to have their reasons. For some, greed was a driving factor. The ability to obtain government contracts, sell state secrets, or even find oneself near a sack of unprotected gold, as Jane once had, could sway the corruptible into government service.

For others, an ideological component drove their desire to join. A fear of the Soviets pervaded every aspect of government and society, and not without reason. The USSR was throwing its innocent citizens in the gulag, executing its political adversaries, manipulating its media, and extending governmental control across borders, even attempting to overtake independent states. Now that the Soviets had the bomb, there was no telling what terrors would come next.

Yet for Liz, the CIA represented something else. It was, quite simply, a chance to serve her country. Her service with the WAC during World War II had taught her that a career built on patriotism might not always be comfortable, but it had the power to preserve liberty, save lives, and benefit millions. The military, however, was not a hospitable environment for Liz. In the immediate aftermath of the war, peacetime posts for women had been confined to nurses. Then, in 1948, Truman signed the Women's Armed Services Integration Act into law. This allowed women to serve permanently in all branches of the military. Yet with the new opportunities also came restrictions. Women could make up only 2 percent of the total force in any military branch, and they were barred from combat roles. In contrast, the CIA offered an opportunity seemingly without gender limitations.

While Liz swooned over the possibilities, career corps training (later named Junior Officer Training, or JOT) was not a gift. The training program was rigorous and intimidating, designed to ensure that each

trainee never felt they were "selected as a member of an elite corps, but rather that he will be given an opportunity to prove by his own performance that he is entitled to training and opportunity for advancement." The CIA was looking for a specific type of officer.

In one memo, the CIA described their ideal candidate as "a guy with brains which he has done a good job of cultivating; a loyal American who believes that being an American is worth doing something about and worth fighting for; to whom earning a big supply of the almighty dollar is not the main objective of his life; who can take it and if necessary hand it out (not so much physically as mentally) and by example; who is stable, manly, hardworking, and realistic, all to a reasonable degree."

This description encompassed Liz's character, with the exception of the word "manly," one she would hardly use to describe herself. In truth, Liz was a beauty: her dark hair was cropped in a wavy bob, and her eyes, a tawny brown, were deep-set and penetrating. In a dress, she appeared feminine and sophisticated, but when she donned casual clothes she could pass for a teenager. The color of her hair, skin, and eyes allowed her to pass for multiple ethnicities, of considerable importance in view of where her career with the CIA was likely to take her. With her savvy and intelligence, she was well suited for a career in espionage. Critically, she was unmarried. Only single women, or those married to another agency employee, were eligible to serve as CIA officers.

Liz was prepared to prove herself during the fourteen-week course. Much of the training, however, was monotonous. Every morning Liz rose early and sat in a room with the other candidates as they listened to lectures on foreign policy, diplomacy, and generalities concerning CIA missions around the world. The mechanics of intelligence were more intriguing, with instructors going over the latest technology, including new spy cameras and the various techniques of interrogation.

In the course, the CIA denounced the use of torture, describing the infliction of pain as "Soviet in nature" (a harsh insult indeed from an

American at that time). Instead, the CIA prided itself on using tools of persuasion and confidence-building rather than methods of torment and suffering. Their goal was not to bully their informants into submission, but instead to form a relationship based on trust. It was a subject that Jane could have taught well, although she would have warned that promises made cannot always be kept. Liz would not learn of Jane's exploits until later, after she'd earned the trust of the agency and become an officer. For now, she was paying rapt attention.

One morning the class practiced a technique called a dead drop. This was a method of passing items between spy and CIA handler. A secret location would be chosen, where the exchange could occur without anyone drawing attention to themselves. In a dead drop, the two would not meet directly. Instead, the item or data would be left in a hollowed-out book or behind a loose brick in an alleyway: that it be a location not likely to be stumbled upon accidentally was key. After the spy dropped the item, the CIA officer would then secretly retrieve the precious cargo. Dead drops could go terribly wrong, of course. Not only could the spies be spotted at the location, but the setup was ideal for an agent who used the arrangement to feed the CIA misinformation, or vice versa.

In their work, Eloise and Mary more frequently performed live drops, where an actual rendezvous occurred between the spy and their handler. Here, the agents found a location where they could meet without raising suspicion, such as a public park or library. Items could be handed over directly, but the risk of being observed was far greater. Surveillance was heavy in the regions of the world the CIA was operating in, and each interaction was potentially deadly. If the Soviets learned who was leaking critical data, it could mean certain death for both the spy and the handler. The mechanics of each technique were reviewed carefully, yet Liz was acutely aware that much of this job could not be learned in the classroom. She'd have to obtain her experience firsthand.

While mornings were spent in lectures, the candidates' afternoons were devoted to studying the Russian language. In later years, the languages would vary based on need and ability, but at that time, the focus on the Soviets was all-consuming. Although strikingly different, in both her background and her physical appearance, from the group of men, Liz brought confidence to her work. She relished the differences that set her apart from the rest of her class and learned to use them to her advantage. While much of her cohort stumbled over the consonant clusters of the Russian language, she glided through conversations with ease, sometimes playfully sprinkling in phrases of Lakota, a Sioux language that no one else in the room could understand.

At the end of fourteen weeks, the mood of the group shifted. They were preparing to leave the country and knew that they were reaching a critical turning point in their careers. The program would not be complete until they spent several months overseas performing on-the-job training. Where they were assigned would serve as their home base, potentially for good. Each trainee was assigned a "theater," or a region of the world, in which they would be stationed. The selection was potentially life-changing. Once assigned to a theater, it was likely Liz would spend the rest of her career in that part of the world.

With trepidation, she opened the envelope that would reveal her fate. Under "theater," these words were typed: "Near East." The news was enough to make anyone breathless. She had drawn one of the most arduous theaters in the world to be stationed in. The region encompassed Syria, Lebanon, Jordan, Israel, Egypt, Sudan, and Iraq, and it was alluring for those intelligence officers who were unafraid to truly prove themselves in the field. Power dynamics in the region were heavily skewed toward the Soviets. While the USSR had been steadily strengthening their relationships, British influence had been dwindling since the end of World War II. American intelligence, so recently emerged, had barely even made a start in the area.

Alaska was as far from home as Liz had ever traveled. The icy

tundra, nestled among her squadron of WAVES, had proved a fertile testing ground for what it was like to work alongside Soviets. As she'd played cards with the pilots from the USSR, making friends with them, she'd also gained insight into their culture, which was certain to become useful now. However, in Alaska, Americans had far outnumbered Soviets. That would no longer be the case.

The Near East was an exciting place for a young intelligence officer. The lure of natural resources, including vast oil reserves, had brought geopolitical significance to the region. Yet there were other reasons to exert American influence. Several countries in the area shared borders with the USSR, and its strategical proximity to East Asia (including Japan and Korea) were important to the CIA's plans.

Part of the Soviets' popularity in the Near East region was due to the weaponry and technology they shared with their allies. Underneath the Americans' noses, Soviet rockets, missiles, and aircraft were being designed, built, and passed around Syria, Iraq, and other Near East countries. Even before she was fully trained, Liz had her eyes set on this target.

As she packed her bags and said her goodbyes, the excitement was building. "I'm not sure when I'll return," she told a friend in D.C. "Certainly not until I fill my shoes with sand." She told everyone she was a secretary, leaving for work with the government. The exhilaration she felt at starting a career in intelligence she kept quiet, along with all the job's details. From her calm demeanor, not one of her family members or friends could perceive the deep desires she was harboring. She not only wanted to do this well, she was ready to dedicate her life to this one exertion.

As the first class of CIA recruits packed up and moved out along the globe, memos were sent to their respective CIA stations announcing their arrival. In Syria, Liz's information was dispatched. She was referred to in official paperwork as "Kubark personnel" (Kubark being the CIA's cryptonym for itself). The trainees had passed the first stage,

and even though they were not qualified officers yet, their identities were already tied to the agency.

This was the start of what was intended to be a lifelong commitment. Yet of the thirty-seven recruits trained in 1950, fewer than twelve would make it more than two years in the CIA. These men would move on to other pursuits, careers, marriages, and families. For Liz, there were no alternatives and no backup plans. She was confident that the agency was where she belonged. She wasn't interested in finding a husband or having babies, choices that she knew would grind her career to a halt. When her friends questioned her on her plans, her answer was simple. She'd never fallen in love before and had no plans of doing so now. What she failed to consider, however, was that life has a way of bringing a person exactly what they aren't looking for.

LOSS

1951

"Tokyo's a sprawling, filthy, uncoordinated, ugly, and noisy city, with no beauty or picturesqueness to recommend it," wrote Mary Hutchison to her friend Ezzie in 1951. As she usually gushed over new locales, Mary knew that her sharp criticism of Tokyo would shock her friends. Still, when she considered where she and Greg had just moved from, a small Japanese seaside village called Kamakura, she couldn't help but vent her annoyance.

Kamakura was perfection for Mary, a place she described as "clean, cool seclusion." It was only an hour south of Tokyo but felt like a world apart. A large statue of the great Buddha, standing over thirty-seven feet tall, was the town's chief attraction for tourists, and she basked in the deity's happy smile. The only thing not to like about the town was the commute into Tokyo. She and her husband, Greg, had to leave the house at 5:45 a.m. every day in order to get to work on time.

Tired by the long workdays, Mary and Greg moved to the big city in early 1951. Mary despised the noise and dust of Tokyo. It was "quite as dirty as St. Louis or Cincinnati," she wrote, "a noisy place, with blaring horns, hooting streetcars, clacking geta (the wooden clogs worn by most of the population on the street), booming temple bells, and shrilling police whistles (all the numerous traffic cops are afflicted with a nervous habit we have come to call twitteritis)."

Mary and Greg Hutchison in Tokyo, Japan, 1952.
Credit: The State Historical Society of Missouri, manuscript collection

Her frustration was also fueled by her current reading material, a three-volume set titled *A History of Japan*, published in 1903 by James Murdoch. She absolutely hated it. "Mr. Murdoch simply translated and assembled a variety of Japanese sources and adorned them with some notes on Christian piety and how much better these heathens would have been if they had had some," wrote Mary. "For this reason, I can stand just so much of Mr. Murdoch, and then I have to have a good anti-Christian antidote like Gibbon or Robert Graves to cool off the hell fires."

Not everything was bad, of course. If she was being honest, Mary had been glad to leave Germany and move to Japan. The workload in Munich had been overwhelming. In addition to debriefing their network of spies, Mary felt chained to her typewriter. Her wrists ached after long hours spent typing up their reports and trying to make sense of the bulk of material obtained from their intelligence gathering. She was exceptionally good at making sense of the chaos, filing reports back

to CIA headquarters that cut through the nonsense and gave them precisely what was needed.

Yet despite her expertise, the past few years had seen her husband rise easily through the ranks of the CIA while she had slogged through the mud. In Germany, the Munich chief of station had resorted to threats in order to obtain what was a modest promotion for Mary. "In considering the merits of this case," he wrote to headquarters in D.C., "I trust that you will keep in mind the fact that unless another reports officer with the subject's ability and speed can be found, we will need at least two people to replace her."

Mary had received her promotion and had then in 1950 been transferred to Japan along with her husband. However, the spy she had worked closely with, Zsolt Aradi, was still stuck in Munich. The Americans were no closer to getting him into the United States than they had been four years earlier. Still, they kept trying. When the CIA contacted *Time* magazine and requested a job for Aradi, a shortcut to getting the man into the country legally, the editorial department responded, "The Hungarians have a lousy reputation at *Time-Life*. There have been scores of them pestering the various departments and being obnoxiously persistent. You know how they can be."

Even worse than Aradi's rebuffed ambitions, however, was the state of operations after Mary left. So much of what they had worked toward was falling apart. Aradi's insights, shaped and reported by Mary, were central to the strategy of aligning American interests with Ukrainian nationalists in order to counter rising Soviet influence in Eastern Europe. Yet it was clear from Mary's reports that their understanding of fractured Russian communities operating in Eastern Europe was deficient. Not much had changed since the end of World War II, when Eloise and her colleagues were handing out bribes like candy in Brussels.

Repeatedly, Mary reported deficiencies in Myron Matvieyko. He was a former Nazi, and one of the men handpicked by Aradi to lead the

Organization of Ukrainian Nationalists, or OUN. Mary's work revealed how dangerous the Ukrainian leader truly was. He was not only a former German intelligence agent, a man who had committed murder and been mired in their counterfeiting operations, but also wasn't communicating with his handlers, leaving out critical names and records that the CIA needed.

In Mary's reports lay echoes of Jane's struggles. It had been just five years since Jane suffered from the ignominy of dealing with former Nazis, men whose crimes and impetuses had come back to haunt her in the last years of her life. Now, the CIA was making itself vulnerable to a man with a past as dark as the Ostrich's or Spitz's. After Mary's reports made the agency's exposure clear, the CIA cut off ties with Matvieyko in 1950, citing his "ineptitude."

But the damage of their association with Matvieyko was already done. In 1951, while Mary had moved on to new operations in Japan, Matvieyko led his coalition of Ukrainian nationalists into western Ukraine. It was a dangerous mission, requiring them to parachute into the region, which had been seized by the Soviets in 1939, and then blend into the Soviet socialist republic. Although dropped by the CIA, Matvieyko was still working with MI6. The group of men had barely gotten their bearings after jumping from a British aircraft when Soviet officers surrounded them. The members of the OUN were brutally interrogated, beaten, and, in some cases, executed. Matvieyko, however, walked away a free man. He had been working for the Soviet Union's main security agency, the KGB, the entire time. Mary's reports had foretold his betrayal.

In the wake of everything that happened in Munich, Mary was determined to bring clarity and discernment to their operations in Japan. First, though, she had to get her day job done. Her cover was as a secretary for the Asiatic Society of Japan. The group had been founded in 1872 with the aim "to collect and publish information on subjects relating to Japan and other Asiatic Countries." No one suspected that the

young woman, praised for her deft understanding of East Asian history, left her work at precisely the same time each afternoon in order to stealthily enter a building that ostensibly housed American airmen. It was really the Tokyo CIA station.

Mary's work in Japan was in many ways analogous to what she had done with Aradi. Their team of CIA officers were identifying Japanese democratic organizations amenable to working alongside the CIA against Soviet interests. In Japan's liberal democratic political party, the CIA found an ally amenable to both providing informants and accepting their bribes.

"A shadow has fallen upon the scenes so lately lighted by the Allied victory," said Winston Churchill in 1946. "Nobody knows what Soviet Russia and its Communist international organization intends to do in the immediate future, or what are the limits, if any, to their expansive and proselytizing tendencies . . . From Stettin in the Baltic to Trieste in the Adriatic, an iron curtain has descended across the Continent . . . The Communist parties, which were very small . . . have been raised to pre-eminence and power far beyond their numbers and are seeking everywhere to obtain totalitarian control."

Wary of the Iron Curtain that was rapidly descending in East Asia, Mary Hutchison sat hunched over her typewriter, repeating many of the same phrases. She typed "puppet regime," "invasion," and "Korea," repetitively. She could see that the same totalitarian impulses that had been making inroads in Ukraine and Hungary were also threatening Korea and China. It didn't seem to matter how often she clarified the results of their intelligence gathering; those in Washington, D.C., were simply not listening.

The CIA was still an unwanted stepchild, one that military strategists tended to ignore. Mary watched the situation unfold with increasing frustration. Their network of spies in Japan was delivering a clear message: North Korea was about to invade its neighbor to the south. Their intelligence was dependable, relying on troop movements and

structural improvements at the 38th parallel, the border between North and South Korea. Then, in early June 1950, CIA sources revealed that some two hundred thousand Chinese troops were assembling at the border. The urgency of Mary's reports increased.

The only way to prevent a large-scale war was to take decisive action immediately. Yet instead of proceeding, Washington preferred to shelve their reports. Senior military leaders distrusted the accuracy of the CIA's intelligence and dismissed the idea that the Soviet Union would allow China to get involved in such an operation.

It was a direct rejection of her work, and Mary was livid.

Behind the scenes, just as the CIA had warned, Stalin was approving the North Korean attack. He viewed the conflict as a means of isolating China from the United States. The Communist Party had only just come into power in China in 1949, and the support of the Russian dictator during this critical juncture strengthened their Sino-Soviet alliance. At the same time, Stalin decried the fighting publicly, calling the United Nations "a weapon of aggressive war." For many, the statement was duplicitous from a man whose violent policies, including labor camps and mass executions, were responsible for the deaths of an estimated twenty million people.

Mary's reports proved prescient on June 25, 1950, when North Korea invaded its neighbor. Even with their intelligence verified, General Douglas MacArthur decided to shut the CIA out from the region entirely, relying instead on his own military intelligence officers. Doing so would prove to be a fatal blunder.

"If we let Korea down," President Truman said to his advisors in 1950 after learning of the invasion, "the Soviet[s] will keep right on going and swallow up one [place] after another."

His plea fell on deaf ears. Less than a year later, following repeated military intelligence errors and with the American armed forces in retreat, General Matthew Ridgway assumed command of Allied forces in the Far East. By this point, with a complete absence of information on

the ground, the Americans were flying almost completely blind. The general's map of North Korea simply had a big red oval that Ridgway called a "goose egg." Inside was scrawled the number 174,000, the expected number of enemy troops. Ridgway strongly suspected that the number was worthless. American intelligence north of enemy lines was woefully inaccurate. The region had become like a vacuum for military strategists, sucked dry of any reliable information.

"We have a curtain beyond the range of our immediate combat intelligence activities which I find extremely difficult to pierce," Ridgway reported, before immediately bringing the CIA into the theater. It was way past due.

By 1951, Mary felt the weight of these ongoing political struggles, and especially the seeming futility of her own role in the East Asia region. Hundreds of thousands of lives had already been lost in the Korean War. An untold number was still to come. The bomb preyed on her fears. Would the Soviets pass the atomic weapon technology along to their North Korean and Chinese allies in the same manner that the United States had once cooperated with the United Kingdom and Canada? Living in Japan, a country so profoundly and so recently devastated by atomic weapons, Mary felt these apprehensions gnaw at her. Between her struggles and her sadness, perhaps it was no wonder that she had soured on Tokyo.

It didn't help that the weather had been miserable. The past two weeks had brought an onslaught of rain. Depressed, Mary sat by the window of their cramped home on a rare day off in the summer of 1951. She was watching her two cats, Parysatis and Joe, squabble with each other. Parysatis, whom Mary named after the Persian queen who ran her own network of spies, was the instigator, always snarling at Joe. Poor Joe would try to win her favor but then give up and start hissing back at Parysatis. Finally, Mary decided that she'd had enough. It was time to get out of the house.

Rambling through Tokyo was not usually an activity that brought

her joy. It could never compare with Kamakura. However, on that wet afternoon she found herself in a district called Jimbocho. Mary could hardly believe her eyes. Both sides of the street were lined with bookshops as far as the eye could see. Not only that, but every little side alley that branched off the main road was packed with even more booksellers. It was a feast for her senses, and for once, Mary could set aside her prejudices against the city. She began filling her arms with as many books as she could carry. "Of course, the bookshops are the best," she wrote, "a vision of all sorts of rare books and odds and ends of literary disjecta membra, in all sorts of languages including the Dravidian."

Murdoch was officially put aside. She had found a reason to love Tokyo at last.

.

"I'll be damned if I'll be the chief S.O.B.," Eloise Page said in her soft Southern drawl to a roomful of men, causing ripples of laughter. It was 1951, and she had just been offered to head a new division, called the Scientific Operations Branch, or SOB. It was a coveted position, and Eloise felt pride at her rapid advancement within the agency she loved. She was just thirty-one years old, and her future at the CIA appeared limitless. In the ten years since she had started working for the government, she had transformed from an inexperienced twenty-one-year-old secretary into an unexpected mix of conservative lady and technological wizard. She was the kind of woman who rolled up her sleeves in tackling operational difficulties before donning white gloves for formal occasions.

Eloise accepted the promotion but, true to her word, insisted that the branch be renamed the Office of Scientific and Technical Operations. Perhaps the most surprising aspect of her work was how much imagination it required. Eloise spent long hours considering new methods of prying intelligence on the scientific and technical operations of

their adversaries. She was pushing the limits of their expertise and had built up a network of scientists, in addition to their spies and officers, that she could rely on. The spycraft she sought, however, could not always be found internally. Sometimes the best ideas came from the enemy.

.

There was no denying that the plaque was handsome. Borne from the wood of an ancient, rare Siberian fir tree, it had been hand-carved by a well-known Russian artisan. Depicted was the great seal of the United States, with its bald eagle, one talon carrying arrows, the other an olive branch. With its impressive, curved beak sculpted deep into the wood, the eagle faced the olive branch, a peace offering. Perhaps the most flattering part of the gift was its presentation. It was not merely handed over by some Soviet diplomat but instead bestowed by a troop of Soviet Pioneers, similar to the Boy Scouts but made up of young girls and boys dressed in white collared shirts with jolly red scarves tied loosely around their necks. The wooden plaque was a "symbol of friendship," presented to American ambassador W. Averell Harriman in Moscow on July 4, 1945. Harriman, charmed by the gift, promptly hung it up in his residence, called Spaso House. There it stayed, unnoticed and seemingly collecting dust, for six long years.

Four American ambassadors passed through Spaso House during that time. Even for diplomats accustomed to luxury and beauty, the house was a treat to reside in. The mansion, built in 1913 in a neoclassical style, boasted a massive sparkling chandelier, painted arabesque ceilings, Ionic Greek columns, and a grand marble staircase. The "symbol of friendship" was hung in the home's library, a room with high ceilings and an ornate fireplace. Unlike the grand rooms below, or even the ambassador's office at the American embassy, this was a room where private conversations could be had. When the secretary of state visited, for

Replica of the great seal carving
presented to the United States
in 1945.
Credit: National Security Agency

instance, it was to this chamber that he was led. A quiet, refined place, ideal for a serious conversation.

The second ambassador to pass through, Walter Bedell Smith, a man who would later be appointed director of central intelligence, found the seal to be a bit dusty. He had the bulky, twenty-four-inch block of wood cleaned up and then placed back where it belonged, behind his desk. Nothing seemed out of the ordinary.

The first inkling that something was not right came in 1951. At the British embassy in Moscow, about a half mile away from Spaso House, a radio operator heard something odd. He was monitoring Russian air traffic on an open frequency when he heard an American accent. He had no idea where it could have come from. Then he heard a voice he recognized; it was the British air attaché. This made no sense—why would this conversation be broadcast?

After the radio operator reported this strange occurrence, intelligence officers, both British and American, began to sweep for hidden microphones. They had plenty of experience. At the end of World War II, a search of the American embassy in Moscow had uncovered more than a hundred listening devices, concealed in all kinds of places, from the legs of the furniture to buried behind the plaster of the walls. The security team was adept at finding these microphones, mostly because

they weren't that difficult to uncover. Each bug had to be fairly bulky in order to house either its battery or a tangle of wires connected to a power source. With these requirements in mind, a team combed through Spaso House, as well as the offices in the American embassy, but despite removing paintings and turning over furniture, nothing showed up. Still, a suspicion, impossible to shake, had formed.

Months later, it was the Americans' turn to hear something strange over the radio. The operator heard voices, speaking with American accents. As he listened closer, he could discern that the conversation was happening within Spaso House. The news was maddening to intelligence officers. They had just sent security teams to search the ambassador's residence and found nothing. They needed help.

In 1952, a technician named Joseph Bezjian showed up at the opulent mansion posing as a simple houseguest. While the Russians were blinded to his purpose, the Americans trusted that he would discover the bug that so many had failed to find. Given the difficulty, Bezjian assumed this microphone must have been radically different than what he'd seen before. Although seemingly impossible, he wondered if the microphone was somehow being turned on from outside the residence. To test this theory, he asked Ambassador George F. Kennan to dictate a memo in the upstairs library and waited. It was an awkward moment for the ambassador, to be sure, as he felt "acutely conscious of the unseen presence." Yet for the technician, the moment was revelatory.

As Kennan's baritone bounced around the room, dictating the fake memo, Bezjian swept his receiver around the furniture and walls. For the same reason that loud, annoying feedback noise is produced when sound from a speaker is picked up by a microphone and then played back through the same speaker, his receiver similarly made a noise as it encountered a microphone. When Bezjian got close enough to the hidden listening device, he heard the grating tones of a feedback loop in his earpiece.

With his equipment set to 1.6 GHz, the technician moved toward

the great seal. His equipment immediately made a sharp feedback noise. This was it; he knew he had found it. He removed the seal but could see nothing obvious. He began to dig into the plaster behind where the seal had hung but quickly realized there was nothing concealed within the wall. It had to be inside the seal itself. Bezjian pried into the back of the great seal of the United States and, to his surprise, found that the wood was hollowed out inside. There, nestled inside the round wood block, was the microphone. There was no wire or battery attached to it. Bezjian thought he was well versed in covert listening devices, but this strange device was like nothing he had ever seen or heard of. That night he slept with the seal under his pillow. The next morning it was bound for Washington.

.

They called it *the thing*. There was no other word to describe the device that seemed almost alien in nature. When Addy first held it in her hands, she was awestruck by its very presence. She didn't know that such a *thing* existed. She ran her hand along the long antenna of the listening device. It was thin and fairly short. Then she gripped the cylinder at the bottom. One side was solid metal, but the other was covered in a thin sheet of fabric. It was obvious that this was the microphone that had been spying on the ambassador and his many well-connected guests. However, the more she looked at it, the more questions she had. Where was the power source? How could a microphone possibly spy on a room's occupants without any visible way to turn it on?

Perhaps most disconcerting was that what she was looking at was *not* new technology for the Soviets. It was obvious that this listening device had been implanted in 1945, when the seal was first given to the American ambassador. It was truly the gift that had kept on giving. But if this device, far more advanced than anything Addy had ever seen, represented the pinnacle of Soviet technology almost seven years earlier, what could they possibly have developed in the meantime?

Addy and her team in covcom, short for covert communications, had been working at the CIA headquarters since its inception three years earlier, but thus far their successes had been minimal. The microdot camera was replaced with the Minox, a new subminiature camera, while other listening and communication systems floundered in development. It was obvious to Addy that they were years behind Soviet technology in covert listening devices. She did everything she could think of, but no matter how much she tinkered with *the thing*, she could not understand it.

Eloise read Addy's reports with dismay. She had sent *the thing* everywhere she could think of. It had gone to the Naval Research Laboratory in Bethesda, Maryland; it had been sent over to Bell Labs in New Jersey; the State Department was stumped, as was the FBI; and despite her efforts, Eloise still couldn't find anyone who could tell her how the damn thing worked. Part of the problem was that the device had been damaged somewhere along the way, perhaps in transit or merely from the grip of many clumsy hands, but the microphone could not even be turned on.

At the CIA they couldn't keep calling the microphone merely *the thing*, so they code-named it Loss. For Eloise, Loss was truly what the device represented. She was experiencing loss after loss after loss. She had missed her opportunity to sabotage the Soviets' nuclear program; she was still struggling to obtain reliable intelligence on Soviet aircraft and weaponry; and now they could not comprehend how a Russian microphone, one hidden in plain sight for years, even functioned.

As Eloise sat in her office in Washington, D.C., in November 1952, dismayed over her failures, she was informed that the United States had just performed its first successful test of the hydrogen bomb. The thermonuclear weapon had been in development for over a decade, and its destructive force was unimaginable in its scope. The bomb had the power of eight hundred Hiroshimas and could set more than a thousand square miles ablaze.

A future was enfolding that frightened Eloise. It was one where the CIA could not keep pace with her country's ability to develop deadly weaponry. The technology might belong to them for the moment, but how long until that atomic seductress switched sides and became the Soviets' mistress? The last few years had taught her that science had no loyalty. Moscow would undoubtedly catch up, and it would happen likely sooner than they anticipated. The road they were heading down was dark and unforgiving.

AQUATONE
1952

In the dark, Liz could be anyone. She could be a bored housewife look-ing for an afternoon of amusement at the movies. With flat shoes, a calf-skimming skirt, and no makeup, she could pass for a teenager, the daughter of a diplomat, killing time after school. In her favorite dress and with a date on her arm, she could be a secretary enjoying a night out. With a hijab framing her dark hair and eyes, she blended in per-fectly. There were no limits to her camouflaging skills.

On this particular afternoon, Liz let the dark cinema enfold her in its shadowy secrecy. The film flickered in front of her, with the actors speaking rapidly in Arabic. One couldn't help but admire the grand and beautiful movie theater, with its large, curved doors and detailed mural paintings adorning the walls. It was a place where a person could spend hours comfortably curled up on the soft velvet seats. Liz let her hand run across the plush fabric until she reached the base of the seat. She pushed her fingers between the cushion and the frame. She kept her movements smooth and easy, careful not to attract notice. When she removed her hand, an envelope came out with it. She slipped it into her purse. She stayed only a minute more and then got up, her head ducked down as she left the darkness behind.

Emerging from the theater, she slipped into the bustling crowds of the Baghdad neighborhood. The streets were lined with bookshops,

Baghdad, Iraq, 1932.
Credit: Matson Photograph Collection, LOC

cafés, museums, and nightclubs. Tourists strolled the boulevards, often remarking on how the city reminded them of New York, Paris, and other sophisticated capitals. The streets were diverse, with Turkish, Armenian, Indian, Afghan, and Egyptian populations living alongside a robust Jewish community, and Westerners were everywhere. The architecture and culture, however, were like no other place Liz had ever seen.

A profound connection existed between Baghdad's natural landscape and the buildings that lined the city streets. From above, rows of sand-colored stucco buildings emerged like sand dunes from the smooth, golden soil that encompassed the city's alluvial plain. The river Tigris cut through the swath of edifices, pottery factories, and mosques, with the eastern bank, the Al-Rusafa district, home to the downtown.

Liz walked leisurely through the area, her pace matching that of the Western tourists around her. Above them, the sound of lively conversation hummed, and the outdoor balcony restaurants were packed with customers leaning over the ornate iron railings. The exotic smell of

Persian cardamom tea, brewed strong and served sweet, wafted down the thick columns that lined the avenues. They were nearing the royal palace, sitting right on the bank of the Tigris. As the tourists stopped to admire the grand beauty of the structure, Liz turned left and then slipped into what appeared like any other shop or government building in the area.

Except it wasn't. Liz had unobtrusively entered the CIA station in Baghdad, whose precise location was a closely protected secret. She was careful to enter the premises only when she was certain that no one had followed her. She cut switchbacks through the streets, using the crowded cover of tourists to ensure that no one was on her tail. It was critical that the station be shielded from curiosity and that her own cover and that of her agents were equally protected.

The dead drop was complete. Once inside the station, Liz could relax, at least for a moment. Even here, among her colleagues, she knew there was a risk of being betrayed. Lately, rumors had been swirling that a mole existed in their office. A memo had circulated among the officers that warned "to be on the alert to suspicious behavior." It was a difficult warning to adhere to considering their conduct was by definition

Elizabeth Sudmeier.
Courtesy of the estate of Elizabeth Sudmeier

"suspicious." The memo was likely provoked by mere gossip, amplified by the paranoid officers among them. Liz had learned not to feed into this fear but instead to play by the rules she had been taught.

Liz was still fresh from officer training. She had spent her first year in Syria, learning the ins and outs of espionage in the field. It had been as much an assessment as it had been training. The officers noted how quickly Liz caught on to the subtleties of their intelligence operations, her understanding of Arabic, and her ability to write reports. She got along well with her colleagues, finding easy camaraderie in the CIA station in Damascus. Before leaving for Baghdad, the group gathered around and toasted the newly minted officer.

Liz wanted, more than anything, to perform well in this field assignment in Iraq. Back in the States, the talk about women in the field was not complimentary. "Women can't blend into their surroundings" was one argument overheard in officer training. "They'll stick out like a sore thumb." "How will they recruit their own agents?" asked another officer. "No man will want to report to them."

Similar arguments were used to exclude people of color. The CIA was expanding its presence across the globe, more than doubling the number of overseas officers from 2,783 to 7,014 in the first six months of 1950. Yet administrators failed to consider how diversifying its force of officers would benefit their operations. Fewer than twenty Black officers worked at the agency altogether. Similar to their female counterparts, their contributions were often minimized, their worth in the field outweighed by racist recruitment policies.

If not sidelined by politics and personal tragedy, Wild Bill could have shown them the way. He knew that the unexpected spy could be the most cunning. In addition to Eloise, Addy, and many other women, General Donovan had been unafraid to hire people of color into the OSS. One of his recruits was Ralph Bunche, a Black man who went on to become the first African American to receive the Nobel Peace Prize for his work resolving the Arab-Israeli conflict in the late 1940s.

The need for Donovan's brand of visionary leadership was starkly apparent to the American intelligence officers working in Iraq. Although Baghdad appeared stable and prosperous to the hordes of tourists that frequented the city, beneath the surface all was not well. Protests, likely encouraged by Soviet propaganda operations, were eroding the relationship between Iraqis and Americans. Organized by an Iraqi communist group called Partisans of Peace, mass protests were breaking out across Baghdad. On November 23, 1952, a large group of protesters burned down an American library, chanting, "Anglo-American imperialists, leave our country!" The following day, after another large protest, Iraqi police fired into the crowd, killing eighteen people and wounding eighty-four others.

In some ways, the work of the CIA in Iraq was similar to what Jane and her team had assembled in France. They were slowly building a stay-behind network of spies capable of continued surveillance of Soviet targets. This was critical in case of an outbreak of violence or a Soviet invasion, which would prompt a swift evacuation of CIA personnel. In case of such a catastrophic event, some brave CIA officers would remain in Iraq, holding together their operations so that not all would be lost.

Liz had entered this dangerous intelligence environment determined to overcome the low expectations she knew many of her colleagues judged her by. Similar to Jane and Mary, her official title was "reports officer." She was compiling intelligence, writing it up, and sending it back home. Many of the male officers around her occupied similar roles. The difference was that her male colleagues were allowed to have direct contact with informants, recruit their own agents, and ultimately have a hand in their own operations, just as Jane had done and Mary was currently doing in Japan. Liz, on the other hand, was stuck in Baghdad doing dead drops, with little hope of running her own agents. Compared to Jane's vital role in France during World War II, it seemed the agency was taking a step backward in the kinds of opportunities it offered women. Liz, however, would not stand by meekly.

Identifying, recruiting, and controlling an agent is called a "full cycle" and is considered the holy grail for espionage agents in the field. The formal steps are spotting, assessing, handling, training, and termination—although not always in that order. It requires the highest level of performance in all areas. Not only does the CIA officer need to locate a person of interest, but they need to exert enough influence to sway the individual to double-cross those around them and betray top secret intelligence. The CIA officer is then that agent's handler, their contact person with whom they train to perform dead drops and other maneuvers to hand over their intelligence to the Americans. The CIA officer essentially asks their recruit to risk their life for them, with potentially little reward or encouragement to offer in return. On the other hand, the officer has as much to lose as their contact. Both their lives are in danger merely from their association.

To accomplish this herculean effort, one that few senior officers could tackle without substantial help, Liz picked an inauspicious target: the dressmaker's shop. Unlike back in the United States, there were no large department stores where clothes could easily be pulled off the rack. Liz, however, did not miss them. The tailors in 1950s Baghdad were a heavenly destination for anyone interested in fashion. The fabrics were brought from all over the globe. Heavy brocades; light, airy silks; and deep satins lined the room. The dresses and suits were custom fit to each client, hung perfectly to each curve, and tailored to give the most flattering fit. They were not cheap, nor could they be produced quickly, but a garment's high quality and timeless style made the investment well worth it for their loyal patrons.

Some shops catered almost exclusively to tourists, with prices that matched their temporary clientele, but others drew a local crowd. It was a quaint neighborhood shop that Liz wandered into on an ordinary afternoon in 1952. There was no stigma attached to her Western garb, as would emerge in the years ahead, and so she chatted amiably with the women in hijabs around her. Liz's friends would tell you that despite her

"pensive nature," she was undeniably warm and funny. She had not needed the CIA to train her on how to make friends. As she sat with the group of women, waiting her turn with the tailor, she asked friendly questions about their lives and what their husbands did for work. She seemed like any other housewife in town, and nothing about her behavior made the ladies question her motives. As she left the shop, Liz smiled. She had found a resource that no male officer in Baghdad had access to.

.

Addy stared at her own reflection. She was looking for improvement, but not in her appearance. In her hands she held a compact, the kind carried by women in their purses and pockets across the globe, handy for touching up one's makeup. For a spy, a mirror could be useful in all sorts of ways, from checking who was behind them to looking around corners. Yet this discreet model, fashioned from plain brown enamel, was Addy's pride and joy. It might have looked like any other makeup compact, but when Addy tilted the device at just the right angle, a code appeared. The engraved letters and numbers would appear to be nonsense, unless you were a CIA officer who knew what they meant.

To her male coworkers, the compact was one of many tools they could hand to a CIA officer being outfitted before heading into the field. Yet to Addy, the mirror meant something else. It was designed by a woman and for women. For a new female officer like Liz, overseas, alone, and likely nervous, that extra technology could feel like a reassuring hand on the back, gently pushing her forward.

There was no doubt that the compact was useful, as was the host of technological delights that Addy and her colleagues offered in covcom. They had tiny cameras, small enough to slip inside a pocket or a pack of cigarettes, that officers used to scan documents in the field. They'd constructed odd-looking elongated spike canisters whose contents could be pushed underground, useful for dead drops. They were even working on a new type of walkie-talkie with far better range than

Coded compact.
Credit: CIA/CREST

the old backpack-style communications used in World War II. Still, for Eloise, these accomplishments were ancillary to their true priorities. As head of scientific and technical operations, she was clear to her staff. "We are prioritizing reconnaissance," she said to Addy and her team.

Eloise was experiencing the lows of repeated intelligence failures. Her team's inability to accurately gauge the status of Soviet nuclear tests and their facilities had been a dire warning sign for their future. If the world powers continued to advance their arsenal of atomic weaponry blindly, then the critical time for diplomatic intervention would be lost. Eloise knew that if they could hand diplomats in Washington reliable information on the status of Soviet weaponry, then it would serve as a vital piece of negotiation in preventing the deadliest war that human beings could dream up.

To this aim, the CIA was pursuing Operation Aquatone. The mission was a radical departure from previous CIA operations. Overhead reconnaissance surveillance had long been the realm of the military. The air force had been sneakily edging their RB-47 aircraft, equipped with cameras, across Russian borders, even heading inland and taking photographs of Siberian cities. At first these flights produced only grum-

bling complaints from Moscow. By the early 1950s, though, the Soviets' tune had changed. On April 8, 1950, a US Navy aircraft was shot down over the Baltic Sea. Just a year later, the Soviets downed another American plane crossing into their airspace. Other countries, notably Britain and Turkey, reported similar incidents. Then, in 1952, the Soviets downed an American air force plane, this time not over Russia, but dangerously close, over the island of Hokkaido in northern Japan. The message was clear: any foreign aircraft coming near Soviet territory would be shot down.

If the CIA wanted the intelligence, they would have to fetch it themselves. At headquarters in D.C., Eloise sat in a room full of men and discussed Operation Aquatone. It would be run by Richard Bissell, an economist who, despite his lack of experience, had been recruited into the agency thanks to his personal connections. The operation used civilian aircraft, flown by non-military personnel and managed directly by the CIA. The project would be top secret, its existence known only to those whose expertise was essential in the plan's development. If the plane was shot down, its very existence would be denied by the American government.

Not just any plane would do for Aquatone. They needed a stealth design that would allow for maximum coverage of their cameras and yet fly at high enough altitudes to evade radar detection. This meant that the plane couldn't be armored. The typical reinforcements given to the frame of wartime planes would be far too heavy. Their plane would need to reach a minimum altitude of sixty-five thousand feet to avoid Soviet radar detection. Yet it would also need to pack some muscle. Since it was likely to tangle with Soviet fighter jets, it needed to escape as fast and as high as possible. Here, reality invaded their plans. No such plane existed, at least not in the United States. Even worse, they weren't sure what specifications were truly needed. How do you build a plane that can outmaneuver your adversary when you aren't sure what your enemy is flying?

While Boeing, Bell Aircraft, and the air force began wrestling with plane designs, Eloise considered practicalities. She needed to convene with scientists who could tackle their questions about air reconnaissance. She began reaching out to her contacts at MIT and Harvard. She also knew a secure communications system would be essential, a task she handed over to Addy and the covcom team.

Of course, high on her wish list was a peek behind the Iron Curtain to see exactly what their spy plane would encounter. This, however, was clearly impossible.

.

On a typewriter in Japan, Mary transcribed a favorite Shakespeare quote. It was from the play *Julius Caesar* and perfectly encapsulated her emotions at the moment:

> *And since you know you cannot see yourself,*
> *so well as by reflection, I, your glass,*
> *will modestly discover to yourself,*
> *that of yourself which you yet know not of.*

The reflection before Mary was twisted not by a manipulative Cassius but instead by senior CIA administrators in Washington, D.C. She was reviewing her fitness report, a yearly evaluation used to assign salaries for CIA officers. Her name was on the report and her picture fastened, but something seemed missing. On the surface everything looked great. Her evaluations were fantastic. Her colleagues respected her, and even her chief of station was fighting for her advancement. Certainly no one, either there at her CIA station or back home in the United States, could deny that she was performing at an exceptionally high level as an officer. She was steadily being given increased responsibilities in her work and had proven adept at handling their network of spies and writing clear reports on the intelligence gained. So why wasn't her pay being

increased? Nothing about the paper in front of her made any sense. It was enough to drive an employee insane.

She was being paid as a GS-11, the "General Salary" range used by the government, and making $5,400 a year. Most of the men she worked alongside, although they had been employed by the agency for the same amount of time, were two to three salary grades ahead of her, with a take-home pay 48 percent higher.

What Mary didn't know was that a portion of her 1952 fitness report had been kept confidential. At headquarters, the section had been labeled "under no circumstances is this report to be shown to the employee reported on." Mary could see all the accolades but none of the criticisms. Hidden from her view was this sharp censure: "She has an inborn (perhaps feminine) tendency to resist direction or guidance," it read, "particularly when she feels she has not had a part in the formulation of the principles of direction." The cutting words had not come from her colleagues in Europe or Asia but instead from administrators who barely knew her in D.C.

Even without access to this portion of her personnel report, Mary recognized that something was wrong. She shouldn't have had to fight this hard to prove her obvious worth to the agency she loved. "Incredible as it may seem after all this long time," she wrote in a letter to her friend, "we are about to leave Japan, and return home . . . We expect to be in Washington for quite a while, but of course one never knows."

At CIA headquarters, they had no inkling of what was coming for them.

PETTICOAT
1953

An old Italian proverb goes, "If you can't live longer, live deeper." Liz embodied this adage as she sat at a café in Rome in 1952, the heavy feeling of good, rich food filling her body and sweet contentment pervading her spirit. Sitting with a glass of wine, she contemplated her future. A long life was not assured, perhaps not even realistic, given the dangers of her profession, but moments like this made her feel deeply happy.

Liz did not sit alone. Across from her was Pirro, an Italian man with rugged good looks. She had met him through a friend during her last trip through Rome on her way to the Middle East. In the past, Liz brushed away men. How could the pleasure of a relationship ever compare to the exhilaration of her work? She cared nothing for marriage and the stability of a "normal" life, such as her two brothers enjoyed back home. At least that was what she had always told her family and friends. Now, Pirro was making her rethink everything. He loved her with a passion that she had not felt was possible. She was forty-one, but his adoration made her feel twenty years younger.

A dedicated CIA officer rarely envisioned a future without espionage. Liz, like so many of her contemporaries, lived in the moment, fully immersed in the operation she was a part of and little contemplating where she would be in the decades ahead, or with whom. Yet with Pirro

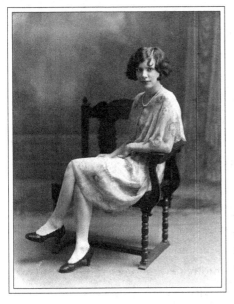

Elizabeth Sudmeier, master of disguise.

Courtesy of the estate of Elizabeth Sudmeier

she could picture a future as a beloved wife, and she imagined having a partner to share in life's struggles. In letters home she told her family that he'd asked her to marry him. Liz said yes.

Yet what neither Liz's friend nor her boyfriend knew was that her career was completely incompatible with Pirro. She was not an American secretary with a life malleable to marriage. She could not simply pick up and move to Italy, or even bring Pirro to the Middle East, without sacrificing everything she had worked for. The rules for CIA officers were clear: when informing your manager that you were marrying an individual who was not an American citizen, you were required to hand in a resignation letter. You forfeited your career in the agency.

Liz knew the regulations, yet she was also aware that some men defied these rules. Arthur Callahan was her station chief in Baghdad. She knew him to be an intelligent, fair, and effective leader. He was a man who was unafraid to bestow responsibility on Liz, despite the prejudices that existed for female officers within the CIA. Instead, Callahan

not only allowed her to pursue her own contacts within the city, he actively advocated on her behalf back to headquarters. He was more than just a dear friend; Liz trusted him with her life.

A few years earlier, Callahan had married a young Syrian woman named Alice Ashkar, whom he had met while on assignment in the region. His marriage to Alice could have been grounds for dismissal, but instead the station chief had merely moved his bride into a large home in Baghdad. It seemed he had suffered not a single negative consequence from the union.

In her heart, Liz wished that the same rules could apply to her. Liz adored Alice, and the two had become close. She could picture their circle of friends, a mix of CIA officers and diplomats, enchanted by Pirro's presence. She imagined moving him into her sunny Persian house, a large home, far bigger than she needed, with several bedrooms and a large, spacious living room. Liz allowed herself to wade in this daydream only briefly. If she was honest with herself, she knew it was a fantasy. The rules that bent for Arthur Callahan and other men in senior positions did not apply to her. She knew that her marriage, unless it be to another CIA officer, or at least an American, would never be accepted by the agency.

Liz was in Italy only temporarily. Her two-year rotation in the Near East division had ended, and although she planned to continue on in the region, she first had to return to Washington. The break from her field assignment was crucial, giving her a chance to reflect on her work, report back to CIA headquarters, and ensure she was given a complete physical. Many officers made the trip home into a cobbled-together vacation, and Liz was no different, stopping in Beirut, Lebanon, before taking the time to loop through Europe and see Pirro. He was everything she wasn't looking for, but despite her cynicism, she felt calm and happy when she was with him.

She had her ticket for a cabin on a French ocean liner, the SS *Île de France*, leaving Southampton, England, in late 1952. After that, she would be immersed in the world of CIA politics and bureaucracy, a

world away from both the urgency of her work in Baghdad and her boyfriend in Rome. She knew it was a chance to think things over, to decide what her future would look like. Pirro loved her and was ready to merge his life with hers. As she gazed into his eyes, immersing herself in the happiness of the present moment, she grappled with the decision before her. Two paths had emerged. Either she would suffer the heartbreak of losing the love of her life or she would experience the despair of leaving the career of her dreams. There was no other option.

.

The first portents of change crept into the agency on a foggy morning in February 1953. Nothing remarkable happened at first. Allen W. Dulles merely stood in front of a crowd of CIA operatives and government officials during his swearing-in ceremony as the director of central intelligence. Dulles himself was not new; he had previously served as deputy director, and his appointment was not unexpected. Yet the events that were about to unfold were without precedent.

As the event came to a close, Dulles thanked the gathering for attending and then turned to his officers. "Do you have any questions?" he asked casually. The Wise Gals were ready for him. Some, like Addy and Eloise, were based at headquarters, while Mary and Liz were temporarily in Washington, awaiting new assignments. They had come back to headquarters as was the custom for all overseas CIA officers, usually every two years. It was an opportunity to file reports, meet with administrators, visit their families, acquire new spy toys and techniques, and get updated physicals and vaccinations. They certainly weren't the only women in the room, however. The space was filled with dozens of female operatives who had chosen that moment to bring attention to a critical issue.

The women peppered Dulles with questions: "Why are women hired at a lower grade than men?" "Do you think that women are given sufficient recognition in the CIA?" "As the new director of CIA, are you going to do something about the professional discrimination against

women?" Even for a modern workplace this line of questioning of a government agency director by his new staff would be perceived as bold, but in 1953, it was unheard of.

Although caught off guard, Dulles indicated that he would start an investigation into pay disparity, and then added, "I think women have a very high place in this work, and if there is discrimination, we're going to see that it's stopped." Dulles was inspired in part by his younger sister, Eleanor Lansing Dulles, a strong, intelligent woman who, although married, continued to use her maiden name professionally. Lansing Dulles had a long career in the State Department as an economist. She often noted the discrimination women received serving in government, saying, "This place is a real man's world if ever there was one. It's riddled with prejudices. If you are a woman in government service you just have to work 10 times as hard—and even then it takes much skill to paddle around the various taboos. But it is fun to see how far you can get in spite of being a woman."

Echoing his sister's words, Dulles's speech was the beginning of a new task force, officially called the Committee on Professional Women, but more casually referred to as the Petticoat Panel, that would study the status of women at the CIA. Although the nickname was deprecating, making light of discrimination against female employees, the women adopted the term in their work, even using it occasionally on their reports as a reminder of what they were up against.

Three months later, the group of women gathered together officially. It was July 31, 1953, and as Addy surveyed the room, she saw ten women standing around. She should have felt comfortable in the gathering—after all, these women were friends and colleagues, many of whom she'd worked alongside for years. But they were not alone. Attending the inaugural event were also a few senior administrators whom they would be reporting to. Allen Dulles, the new director they had just heckled, was there, along with Lyman Kirkpatrick, an officer who had contracted polio a year earlier and was now confined to a wheelchair. The presence of the director lent a formality to the occasion.

Addy warmly greeted Eloise and then introduced herself to Mary and Liz. She didn't know it yet, but the four of them would grow close over the next few months.

Addy had recently been promoted to acting chief of cryptosystems in the covcom branch. It was a position of "considerable responsibility." As a supervisor, she was known for getting the best out of her colleagues, even diving into her own experiences to motivate those around her. "[Addy] has achieved excellent espirit de corps among members of the branch," read a recent personnel evaluation report. Her colleagues described her as "calm," "unruffled," and "pleasant." Yet despite these tranquil adjectives, Addy's approach to her work was nothing short of insatiable.

The thirty-nine-year-old was in a constant state of improvement. Even as she spent long hours at work and struggled as a single parent while financially supporting her mother and father, she was also taking intermediate Russian classes at the agency and keeping up to date with the technology in her complex field. A year earlier, in 1952, she had completed an army extension course in signals communication, with an emphasis on hidden audio surveillance, that would prove vital to her future. She was determined that no *thing* would get the best of her.

While on paper the sheer amount of her activity seemed overwhelming, life was in some ways getting easier. Her children were growing up. She had once struggled to give them the attention she felt they needed, relying on her parents to watch them during late nights at work, but now her three teenagers were mostly able to look after themselves. She still worried about them, of course, but she also saw a life ahead that could be starkly different from the years past. Her children were poised to head off to college, find careers they loved, and hopefully embrace healthier romantic relationships than what Addy and her husband had modeled for them.

Addy was eating lunch one weekend with a group of mothers from her children's school. The other women divulged their fears of what life

Adelaide Hawkins
(far right) with friends,
1952.
*Courtesy of the estate of
Adelaide Hawkins*

would look like once their children left the nest and pondered what purpose would fill their days. Addy was quiet.

"What about you, Addy?" one of the ladies asked. "How will you fill your days when Don leaves?"

"Oh, I'll just keep at my job," she replied. "They keep me busy."

Some of the Arlington mothers pitied Addy. Divorce was seen as a disgrace among well-connected Washington women in the 1950s, and an unmarried mother of Addy's age was therefore a person to be looked down upon. Not one of the ladies had any idea that the modest government clerk who sat among them was really a deputy chief at the CIA. Nor did they realize that she was coming to the lunch fresh off a Pan American flight from Frankfurt, Germany.

Addy had traveled in a manner that few could afford in the 1950s, by air, with the bill footed by the CIA. The transatlantic flight would have fulfilled most anyone's dreams of luxurious travel. There were comfortable seats, wine poured into crystal goblets, and a multicourse meal that included prime rib and lobster. For Addy, it wasn't nearly enough.

While Addy gave no hint about how critical her job was, she had no doubt about what she wanted for her future. She had her eyes on the one prize that the agency still withheld from her: a rotation overseas. Only a field assignment would allow her to move up in the ranks at the CIA and give her the full responsibility she desired.

Autonomy was on the horizon, but only if she could grasp it. If the CIA could not radically alter the limitations placed on their female officers, then Addy might never break free. Her placement on the Petticoat Panel was driven by her desire to make the CIA operate more justly for her female colleagues, yet buried within this noble ambition was her longing to advance her own career.

Addy approached the task force with a deep loyalty to the agency she loved but also with a discerning eye to the needs of its female employees. She knew that the better their documentation was, the more likely their proposed changes would be accepted. They needed both anecdotal stories that described what life was truly like for a woman in the CIA, combined with the hard data of how much people were paid in relation to their government service (or GS rank), their experience, and their education. This combination of evidence was most likely to get them the validation needed from senior administrators for serious change.

Almost immediately they hit a wall. It was early August, and the group of women who would serve on the panel were gathering. There were twenty-two of them altogether—thirteen primary members and nine alternates. They were spread out among different departments and represented a range of pay grades. Some, like Liz, were new officers, fresh out of Junior Officer Training. Others, including Eloise and Addy, had been with the CIA since the very beginning and worked their way up into management positions at headquarters. Still others occupied a middle ground—Mary, for example, had served overseas her entire career thus far, but her evaluations and placements reflected the challenges of being a "contract wife," married to another officer and subject to the whims of his career.

Their pay grades ranged from the low-level GS-9 to the highest rank occupied by a female officer in the CIA, GS-14. Liz was a GS-9, Mary a GS-11, Addy a GS-12, and Eloise a GS-14. The four of them represented a remarkably wide range in education, with Mary holding a PhD, Eloise and Liz being college graduates, and Addy having finished only high school. Yet despite the many life experiences that divided them, they had been brought together for this one defining moment in CIA history. What they were trying to accomplish—pay equity for women—had never been attempted before in a government office in Washington.

Eloise could feel the pressure of the moment building. *This is going to be an uphill battle*, she realized. She knew that the "older agency chiefs" might speak well-meaning platitudes, but when it came down to it, they would drag their feet at any sign of meaningful change. Still, the sweet perfume of potential tinged the air. She knew that it wasn't just about her, but about the future of the agency. *We're preparing the groundwork for our sisters*, she thought.

Their surroundings certainly did not reflect the grandeur of their ambitions. They gathered together in the L-building, a shabby, temporary structure on the National Mall that sat beside the reflecting pool in front of the Lincoln Memorial. It had been built quickly and shoddily in the 1940s during the boom days of World War II. Now it was one of a row of matching, dilapidated wooden buildings that had recently been allocated to the growing needs of the CIA. The roof was made of tin, producing an echo chamber for the frequent summer rain showers, and the humidity was so high that the women's clothes stuck uncomfortably to their backs. Their documents often gummed together, too, particularly the carbon copies made of their meeting notes. "Without air conditioning," described one officer, "the soggy summer in Foggy Bottom meant that like the Dead Sea scrolls, some files had to be peeled apart."

Despite the threadbare conditions of their workplace, the meeting began with unvarnished optimism. There was a real sense that change

was on the horizon and their proceedings would bring equity into the CIA's practices. Perhaps this was why it was so disappointing when Dorothy Knoelk, who worked in the training department, announced to the room of women, "We don't have the data and I don't know how to get it."

The data she was talking about was very basic information, starting with how many employees worked at the CIA, and how many of those were women. The Wise Gals might have expected such a setback. While specific, granular information (like the numbers of foreign spies operating out of East Germany) could be easily obtained by Eloise, the CIA was less apt to provide the same transparency for its own workforce. The total number of employees turned out to be a closely guarded secret within the agency, and when Dorothy had inquired about getting the precise numbers of women who worked for the CIA, along with their backgrounds, pay grades, and experience, she was told that the information could not be handed over; it was a "security risk."

It was just like CIA administrators to tell them they could put together their panel but then start throwing up bureaucratic roadblocks to keep them from getting any work done. The women realized they needed to put pressure on the organization to give them the information they needed. After all, it didn't matter how many individual stories of hardworking female heroism at the agency they compiled if they didn't have the statistics to back up their claims.

When Addy considered how much classified material she had read over the years, the idea that she couldn't be trusted to keep the total number of CIA employees confidential was laughable. She found a sympathetic ear in the chief of CIA communications, General Harold McClelland, who listened to her concerns and ended up agreeing with her.

"It seems to me that they have been approved to work in the agency without restriction," McClelland said in a meeting with senior administrators that discussed the Petticoat Panel, "and with due caution, I don't see any reason they shouldn't have it."

Shortly afterward, the personnel department handed over the data. The women finally had what they needed to get started.

.

Church was not a place of peace, of inclusion, or of spiritual growth. At least that was how Eloise felt. She had a deep aversion to spending her Sundays in a place that did not provide what it promised. It hadn't always been that way. When she was a child, every Sunday was spent in church. Her father was deeply religious; he even considered himself a sort of "lay minister." He preached fervently at home, drilling into Eloise and her brother the virtues of a Christian life.

Then, when Eloise was eleven, her brother caught a cold. It started out as any other illness, but soon the boy wasn't able to lift his head or get out of bed. The pneumonia racked his body with fever and made it impossible for him to breathe. The family knelt by his bedside praying, and Eloise was certain their appeals would be answered. Sadly, the world was still two decades away from the antibiotics that could save him, and there was nothing for the doctors to do but wait and hope he would recover. He didn't. At eight, Randolph Page Jr. was dead. With her only sibling gone, Eloise said it felt like God had abandoned her.

In this unsteady state, Eloise attended church with her mother and father. She was sitting on a hardwood pew one Sunday morning in their Southern Baptist church in Clark County, Virginia, when a Black family wandered into the white columned place of worship. The idea of white and Black people sitting together to worship was shocking in Virginia in the 1930s. The family was met as intruders by the white parishioners and immediately escorted out of the building.

As brief as the event was, it left its mark. Little else was spoken of that Sunday. Yet as she listened to the conversations around her, all of which decried the audacity of the intruding family in entering their sacred halls of Christianity, Eloise felt a deep repulsion. She was a white child, raised in privilege in the South, and yet even she could recognize

the injustice of what she had just witnessed. In response, she shut the door on religion.

Now, decades later, Eloise's feelings had shifted, once more prodded by grief. Her father, the man she loved more than any other on earth, had recently died. She was thirty-three and felt lost without him. He had always been a guiding force in her life, and now, as she navigated the intense politics of a life in government, she missed his steady hand. She was desperate to be near him, and so she entered a striking redbrick church in Georgetown. It was not Southern Baptist, the church of her childhood, but instead Episcopalian, and yet as she read the familiar prayers and sang the well-known hymns, she felt a deep-seated peace grow within her. With sudden clarity, she could hear her father's voice. It was almost as if he was in the room with her. She called out to him— quietly, as it was in the middle of service—and he answered her prayers. She had found the respite her soul needed.

Religion was reentering Eloise's life at an ideal time. She was over-whelmed with the pressures of her work and the added push of the Petticoat Panel. Yet despite how busy she was, Eloise took the task seri-ously. She knew this was a golden opportunity to make definable change in the agency, and she wasn't going to waste it.

By late summer, they finally obtained the data on CIA officers bro-ken down by gender, experience, and background. As they compiled the numbers, they were shocked at what they found. The situation was even worse than they had expected. Women comprised 21 percent of all pro-fessional CIA employees, when clerical and custodial jobs were excluded. Yet the median pay grade for women in every department was, on aver-age, three levels below the men they worked beside. Even worse, not a single woman occupied an executive position within the agency. Eloise held the highest position in the CIA as a branch chief.

Government salaries had increased a dramatic 55 percent in the past ten years, yet women at the CIA were not reaping these benefits. Only a small percentage were being hired in a professional capacity at the

agency, and when they were, they made significantly less money. For the exact same position, women were hired at an average annual salary of $3,825 while men were at $4,600.

It was also striking how few women were allowed to work in the field, where the real action and opportunities were. While female officers comprised 25 percent of employees at headquarters in D.C., they made up a measly 7 percent of operatives in the field. These were numbers that Addy did not find encouraging on her current quest to receive an overseas assignment.

While the women started by examining the numbers for professional positions at the CIA, this didn't mean they were excluding clerical positions from their analysis. Eloise knew to do so would be a mistake. In one meeting, she pointedly called the clerical jobs "stepping-stones" for higher-level jobs, especially for women. How could she not? After all, she herself had once been a secretary. She pressed the panel to focus on how they could encourage advancement from within those positions, which made up some 80 percent of jobs for women at the agency, into intermediate and professional positions.

As they parsed the data, intent on presenting an argument so statistically compelling that it could not be ignored, they also leaned into their personal experiences. At one meeting, they decided to make a list of every misogynistic comment they'd heard at the agency. It was a long catalog of complaints and it looked like this:

1. "Women won't travel."
2. "Women aren't qualified to perform in those positions that they don't occupy."
3. "Women can't work under the pressure of urgency and special considerations inherent in much of the agency's work."
4. "Women are undesirable candidates for long-range employment because they frequently interrupt or terminate their employment for marriage or family reasons."

5. "Women are more emotional and less objective in their approach to problems than men. They are not sufficiently aggressive."

6. "Men dislike working under the supervision of women and are reluctant to accept them on an equal basis as professional associates."

7. "The economic responsibilities of women are not as great as those of men. Women should not be employed in higher-paying positions and deprive men of these opportunities. Women should not be employed at all when men are in need of employment."

Behind every unreasonable quote was a story, and the conference room soon filled with shared experiences. It was like digging in a garden and uncovering a massive but hidden root system underground that connected the individual plants. In their shabby quarters, a building that the director had called "a damned pig sty," the panel relished their unexpected ties to one another.

Everyone loved the vivacious Liz, with her stories of life in Baghdad and her Italian boyfriend, with whom she still wasn't sure what to do. Mary, fresh from her travels from Japan, a trip that had taken six weeks, was perhaps the most opinionated of the bunch and spoke of favorite foods and books from across the globe.

It was Eloise, however, whose stories drew everyone in. In their free moments, they all wanted to know about Donovan and what he was truly like. Addy had her own tales to tell of life with him in the States, but it was Eloise who had spent the most hours abroad with the general. She roused the group with her tales of running Donovan's life and schedule, describing the general's demanding temperament before adding, "I played it for everything it was worth." There was no denying the truth of this. Her promotion following World War II had been stratospheric.

Yet even as they shared the ridiculous complaints about women they'd heard over the years, they knew that what was being said about them, right that very minute, was likely just as merciless. Senior executives, all of whom were male, were repeatedly demeaning the work of the panel, behind closed doors and even to their faces. When faced with reports about widespread harassment from male colleagues among female agents working in the field, Richard Helms laughed. "How do you make a gentleman out of a boor?" he said, dismissing the matter.

In the years since Helms had hired Mary, his rank within the CIA had grown considerably. He was now part of a core group of senior CIA officers, which included Allen Dulles and Frank Wisner, who had moved swiftly into leadership positions following World War II. Dulles was the new director of central intelligence, while Wisner led the clandestine arm of the agency, and Helms was right underneath him as chief of operations.

While each of these three men debased the women on the panel and questioned why they needed to consider the plight of their female employees, they lacked the introspection to assess their own promotions within the CIA. In reality, Helms's and Wisner's quick rises in rank and pay at the CIA were questionable.

Wisner was currently under an FBI investigation for an alleged affair he'd had years earlier with a woman revealed to be a Soviet agent. The pressure was on him, both at work and in his personal life. By the early 1950s, he was struggling with severe depression, and colleagues noted that his conduct in the office was "erratic." Richard Helms would gradually begin taking over some of his duties. Those responsibilities, however, were shifting.

"I want you to be sure," Dulles told Helms, after he was appointed as director, "that everyone in operations has it firmly in mind that the White House and this administration have an *intense interest* in every aspect of *covert action*." This was a surprise to Helms, whose work, up

until then, was focused on intelligence collection. He did not like what he was hearing.

Covert action was poised to become a source of contention among officers at the agency. On one side you had officers like Helms, Addy, Eloise, Mary, and Liz, whose work was rooted in espionage, the "theft of secrets." On the other, you had powerful officers like Dulles and Wisner, who saw covert action—such as paramilitary operations in Korea—as a way to raise the profile and the budget of the CIA. Wisner poked fun at officers like Eloise, Addy, Liz, and Mary, describing the Office of Special Operations as "a bunch of old washerwomen gossiping over their laundry."

Covert operations are conducted against foreign groups or states that have been identified as hostile, or in support of those considered friendly. While clandestine operations were designed to be entirely secret, with neither the act nor its actors revealed, covert operations were instead deniable. They were intended to be noticed but not traceable back to the United States. "No aspect of CIA operations," Helms later wrote, "has attracted as much public comment or as many screams of outrage as the operations now categorized as covert action."

Covert actions ranged from mild to extreme, encompassing election manipulation, bribery for news coverage, assisting guerrilla groups, and strategic paramilitary operations. Paramilitary operations were by far the most expensive, defined as "forces or groups distinct from the regular armed forces of any country, but resembling them in organization, equipment, training or mission."

Although concerned about the future of the agency, Helms's record was hardly spotless. After the war, he had worked alongside the Gehlen Organization, the group of Nazi spies who had delivered useful intelligence but whose ranks were riddled with East German moles who many in the intelligence agency (such as Eloise) had quietly criticized. Now acting as a deputy to Wisner, Helms was pursuing contentious

policies (alongside his boss, and with his full knowledge and consent) that would damage the CIA in the years ahead. Among their many missteps was the use of mind-control drugs as part of a controversial program called MKUltra, which led to the suicide of an army scientist named Frank Olson in 1953. Eloise and Addy, with careers just as long but not nearly as flawed, could hardly imagine obtaining such critical leadership roles.

If half the battle is knowing your enemy, then the Petticoat Panel was certainly making progress. They knew exactly what arguments would be used against their reports and were determined to preemptively tackle the shortsighted viewpoints of the senior executives.

"It is probably offensive to many men," the panel wrote, "to find a woman occupying positions superior or even equivalent to theirs. It is also probable that many women prefer to work for men. In part, this preference comes from a traditional attitude toward women which will be affected only through a slow evolution of sociological change." For Addy, Eloise, Liz, and Mary, there was no time like the present to change society.

.

> *The questioning of*
> *Man or Woman*
> *What makes us who we are?*
> *Can it be known?*

These four lines concluded a poem that Mary scribbled down hurriedly one evening. Her handwriting, never good, was especially messy. No one would ever read this chicken scrawl, she suspected, and so she let the words flow easily. With the outpouring of lines on the page came her own released emotions. She was deep into her work on the Petticoat Panel, and the delineations between men and women were weighing heavily in both her mind and her work.

Being back in Washington made her appreciate the life she had built overseas. "I'm trying to behave like an American citizen again," she wrote in a letter to a friend. But it was proving taxing. It was much more fun to be someone else overseas than a stranger in her homeland. She was already hoping that she wouldn't have to pretend for long.

Mary decided to do something she had never done before. She was going to take four days off work. It wasn't a holiday, and she wasn't sick. She wasn't going to travel anywhere, visit family or friends, or even spend time with her husband, Greg. Instead, she wanted to be alone with her thoughts, make peace with her past, and contemplate her future.

With her vacation, Mary decided to spend as much time as possible at the Smithsonian. The museum was a link to a very different life, the path not chosen. Just two years earlier, she had told her CIA station chief that she'd been offered a job in archaeology for more money than she made at the time. If her salary wasn't raised, she threatened, she'd leave. Under pressure, the CIA had raised her pay . . . and Mary had closed the door for good on the prospect of the excavations and archaeological digs that had once formed the height of her ambitions.

She loved the stately brick building of the Smithsonian, but until then she'd had little time to explore it. She wandered the galleries happily, lingering in the Latin American archaeological section, inspecting ivory carvings from Alaska, and poring over the Easter Island statues. She was admiring a copy of one of the world's oldest prehistoric statues, a bison sculpted in clay, when a guard approached her.

"You have good taste," he told her. "Sure makes the modern sculpture downstairs look sick, don't you think?" Mary had to agree. There was so much beauty in the past. She spent so much of her time focused on the future, trying to determine what was next, that she tended to lose sight of her roots.

Mary's current read was *Period Piece* by Gwen Raverat. It was a recently published memoir by a granddaughter of Charles Darwin. Mary delighted in the clever writing style and was amused by the passages on

how children should be raised, the parties, and even the descriptions of their clothes. Yet one line stood out to her: "The chief thing I learnt at school was how to tell lies." Substitute "school" with "the CIA," Mary realized, and the same sentiment could be applied to herself.

Deceit made up the bulk of her communications in those days. She spoke Russian impeccably, had been studying it for years, yet none of her friends or family had ever heard her speak a word. As an officer, she was being sent around the globe by the US government, but everyone she knew, except Greg and her professional colleagues, assumed she merely followed her husband for *his* work.

Unfortunately, the CIA seemed as blinded to the value of her career as her family and friends were. While Greg received a per diem during their time in Washington, she did not. The agency summed up the reason for the inconsistency: "subject's presence . . . is primarily due to a desire to be with her husband." Mary was being penalized financially just for being married. She needed to remedy this.

By autumn, the trees that lined the National Mall had turned a fiery red. As Mary walked to the Petticoat Panel meeting in the "pig sty" in 1953, she passed the Lincoln Memorial Reflecting Pool. The bright colors of the leaves reflected in the glassy, still water like an underwater fire, burning deep and hot. Submerged within her, Mary's intensity was ready to unleash its heat on the CIA.

In many ways, Mary knew how lucky she was. The work she and the other women did on the panel was elucidating not only the inequities that existed within their workplace but also a frank comparison of how the CIA compared to other government agencies, and the American population as a whole.

While women represented 39 percent of the total staff at the CIA (professional and clerical), these numbers were far lower elsewhere. Just 30 percent of the total employed population in the United States was female, and in other federal agencies, that dropped down to 25 percent. Women were also being paid far higher wages in the CIA than at other

government agencies, as well as in comparison to the population as a whole.

While this news was heartening for many on the Petticoat Panel, their work was not just about gaining equity for female employees—it was about saving the agency they loved from itself. Every year since the CIA had been established in 1947, it was hiring fewer women into professional positions. The agency was moving quickly away from Donovan's vision of a diverse force of officers. This increased homogeneity lent a vulnerability to their operations. The lack of diversity, in both thought and outward appearance, weakened their missions—and even potentially made their officers easier to identify in the field.

What was particularly worrisome was the high rate of turnover among young female officers at the agency. The senior executives were quick to dismiss this concern as "the weakness of the female sex" and "their predisposition to marriage and family," but the panel had found otherwise. According to their latest survey, the number one reason that young women were leaving the CIA was to "take a different job." These former employees indicated that better supervision might have prevented their resignations.

As the Petticoat Panel gathered in D.C. on that fall day in November 1953, they knew they were approaching a turning point. They were just a small group of women, working hard on a side project during the day and in their off-hours, but they were determined to revolutionize a government agency. They prepared their report. The nearly one hundred pages were filled with hard data, carefully plotted graphs, anecdotal stories, and every comeback the women could think of. How could this not work?

.

"Some of the statements made in there are pretty wild," said Colonel Lawrence K. White, known to his friends as Red, as he sat in the Director of Central Intelligence conference room among a group of men.

Their surroundings could not be more different than the "pig sty." The room was constructed for comfort, well insulated, with a proper roof, and even filled with cushy upholstered chairs. Ten men gathered together to discuss the findings of the Petticoat Panel.

"After I read the report, I was frankly at a loss to know what to do about it," continued the colonel, who had served heroically in World War II and was now an assistant to the deputy director for administration at the CIA. He was not alone in this sentiment. The attitude in the room was poisoned against the women from the beginning.

"The statistical charts got me dizzy for about twenty minutes after," one of the men began. The others in the room agreed with him.

"Very feminine report," replied an administrator named Mr. Baker.

"I tell you this business about people getting married and pregnant," said Colonel White, "I just don't see how you as a group expect supervisors to put quite as much money on you as they do someone who is not subject to these hazards." What the colonel failed to note, of course, was that he had a few of these "hazards" at home himself. Their names were Elizabeth, Lawrence, Susan, and James.

The mood in the room turned dark quickly. "I had a feeling that these people were not too much disturbed about this situation, but they thought they had to do a job," a general in the room declared.

"You mean the women that wrote this were not disturbed about the prospects of their getting pregnant or married?" Baker asked incredulously.

Before the general could answer, Richard Helms bluntly cut in. "I would just like to make this observation," he said, "that I swear to goodness that since I have been around here it would seem to me that an able woman has had a damn good opportunity and very fair treatment in this agency. In fact, I don't know a single case that has ever come to my attention where a person who was conscientious and very good hasn't gone forward, been promoted, held decent jobs, been courteously treated, received recognition, and everything else . . . at least the

Clandestine services which is hardly the kind of thing that would normally attract an awful lot of women . . ."

He continued: "It would seem to me they were allowed to go ahead about as far as their capabilities and circumstances permitted. There are some very definite limitations which we can never change in certain field situations, certain areas of the world, which are pointed out in the report quite fairly. . . . There is the other point that Red makes that there is a constant inconvenience factor with a lot of them. You just get them to a point where they are about to blossom out to a GS-12, and they get married, go somewhere else, or something over which nobody has any control, and they are out of the running . . ."

One of the men then told of his experiences with a division chief who flatly refused to work with women and then added, "I worked with this group not as much as with some others, and I think it is important to remember how it came into being, because of a couple of wise gals at an orientation meeting asked the director about three or four questions, and that is the reason the task force was set up."

The committee moved on to the graphs that the women had prepared so carefully. It was clear that Helms hadn't closely examined his. "Is it really statistically ascertainable that a woman doing like work with a man is getting paid a grade or two below the man?" he asked. "Because that had never been my impression, and I am just curious."

"You can demonstrate that they are a grade or two below," Baker answered, "but it is impossible to prove the work is the same." It was a direct refutation of the panel's findings.

It wasn't enough to cast doubt on their numbers. Helms then began to disparage the agency's female employees, saying, "It is just nonsense for these gals to come on here and think the government is going to fall apart because their brains aren't going to be used to the maximum."

"I was very amused in talking to a British representative," added one of the other men. "We got actually on the subject of careers for women in the organization, and they have given up. He said that as far as their

field organizations are concerned, their success with them has been at such a low-level, and there are so many areas in which they can't possibly use them except for strictly clerical work, that in the professional field they just think it isn't worth the time and training."

With that, the men realized that it was 5:05 p.m., and therefore time to adjourn. They packed up the reports that twenty-two women had labored to prepare, fully intent on ignoring every word within them. The conversation slid off into personal matters, and just like that, the years of struggle, months of precise documentation, and moments of desperation vanished. It was all over.

PART IV

.............

"FUMBLING IN THE DARK"

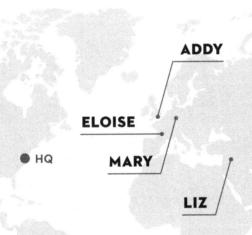

FARMER
1954

Baghdad in 1954 was just as Liz had left it. The weather was still hot and dry; the tea was still fragrant; the dressmaker's shop just as welcoming; and even her station chief, Arthur Callahan, remained unchanged. Liz was coming home to a familiar world, but it wasn't the one she had envisioned.

She was leaving two deeply rooted desires behind. The first was in Washington, where she had watched the Petticoat Panel's work collapse into nothing. Eight months of concentrated effort, snuck into odd hours so that it wouldn't interfere with her job, had resulted in mocking comments from her superiors and no tangible change whatsoever.

She felt that her and her colleagues' argument was well formed, backed up by irrefutable data and analysis, and their recommendations straightforward. Even their language had been carefully crafted, like a sugar-laced medicine, to make the hard truths easier to swallow. Among their lists of recommendations were two central policy changes. First, they recommended greater recruitment of women into the agency, with an eye for individuals suitable in professional (not clerical) positions. Second, they requested that supervisors more carefully consider the plight of their female employees, especially when an officer was eligible for a higher pay grade. These changes, which might have made the difference to so many, were buried under prejudice and preconceived notions about

how women performed in the CIA. At its base, it was Liz's work they were belittling. How could she not take offense at their dismissal of the Petticoat Panel's reports?

At the same time, she was saying goodbye to Pirro. Her parting with the handsome Italian was both sad in its finality and bitter in its tone. Her words ensured that he would not repeat his marriage proposal to her. If her experience with the Petticoat Panel had taught her anything, it was that while the rules might bend for men, they remained rigid for women. She could expect no leniency from the administrators at the CIA. Love was a luxury she could not afford.

"My parents still love him," Liz confided to a friend, "and so do I." But it was not to be.

If she couldn't have the man she deeply loved, Liz decided to dedicate herself fully to her work. It was the compromise she had always known was waiting for her, and now that she had made her decision, it seemed that there was no turning back.

Liz was attempting to obtain the intelligence of Eloise's dreams: a phantom of the skies known by the code name Farmer. The aircraft was a twin-engine high-performance fighter plane, the only one of its kind in the Soviet Union. Farmer, known by the Russians as MiG-19, had taken its first flight in September 1953. The Americans had heard whispers of its presence and unprecedented power, but the true capabilities of the plane were still a mystery. Those capabilities were what Liz needed to find out.

Iraq was riddled with spying and Soviet weaponry. To win favor with Iraqi generals, the Soviets were gifting their most advanced military arsenal. They were not interested, however, in swaying the royal Iraqi leaders. Instead, their aim was to stir insurrection among the people. The Soviets were counting on a revolution that would allow them an opening for greater influence in the region, and toward that end they were lighting the fires of anti-Western sentiment across the country. Their progress was steady.

The information about Farmer that Liz sought was so top secret that it could not be gained from the royal family or government officials. Instead, she needed to find those individuals, preferably in the military, with ties to the Soviet Union, who would have access to the specific, highly classified intelligence she required. None of their current spies could provide them with the data on how Farmer worked. Instead, Liz turned to the dressmaker shop.

It was an afternoon like any other when Liz walked into her neighborhood tailor shop, where she was already well known. The shop was humming with activity as women chatted with one another, debated dress styles, and selected rich fabrics in bright hues. Among the myriad topics of conversation, the women discussed what their husbands did for a living. Here, Liz was careful not to appear too inquisitive. She politely asked about the women's lives much as any friend would start a casual conversation. Her questions were curious but not prying. It was the art of forming an intimate friendship, and Liz was elegant in her manipulations. When asked about herself, Liz weaved tales of a married life that in reality she could hardly imagine. Every word of her story was a lie, yet no one suspected her.

Through her manipulations, Liz had transformed the tailor shop into her own spy network. Soon nearly every woman working in the store was reporting to her. They told her about their clients and shared the plethora of rumors that ran through the shop. As her nascent organization grew, Liz's hand-tailored wardrobe was simultaneously expanding. Every article of clothing was paid for by the US government.

One source in particular struck Liz as promising. This woman had complained to one of her spies about her husband. He was a member of the Iraqi military and worked with the Soviets. Liz approached the woman and struck up a conversation. In a voice that did not betray her true interest, she asked what he did. "He's an engineer," the woman replied. Every alarm bell went off in Liz's head, yet she sat quietly, her hands in her lap, pretending to be bored.

She knew better than to rush. First, she would fully gain this woman's confidence. Next, she'd speak with her husband, a man named Ibrahim. After assessing his character, she would take a dramatic risk, revealing her interest to this man and convincing him to betray the trust of those he worked with. All this was plotted out in her mind before she even knew what kind of weaponry the man had access to.

When you consider how much can go wrong in an operation, it's astonishing that one ever works at all. Of the many people CIA officers encountered in Baghdad, only a small percentage would potentially be beneficial to their operations. A fraction of those were willing to partner with Americans, with some individuals twisting the relationship for their own purposes. In the end, it was a mere smidgen of all these associates who could possibly provide reliable, trusted intelligence.

As Liz began her operation, she knew the odds were against her. Still, she plodded ahead, ingratiating herself among strangers. When she learned that Ibrahim had access not only to Soviet resources but also to a vast library of technical manuals, she knew she had selected the right target. Over the course of their conversations together, Liz convinced Ibrahim to work as a spy for the CIA. She had officially recruited her first agent.

"Men—foreign men," one female officer explained, "will tell a woman darn near anything." To those outside the CIA, the feat might seem ordinary, but within the agency, her colleagues were amazed at her achievement.

Recruitment, however, was just one half of the puzzle. Next, Liz would need to control her new spy. To do this, she taught him how to secretly transfer documents to her, conducting both live and dead drops. They went through each step together, preparing for how they would act around each other and in what manner material would pass between them. Since they were stealing technical plans of great value to the Soviets, time would be of the essence. They also had to make sure that no

one noticed that the documents were missing, so the pages then needed to be returned to the offices from which they were taken.

They met in casual locations, surrounded by others. At a coffee shop, Ibrahim greeted her, and the two chatted amiably for a few minutes. To the casual observer, it would seem they were acquaintances, not close friends, who happened to run into each other. Yet as Liz said farewell, she picked up a spool of rolled paper that was sitting on the table. It was a section of a technical manual. She carefully brought it to the CIA station in Baghdad, where the document was quickly copied.

Photocopiers were still years away from development, but fortunately Liz was not obliged to copy hundreds of pages by hand. Thanks to Addy, the team in covcom, and the technical services group at the CIA, they had the spy camera. Pointing the camera at each successive page and shooting an image was a relatively simple task. Still, Liz scribbled notes after each session. In order to write her reports, which were sent to the administrators in Washington, she needed to quickly summarize what each page of the dense, technical material contained.

The manuals were written in Russian, but the words and diagrams were so highly technical that it read like a scientific dialect inside of a foreign language. Eventually, more proficient translators would go through the manual, then a team of scientists, but until that time, the CIA needed to have some idea of what they'd obtained. Liz's notes took the complex slew of ideas and simplified the advanced Soviet science into clear, comprehensible English.

Once the pictures were taken, Liz hurried back to the meeting point and handed the papers back to Ibrahim. Every moment she was delayed could have meant the difference between life and death. Her station chief described the dire situation, writing, "Apprehension by the security authorities of the agent or of [Liz] while engaged in this operation would probably mean death for the agent and grave consequences for [Liz]. [Liz] has been fully aware of the risks involved, but in the best tradition

of [CIA] has never hesitated to accept these risks because of the importance of the material involved."

One afternoon, the reward finally proved to be worth the risk. When Liz brought the papers back to the CIA station, her body tingled with excitement. These were not merely any technical manuals, but the specifications of the secret Soviet fighter plane, the Farmer. The complete operating and maintenance instructions were sitting on her lap. She was the first American to have ever gotten a glimpse of them.

The plane was incredibly light and nimble. It weighed just 12,340 pounds and could reach an altitude of 50,800 feet. Yet what most impressed Liz was the speed of the single-seat twin-jet aircraft. She could hardly believe that the numbers she was reading were real. What she was looking at was a plane that could fly faster than the speed of sound. There was nothing like it back in the United States.

Liz knew what this meant. The Farmer was the world's first supersonic aircraft to be mass-produced. It could fly far higher than their radar could detect. If it spotted an enemy plane, it could likely outmaneuver it . . . and possibly shoot it down. The manuals Liz held in her hand not only provided needed insight into what they were up against; they represented a blueprint for their own success.

This was the plane that the US's future reconnaissance aircraft would have to beat.

It was clear from the paperwork that Liz had stolen that such advanced technology had not come easily to the Soviets, nor was its design perfected. The Farmer, or MiG-19, had been rushed through production, and so the plane suffered from occasional in-flight explosions. A pilot, perhaps already risking his life in a perilous operation, knew that when he climbed into the distinct-looking bubble cockpit, he might not be coming out, ever.

No CIA agent had reported seeing the Farmer in person yet, but Liz's detailed technical findings, complete with diagrams, were as close as they could wish for. Yet Liz knew the operation was truly just

beginning. If she led with a steady hand, alert to the risks involved, she could obtain a stream of intelligence that would feed the CIA for years.

In Washington, they looked over the plans for the Farmer with a mixture of envy and relief. A new member of the CIA was about to be sent overseas, and she was fated to spend her life tangling with the Soviet fighter plane. Her name was the Dragon Lady.

MUSKETEER
1956

"Subject's sex and family circumstances make her a difficult rotation assignment in the communications field."

These fifteen words, typed into Addy Hawkins's personnel report, were an anchor. They tied the divorced mother of three to the shores of the United States. Yet in the wake of the Petticoat Panel, Addy was no longer content to wait. Her experience with the panel had made it clear that CIA administrators could not be counted on to do what was fair and just.

Whereas at twenty-seven she had humbly submitted to her supervisor's orders, at forty-two she was willing to push the boundaries. She communicated her arguments with a clarity that suited her years at the CIA. She had the expertise and the seniority, and now her children were grown.

Technically, Don, age eighteen, was still living at home with her, but even he, the baby of the family, was on the precipice of adulthood. Her elder son, Eddie, was in college; her daughter, Sylvia, had recently married.

"It's finally happened," Addy told a colleague in 1955 when she got the news. She was leaving Washington for a European assignment. Even better, she would be able to bring her younger son with her. Addy loved having Don with her. Parents are not supposed to have a favorite, but children often have an inkling which sibling is loved most of all, and

"baby" Don had been doted on by Addy and his siblings all his life. Don was interested in attending architecture school in London, and Addy knew this would be the perfect opportunity for him to live overseas.

"This is going to be the best thing for you," she told him. She could have easily said the same words to herself.

It would have surprised Don to learn that Addy was already a world traveler. Her trips to New York "for work" had in fact taken her on flights across the globe—from Germany to England to France. Yet this rotation assignment was different. She would not be spending a rushed week at the CIA station in Frankfurt, instructing men with far less experience than herself on how to communicate securely. Instead, she would be a security and communications officer integral to the mission.

In London, Addy received a file that included a cryptonym she did not recognize. "Musketeer" was printed in bold letters. It was sandwiched in between code she was desperate to unravel. Yet the enemy communications she was trying to pry open were surprisingly not Soviet in nature. Instead, they were from their allies.

Addy was tiptoeing into a prickly and possibly explosive situation. Earlier that year, Addy's communications started keeping a close watch on Egypt, particularly after the country's president, Gamal Abdel Nasser, assumed control in 1954 and subsequently nationalized the Suez Canal. The canal, the strategically important connection between the Mediterranean Sea and the Indian Ocean, created a bridge between Africa and Asia. By 1955, more than half of the world's oil supply, including two-thirds of European oil, passed through the canal.

"We shall defend with our blood and strength," President Nasser said of the Suez Canal, "and we shall meet aggression with aggression and evil with evil." His ferocity was directed at England, a consequence of the European nation's long occupation of the region. With the decline of British colonialism, the Egyptian government was shrewdly playing the West against the East. For the Americans, the situation was highly uncomfortable.

A year earlier, Nasser had approached the United States about purchasing weapons. In addition to the complexity of the region's own power dynamics, heightened since the creation of Israel in 1948, the Cold War had brought its own influence into the Middle East. President Dwight D. Eisenhower's administration didn't want to sell Egypt guns, but neither did they want to anger the new government. Instead, they requested payment, some $27 million, up front. Knowing that Egypt could never afford such a sum, the demand struck an odd middle ground between refusal and compliance. In response, Nasser demanded the weapons, threatening to go to the Soviet Union if the United States didn't comply. "Sounds suspiciously like blackmail," Eisenhower replied, vowing not to give in.

Nasser then followed through on his threat, making an arms deal with the Soviet Union worth between $80 and $200 million. The bargain included Soviet fighter planes, even the new Mig models that Liz was slowly unveiling in Baghdad. It was no wonder the CIA felt Addy needed to watch this newly liberated from colonial rule and now heavily armed region closely.

But the CIA had a new trick up its sleeve. While Liz's reports had detailed the fighter planes that America and its allies would be up against, they also helped inform what the United States needed to match their adversaries. The agency's answer was a slick, new plane under development, called the Dragon Lady.

The nickname was not complimentary, but rather a nod to the plane's difficult, temperamental nature. She was a U-2 spy plane, one of the most striking jets ever made, painted matte black and stretching almost twenty meters long. Her wings were elongated and narrow, giving her glider-like capability. She flew fast and high and was able to hover at the edge of space, reaching altitudes of more than seventy thousand feet. It was enough to evade the MiG-19. Beneath the beautiful shell, however, she was deadly.

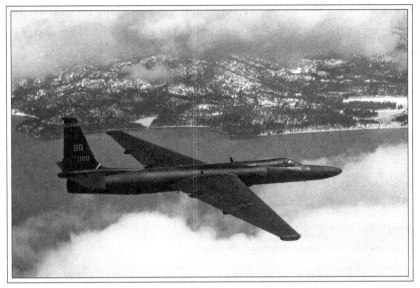

The U-2 Dragon Lady.
Credit: US Air Force photo by Master Sergeant Rose Reynolds

A pilot needed to be sure of himself to sit in Dragon Lady's single-seat aircraft. During testing runs in 1956, she killed three pilots. One of them, Frank Grace, was flying at night when he climbed too steeply at takeoff, causing the engine to stall at fifty feet. The plane fell like a rock out of the sky and then flipped onto its left wing before crashing into a power pole. Grace died instantly.

CIA director Dulles was firmly against the Dragon Lady. He feared moving the agency away from its core of human intelligence and toward technology. Addy felt the opposite. With the same fervor that she brought to the Petticoat Panel, Addy used her passion and expertise to help secure communications between the U-2 spy plane, their ground stations, and transmission back to Washington. The plane's advantages were undeniable. Inside her belly were fitted the most expensive camera lenses that money could buy. The Dragon Lady had the ability to take pictures of the ground from an altitude outside the range of enemy

missiles. The MiG-19 simply could not match its altitude. After the struggles of the Petticoat Panel, utilizing the Dragon Lady on her next mission had become Addy's highest aspiration. Now her fate was entwined with that of the spy plane. They both had to succeed.

.

The conclusion of the Petticoat Panel was like an explosion, sending its prominent officers careening across the globe. Liz was in Baghdad, Addy was in London, Mary was preparing to move to Frankfurt, and Eloise was in France. Yet in their far-flung locations, they were all focused on two things: the Soviets, first and foremost . . . and, more surreptitiously, the movements of their allies.

It had been some time since Eloise had set foot on the European continent. The setting fit her mood. She was escaping the bureaucrats of Washington and focusing on her work. France, far from the sticky politics of the Beltway, felt like a breath of fresh air. Of all the women, Eloise was perhaps the most philosophical about the failures of the Petticoat Panel. She recognized that the administrators they were dealing with would never change. She called the men "feudal barons" who "could never consider women as their equals."

In the face of ingrained prejudice, there was really only one practical thing for Eloise to do. She would keep her head down and remain working. For an officer at the CIA, such an attitude was second nature. You were expected to perform exceptional tasks without tangible recognition. While it was biased that female officers were asked to do so for less money, Eloise knew that it didn't make their work any less important, only less fairly compensated.

In an internal memo sent by the KGB in 1956, the Soviet agency disparaged the "capitalist tendencies of the West." Yet these same Soviet intelligence agents might have been surprised by the motivations of their female adversaries. In Eloise, they would have found an officer who

worked not for lavish monetary compensation, or for the gratification of her ego, but instead for a deep loyalty to her country.

As chief of scientific and technical operations within the clandestine service of the CIA, Eloise was working out of their station in Paris. Her group was helping to coordinate the Dragon Lady's complex network of industry scientists, internal researchers and analysts, and the air force. Her group acted as a bridge between the science and technology arm of the CIA and their clandestine operations. It was critical for the Dragon Lady to be operated by the CIA, not only because they required the intelligence that its aerial photography could provide but also so that the flights over enemy territory would not be immediately associated with the US military. The matte-black plane would look unquestionably different wrapped in the air force's camouflage pattern.

As reports and data flowed into the station, they also questioned whether something was afoot nearby in France, although the details were still murky. As it turned out, British, French, and Israeli government officials were meeting in secret at an ivy-walled villa outside Paris, where they finessed their plans for an operation they were keeping quiet from their American allies: Musketeer.

The operation was a power grab for the Middle East. The intrigue would begin with Israel invading the Sinai Peninsula. England and France would then intervene, pretending to act as neutral mediators. They would demand Israel withdraw from the region and that the area around the Suez Canal, as part of the negotiation, be declared a neutral zone. Israel, in on the planning, would of course agree, but Egypt, they predicted, would not. This would give the three countries the justification they needed to invade the region and overthrow the Egyptian president, ultimately giving them the unfettered access to the canal that they desired for oil transport.

The Americans were not invited to the secret meeting, nor did they approve the plan to topple the Egyptian government. Instead, the actions

of their allies had forced the United States to side with the one nation they always preferred to go against: the USSR. In late summer 1956, the British prime minister, Anthony Eden, told Eisenhower that they would "break Nasser" and were planning a new military operation. Eisenhower responded sharply, saying the action was based on "emotion rather than on fact or logic" and warned of the "unwisdom of even contemplating the use of force."

Eisenhower was acutely aware of how fragile peace was. In the 1950s, many Americans viewed the atomic bomb as a slumbering giant, waiting in the wings for the unthinkable to occur. Yet in the intervening years since the Soviets had gained the bomb, Eloise had watched the atomic weapon woo its admirers. The bombs had become pervasive in the United States, growing from a mere fifty at the start of the decade to a stockpile of twelve thousand atomic bombs throughout the 1950s. The bomb tempted its devotees, who saw in its power a potential swift end to international conflict. And, possibly, to everything else.

Fortunately, Eisenhower was not easily swayed. In 1954, when the president's advisors had proposed using nuclear weapons in Vietnam, the president replied, "You boys must be crazy. We can't use those awful things against Asians for the second time in less than ten years. My God!" But now, just two years later, the bomb was casting its deadly shadow across the Middle East.

"All wars are stupid," Eisenhower once said. "They can start stupidly." In 1956, Addy and Eloise were the antidote to imbecility. While the CIA was organizing flights of the Dragon Lady over the Middle East and North Africa, Addy was running through Allied, Soviet, and Egyptian transmissions with a fine-tooth comb, while coordinating covert communications with the Dragon Lady. And some disturbing signals were emerging.

The first sign of instability happened in October. Eloise eyed the photograph with caution. The Dragon Lady had taken the picture from tens of thousands of feet above ground, and yet the image was clear and

convincing. In Israel, there were not ten, not twenty, but sixty jets on the ground. Rather than being commercial aircraft, they bore the signature swept-back wings of the French Mystère bomber-fighter jets. The closer Eloise examined the evidence before her, the more suspicious she became. Something unusual was happening.

Israel was allowed to possess only twenty-four of this particular jet, a number that had been negotiated as part of the Tripartite Declaration of 1950 in an attempt to balance the weaponry between nations. Now, it was clear to Eloise that France was defying this agreement, and the outcome could be devastating. The intelligence was sent back to Washington, where it would be disseminated to the agencies before being reported to the president. When Eisenhower heard the news, he said that he felt "we were cut off from our allies."

It was about to get worse. Soon after the CIA spotted the planes, Addy noted a significant uptick in communications between Paris and Tel Aviv. Then radio traffic increased between Britain and France. Try as she might, Addy struggled to break the code. They were running out of time. When they reached out to Britain and France, they received nothing in return. The United States was in a communications blackout with its allies. Regular reports that Addy and Eloise received from their colleagues in British and French intelligence ceased. At the same time, prominent British, French, and Israeli diplomats mysteriously left the United States, all at the same time.

In response, the CIA upped its flights of the Dragon Lady over Israel. The spy plane spotted something unsettling to the Americans: the Israeli army was mobilizing. Not just that, but the scale of their armament was massive. After the intelligence was analyzed, one committee determined it was "on a scale which would permit Israel to occupy Jordan west of the Jordan River, penetrate Syria as far as Damascus . . . penetrate Egypt to the Suez Canal and hold parts of [the] Sinai for [a] considerable time."

Eloise, because of her position as chief, was reporting directly to

Richard Bissell, the administrator of the CIA's U-2 program, and Allen Dulles, the director of the agency (and the man who had both started and ended the Petticoat Panel). Despite her unsatisfactory experience on the panel, she liked Dulles. Unlike some of the higher-ups Eloise had worked with over the years, she got the sense that Dulles really listened to her. He wasn't satisfied in merely reviewing reports; instead, he wanted to speak directly with his staff. Even better, he wasn't afraid to bring his officers to the White House and have them report directly to the president. Eloise had walked through the West Wing on several occasions, with Dulles by her side, ready to debrief the president on the CIA's clandestine technology. She noticed that Dulles seemed unusually charmed by the boots-on-the-ground work CIA officers performed. At his heart, Eloise believed, he wished he were a case officer, working overseas and engaging directly with a network of assets, instead of sitting in his lofty position as director.

The images collected from the U-2 convinced Dulles, and other administrators at the CIA, that the danger was imminent. "I'm positive the Israelis will attack shortly after midnight tomorrow," Deputy Director Robert Amory told President Eisenhower. "I'm prepared to lay my job on the line that there's a war coming tomorrow or the day after."

Two days later, on October 29, 1956, an American spy plane was circling the region when the first shots were fired. Six brigades of Israeli troops stormed into Egypt, overran the country's defenses, and gained a position close to the coveted Suez Canal. It was the moment they had all predicted, yet the White House press secretary, the secretary of state (who also happened to be Allen Dulles's brother), and later even the president called the attack "a complete surprise." Soon after, French and British forces swept in to "rescue" the Egyptians. Operation Musketeer was in full effect.

On October 30, the plot reached its pinnacle. Acting as saviors, Britain and France issued an ultimatum. They demanded that Egypt and Israel retreat to create a ten-mile bubble around both sides of the Suez

Canal. They would then act as intermediaries, concentrating their forces at the canal and separating the two warring parties. Aware that Nasser would never agree to the terms, they anticipated three distinct advantages: Nasser would be ousted, Israel would gain territory in the Sinai, and, perhaps most important, the canal would return to French and British control.

Despite the claims of shock and surprise emanating from Washington, the intelligence collected by the CIA had prepared them for this exact crisis. Now, decisions needed to be made. As influential as Addy and Eloise were, they played no role in the final decision-making. Their job was clear: collect the data Washington needed to design the most informed strategy possible. And it was gratifying for both women to so clearly see the strong influence of their work reflected in Eisenhower's talking points. "I feel I must urgently express to you my deep concern at the prospect of this drastic action," the president said in response to the crisis. "It is my sincere belief that peaceful processes can and should prevail to secure a solution."

The situation was complicated by another global instability, this one in Hungary. In 1956, at the same time that Israel began mobilizing its troops in the Suez Canal, the Hungarian people revolted against Soviet rule in their homeland. After Joseph Stalin's death in 1953, the extent of his atrocities surfaced, prodding those who lived in Soviet territories, particularly in Eastern Europe, to demand freedom of press, speech, and religion. After a new government was installed in Hungary in October 1956, Soviet troops were ordered out of the country. But while the new Soviet leader, Nikita Khrushchev, had criticized Stalin and his reign of terror, that did not mean he would loosen the Soviet grip over Eastern Europe. In a move that shocked world leaders, the Soviets ruthlessly attacked the Hungarians, crushing the democratic revolt.

Yet even as their tanks rolled into Budapest, the Soviets saw an opportunity to use the Suez Canal instability to their own purposes. They loudly denounced the actions of France and Britain in Egypt as

"barbaric," positioning themselves as allies with Egypt (and its rich oil supplies), against France, Britain, and Israel. Khrushchev began to move Russian troops into Egypt, ready to engage in war. The ploy seemed to be working. Soviet influence was rising rapidly among Egyptians, and across the region. The Dragon Lady watched all of this unfold from above, sending back alarming images to the CIA. The region seemed on the precipice of implosion, ready to drag the rest of the world down with it.

From this precarious perch, at a moment when it seemed that even a light breeze might set off a nuclear war, Eisenhower reached out once again to Britain and France. With the presidential election a week away, few on the world stage expected much from the man on the campaign trail, yet Eisenhower's reasoning was persuasive. If Britain and France did not immediately agree to a cease-fire, World War III was on the horizon. On November 6, the two countries agreed. Operation Musketeer was dead.

In the aftermath of the failed plot, Britain's influence as a world power had sunk to depths once almost unimaginable to Addy and Eloise—even as the US's authority on the world stage was swiftly rising. Just a few years prior, the fledgling CIA (and the OSS and CIG before it) had been like British intelligence's annoying little sibling, unproven and untested, tugging on the coattails of MI6. Now the roles were reversed. In this Cold War era, it was *American* intelligence agents who were accurately predicting the future and using their technology to shape global policy. The CIA was rapidly expanding across the Middle East, desperate to counter the Soviets' rising influence in the region, while the British were in retreat, relying on American reports. It was the CIA's intelligence, combined with steady leadership, that had prevented nuclear war.

It seemed that Eloise and Addy had barely a moment to recover when a new threat began heading their way. This one was coming straight at them from the sky, and it looked . . . otherworldly.

NSG5520

1957

Being in the CIA was occasionally akin to life as a lab rat. At her yearly physical, Mary's height and weight were checked by a battery of doctors and nurses, who then examined her vision and hearing and goodness knew what else. Urine and blood samples were sent off for analysis. Because she was heading overseas, the tests and vaccinations were numerous (and painful!); Mary joked she was becoming a human pincushion. "This is easy," she said sarcastically as she pulled up her sleeve and received typhoid, tetanus, smallpox, and polio shots.

A nurse then inserted a small amount of diphtheria toxin under the skin of her arm. It was called the Schick test, and if the spot turned red and swollen, it meant she was susceptible to diphtheria, a potentially deadly disease with no vaccine available. After she was done being poked and prodded, the doctor told her, "Well, you don't have anything to worry about, everything is good and solid," and Mary returned home.

It was Inauguration Day 1957, and while the occupant of the White House, Dwight D. Eisenhower, would remain the same, Mary's house at 41 D Street in Washington would acquire a new owner. One might think that the beautiful brownstone, built in 1776 and nestled just blocks from the Capitol building, would sell quickly, but the inner-city location

had fallen out of fashion and changing neighborhood demographics were a sad harbinger of the racial and social unrest to come in downtown D.C. Mary remarked in one letter that "the prospect of colored neighbors seems to bother some people . . . It's despicable." She did, however, complain about the white family next door who, with four kids and two puppies, was always yelling about something.

As she packed up boxes and made her to-do lists, Mary noticed a giant float glide by the window. A parade was heading down the boulevard in celebration of another four years of Ike. The weather was bitterly cold outside, and Mary was happy not to join in the inauguration festivities. There was little time to party as she wrestled with the magnitude of her and Greg's belongings. The number of items they had brought back from Japan alone was incredible. Among their myriad possessions was a collection of two hundred carved black cats that their landlord in Tokyo had begged them to accept.

Still, the real issue for Mary was her books. There were hundreds of them, in multiple languages, and she hated parting with any. For years, she had kept long lists of every book she read, often accompanied by her own notes or thoughts, and the idea of losing her precious, well-documented collection was heartbreaking. Fortunately, the CIA had doubled their weight allowance (which Mary considered fair, as both she and Greg were officers), yet she knew that some of the volumes would have to go.

With her arm still smarting from her inoculations, she flipped through her current book, *From an Antique Land*, by Julian Huxley. The words were inspiring for a woman about to set off on a new adventure. "It is one of the duties and privileges of man to testify to his experience," Huxley wrote, "to bear witness to the wonder and variety of the world with which he finds himself." She might not have been a man, but the words resonated within her. The Petticoat Panel had left Mary bruised but not busted. Now, she was moving overseas again, where new

prospects awaited her. She knew she belonged there, no matter what the administrators in Washington might think.

.

The sky was falling. At least that was what Eloise feared. The past few years had seen a dramatic shift in her anxieties. She was still concerned with the threat of nuclear war, yet that frightening prospect no longer held the chief urgency for her group in scientific and technical operations. In 1954, the CIA had deemed Soviet rocketry "a highest priority national intelligence objective on the same plane as the Soviet nuclear program." Since that time, the agency had secretly been contributing money to American rocketry labs. In a 1955 joint army and navy proposal, the CIA's "intense interest" in the space program was noted, as well as the agency's belief that "considerable psychological warfare value and scientific prestige will accrue to the United States if we launch the first artificial satellite." However, concealment was critical, as the development of the first earth satellite should not be seen by anyone, either American or Soviet, as a military venture.

Scientists had been dreaming of earth satellites since Isaac Newton first contemplated the possibility in 1687. It required what was, until 1957, unattainable: a rocket powerful enough to shoot a small craft high above the earth. The satellite needed to reach an altitude that balanced the tug of the earth's gravitational pull with its own inertia. Scientists in the US had long been frustrated by the lack of funding for this type of exploration, but now, with the threat of Russian rocketry, military funding suddenly opened up. The scientists, of course, had little idea that the CIA was behind their sudden good fortune.

Eisenhower was wary about militarizing space under the auspices of exploration. He worried that a space race could rapidly develop into a space war. With those fears in mind, the government had to choose whether the navy or the army would launch America's first satellite.

While the army's Jet Propulsion Laboratory was further along technologically, the administration chose the navy's Vanguard project in 1955 as the home of the rocket program. Chief among their reasons were these considerations: the navy's project was more scientifically ambitious and, perhaps more important, Wernher von Braun (the Nazi scientist behind Germany's deadly V-2 rockets) was not involved whatsoever. Von Braun had been brought to the United States as part of Operation Paperclip after World War II, and his mere presence as part of the US Army lent a threat to a potential rocket-launch project that Eisenhower could not sanction.

Eloise watched the political wrangling over America's satellites with unease. She knew from her intelligence that the Soviets were not being so delicate. They were intent on winning, whatever the perception of their adversaries might be. If the Soviets took the first lap in the space race, Eloise knew it would be more than a scientific victory. Such a conquest would be used to tout their superiority worldwide, strengthen their propaganda, and gain new allies. Even worse, it would mean that the Soviets had rockets so powerful that not only could they shoot an item up into space, they could also fire one closer to home.

The Dragon Lady had already spotted the Soviets' new rockets. They were initially tested not to haul a satellite into space but to carry a hydrogen bomb over the ocean. It took the spy planes months to discover the Tyuratam missile center, hidden in the Betpak-Dala desert, south of the Aral Sea, in Kazakhstan. It was the massive amounts of concrete that gave away the location, enough for the blockhouses, missile service towers, and a series of launchpads, all of which rose from the sandstone for a span of fifteen miles. Images taken from this secret location and analyzed by the CIA's photographic interpretation division gave Eloise her first glimpse of the Soviets' R-7 rockets.

While the US Navy's rockets spent the summer of 1957 strewn across the New Mexican desert following a series of launch failures, the Soviets' R-7 flew to a height of more than 3,700 miles in August, making it the world's first intercontinental ballistic missile, or ICBM. The Russians

boasted that it could be shot "into any part of the world." The significance was chilling.

ICBMs were a high-priority target for Eloise. These rockets were defined by their high speed and ability to deliver their payload over many thousands of miles. Unlike bombers, whose mission could be recalled after launch, ICBMs were sent directly to their target from the surface, making them extraordinarily dangerous, particularly as they were designed primarily to carry nuclear weapons. The Soviets' new ICBM had only crude guidance systems, yet from their secret missile silo, they could easily target European capitals, even those many thousands of miles away.

Fortunately, Addy was listening in to the goings-on at the Tyuratam missile center in Kazakhstan. At covcom, they carefully monitored all transport flights to and from the facility. They listened to the teams practice countdowns over the radio, and they snooped on all communications between the secret launchpad in Tyuratam and its associated airbases in the USSR.

Ground stations in Turkey and Iran used line-of-sight radar to intercept the transmissions. Addy had been spying on communications this way for over a decade, receiving transcripts from stations across the globe and then analyzing the data in-house. Now they were adding in radar-equipped naval ships and aircraft that could verify if a test had been performed, the trajectory of the rocket, and even, possibly, where it landed.

Addy noted in her reports the distinct nature of the rockets on radar, called radar cross-section, or RDS. The squiggly lines, radiating out from the center, were created by the object's electromagnetic wavelength and offered a wealth of information. Because each rocket reflected radar energy back to its source, a trait that was determined by its composition, each RDS diagram was a signature. Once they determined what each model of rocket looked like on radar, they could precisely track the type of tests the Soviets were up to and even assess how they were going.

Taken all together, the wealth of communication data clearly demonstrated that the Soviet R-7 rocket was far ahead of the navy's own

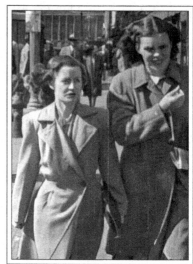

Adelaide Hawkins (left) with a friend
in the 1950s.
Courtesy of the estate of Adelaide Hawkins

Vanguard. From 1953 to 1958, data analyzed by the communications group revealed seventy successful tests, twenty-four cancellations, one failure, and twenty-three cases where they couldn't be sure what had happened. The Vanguard, on the other hand, had yet to complete a successful launch.

The data was not only being analyzed by covcom but also shared between intelligence groups. For the first time, Addy was allowed to work directly with the National Security Agency, the NSA. This new responsibility was bestowed in London, after she received an overdue promotion. She was now chief of covcom. It was validation that fighting for the overseas experience had been worth the struggle, not just for her own gratification but for her advancement within the agency. However, in true CIA fashion, Addy had received the elevated position without a pay raise.

By the summer of 1957, Eloise's and Addy's independently filed reports began increasing in intensity. The Soviets were ramping up for a historic launch, and there was no doubt about the significance of this moment. A mounting frustration for the CIA, however, was Eisenhower's tight grip on the U-2 program. Although the CIA repeatedly assured

the president that the reconnaissance flights were performed at an altitude that allowed them to evade Soviet detection, Eisenhower did not trust the Dragon Lady. He frequently denied the CIA the ability to perform missions he considered too risky and even changed the Dragon Lady's flight paths.

For those with their eyes on Soviet rockets, the restrictions were often maddening. The photographs the Dragon Lady brought back from Tyuratam and other Soviet airbases were giving American intelligence some of their best information—but their ability to use the Dragon Lady was seemingly restricted at every turn. There was no substitute for the image analysis the CIA was performing, and without it, America was entering the space race severely hampered. Yet Eisenhower believed that there were more important things than "winning" the space race. His focus was on preventing war.

The Soviets, of course, were already boasting that an earth satellite was imminent, but this was not surprising—they had been making similar claims for months. American scientists were nearly as bad, promising a satellite would be launched quickly, despite the repeated failures of the navy Vanguard rocket.

The gaps in spy plane surveillance made it more difficult to predict what the Soviets were up to, but that didn't stop the CIA. After all, Eloise had intelligence that no spy plane could offer. Back in scientific and technical operations, she was carefully piecing together the picture through her vast network of communications intelligence, technical reports, radar analysis, and—crucially—the powerful network of spies she had built from her high-level contacts within the scientific community. She'd managed to obtain reports directly from Soviet scientists working in Tyuratam, an impressive coup considering the Soviets' tight grip on their workforce.

"I know everything there is to know," Eloise told a colleague. "We have the angle of launch, the size of the craft, the apogee, and the date." It was May 1957, but Eloise was certain the Soviets would launch their

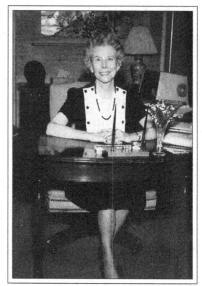

Eloise Page at her desk at CIA
headquarters.
Credit: CIA/CREST

satellite that fall. She gave a date range of September 20 to October 4. By July, she was certain the date they all feared was rapidly approaching. She warned her staff that it would be October 4, 1957.

Eloise, although prominent in the CIA, did not make policy decisions. Few in the agency did. The role of a CIA officer was to inform those in the American government who did make such resolutions, omitting personal bias. Yet Eloise felt strongly that her government was making an enormous mistake by not warning the American people about the imminent Soviet satellite. She predicted the massive negative psychological impact that news of a Russian-launched satellite would have on the American people—one just as significant (if not more so) as the fear it would instill in the scientific community.

The CIA loved nothing more than forming large, bureaucratic committees to tackle such questions. The one working on the Soviet satellite problem was called the scientific and technical intelligence committee. At its head was an administrator Eloise knew only too well from his days on the Petticoat Panel: Colonel White. Just a few years before, Eloise and White had tangled over how women should be promoted and

compensated at the agency. White had been unrelenting in his dismissal of female officers and the "hazards" and "inconvenience" of their employment. Now the two were arguing again.

Eloise was adamant that the CIA should write up a memo directly for policymakers in Washington so that everyone would be privy to the valuable intelligence about the imminent Soviet rocket launch her team had gathered.

"No," White responded, "I'm not going to do that, because that comes from the Soviets and I don't believe anything the Soviets say." Eloise stressed that the intelligence could be relied upon, giving her reasons cogently. Colleagues at the interagency meeting, which comprised both members of the CIA and the Department of Defense, were persuaded by both the strength of her reports and her cool and self-possessed nature.

"She's like an iron butterfly," members of the NSA whispered later, struck by the potency contained within her diminutive frame. The nickname would stick.

White, however, was unmoved. "Nope," he said. "We are not going to put it out."

Eloise was furious. White was directly attacking the validity of her intelligence by labeling it as Soviet disinformation. His remarks were not only insulting but untrue. In her desperation to get the information released to the American people, she decided to do something she knew was against the rules.

It was July 1957, and Eloise felt the urgency of the moment, even in the muted atmosphere that was typical of Washington in the summer. Lawmakers were off on vacation, and tourists filled the National Mall amid the hot and sticky weather. Eloise was running late, as usual, and so she rushed to Colonel White's office, located off D Avenue, at CIA headquarters. She had decided it was time to turn on the Southern charm. While previously she had argued about the effect the unexpected satellite would have on Americans, now she would make the threat more personal.

"You really ought to put this out," Eloise told Colonel White, "because if you don't, it's going to go off and we are going to have an intelligence failure." She put emphasis on the word "failure." They both knew that if the Soviet satellite launched without warning, it would be the CIA who would be blamed for "not seeing this coming." The press would look for a convenient scapegoat among Washington officials, and in his position as deputy director of administration and head of the committee, it was inevitable that White would share some of this blame. Yet even with his reputation threatened, White still would not agree.

"I don't care," he said to Eloise, completely dismissive of her argument and of her. In the finality of his tone, she could tell there was nothing more to do.

"Well," Eloise said, "I bet you a case of champagne that the launch is going to go off. Just as I said it will."

White nodded, accepting the bet.

.

The grand hall of the Soviet embassy in Washington, D.C., was a room designed to make an impression. The walls radiated gold, as did the ornate molding, the gilt on the fireplace, and even the aureate embellishments of the grand staircase. At night, the radiance of so much gold in one spot was enough to momentarily stun incoming guests. But that night, other news would shock the attendees. When Eloise learned that the Soviets had decided, "at the last minute," to hold a cocktail party on Friday night, October 4, 1957, it didn't take a spy to guess what they were up to.

The guests who gathered that evening were a mix of scientists, journalists, and politicians. As Walter Sullivan, a *New York Times* reporter, made his way through the throng of partygoers, he asked one of the American scientists about a strange report that had just come over the wire. "What have they said about the satellite?" Sullivan asked. "Radio

Moscow says they have got a satellite in orbit." Moments later, the report was confirmed.

The Soviets had done it. The earth had its first artificial satellite. On cue, glasses of cold Russian vodka were passed out on trays. The guests suddenly found themselves at a celebratory soiree and, bewildered, raised their glasses in unison, toasting a piece of metal the size of two basketballs. The Soviet satellite named Sputnik flew over their heads every ninety-six minutes.

The following Monday, Eloise found herself surrounded by a different kind of beverage. "Crates of champagne!" she yelled out to her coworkers as her workspace filled with bubbly. Colonel White had been deeply wrong to doubt her, but at least he was true to his word. Congratulations poured into Eloise's office that day from all corners. One might have thought that Eloise had launched her own personal satellite by the shower of compliments that followed her everywhere she went. A letter of commendation from the office of scientific intelligence followed. It might be the Soviets' day, but Eloise was reaping the glory.

Eloise's role was acknowledged only within the CIA, of course. Outside the agency, the Soviet satellite ignited the exact reaction that Eloise had predicted. There was fear, anger, and shock on the faces of her fellow Americans. The Russians, however, were using the moment just as she had foretold, creating a steady stream of propaganda that flowed out of the USSR's borders and into the laps of potential allies.

One of the Soviets' more ingenious schemes was their "Sputnik clubs." These were set up in Western European countries "to enlighten people about our time's immense progress in science and technology through expert information, talks, lectures, and films." The CIA was not fooled by the outreach, remarking in one communication, "Obviously the intent is to attract people to communism."

While the Soviets boasted of their superiority across the globe, in the United States, the focus turned, as predicted, on the "failure" of the CIA

to anticipate this event. At a news conference aired on the ABC television network, Trevor Gardner, a former assistant secretary of the air force for research and development, criticized the CIA, calling the situation a "full-scale national emergency" and suggesting that a congressional committee should be assigned to probe the intelligence lapse. This sharp critique of the CIA, coming directly on the heels of what the American people believed to be a failure in the Suez Canal crisis, was both damaging and infuriating for those officers at the agency who knew their own foresight during both operations.

"In view of the unfavorable comments we have been receiving," wrote Frank Wisner, deputy director of plans at the CIA, "in a part of the press alleging another intelligence failure for lack of advance warning of the USSR earth satellite, we send a message to certain key stations to counteract these allegations." Wisner, like Eloise, was a founding member of the CIA, yet unlike her, he had risen quickly through the ranks of the agency. His proposal was too little, too late. It could not make up for the advance warning they could have given the public if they'd listened to Eloise.

While it was a pleasure to be told she had been right, there was also much to displease Eloise. This was the first time in history that US airspace had been penetrated. Not even during World War II had such an event taken place. While the scientific achievement was heralded in newspapers across the globe, Eloise was concerned with the turning point Sputnik represented technologically. She knew that the advent of satellites was certain to change espionage. Sputnik itself represented no threat—in fact, the metal sphere had little tangible scientific value—but it signified how her world was about to alter dramatically.

If Eisenhower had so chosen, he could easily have instructed the army to launch a satellite similar to Sputnik a year earlier. The Juno rocket, launched by the Jet Propulsion Laboratory and the US Army on September 20, 1956, had flown 3,335 feet into the air, higher than any rocket at the time. Yet it carried no satellite at its peak. If Eisenhower

had let the Jet Propulsion Laboratory move forward, it would have been America celebrating right then. Instead, the White House still stubbornly clung to the navy's rocket program. Even after a second Sputnik was launched on November 3, the administration wouldn't give the California rocket scientists the go-ahead. Here was where the frustration lay for CIA officers: in an administration that had been handed everything but turned it all away.

On December 6, it was finally time for America's satellite. At the CIA, they called it NSG5520. "We are primarily concerned with the prestige and psychological aspects," read an internal agency memo. The truth was more complex. Eloise and Addy were intimately aware that the next era of scientific intelligence would be based on the technology that the Soviets were now flaunting. They needed to catch up.

It was shortly before noon at Cape Canaveral when the booster rocket ignited on the launchpad. Sitting atop the third stage of the Vanguard launch vehicle was a spheric metal satellite, its appearance reminiscent of Sputnik, so much so that the Soviet leader, Khrushchev, mockingly called it a "grapefruit." Just seconds after lift-off, the rocket began slipping back to earth. Within moments, the fuel tanks burst into flames, consuming the entire launchpad in a bed of fire. The press would call it "Flopsnik," "Oopsnik," and "Nogoodsnik." The Soviets asked if the United States would be interested "in receiving aid under the USSR's program of technical assistance to backward nations."

Enough was enough. Eisenhower finally allowed the Jet Propulsion Laboratory to move ahead with their satellite. In California, the scientists celebrated, although they wouldn't have much time. The group would launch the first American satellite, named Explorer 1, just fifty-six days later, on January 31, 1958.

Eloise was not interested in the aurora polaris, the glow of the air, solar radiation, cosmic rays, the earth's gravitation, or the physics of the ionosphere. She had no inkling of why spacecraft should journey to the moon, to Venus, or even to the red planet, Mars, which had long

captured human fancy. While the scientists looked upward, their imaginations bursting with the possibilities of exploration, Eloise's gaze was downward, looking upon the earth itself. Instead of partaking in the beauty of space, what she saw was the stuff of nightmares.

.

There are cities that exist on no official map. No road sign leads the way to their gates, nor can directions be obtained. Even the name is a closely guarded secret. These are communities filled with inhabitants who have been declared missing by their loved ones. Residents inside the walls may perform stressful jobs, but at least they get to send their children to excellent schools. These families live in isolation, not just geographically but from society in general. For many, residence in such a town is seen as a privilege, one that includes free housing, scenic parks, and a close-knit community. Yet behind the beauty of these invisible walls, the underbelly is rotten. The landscape, beautiful as it may appear on the outside, is so severely polluted that it is steadily poisoning its residents.

The contamination of one of the oldest closed cities in Russia began in 1946. It was at Lake Irtyash, just ten miles from the nearby city of Kyshtym. Here was the start of the Soviets' secret nuclear program, and a town was built around the complex, known by the code name City 40. The location proved fortunate in 1949, when the Soviets produced their first successful nuclear bomb here, far from the Americans' prying eyes.

To keep the location as secret as possible, they chose not to build storage tanks for the radioactive waste. Such construction would only slow them down and possibly give away their position. Instead, they dumped the waste into the lake, where it eventually flowed into the Arctic Ocean. By 1951, they had to stop. The lake was so highly polluted that even standing on its shore posed a hazard. They started dumping the waste in the adjoining rivers instead. Thousands of workers were exposed to dangerously high levels of radiation and even in villages

outside of City 40, the effects of radiation sickness could be felt for miles downstream.

It was around this time that the CIA started taking notice of the closed city. "The reports locate the atomic energy installation from 6 to 35 kilometers east of Kyshtym, in a wooded area on the shore of a lake," read a 1951 report. "The lake mentioned is Lake Irtyash and the installation is situated on the southeast shore." Now that they had spotted it, the agency kept a close eye on the area.

In 1953, the CIA noted that the Soviets had finally built storage tanks for the nuclear waste accumulated at the weapon facility. It was certainly past due. What they didn't realize, however, was that in the Soviets' haste, the construction was shoddy and insecure.

The first sign that something was amiss was the color of the sky. Residents of the Ural mountain range, two hundred miles south of City 40, noticed an intense violet color spreading across the horizon during the late afternoon of September 29, 1957. Soviet officials were quick to respond to inquiries, saying that the colors were nothing more than a strange and unexpected show of the northern lights. The aurora borealis made a convenient scapegoat.

In reality, the cooling system of the plutonium-processing plant in City 40 had failed, causing an uncontrolled reaction within the plant and an explosion of the nuclear waste tanks. The closed city, already heavily contaminated by years of nuclear waste dumping, now swarmed with radioactive contamination. In Kyshtym, the Soviets told their citizens a coal boiler had exploded and asked everyone to clean up the mess with rags and mops, but not with an inch of protective gear. More radiation was released from City 40 than the later Chernobyl accident in 1986, and yet the world heard not one word about the disaster.

At the CIA, the officers looked on in horror. At first the spy planes weren't certain what they were witnessing. "Cloud cover" was blamed for the difficulty, but then the area sharply came into view. The images,

combined with Eloise's contacts within the Soviet scientist community, confirmed their fears: it was the worst nuclear disaster the world had ever known.

Now they had a choice to make. Coming on the heels of Sputnik, it would be a satisfying coup to reveal the Soviets' ineptitude with their nuclear weapon. Yet if they did so, the extent of their reconnaissance would be revealed, and the next nuclear test facility might not be so easy to spot.

Under pressure, American intelligence chose to keep the Soviets' secret. Eloise, once so desperate to warn the American people of Soviet technology, remained quiet. As the radioactive wind blew through some two hundred towns, impacting thousands of lives, there was no outrage, no heated discussion, no coordinated cleanup effort, and no rush to give aid. The CIA was keeping their adversary's darkest secret. Yet the nuclear accident was a reminder of something else: it wasn't just weapons that posed a threat to Americans; a simple accident could be the downfall of them all.

BLUEBAT
1958

A rhythmic beat of drums pierced the early-morning quiet shortly after 6:00 a.m. on July 14, 1958. The Egyptian marching song echoed through apartment buildings, reverberated across streets, and grew in intensity as radios across Iraq dialed in. CIA operatives living in Baghdad woke up in a panic. They knew what this song meant, and they were terrified.

"Oh, this world," the lyrics boomed in Arabic, "watch and listen. The enemy came coveting my demise, I shall fight with truth and defenses. And if I die, I'll take her with me." The song was "Allahu Akbar," translated to "God is the greatest," and Liz, as well as every other CIA officer in the region, knew that if it played on the radio, it could mean only one thing: they needed to leave the country, now.

The march had been written for the Egyptian army during the Suez Canal crisis two years earlier and had become a popular rallying cry throughout Egypt and Syria. It symbolized the rise of Arab nationalism, the fall of colonialism, and the need to present a unified front against Western imperialism. Since he had bested the British, French, and Israeli forces, Gamal Abdel Nasser, the Egyptian president, had become a hero throughout the Middle East. Now, his calls for revolution were being heard far and wide.

Nasser's influence was effectively spread over the airwaves using his "Voice of the Arabs" radio station. Pocket transistor radios, newly inexpensive and rapidly becoming ubiquitous, amplified Nasser's message across the region, and soon his followers were broadcasting for eighteen hours a day. The station was transmitted from a newly constructed concrete spire in Cairo. At 614 feet, the tower was the tallest of its kind in the Middle East and Africa. It also happened to be paid for with American tax dollars, prompting the nickname "Roosevelt's erection."

As tall as the radio tower was, Liz was nine hundred miles away, and she knew that the song she was hearing could not be coming from Egypt. The music was emanating from Iraq's own national radio station. It was broadcast from a radio tower that was presumably controlled by the royal family. This was precisely what made the sound so chilling.

There had been hints of what was to come. Just a few weeks earlier, in May 1958, the CIA was listening to a conversation recorded by the FBI between two men in Washington. They were both military advisors, one working at the Egyptian embassy, the other at the Syrian embassy. The chatter indicated that Russia was pulling the strings in a sophisticated plot to overthrow Jordan's King Hussein. A date had been chosen for the king's assassination: June 4, 1958.

When the CIA learned that Syrian, Egyptian, and Soviet forces were conspiring against King Hussein, they were hardly surprised. The Jordanian monarch was just twenty-two years old, but he was already aligned with the Americans. He was considered "staunchly anti-Communist," which of course posed a threat to the interests of the Soviets in the region. Yet he was also a popular ruler, particularly after instituting a constitutional monarchy in his country a year earlier. His example of how a royal family could represent the people's interests was therefore a hazard to the Egyptians. What made the situation so dangerous was the presence of Syria in the conspiracy. The neighboring country, aligned with the Soviet Union, was heavily armed. The USSR had

sent the country 24 of their Mig fighter jets, 130 tanks, and more than 100 of their own people to act as advisors and technicians.

Jack O'Connell, working as an intelligence officer out of the tiny, three-person CIA station in Jordan, quickly warned the king of the plot. They launched an operation, installing secret listening devices throughout military offices and in the royal palace, which ultimately disclosed that twenty-three members of the country's military were part of the conspiracy. The men were arrested, and Hussein's life was spared—at least for the moment.

On July 10, while O'Connell was still grappling with the case in Jordan, the commander in chief of the Iraqi army made a surprise visit to King Hussein. His purpose was to warn Hussein of the "Egyptian plots." After assurances that they were taking care of the perpetrators, Hussein turned the tables. He expressed his own concern for Iraq, and particularly the safety of his first cousin, King Faisal II, who sat on the throne there. He warned specifically of two military generals who had been stationed previously in Jordan and whom he suspected of having communist sympathies. The Iraqi commander merely brushed off the warning, saying, "We can take care of ourselves; we're worried about you."

Little direct contact existed between CIA officers in Baghdad and Amman. Instead, intelligence was routed through Kermit Roosevelt, grandson of Teddy Roosevelt, who served as CIA chief of the Near East theater. Liz, however, did not need to read O'Connell's report to fear for Iraq's stability. CIA officers in Baghdad had worried over the fate of the monarchy since the Suez crisis had ignited a fervor of pan-Arab nationalism across the Middle East.

Liz had witnessed the city's slow alteration. Protests against Western imperialism were increasing by the day, and antagonism toward Western tourists, once rare, was now accompanied by acts of random violence. At the American embassy, even young diplomats sensed the high

tensions, and at the CIA station they began making bets as to when the country would fall.

While some junior officers in Iraq were frustrated that administrators in Washington did not take their concerns over the stability of the country more seriously, they could not refute the lack of evidence. Unlike Jordan, the CIA station in Iraq had intercepted no guilty communications between Egypt and Syria. Unbeknownst to them, however, the substantiation they lacked was at that very moment sitting on a desk in Washington.

A report had come in, not from Baghdad but from Arizona. An Iraqi student temporarily in the United States had received a call from a relative back home. After the telephone conversation, he swiftly began packing his things to leave. When a friend questioned his abrupt departure, he told him "that important political events were impending in his home country" and mentioned an upcoming date in July. Although it came to Washington in time for an investigation, the CIA thought little of the account. Administrators saw no real cause for concern. On July 14, that would shockingly change.

There is something about the month of July that is fortuitous for revolutions. The United States has the fourth, France has the fourteenth, and Egypt has the twenty-third. Perhaps it is a month that all monarchies should be wary of. In Baghdad, the events of July 14, 1958, started before dawn. A group calling themselves the Free Officers, the same name as the Egyptian revolutionaries in 1955, first skirted the city to the north, before moving into Baghdad's streets. They picked their locations for the coup strategically for maximum effect: the headquarters of the police, the airport, an army encampment in the city, the prime minister's residence, a building that housed weapon and ammunitions stores, and, of course, the palace in which the royal family slept.

Before the sun rose that July morning, a battalion of revolutionaries silently surrounded the palace. Once everyone was in place, they opened fire, killing as many palace guards as possible. Inside, the commotion

awoke the royal family and they began to make urgent telephone calls, desperate to enlist the aid of their allies across the globe. It was too late. Their guards were no match for the military aggressors and, besieged, the palace fell. King Faisal II, the crown prince, and the female members of the royal family were all ushered outside by 8:00 a.m. The Free Officers opened fire, and within minutes the family lay dead in the courtyard. With brutal finality, the monarchy was over.

Meanwhile, Radio Baghdad, which had begun broadcasting the song "Allahu Akbar" at 6:00 a.m., was now making a string of announcements. "Noble people of Iraq," the first proclamation declared, "we have undertaken to liberate the beloved homeland from the corrupt crew that imperialism installed . . . We have taken an oath to sacrifice our blood and everything we hold dear for your sake." The Iraqi people were then urged to join them in the streets and "watch the edifices of tyranny crumble."

Immediately, CIA officers in the country knew they had to escape. The life of every Westerner there was under threat. Liz understood that even stepping into the street outside her home could mean her doom. Crowds had amassed; the sounds of gunfire, shouting, and looting filled the boulevards; and the city was writhing in turmoil. The bodies of the king and the prime minister were later mutilated and dragged through the streets before being hung from lampposts. The chaos would linger for months. In the crowd, many held pictures of Nasser and shouted his name, and his face was even plastered on the fronts of Iraqi tanks, a circumstance that swayed some civilians and CIA operatives into believing the Egyptian president's role to be central to the revolution.

Every escape route was soon blocked off by the military coup. Crowds swarmed over lines of cars backed up on the bridges leading out of the city. They pounded on the glass and even pulled people from their vehicles. The British embassy was targeted early on and set ablaze, with one staff member brutally murdered. Then three American citizens were killed, while many others were thrown in jail. The CIA officers had prepared for this very moment and yet, when it came time, it was

heartbreaking to leave. They were abandoning everything—their jobs, homes, colleagues, and friends. Only a few flights were left, the minutes were ticking away, and the men, along with their families, made a mad dash to get on board.

But not Liz. She wasn't going anywhere. While her friends and CIA colleagues escaped the nightmare of a country torn apart, Liz stayed behind. Someone needed to remain in Iraq so that they could control their assets in the country. If everyone left, the network of spies they had built would collapse entirely. It was a painful decision to make, but Liz offered to remain in Baghdad. She was confident in her abilities.

In all honesty, Liz was better at subterfuge than her male colleagues. Her female colleagues stationed across the world agreed. "[Women] were much better at detecting surveillants on foot," one officer noted. "I always put that down to women being more sensitive to who's near or in their space, for physical protection. You know, somebody moves in on you, you're going to want to know." In her abaya (a loose, robe-like dress) and with her intimate knowledge of Iraqi customs, Liz fit in seamlessly.

In the confusion of that July morning, Liz watched her city and her work family shatter like the windows of the shops around her. The silence of isolation pressed in on her. There was not a soul she could reach out to for comfort. Her family in the United States felt a world away, and she could not risk calling them, nor could she tell them the horrors she was living through. Pirro, too, was far out of her reach. As much as she would have loved to have heard his voice, if only for the relief of a friend's presence during a dark time, she knew better than to risk her security. She could not be sure who might be listening, and now, more than ever, she needed to hide her American roots.

.

While Liz tried to remain calm in Baghdad, panic was spreading in Washington. At 8:29 a.m., John Foster Dulles, the secretary of state, put in an urgent call to President Eisenhower. He described the coup in Iraq

and explained that "we have a call from Lebanon to come to their aid." Dulles then expressed his fears for King Hussein's life, saying, "Jordan can't stick." For the secretary of state, it seemed that their influence in the Middle East had collapsed overnight. "We always felt we would lose the Arab world," Dulles confessed to the president.

A few hours later, an emergency meeting of the National Security Council was convened. The room was packed with the leaders Eisenhower depended on for crucial foreign policy decisions: the vice president, the secretary of state, and the secretary of defense, among others. Vice President Richard Nixon urged military action in Baghdad, but Eisenhower, alert to the fact that military intervention was like quicksand—fast to drop into but sticky to extract from—was resistant to the idea.

"If the Iraq coup succeeds," the CIA director said at the meeting, "it seems almost inevitable that it will set up a chain reaction that will doom the pro-West governments of Lebanon and Jordan and Saudi Arabia, and raise grave problems for Turkey and Iran." From his perspective, the entirety of the Middle East would be swept up in the Arab nationalist wave led by Nasser, with the USSR certain to reap the benefits.

As the meeting came to a close, Eisenhower spoke the words that would define America's complex relationship with the Middle East for the next five decades: "We must act or get out of the Middle East entirely."

.

American marines emerged from the Mediterranean Sea the way the creature from the black lagoon surfaced from his lair: slow and strange. It was July 15, 1958, and this was the first time the United States had combat boots on the ground in the Middle East. Except at this moment, it was technically boots on the beach.

The Lebanon coast was warm and sunny that summer afternoon. It was 4:30 p.m., and the weather was sizzling hot. Families played in

the sand, music streamed from transistor radios, and vendors sold cold drinks and cigarettes. While bikinis were prohibited at many European beaches, women freely wore the skimpy swimwear in Beirut. The Americans could scarcely discern a difference between the foreign shore they had landed on and the beaches familiar to them back home in the United States.

Beachgoers gawked at the bizarre scene, uncertain what it meant, while the marines were just as baffled. It had already been a "long and confusing day," as they distributed ammunition, cleaned weapons, and loaded equipment aboard transports, all from roughly 120 nautical miles offshore Beirut. Now that Operation Bluebat had begun, the perplexity was deepening. The 1,700 men emerged from their amphibious vehicles heavily armed, expecting to encounter resistance, and instead found only

Beirut, Operation Bluebat, 1958.
Courtesy of the Norman Schiller Collection, photographer unknown

a relaxed beach scene. Offshore, seventy warships, including three aircraft carriers, were ready to back them up. As the waves lapped their boots and vendors rushed to sell them cold Coca-Colas, the commanders pondered the wisdom of their orders.

In Washington, Eisenhower was painting a vastly different picture. "Yesterday was a day of grave developments in the Middle East," began the president in an address to the nation on July 15. "In Iraq a highly organized military blow struck down the duly constituted government and attempted to put in its place a committee of Army officers. The attack was conducted with great brutality. Many of the leading personalities were beaten to death or hanged and their bodies dragged through the streets. At about the same time there was discovered a highly organized plot to overthrow the lawful government of Jordan. Warned and alarmed by these developments, President Chamoun of Lebanon sent me an urgent plea that the United States station some military units in Lebanon to evidence our concern for the independence of Lebanon, that little country, which itself has for about two months been subjected to civil strife. This has been actively fomented by Soviet and Cairo broadcasts and abetted and aided by substantial amounts of arms, money and personnel infiltrated into Lebanon across the Syrian border."

As Eisenhower leaned heavily on his themes of Soviet influence, what he failed to mention was that President Camille Chamoun was illegally seeking a second term as president and that the military action in Beirut, rather than being connected with the violent coup in Iraq, was, in reality, a sideshow. America was rushing into Lebanon on a false pretext. Liz and her colleagues in Baghdad had submitted no evidence that the overthrow of the monarchy in Iraq was in any way tied to Lebanon, Egypt, or the Soviets. Yet CIA officials in Washington were convinced it was so, and had thus persuaded Eisenhower, who made strong parallels to German aggression in World War II to justify the military action, saying, "What we now see in the Middle East is the same pattern of conquest with which we became familiar during the period of 1945 to 1950."

Meanwhile, at the Ramstein Air Base in Germany, the air force was preparing for an escalation in hostilities. An "old shaky," a Douglas C-124 heavy cargo aircraft, was loaded with "Honest Johns," the first nuclear surface-to-surface American missiles. Their presence made the battalion uneasy. "I did not favor the idea," Major General David Gray said years later, "of being saddled with a weapon I could not visualize needing."

The Soviets were conducting their own naval maneuvers in the Mediterranean. After troops landed in Lebanon, Nikita Khrushchev sent a message to Eisenhower warning against further action. It "was couched in the rudest and most provocative terms," Eisenhower wrote, and "included threatening overtones."

The table was set, with everything in place for the start of World War III. Yet in Iraq there was one woman, standing alone, willing to do anything for her country. The intelligence she collected was about to make the difference between war and peace. With the chaos of a million voices clamoring around her, Liz had never been so alone.

AERODYNAMIC

1959

"In one way we seem to have arrived in Frankfurt yesterday," wrote Mary in 1958, "in another we seem to have been living here all our lives." Moving to Germany felt in many ways like coming home. Mary's years in Munich after World War II had given her a first taste of life as a CIA officer. Back then, she had found triumph in her work, but she had also experienced frustration at her slow promotion within the agency. Some things hadn't changed. She was returning now with greater responsibilities but not a commensurate raise.

"I have gone to work in a new section," Mary wrote home to her mother, "doing a job that will be much more interesting, I think. I will have some opportunity for research and writing, which I enjoy, and more for getting out and meeting people than I have had in my last job . . . I certainly won't be bored. It is a step up, too, although not an actual promotion."

What she could not tell her family, of course, was that the people she would be meeting were spies and that her presence in Germany was the continuation of an operation she had initiated years earlier. She was a field officer in the clandestine service of the CIA, also called the directorate of operations and sometimes referred to as the "department of dirty tricks."

For the first time, Mary was directing her own staff. One of her first

decisions was to hire a woman named Jean into her office. There were still woefully few female officers in the CIA, and for the women on the Petticoat Panel, it was clear that the only way this would change was for them to do something about it themselves. It was not easy to train a new officer or to promote one from within the ranks, and Mary knew that the retention rate was low, but still, she felt that hiring women was "well worthwhile."

Arriving in Frankfurt, Mary was handed a top secret memo that read as follows:

1. Exploit Ukrainian nationalist tendencies in the Soviet Ukraine for political and psychological warfare purposes.
2. Increase contacts with Soviet Ukrainian citizens, both within their own country and in other parts of the world, for communication of ideas.
3. Identify and increase tensions between the Ukrainian population and the Communist party elite in control of the government.
4. Stimulate among Ukrainian citizens intellectual ferment and the desire for more freedom to express Ukrainian national themes in art and literature.
5. Subvert and defect accessible Soviet Ukrainian personnel.
6. Attempt to establish a nucleus of opposition within the Soviet Ukraine as a point of political focus for agitation and unrest.
7. Negate Soviet attempts to demoralize and destroy the Ukrainian emigration in its fight against Communist oppression of their former homeland.

The list was part of Operation Aerodynamic, and Mary's role was once again to make contacts with Ukrainians, just as she'd done in the aftermath of World War II with one of her first assets, Zsolt Aradi. But the political landscape was changing quickly. When she had left

Germany the last time, she had witnessed the first inklings of a new, paramilitary CIA—one that was not just collecting information but also carrying out covert operations. One such operation was born out of that same Ukrainian network that Mary had built years before with Aradi—back in 1952, several men had been armed and dropped behind Soviet borders in a paramilitary experiment carried out jointly with British intelligence. The mission (with a goal of infiltrating the Soviet Ukraine with rebel soldiers) had been an abject failure, and all their men had died. These "covert operations" had in fact attracted unwanted attention . . . and could even be traced to the United States.

Despite the catastrophe, the Ukrainian operation would serve as a template moving forward. The agency was arming and training rebel groups to overtake their leaders and enemies across the globe. While Ukraine had been a disaster, the CIA had more success with back-to-back operations in Iran and Guatemala, where covert action was able to deftly oust leaders considered undesirable.

Emboldened by success, the balance between espionage and covert action was shifting at the CIA. While Mary was settling in to intelligence work in Frankfurt, elsewhere a very different, and far more expensive, CIA was emerging. The activities diverged so greatly from the espionage, intelligence, and counterintelligence work of Eloise, Mary, Liz, and Addy that it seemed an entirely new agency had materialized.

In Southeast Asia in 1959, the agency was working closely with US special operations forces, training Laotian soldiers in warfare techniques in an alliance against the North Vietnamese and, by extension, the Soviets. The operation would be one of "the largest paramilitary operations ever undertaken by the CIA." It would also be one of its most expensive, costing, during its last years of operation, some $500 million a year.

"Let me make this clear," Allen Dulles, the director of the CIA, told Richard Helms. "We have to face the fact that because espionage is relatively cheap it will probably always seem inconsequential to some of our

less informed friends on the Hill—in both houses of Congress. They're accustomed to dealing in billions. What kind of impression can it make when I come along and ask for a few hundred thousand dollars and a bag of pennies?" In the eyes of Dulles, and other CIA administrators in Washington, the cost—and therefore the work—of agents like Liz in Iraq and Mary in Germany was a mere sack of chump change.

For those with their eyes set on more expensive and deadly operations in Washington, Mary was a dinosaur, doing the intelligence work of years past. Some at the CIA felt that what she was attempting was impossible and dismissed the Ukrainians as an "unsteady ally" lacking a "nationalist mindset." Yet Mary still had the framework that she and Zsolt Aradi had built for collaborating with Ukrainian nationalist groups. From this basis, the station in Frankfurt had strung together a new network of spies.

They came from all different backgrounds: chemistry professors, journalists, and even dancers in the Bolshoi Ballet. Many had spent time in the gulag, even after the death of Stalin, for espousing their beliefs. The united goal of this new class of spies was to see Ukraine emerge as an independent state once again. The Americans, on the other hand, with different motivations, labeled this sense of nationalism as "political warfare." It fit perfectly within the Cold War power struggle.

From the CIA station, Mary was attempting a playback double agent operation. They had identified two individuals who were KGB agents sent to spy on the American Ukrainian operations. The CIA then carefully recruited both men, sending them back into Soviet Ukraine territory. They were given the code names Aecarthage 1 and 2. They acted as double agents, "playing back" the information received through the KGB while pretending to work as couriers for the CIA.

As previously, CIA officers were not directly controlling the spies, instead using Ukrainian go-betweens. Mary was using one of the groups involved with Aradi back in the late 1940s: the Organization of Ukrainian Nationalists, or OUN. To hide their true purpose, these individuals

worked undercover as members of the Ukrainian émigré movement involved in anti-Soviet propaganda. The CIA carefully hid any evidence of their own financial backing.

Mary knew that the problem with any human intelligence operation was understanding where the true allegiances of the double agents involved lay. This was critical, because in order for the operation to be carried out, the Americans had to reveal verifiable intelligence. It was the only way they could convince the KGB that the double agent was delivering on their instructions. At some point, however, the boundaries could blur. The CIA had to be sure it was getting more than it gave away.

Mary, as the supervisor of the reports officers at the CIA station in Frankfurt, was responsible for making sense of the accounts coming from their agents, assessing their meaning and abilities, and transmitting the critical intelligence securely back to Washington. However, like Liz, she never allowed herself to be limited by her status as a reports officer. Although Liz acted like an operations officer, clandestinely recruiting and handling her own spies, administrators were loath to give female officers the title. It was easier to have them do the work without the recognition.

Mary's interviewing skills, as well as her language abilities in German, Russian, Greek, Spanish, and French, made her instrumental in working with their Ukrainian agents. In some ways, she also had an analyst's heart. Perhaps it was her vast research training, or her work as a PhD candidate, but she was adept at sifting through intelligence. While most analysts were hunkered down in Washington, Mary was invaluable in Germany, combining her ability to study reports with her years of experience working in human intelligence.

Mary was not just building a spy network. She was forming an alliance with Ukraine that she hoped would serve her country well for decades to come. The Ukrainians, she was certain, had a future with the United States. Unfortunately, things were getting sticky right from

the start. Aecarthage 1, one of their playback double agents, had just disappeared.

.

In a conference room in Washington, Senator J. William Fulbright was loudly complaining about the amount of money the United States was wasting on the CIA. In the room was President Eisenhower; John Foster Dulles, the secretary of state; and his brother, CIA director Allen Dulles. The CIA's cautious reporting on Iraq prompted Fulbright to say that the intelligence agency was "fumbling in the dark." If he could have seen Liz at work, on the front lines in Iraq despite the dangerous conditions on the ground, he might have changed his mind.

Far from bungling, Liz was obtaining key information on the Iraqi military leaders who were responsible for the overthrow of the government during those early, chaotic days after the Baghdad military coup and the CIA's evacuation from the city. By the summer of 1958, she was the only one left in the country and was still running not only her own agents but also those of all her colleagues. Relying on these human intelligence sources, Liz knew that her information was clear. This uprising was not the work of Nasser in Egypt. In fact, it seemed the fundamentalist-based uprising might present possible *competition* to Nasser's secular rule. Nor was the coup controlled by the Soviets. Instead, two generals had led the revolution in Iraq, and the government they formed, while heavily Arab nationalist and anti-Western, was not necessarily friendly to the Soviets. As it turned out, Jack O'Connell, the CIA agent in Jordan, had warned them to watch those two men specifically several weeks ahead of the coup.

In Washington, Liz's report made it clear that it was the administrators, rather than the officers in Iraq, who had failed to connect the dots. They had the warnings of their agents on the ground, the fears of the embassy staff, the counsel from the king of Jordan, and even a proposed date from an Iraqi citizen in Arizona. What they didn't have, however,

was any evidence that either the Egyptians or the Soviets played a role in the revolution.

Yet if this were true, why exactly were American troops in Lebanon? This was the critical question. Liz's reports proved that the National Security Council had rushed to judgment, sending warships and even atomic weapons, which were still in route, to a country with no ties to the Iraqi coup. Now they had to pull back the marines before the Soviets decided to retaliate for what they labeled as Eisenhower's "aggression." The Lebanon action had almost certainly made things worse. Following the upheaval in Iraq, Nasser had traveled to the USSR, and both leaders were now threatening war for America's precipitate actions in the Mediterranean.

Fortunately, the commanders in Beirut were able to adapt swiftly to both their environment and the influx of new intelligence. Admiral James L. Holloway Jr., landing on the beach on July 16, 1958, rapidly assessed the operational environment. What he saw was essentially a peaceful beach scene, and he perceived that the Lebanese people were, for the most part, friendly to the American forces. Labeling the intelligence he had been given by administrators in Washington as "out of date and unreliable," he quickly made changes to their strategy. By late July, new intelligence shed light on the situation in Lebanon. Deployment of additional infantry troops was canceled and, critically, the "Honest Johns," the nuclear artillery, were recalled. It had been a close call, but instead of tumbling down the edge of a cliff, Eisenhower chose to slowly back away.

American troops stayed two months in Lebanon. Their purpose morphed from the aim professed by Eisenhower early on—protecting the Lebanese president, Chamoun—to convincing the corrupt politician to step down. Their presence, instead of aggressively fighting Soviet and Egyptian forces to take over the Middle East, more sedately helped ease the peaceful transition of power. There might be nothing they could do in Iraq, but at least they had sidestepped an unnecessary war in Lebanon. Future generations would not be so lucky.

Still in exile, Arthur Callahan, the CIA station chief in Baghdad, was considering the work of his officers. When he reflected on all that Liz had achieved in the past year, it was clear that the woman was not only intensely talented but incredibly brave. She did not hesitate to risk her life repeatedly in order to gather critical intelligence. Callahan was considering nominating Liz for one of the highest honors a CIA officer could receive: the Intelligence Medal of Merit. The award was given "for the performance of especially meritorious service or for an act or achievement conspicuously above normal duties which has contributed significantly to the mission of the Agency." While Callahan knew that she had earned the honor, what he did not expect was the explosive reaction in Washington the nomination was about to incite.

.

The Red Army was marching into New York City. Soldiers dressed in green military fatigues with bright red stripes stormed the Fifty-Ninth Street Bridge and then swarmed into Manhattan. Hailing from across the East River, they were intent on taking the city and striking down any Americans who crossed their path. William Donovan leapt from his hospital bed and ran out into the streets, dressed only in his pajamas. There was no time to get dressed; the situation was urgent. He might have been seventy-six years old, but he was unafraid to fight the Soviets to the death. Donovan, then, now, and forever, would always be courageous.

His delusions, however, were worsening.

Eloise watched her former boss's descent into dementia with intense sorrow. Seven years earlier, in 1952, the father of American intelligence had been close to achieving one of his greatest ambitions: to be made director of the CIA. Eisenhower was a close friend of his, and the celebrated general had campaigned on Donovan's behalf. When Eisenhower was elected president, it seemed likely that Donovan's long service to American intelligence would be rewarded. Instead, the honor went to

Allen Dulles. Still, unlike in years past, Donovan wasn't shut out of CIA operations. Eisenhower made him ambassador to Thailand, and in this position, he was able to observe CIA operations across Southeast Asia.

It was in Thailand that Donovan betrayed the first signs of the devastating degenerative mental disease. At first, his decline was slight, but soon his deterioration become noticeable to those close to him. Aware of what was coming, he resigned from his position in 1954 and returned to Washington. By 1957, he was hospitalized. In Donovan's last days, after he "staved off the Red Army from invading Manhattan," President Eisenhower visited his bedside. The two generals spent a quiet afternoon together. Eisenhower was just seven years younger than Donovan and dealing with his own serious health issues. In the intimacy of their visit, it was clear that time was catching up to them both. Eisenhower later told a friend that Donovan was "the last hero."

After Donovan's death on February 8, 1959, the CIA sent a cable to each overseas station that read, "The man more responsible than any other for the existence of the Central Intelligence Agency has passed away." For those women he had hired and trained, particularly Addy and Eloise, it felt like the end of an era.

Mingled with the sting of losing her mentor came the glee of happy news for Eloise. Her ambitions had never been as lofty as Donovan's. She did not have a burning need to be the director of the CIA. Yet she desperately wanted to rise above the low expectations the Petticoat Panel had imposed and, perhaps most important, feel that her talents were recognized by the administrators who were so quick to dismiss female officers. In 1959, she made it one step closer. While she coveted a station chief position, a prized position within the agency, she could not complain about her promotion. She was now chief of special operations. She was organizing and directing clandestine espionage operations, primarily against sensitive Soviet targets, all across Europe. A woman had finally breached the upper echelons of the CIA.

In her new position, Eloise was privy to many secrets. One of them, however, was poised to become a nuisance. Eloise learned of a hidden safe in CIA headquarters where a small quantity of a deadly substance was hidden. It was a shellfish poison, extracted from Alaskan clams, called saxitoxin. The purified toxin was packed within the grooves of a set of small needles. The needles were so tiny that they could be concealed in nearly any container. It required just one scratch across the skin to kill. There was enough poison in the safe to kill five thousand people. One man, however, refused to die.

"THE WORK OF A MAN"

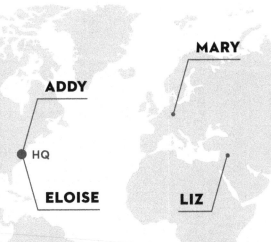

MUDLARK
1960

Addy's life was a swirl of secret messages, radar data, weapons systems readings, and shipping manifest logs. She listened in to stealthy communications between humans, and she spied on those sent by machines. With the rise in technology came a flood of new data. There were photographs from the spy planes, conversations caught by covert listening devices, and thousands of pages of documents. Her office at CIA headquarters in D.C. was awash in information as it came pouring in from all corners of the globe. Yet it wasn't always the noise that caught Addy's attention. Sometimes it was the silence.

Operation Grand Slam began before dawn on May 1, 1960, at the Peshawar airfield in northern Pakistan. The first sign that this mission would be different than others was when the radio suddenly stopped working. Try as they might, the group could not get communications to work on board the Dragon Lady. Technicians wrestled with the system for more than an hour, becoming increasingly frustrated as the precious darkness slipped away from them. The pilot, meanwhile, feasted on steak and eggs. It was a heavy meal for a man about to reach into the stratosphere, but as he well knew, it could be his last. The Dragon Lady was merciless.

The planes had a way of getting under a pilot's skin. In 1959, the sleek beauties had been painted a glossy midnight blue. They were still

the world's highest-flying aircraft, but their existence was no longer a closely guarded secret. A few months earlier, in September 1959, a U-2 spy plane flying over Japan experienced engine problems and made an emergency landing in a civilian airfield. Japanese newspapers reported on the unusual event, describing a plane built for high altitude and even mentioning the glass-encased windows fitted into the belly of the plane, a design ideal for reconnaissance photography. In reality, the disclosure was trifling. The Soviets already knew about the U-2 spy planes and had been spotting them on their radar for some time. They just couldn't catch one.

Eisenhower, always cautious about the spy planes' flights over the USSR, had limited their use. If a plane was shot down, the extent of their technology would be known. Secrecy was in some ways more important than the intelligence their cameras offered. Yet there was still Tyuratam. The undisclosed nuclear test facility in Kazakhstan needed to be watched closely. The CIA was still keeping the Soviets' secret about the region's nuclear disaster, but the agency knew that another cataclysmic event could happen at any time. And what of the offensive weapons the missile center was developing?

May 1, 1960, marked a special test of the Dragon Lady. She was going to fly over the entirety of the USSR, stretching from the southern to the northern tip, in the longest operation over the country yet undertaken. It was coincidentally going to take place on a public holiday, International Workers' Day, when a massive parade would be held at Moscow's great square. The U-2, however, wasn't there to take photographs of the revelry. Its mission was to get data from Tyuratam, and from there pass over a string of Soviet airbases and closed cities.

In all the Dragon Lady's twenty-four flights over the USSR, this was the first time Eisenhower was desperately pressing the mission to go ahead. In less than three weeks, on May 17, the American president was planning to meet with leaders of the Soviet Union, Great Britain, and France. He wanted to go into the Paris summit thoroughly prepared.

Among other topics, the leaders would be discussing a possible nu-clear test ban. Without an accurate understanding of Russia's atomic capabilities, and specifically nuclear missile development, it was nearly impossible to settle terms. They certainly could not count on the Soviets to disclose the entirety of their technology. Yet as they rushed through Operation Grand Slam, they did not consider what that date, May 1, truly meant to their adversaries and how spying on that holiday in par-ticular might be perceived.

In the early-morning hours, the technicians in Pakistan finally got radio communications working at the station. In Washington, it was evening, around 8:00 p.m., but Addy waited patiently as the system was fixed half a world away. She was accustomed to working at this hour; it was when the Dragon Lady usually took off on its Soviet reconnaissance missions. An hour passed by, and then two. Addy waited. Finally, a mes-sage coded from Pakistan to Turkey to Washington came through. In Morse code it read, "JGOHB." They were asking for permission to go. The covcom team sent back the order to Turkey with the morse code message HBJGO, or OK to proceed. It was forwarded by radio fre-quency to Pakistan. Operation Grand Slam was officially a go-ahead.

Pilot Francis Gary Powers, waiting in the cockpit, eased the plane into the sky and started heading northwest. Around 5:30 a.m., he slipped over the Soviet border, firmly believing that he was alone, nearly invisi-ble to the world, as he sat cloaked in the spy plane.

.

There is an Iraq that might have been. Before everything changed in the summer of 1958, the city commissioned a host of prominent architects, hailing from around the globe, to evoke the grandeur of the ancient city and reestablish Baghdad as a cultural haven. From 1957 until the proj-ect's abrupt end in 1958, Frank Lloyd Wright was one of those artists captivated by the potential of this ancient, evocative metropolis, and he began to design a "plan for greater Baghdad." His work, in his typical

fashion, did not obliterate the region's cultural heritage, but instead worked within it.

Although he was originally commissioned to design just one building, Wright's passion for the project soon expanded to include a botanical garden laden with date palms, a cultural center, a bazaar, a post office, and a university. Of particular beauty was his vision for a massive, gilded statue of Harun al-Rashid, the fifth caliphate to succeed the Islamic prophet Muhammad. The ancient ruler initiated the Islamic golden age, a time when the region was rich not only economically but also culturally and scientifically.

The golden age stretched hundreds of years, from the eighth century until the fourteenth. During this time, Baghdad was one of the most populous, educated cities on earth. At its height, Baghdad was bursting with academic scholars, and it was home to a so-called House of Wisdom, a grand and beautiful library filled with books on philosophy, history, medicine, astronomy, and physics. The House of Wisdom was emblematic of an enlightened Baghdad. When the library was irremediably demolished by the Mongols in 1258, the golden age perished along with it.

The crown jewel of Frank Lloyd Wright's plan for Baghdad was not a library but an opera house. After flying over the city in an airplane, he convinced the Iraqi monarchy to relinquish an island for the project, one perched in the middle of the Tigris River, which ran through the city. There he dreamed up the "Crescent opera civic auditorium," with a tall, elegant spire and dramatic arches. It sat on an isle within an island, surrounded by what Wright called "the garden of Eden"—a gathering of concentric flower beds, wide marble steps, fountains, and a delicate footbridge that led to the entrance of the theater.

For Liz, this version of Baghdad felt a million miles away. The city she once knew was forever altered. Even as her colleagues began to return, it was clear that their operations required more artifice than ever before. In the new anti-Western atmosphere, even catching a whiff of

their spying could mean death for all those involved. The CIA director recognized the jeopardy his officers faced, calling Iraq "the most dangerous spot in the world."

Still, there was work to do. Because Liz had stayed behind during the tumult of revolution, the CIA had not lost the spies they possessed in the city. She had carefully kept in contact with their assets, and she maintained a steady stream of intelligence flowing back to Washington.

Not only had she preserved their assets in-country, but she had even grown their operations. In addition to her connections at the tailor, Liz was setting up a spy ring at her hair salon. The setup was close to ideal: nearly every woman coming into the shop to get her hair done was certain to discuss her personal life. In a place that felt safe and welcoming to its clientele, it represented a revolving door of women discussing their spouses, friends, fathers, and brothers and revealing highly sensitive aspects of their work. While the women had their hair washed, cut, and set, they did not suspect that the sympathetic ear of their stylist was in reality gathering intelligence for Liz and the CIA.

The names she received from her stylist network yielded a new crop of spies, gathering data from within the Iraqi military. With fewer Westerners in the city, conducting live and dead drops had become more challenging. A casual meeting in a coffee shop was no longer a simple matter. The risk was dizzyingly great, but so was the incentive. Liz's spying had just uncovered the Soviet's newest fighter jet: the MiG-21.

In 1960, this jet was a terror of the skies. The MiG-21F-13 possessed a single thirty-millimeter cannon and a pair of R-3 air-to-air missiles. It was joined by yet another new fighter jet, the Su-9, which featured on-board radar, the ability to match the Dragon Lady's ceiling height, and four powerful air-to-air missiles. Equivalent American jet fighters were still years away. These were the planes that could finally take down the Dragon Lady.

Even the old MiG-19s, however, could pack a surprising punch with the right pilot. Unbeknownst to the Americans, in 1959, a MiG-19 flew

to a height of 54,414 feet and caught a glimpse of the Dragon Lady and her telltale wings. It was clear that the American spy plane was finally within the Soviets' grasp.

Eloise, meanwhile, was concerned about the reports coming from her network of scientist spies. The Soviets had developed a new surface-to-air guided missile battalion, or SAM, designed to take down high-altitude reconnaissance aircraft. It was first sent to the Soviets' allies in China, where the missiles were deployed against Taiwanese reconnaissance flights. Now they were positioned in Russia. New photographic evidence, taken on the ground in 1959, had spotted the plane killers in a closed city named Sverdlovsk. The city was of particular interest to Eloise, as it was the site of a biological-weapons facility where she was gathering intelligence. It was no surprise, then, that the closed city, full of potentially deadly secrets both biological and explosive, would be chosen for the Americans' spy plane route. Still, the risks were rapidly growing. By chance, another newcomer was coming to Sverdlovsk: a brand-new Su-9 that had just been delivered by the Soviets. In 1960, Sverdlovsk was likely the most dangerous city on earth for an American to fly over.

.

At 5:36 a.m. on May 1, 1960, the Soviets spotted the Dragon Lady. She slipped over the border from Afghanistan and headed north. Word was immediately sent up the chain of command, and by 6:00 a.m., air defense headquarters in Moscow was coordinating interception of the foreign invader. After Khrushchev was informed, the Soviet premier became enraged, certain that the Americans had chosen the holiday deliberately to inflame hostilities. International Workers' Day, also known as May Day, was a celebration of the labor and the working classes and was hugely important in the communist USSR—it would have been comparable to a Soviet plane flying over the United States on the Fourth of July. Khrushchev ordered his military "to destroy the

target at all cost." Sergey Biryuzov, the commander in chief of the Soviet air defense forces, took the directive literally, announcing to his staff that he would turn himself into a missile if he had to in order to sink the "damned intruder."

Meanwhile, in Washington, the flight was monitored without any inkling of the rage gathering on the opposite side of the globe. Yet, had administrators put together the pieces, there were signs of impending doom. First was data from the covcom team, obtained on April 9, that had picked up Soviet communications during the Dragon Lady's last flight over the USSR. It was clear from the radio chatter that the Soviets were tracking the American spy plane the entire time. What was odd, however, was that no effort to intercept the aircraft had taken place. It gave a false sense of security, one they should have been wary of.

Second was Liz's intelligence on the new Soviet fighter planes. It was clear from the specifications Liz had provided that the Soviets now had the airpower to intercept the plane. Next were the SAMs, the surface-to-air missiles that one CIA officer had called "the greatest threat to the U-2." These were documented to exist along the Operation Grand Slam flight path. Oddly, this had never been taken into consideration when plotting the route. Lastly, there was the date itself. May 1 was no ordinary day on the Soviet calendar. The skies were quiet and clear, with few military flights operating on the holiday. An intruder was likely to not only be noticed but also draw military vengeance.

It was 3:30 a.m. in Washington when suspicions flared. In the operations center at CIA headquarters, the Dragon Lady disappeared. Radar tracking had stopped abruptly two hours earlier, when the plane was southwest of Sverdlovsk and about halfway through its mission. There had been no word from the pilot since the start of the operation hours earlier, when he had reached sixty-six thousand feet and told the operators in Pakistan that the mission was proceeding. All was quiet.

The silence was what sparked fear at the CIA. Quickly, phone calls

were made and senior officers dragged out of bed. Even before Gary Powers and the Dragon Lady were overdue for arrival in Norway, a team was assembling at the CIA. Addy rushed to the Matomic Building on H Street, fearful of the situation she would find when she arrived.

The CIA called it Operation Mudlark. An American spy plane was missing over the Soviet Union, and American intelligence was clueless as to what had happened to it. It was almost as if it had vanished mid-flight. Addy worked closely with the NSA and the US Air Force as they tried to trace the plane's last moments.

Their immediate fear was technical difficulties, which had seemed to haunt the mission from the start. Not only had they struggled with the radio, but soon after, the autopilot on the Dragon Lady had failed and Powers had switched to manual flight. At headquarters, they began to postulate what else could have gone wrong.

Addy played an unusual role in the group. She was a high-level liaison with the NSA and the air force, adept at analyzing complex data. With a staff now working under her, Addy assessed communication system data and performed cryptanalysis. As she reviewed their intelligence, it was clear that the Soviets had been tracking the Dragon Lady but then had suddenly stopped. No communication from the pilot shed light on what had gone wrong. Addy could not make the invisible appear. Try as she might to find a connection, the Russians had left no obvious trail on their possible role in the mysterious vanishing plane.

As the hours ticked by, it became clear the Dragon Lady wasn't coming back. Whether the intentional act of the Soviets or merely an accident, the plane was likely destroyed somewhere over the USSR. Sadly, Gary Powers was almost certainly lost along with her. The chance of surviving a high-altitude accident was slight. The question now was how the United States should account for the wreckage of their plane strewn somewhere across the Russian countryside.

The CIA had prepared for such a moment. They had already picked out a disguise for the Dragon Lady and even plotted an elaborate

Dragon Lady hastily painted in NASA colors with fake serial number, 1960.
Credit: National Aeronautics and Space Administration

charade. On May 2, the CIA had NASA call a press conference to declare that a plane conducting weather research had been lost north of Turkey. To further the deception, a few days later they trotted out a Dragon Lady painted boldly in NASA colors with a logo and a fake serial number printed on the side. At Edwards Air Force Base in California, some NASA engineers snuck between the reporters to get a glimpse of the plane. They looked up at the aircraft in awe. They'd never seen such a thing before. Unfortunately, the target the CIA most wanted to mislead, the Soviets, was hardly impressed at all.

.

"She can make an intelligent and useful contribution in the operational field," read Mary Hutchison's personnel report, "but the choice of jobs open to her is obviously limited. Subject is married to a CIA staff officer. This, of course, restricts her availability for assignment."

It might have been "obvious" to the CIA, but Mary was annoyed with her slow advancement in 1960. From her perspective, Mary said it

was "very difficult . . . for a woman to get into a position where she really commands. No matter how capable she is, she will not be able to because she is a female."

This didn't mean that Mary wasn't going to try. As her husband observed one cold morning in 1960, "Germany looks best under a light coat of snow." Mary was going to allow the identity of being a wife to surround her, giving her a gentle, nonthreatening facade, like a dusting of snowflakes. Meanwhile, she would work like hell underneath the wintry camouflage until she got the position she deserved.

Operation Aerodynamic was not cooperating with her aspirations. Already, her team had lost touch with one of their double agents. The man had disappeared into the Soviet wilderness, leaving not a trace behind him. Then a second double agent had gone quiet. They could only hope he might return to them. Mary took each of these losses personally. She could not know if they had abandoned the CIA or been caught and killed. These men were not simply faceless spies to her; she had nurtured relationships with each of them. To have her agents vanish without a trace was distressing. It felt like a personal failure, and among her colleagues at the CIA station in Frankfurt, she blamed herself.

Even as the operation struggled, the need for a network of spies had never been more pressing. Mary had recently learned of a Soviet biological-weapons facility newly constructed in Gvardeyskiy, Kazakhstan, south of the one Eloise had contacts with in Sverdlovsk, Russia. Ukrainians were uniquely positioned to gather information in Kazakhstan, as the Soviets had been exiling Ukrainians to the country since the 1920s. After World War II ended and the USSR swallowed up western Ukraine, a huge wave of Ukrainian deportees were sent to Kazakhstan, many of them scientists. Among the groups expatriated were the OUN, the Organization of Ukrainian Nationalists, which Mary had helped identify and turn to American interests years earlier.

The CIA was still uncertain of what was being produced at the facility, but the threat of biological weapons was emerging as a major

cause of concern for the CIA and particularly for Eloise back in Washington. They suspected that the Soviets might be weaponizing anthrax, an ancient bacterium thought to have originated in Egypt and Mesopotamia in 700 BC. Anthrax had been used by Germany during World War I to infect enemy livestock, and then by Japan in the 1940s, when eleven Chinese cities were sprayed from the air with an aerosolized form of the pathogen.

It certainly made sense that the Soviets were experimenting with bioweapons. After all, the United States was doing the exact same thing. Not only had American scientists filled bombs with anthrax during World War II, but they were now tinkering with the lethal potential of a host of different bacterial, viral, and fungal agents. The field was emerging as one of the most dangerous to humanity.

For Mary, Ukrainian scientists represented an ideal agent within Kazakhstan, especially if the person recruited had been exiled due to their involvement in the OUN. There were forty million Ukrainians living under Soviet rule. In Kazakhstan they were viewed as compatriots, both nationalities having been victims of the Soviet Union. Now, the CIA needed a way to find them.

"We must change our tactics," a secret report read. They determined that for Operation Aerodynamic to work, it needed to be much bigger. They had to spread out their Ukrainian recruiters, across conferences, festivals, port cities, and any potential location where contact with a Soviet Ukrainian could be made. Propaganda would be inflated as well, with a flood of new books published by Ukrainian writers and poets, seventy hours of radio programming a month, a language journal, and even a newspaper, *Ukraine Today*.

Very few of those involved in the propaganda operations suspected that the CIA funded their work or that American intelligence was intent on building support for an independent Ukraine. Yet as the operation expanded, new contacts were identified within Kazakhstan. One CIA officer observed of the operation, "Some form of nationalist feeling

continues to exist . . . there is an obligation to support it as a cold war weapon."

.

On May 5, Khrushchev disclosed the truth about the American spy plane's fate. "We said that the aircraft should be shot down," the Soviet leader announced. "This was done . . . Just think what would be the reaction of the United States if a Soviet plane flew over New York or Detroit. This would mean the beginning of another war." The fate of the Dragon Lady's pilot was still unknown, but the CIA assumed he must be dead.

In reality, Powers had first been followed by a Su-9 Soviet fighter jet before crossing into the airspace over Sverdlovsk. Once within their engagement zone, no less than fifteen SAMs had been shot at the American plane. The shock wave alone was enough to rip the plane apart. The right wing of the Dragon Lady broke off first, and then the left wing, leaving the plane spinning downward, tail first. Powers knew he had to eject from the plane, but his seat jammed. He jettisoned the transparent cover that protected the cockpit, unsecured his seat harness, and then hung from his oxygen hose before bailing from the ill-fated plane. Because his seat didn't eject, the self-destruct device implanted in the plane did not detonate. If it had, all evidence of the plane's reconnaissance abilities, including the cameras and film, would have been destroyed just as the CIA intended.

The Soviets were so desperate to destroy the American invader that even as the Dragon Lady's wreckage fell from the sky, they continued to attack the plane. Circling the plane were two MiG-19s. They were prepared to ram the plane, but soon it became clear that such an action wasn't needed. Instead, they surveyed the wreckage and reported their findings to ground control. Confused by their presence and wanting to be sure the Dragon Lady was dead, a Soviet commander on the ground ordered the next round of SAMs to be fired in their direction. Sadly, the

aircraft he perceived as a foreign enemy were in fact the Soviets' own fighter jets, and one of the MiG-19s was hit. The pilot, Senior Lieutenant Sergei Safronov, ejected from the plane, but his injuries were severe. He died as his parachute floated down to earth.

Gary Powers, meanwhile, had reached the ground safely, but without any hope of escape. He was so deeply entrenched within the borders of the USSR that he knew capture was inevitable. Around his neck lay a hollowed-out silver dollar that concealed a needle dipped in lethal poison. It was a bioweapon whose disclosure would mean embarrassment for the CIA should it become public. Eloise was well acquainted with the shellfish poison he wore, just as she knew where it was stored within the CIA headquarters and what its intended use was.

CIA officers had long been carrying a means of suicide along with them on their missions. Even Jane had carried an L-pill, the L short for "lethal," as she gathered spies in France. If captured, Jane would have suffered torture at the hands of her interrogators. However, there was no reason for Powers to kill himself with the poison. He was not a spy, and the silver dollar was never intended as a means for him to escape questioning.

In all honesty, there was no expectation that either the plane or its pilot could survive a fall from seventy thousand feet. Even if Powers did miraculously live, the pilot held no real secrets; it was the plane that

Hollowed out silver dollar for concealment of saxitoxin-laced needle in the 1960s.
Credit: CIA/CREST

posed the real threat to American intelligence. The poison was there not to prevent his capture but to provide relief in case he lay dying in considerable pain. While Powers could give the Soviets nothing of tangible value, the Dragon Lady, laid bare, could tell all.

Back in Washington, the dramatic action over the Russian closed city was still unknown to the group. In fact, the NSA was telling Addy and those working on Operation Mudlark a very different tale. According to their intelligence, Powers had not been shot out of the sky but had descended slowly. From communications obtained between Soviet military air traffic controllers, they believed Powers had dropped from sixty-five thousand feet to thirty-four thousand feet in a controlled fashion, before ejecting out of the plane. The man was possibly a traitor, a defector to the Soviets who might, as one wild rumor claimed, be partying at a Sverdlovsk nightclub at that very moment.

What they didn't realize was that the plane the NSA was following from Soviet communications was not theirs. Just as the Soviets had muddled their plane for the American aircraft, the NSA was suffering the same confusion. The plane they had tracked was the unfortunate MiG-19 whose pilot had been killed by friendly fire.

On May 7, 1960, the Soviets announced that the American pilot, Gary Powers, was alive and in their custody. "Comrades, I must tell you a secret," Khrushchev announced. "When I was making my report, I deliberately did not say that the pilot was alive and in good health and that we got parts of the plane. We did so deliberately." The news seemed to enforce the NSA's story about the pilot's double-crossing behavior. After all, how else could he and the plane have survived such a horrific crash?

In any case, there was no longer anything left for Operation Mudlark to conceal. The Paris summit, the very reason for Operation Grand Slam's audacious flight over the USSR, ended in disaster. "It is either peaceful co-existence, or war," the Soviet premier declared in France, "which would spell disaster for those now engaging in an aggressive policy. We therefore consider that a certain amount of time should be

allowed to elapse, so that the present issues may simmer down and those responsible for shaping the country's policies may analyze what a responsibility they have incurred in proclaiming an aggressive course in relation to the Soviet Union and the other socialist countries."

The Soviets criticized American spy tactics not only at the Paris summit but later that month at the United Nations Security Council. Angered by their hypocrisy, Eisenhower decided to strike back. The United States had not yet revealed *the thing*, the covert listening device hidden in the residence of the American ambassador in Moscow. Now, in order to prove to the security council that spying was mutual between the countries, they trotted out pictures of the great seal of the United States carved in wood and described its discovery.

What was not mentioned, of course, were their own hidden plans for the Paris summit. The CIA had been planning to bug multiple hotel rooms where members of the Soviet delegation would stay. Their technology was not quite as slim and elegant as *the thing*, but at least Addy knew how it worked, thanks to her colleagues in British intelligence who had finally cracked the advanced technology. *The thing* had confused the Americans with its sheer simplicity: it was a passive covert listening device that instead of using a power source of its own was turned on by a radio signal sent by the Soviets listening in nearby.

The Dragon Lady, now in the possession of the Soviets, was the opposite of simplicity. However, even its superlative technology, what one officer hailed as the CIA's "greatest asset," was worthless without complementary human intelligence operations. The Dragon Lady had taken pictures of Sputnik's launch site, but it was the human intelligence gained by Eloise that ultimately furnished the details of its impending launch. When Khrushchev boasted that Russian ballistic missiles were in "mass production," it was pictures from American spy planes, coupled with intelligence gathered on Soviet facilities, that proved he was lying and that the idea of a "missile gap" between the two countries was a fairy tale.

Addy's group acted as a bridge between the widening gulf of human intelligence and technology. Her analysis of different communications intelligence "dominated operations planning." However, she needed all the tools at her disposal, and the Dragon Lady was no longer flying over the USSR. Now, even the stations in Pakistan and Turkey were cleared out. It was a profound loss. Losing their eyes in the sky, particularly over the closed cities of the USSR, was a frightening prospect. Fortunately, Addy and the CIA had an alternative.

The operation was called Corona. Unlike the security drawbacks of the Dragon Lady, the technology offered surveillance without a human being attached. The group at the CIA was developing spy satellites that could take high-resolution images far beyond the reach of any Soviet fighter jet or SAM.

The technology was complex, and by the summer of 1960, Corona was struggling. Eleven failed launches had taken place, one after another. While the United States had multiple civilian satellites circling the earth, launching a spy satellite was turning out to be far more complicated than the CIA had expected. The reason, surprisingly, was because the spy satellites were required to fly lower. While scientific satellites orbited at more than two hundred miles above the earth, the spy satellites needed to orbit at half that altitude in order to preserve the clarity of their photographs. This meant that the launch was everything: they could not go too high or too low—they needed to hit their mark at just the right speed and altitude.

Finally, on August 18, 1960, on their twelfth try, the spy satellite survived launch and entered orbit. A gigantic camera was now circling the earth. The cameras housed inside the satellite were, at over five feet long, massive. Later models would be even bigger, stretching to over nine feet. The lenses were specially designed for the application, yielding a clarity so impressive that even individuals could be recognized from the photographs. The film, manufactured by Eastman Kodak, was more than eight thousand feet in length. If someone had happened upon

the novelty-size photographic setup, they might have assumed it was designed for giants.

By chance, the success of Operation Corona came on the same day that pilot Gary Powers was punished by a Soviet court. On August 18, as Powers was being sentenced to ten years in prison for his role in the spy plane operation, the first American spy satellite orbited the earth seventeen times and took its first images of the world below. Once done, a hatch opened in the satellite, and the roll of film was released. As it plummeted down to earth, a plane flew by and caught the precious film in midair. Altogether, the images covered some 1.5 million miles of the Soviet landscape, more total coverage of the USSR than every Dragon Lady flight combined.

The metal eyes in the sky seemed an innocuous solution to a dangerous problem. Yet in some ways, they were about to make everything worse.

LINCOLN

1961

The Near East theater was erupting in controversy. At the heart of the debate: Liz. It started innocently enough when Arthur Callahan, chief of the Baghdad station, nominated Liz for the Intelligence Medal of Merit. For Callahan, there was no question that Liz's bravery in Iraq merited the high honor. Senior administrators, however, disagreed. They could not believe that a woman, a mere GS-12 officer, was deserving of the recognition. Never in the history of American intelligence had a woman been awarded the prestigious medal.

Once again, Liz's worth was being weighed by the CIA . . . but this time the Wise Gals weren't there to back her up. Still, Liz had a distinct advantage in 1961 that she had not possessed eight years earlier: she had men on her side. Instead of stewing in relative anonymity in Washington, she had male colleagues, particularly Callahan, who were ready to fight for her. These officers knew that to deny Liz this honor would be a severe injustice. She had earned this medal with the critical intelligence she had gathered during her full recruitment of Iraqi military spies and her stay in Baghdad during the revolution.

The Middle East had become home for Liz. She loved the region in spite of its flaws and dangers. The streets of Baghdad, while not always comfortable, were as well known to her as the grasslands of South

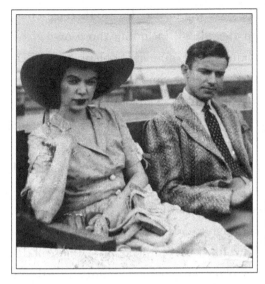

Elizabeth Sudmeier.
*Courtesy of the estate of
Elizabeth Sudmeier*

Dakota had once been. She had a large network of friends, comprising a mix of CIA officers, diplomats, and Iraqis, whom she cherished.

While senior administrators in Washington debated her merit, Liz continued her work, spreading her spy network farther and deeper across Iraq. If you wanted an officer who could make friends quickly and assess loyalties at lightning speed, Liz was your woman. Whether her worth would ever be recognized outside the Middle East, however, was still as unsettled as the Iraqi government.

.

For a brief sliver of time, in early 1959, Americans wholeheartedly loved Fidel Castro. TV host Ed Sullivan compared the revolutionary leader, who had overthrown his country's military dictator, to George Washington, and *Life* magazine put him on their cover, declaring him a "bearded rebel scholar." "Fidelmania" swept the nation, with the Cuban speaking to crowds of more than thirty thousand in New York City's Central Park, where one woman declared, "Fidel Castro is the best thing to happen to North America since Rudolph Valentino."

The love affair quickly soured. After establishing a communist state

just "eight jet minutes from the coast of Florida," Castro then national-ized commercial interests on the island, including those owned by Americans, businesses worth hundreds of millions of dollars. Soon after, a shipment of weapons arrived from the Soviet Union. Eisenhower knew it was just the beginning, and a plot began to thicken.

The CIA had some experience in getting rid of undesirable presi-dents, prime ministers, and dictators. Covert operations in Iran and Gua-temala in the 1950s, ousting unwanted leaders, had been labeled "successful" by senior CIA administrators. Now Cuba was in their sights.

The operation was overseen by Richard Bissell, the administrator who had supervised both the Dragon Lady's development and her de-mise over the USSR. Eloise didn't like Bissell, and not just because of the recent loss of the American spy plane. She considered him unworthy of his senior position in the CIA, lacking in, as she said frankly, "common sense." The CIA *needed* common sense right then, at least in Eloise's opinion. Instead, the rise of covert action, and even guerrilla warfare, was taking over the agency.

Mary was flying directly into the lion's den. Leaving Greg in Ger-many, she'd explained to her parents that her office was "a little busy" and so she was traveling to Washington in April to "help out." She hoped to have time for "sightseeing" and "going to the Smithsonian." In reality, Mary had no time to spare. There would be no museum visits and no occasion for leisure. She was headed straight to CIA headquar-ters to assist in the operation that was swallowing up all others at the agency with its scope and urgency.

Mary had no idea what she was getting into. She was coming into an operation that had already been labeled "unachievable" by the CIA. It was a bewildering situation for an outsider to stumble into, especially an officer like Mary, who had not been given the full picture and did not have any real authority in the operation.

The group responsible for the planning of the Bay of Pigs was far above Mary's reach, or that of most CIA officers for that matter. They

were known as the special group (consisting of Dulles, along with several members of the president's inner circle) called the 5412 committee, and they met weekly to consider the CIA's covert paramilitary operations. What had started as a relatively small three-hundred-person operation by those trained to infiltrate the Cuban military and provoke an uprising had grown to a large, amphibious assault.

By the end of 1960, just before he was to leave office, Eisenhower questioned the wisdom of the expanding operation, asking "whether the situation did not have the appearance of beginning to get out of hand?" Still, the outgoing president approved the plans to strike Cuba, while emphasizing that it would be the incoming president, John F. Kennedy, who would ultimately decide if the Bay of Pigs invasion was going to move forward.

A few months after taking office, in March 1960, President Kennedy did just that. The plan Kennedy approved called for two airstrikes against Cuban airbases, followed by a surprise attack by US-trained Cuban exile battalions. The invading force, being just 1,400 men, could not overpower the Cuban military. "It is expected that these operations will precipitate a general uprising throughout Cuba," read one CIA memo written in early 1961. "A general revolt in Cuba, if one is successfully triggered by our operations, may serve to topple the Castro regime within a period of weeks."

That was the official line, but behind closed doors, many officers at the CIA were skeptical. Mary, who had played a role in a plethora of sophisticated intelligence operations, was appalled at the state of American espionage in Cuba. The Havana station "lacked access to high-level military sources," and despite repeated requests from headquarters, they could not deliver military reports. Then, at the end of 1960, they lost a covert listening operation, further restricting their intelligence.

Some of the attempts to break up Castro support in Havana were downright juvenile. At one point, during a meeting of Castro sympathizers, undercover agents spritzed two leftist speakers with a scent the CIA called "Who, me?" The putrid perfume was a fart spray and seemed to

symbolize the maturity of intelligence operations in Cuba. Just when it seemed it could not get worse, the station itself was closed, along with the embassy, in January 1961. Havana became a black hole for intelligence.

Outside of Cuba, things were no better for the operation. "Not one American speaks or understands the Spanish language," read one report from the training base in Guatemala, "and the Cubans do a great amount of talking . . . It would, therefore, be of significant value to plant an American there who does speak and understand Spanish."

Mary's fluency in Spanish, as well as her gift for analyzing and writing intelligence reports, could have been critical in planning the operation, but instead she sat on the Bay of Pigs task force in early 1961, powerless to improve their lot. Mary knew that ideally, clandestine operations informed their covert counterparts, working hand in hand to further the mission. Yet instead of influencing the strategy, Mary was acting like a funnel, helping to make sense of the landslide of reports that would roll in once the action started.

Before dawn on April 15, 1960, Mary sat in a room with her colleagues as the operation unfolded with slow brutality. Right from the start, the plan went awry. The first airstrike missed the majority of its targets, leaving Castro's airbases intact. As the supposedly Cuban planes landed in Miami after the bombing, questions were immediately raised. The B-26 bombers, although painted in the colors of the Cuban army, were revealed to be American planes.

Now that the bombers were known to belong to the United States, Kennedy canceled the second and third airstrikes. He did not want them flying over Cuba, a wise precaution, but it was a critical blow to the operation. The CIA had warned against this very event, writing, "Since our invasion force is very small in comparison to the forces which may be thrown against it, we must compensate against numerical inferiority by effective tactical air support."

Although air support was canceled, the president decided to move ahead with the invasion. In the wee hours of April 17, 1,200 Cuban

exiles, carrying American weapons and trained by the US military, reached the Bay of Pigs. Castro learned of their presence almost immediately and ordered a counterattack. By 5:00 a.m., Cuban planes were circling the area. Under fire, one landing ship ran aground off the Cuban coast, forcing a battalion to leave their weapons behind and swim for shore. The beach was no safe haven for them. Castro had ordered twenty thousand troops to engage the invaders.

At headquarters, Mary could only listen in shock to the reports coming in from the commanders on the ground. The details were so distressing that the CIA officers around her became physically nauseated at what they were hearing. The Cuban exiles begged for supplies and air support, none of which the United States would supply. With Cuban army tanks approaching, one commander cried, "I have nothing left to fight with," before adding, "Am taking to the woods. I can't wait for you."

There was no reason to stay; no help was coming. Overwhelmed and outnumbered, 118 Cuban exiles perished on the beach while more than a thousand were rounded up and thrown in prison. At headquarters, Mary and the officers looked at one another in horror.

.

Far from the drama of the Cuban operations, Eloise was contemplating a more sedate campaign. It needed no vast military force or even a presidential blessing. It was called Operation Lincoln, and unlike the action in Cuba, its aims were clandestine. Although the CIA director had been swayed by the promise of paramilitary missions, there were still those at the CIA, such as Eloise, who remained focused on the foundation the agency had been built upon: espionage.

April through October was the season for wanderers in the Northern Hemisphere. Even with tensions high between the Cold War adversaries, American tourists were still planning sightseeing adventures behind the Iron Curtain. This was especially true in 1959, when the Soviet Union began expanding visa access to visitors. The country

needed the tourist economy, and visitors were enticed by an intriguing slogan: "It is not just a trip, it is a trip into a new world."

American tourists could ride the Trans-Siberian Railway, also called the route of the tsars, which stretched from Moscow to Vladivostok. They could soar atop Mount Elbrus in a cable car, attend a "world festival of youth and students," or simply marvel at the beauty of Russia's ancient cities. As tourists took in the sights of the Soviet landscape, they were armed not with guns, as the Cuban exiles were in Guatemala, but instead with cameras, notebooks, and their own conversational ability. They had one other advantage—they were trained by the CIA.

In 1959, the CIA screened nearly four thousand travelers, ultimately selecting sixty-four individuals to participate in Operation Lincoln. For Eloise, the operation was ancillary to her network of scientist spies in the country. Still, you never knew what might turn up. Unlike the Cuban operation, Americans involved in Lincoln were selected who spoke the native language, giving them the opportunity to make connections with Soviet citizens. Some also boasted technical and scientific backgrounds that would aid them in their observations of Soviet weaponry.

By the end of 1959, the group of tourists-turned-spies had mapped out a network of antiaircraft missiles previously unknown to American intelligence. It seemed likely that 1960 would grow the nascent operation, but the downing of the Dragon Lady quickly doused these hopes. In the aftermath, the Soviets had enacted strict new policies, forbidding photography and even sketchbooks in the hands of tourists. Lincoln, however, still had one entirely legal recourse: the Soviets had not yet prohibited the old-fashioned ability to make friends.

With CIA overflights of the USSR grounded, the need for intelligence within Soviet borders was growing. Yet with the necessity came greater risk. It was a situation that worried Eloise. She knew the American citizens they were sending into Russia were taking a gamble by working with the CIA. She insisted that the operation be entirely aboveboard, without hidden cameras or secret note-taking systems. Selection

of tourists was just as critical. Extensive background checks were carried out on each individual, both to ensure their suitability to the operation and to identify the possibility of Soviet agents infiltrating the mission. The CIA, while technically not authorized to investigate its own citizens, had found a back door into domestic spying.

Despite the risks and the intrusion of privacy, the CIA was awash in patriotic Americans ready to sign up. "Toward the end of February I am going to the Mediterranean area," wrote the author John Steinbeck to the director of the CIA in the 1950s. "If during this period I can be of any service whatever to yourself or to the agency you direct, I shall be only too glad." In response, the director of the CIA invited Steinbeck to visit him in Washington before his trip. The famous author, a favorite in the USSR after the publication of *The Grapes of Wrath* and its portrayal of the effects of capitalism on sharecroppers, would go on to travel in Russia in the early 1960s. He was one of possibly many Americans gathering intelligence clandestinely for the CIA.

Eloise, however, was not especially interested in recruiting writers. For Operation Lincoln, she decided to steer the program toward recruiting American scientists willing to travel to the USSR. She had the advantage of already knowing many of them, as her connections within the scientific community had grown exponentially since she had tracked and tested Soviet calcium from Berlin factories in 1949.

Intense training prepared the scientists-turned-tourists-turned-spies. Under Eloise's guidance, the group was briefed in the organization and practices of the Soviet Academy of Sciences, with the aim of intellectually bonding with their Russian counterparts. The program was no longer a random shot in the dark. Eloise selected Soviet scientists tailored to each American tourist, with comprehensive background information on the personality of the scientist they were to casually meet and a dossier on their field of work. In addition, the American tourists were trained in the art of Soviet counterintelligence and how to defend against it.

In 1960, fifty-five Americans were screened and briefed by the CIA

prior to their travel to the USSR. Of them, thirty-four returned with significant intelligence on air defense missile sites, flight routes, and the technical details of missile weaponry. The quiet operation was swiftly becoming one of the CIA's most successful. Obtaining reliable intelligence within Soviet borders had always plagued the agency. Now, it seemed, they had found a way in.

.

"Victory has a hundred fathers," President Kennedy famously said after the Bay of Pigs, "but defeat is an orphan." While his press secretary urged him to fault his military and intelligence chiefs, Kennedy was quick to take responsibility for the failed mission in public. In private, however, the story was different.

"What the hell do they want?" Kennedy responded to his press secretary. "Say we took the beating of our lives? That the C.I.A. and the Pentagon are stupid?" In Washington, various agencies were pointing fingers at one another, but inside the White House, the blame was laid squarely at the feet of American intelligence. Kennedy was ready to clean house.

First to go was Allen Dulles, the steadfast director who had wholeheartedly championed paramilitary operations at the agency. Next was Richard Bissell, deputy director of plans, who had been in charge of the Bay of Pigs operation. Yet even as the men behind the failure dropped out, it seemed their legacy was likely to persist. Undeterred, the Kennedy administration was plodding ahead on new paramilitary operations targeting Castro.

These new operations would not be planned inside Washington. The CIA headquarters was moving to a massive, 258-acre complex across the Potomac River in McLean, Virginia. Thirty acres of the property was purchased from two pioneers of the women's labor movement: Florence Thorne and Margaret Scattergood, who had purchased the land along with a spacious colonial house in 1933. When the CIA approached with an offer to buy the property, the two women agreed with one

contingency: that they be allowed to live out the rest of their lives in the house. Caring little for the home, the CIA agreed, and the two women spent the next forty years living among their nosy neighbors.

In the seclusion of their new headquarters, the CIA did not intend to let Cuba "decide its own destiny." On the contrary, the fate of the country was becoming increasingly worrisome. In the wake of the Bay of Pigs, Castro had joined the Soviet bloc. If any question had existed as to the nature of the Cuban leader's allegiances, it was now gone.

.

On October 30, 1961, the USSR unleashed the Tsar Bomba, the world's most powerful thermonuclear weapon. The fifty-megaton hydrogen bomb was dropped from an airplane over the cape of a remote Russian island in the Arctic Sea. As much as they would have liked to have concealed their handiwork, the experiment could not be hidden. The blast from the bomb was equivalent to 3,800 Hiroshimas and caused a mushroom cloud to rise more than forty miles into the air. In the wake of such destructive power, the fate of Cuba was even more pressing. After all, the tiny island nation was just ninety nautical miles from the southern shores of Florida, and now that Cuba was allied with the USSR, there was no telling what weapons Castro might be given access to.

It was late afternoon on September 29, 1962, when the newest member of Corona, an earth-orbiting photographic satellite, launched from the Vandenberg Air Base in California. Addy watched as the satellite roared past the atmosphere and then began circling the globe at speeds the Dragon Lady could only dream of, an unmatchable seventeen thousand miles per hour. While most satellites prior had been focused on the USSR, for mission 9045, the new kid on the Cold War playground was being photographed. A report from the NSA indicated that a buildup of Soviet weaponry was happening on the island and that intercontinental ballistic missiles were present. Corona was being sent to follow up on the story.

As the satellite passed over Cuba, it took some of its worst images.

Resolution had been improved on the new Corona satellites, but despite this, the quality was poor, the subjects grainy, and the weather uncooperative. Yet in between the heavy cloud cover, officers at the CIA's photographic interpretation division thought they could make out the blurry lines of the Star of David on the ground below. The six-sided star represented a chilling weapon to the American team: the SAM, the surface-to-air missiles that had taken down the Dragon Lady over the Soviet Union. The shape couldn't be seen from the ground, but from above, the weaponry distinctly formed a star outline, unlike other missiles.

Cuba had these deadly bombs, within range of the US and its 190 million citizens.

Now, a choice had to be made. To confirm their findings, the CIA would have to send a U-2 spy plane over Cuba. Yet if they were correct in their guesses, the weapon could take down a Dragon Lady over the island. The situation was impossible.

Soviet SAM site from aerial reconnaissance photograph, 1962.
*Credit: Department of Defense Cuban Missile Crisis Briefing Materials,
JFK Presidential Library and Museum*

PSALM

1962

In a bistro in Paris, Mary and Greg sat together in hushed observance of what was to come. The small table was covered in a snow-white table-cloth, and the two sipped on red wine from Clos de Tart, a vineyard formed by nuns in 1141. There was a flurry of activity as the plates arrived at their table and the smell of boeuf bourguignon intoxicated their senses. Besides books, there was nothing Mary loved more than rich food. France was paradise for the fifty-year-old CIA officer, although the city was far from idyllic at the moment.

As Mary walked around the City of Light, traces of violence could be seen everywhere. She noted the "machine guns on the top of every main building" and "more gendarmes than I knew existed." On March 18, 1962, France had signed a treaty with Algeria, ending their seven-year war and more than 130 years of colonial rule. In the aftermath, more than a million Europeans living in the North African country were fleeing to France. With the influx of newcomers came violence. Car bombings and terrorist attacks, resulting in the deaths of dozens, were being conducted by the Secret Army Organization, a right-wing paramilitary group opposed to Algerian independence. Their motto was *"L'Algérie est française et le restera,"* "Algeria is French and will remain so."

Mary was in Paris as part of Operation Aerodynamic. The past year had sent her buzzing around Europe, from Rome to London to Geneva,

and all across Germany. Like a spool of paper unraveling, Aerodynamic was rapidly gathering agents, forming a net across Europe. The net, unfortunately, did have some holes in it. Not everyone the CIA approached for the operation was honorable, or even useful. Just as Mary had noted a decade earlier, some Ukrainians had a history of working with Nazi Germany. Others were useless to the operation, including one target she described as "a rather simple old man lacking in security discretion." Highly prized among their spies, however, were the Ukrainian scientists they were conscripting. By 1962, it was "one of the most effective CIA operations in approaching disaffected Soviet citizens."

One Soviet the operation had managed to snag was a scientist working in the biological-weapons facility in Kazakhstan. As no spy plane or satellite could peer through the facility's walls, espionage was essential. The most difficult part of recruiting Ukrainian scientists was finding them. After that, widespread bitterness toward the USSR made their task relatively straightforward. As one source explained, "Ukrainian inventions in the field of science always get credited to Russian scientists and . . . Ukrainian researchers always get transferred to Russian cities on the eve of their announcement."

This new Ukrainian agent primarily researched viruses, and this individual's knowledge of biological warfare operations was frighteningly detailed in its scope. Through the new spy, Mary learned that the Soviet biological-weapons program was far larger than she'd expected. Not only were they making anthrax, they were also producing vast amounts of other deadly pathogens, such as smallpox, rabies, and typhus. It was obviously not just nuclear proliferation that the United States needed to tackle in their negotiations with the USSR, but the growing threat of these lethal biological weapons.

As with all their contacts in the operation, the spies were not directly in touch with the Americans. Instead, the informants met with Ukrainian agents the CIA had code-named Aecassowaries. To lessen the personal risk for these men and women, Mary met with the agents

clandestinely, collecting the intelligence verbally, and then writing up progress reports for each case, along with her expectations for the future. The espionage operation, which had once seemed so flimsy, riddled as it was with vanishing double agents, was now producing some of the most reliable intelligence on the inner workings of Soviet biological research.

Yet as Mary sat in the bistro in Paris, savoring the pleasure of being in a favorite city, despite the circumstances, her mind was wandering back to the United States. Their tour of duty in the European theater, while it had been extended, was now coming to a close, and it was time for her and Greg to travel back to Washington. It was part of being an officer, and yet in letters home, Mary spoke of her "longing to stay among the Germans." She was hoping to return for another tour.

After Mary's involvement in the Bay of Pigs operation, it was perhaps understandable that she would want to stay in Germany. The CIA she had joined years earlier was not the same agency that existed now. The Bay of Pigs had irreparably changed both the personnel and the perception of her employer, but it had not stripped the CIA of its controversial actions. Despite the headaches paramilitary operations were causing the CIA, and the angst to come, the espionage work that Mary offered was still perceived by some at the agency as second-class.

.

Mary was not the only one returning after an extended tour overseas. Liz was on her way back too. Although she had told her friends at home that she was giving Pirro up for good, and definitely not marrying him, she stopped in Rome on her way to Washington. She couldn't help herself. It was good to see a friendly face after the struggle of the past few years in the Middle East. She wasn't changing her mind, and she knew deep in her heart that she wouldn't give up the CIA . . . but still, even if it was just a few moments with the man she loved, it was worth it.

Back at headquarters, she had little idea of what was waiting for her. The uproar over her nomination for the Intelligence Medal of Merit had

not lowered in intensity, with one officer calling it a "monumental struggle." Her boss, however, had decided to take no more of this nonsense. Administrators were still complaining that Liz wasn't even a GS-13, and not technically an operations officer. Operations officers were those who clandestinely spotted, assessed, developed, recruited, and handled foreign spies at the CIA. While Liz was classified as a reports officer, her work was undeniably in operations. She checked every box on the list, something that many of her male colleagues, while better paid and with a higher status at the agency, could not claim. The problem was not her rank but that she was a woman. Arthur Callahan demanded to his supervisors that Liz receive the award, asserting that she "does the work of a man."

Finally, in August 1962, Liz received her medal. She dressed up for the event, wearing a flouncy dress and a double string of pearls, as she was ceremoniously handed the large award and paper certificate. The medal itself, while so earnestly fought over at the CIA, was strangely nondescript. Encased in its velvet box, the words "For Merit" were stamped prominently on the front, along with an eagle head, a shiny star, and a bough of oak leaves. Engraved in small lettering, almost like an afterthought, and curving along the bottom edge of the three-inch bronze medallion, were the words CENTRAL INTELLIGENCE AGENCY. On the back, Liz's name was printed in the middle of a wreath of laurel. It was unmistakably handsome, but Liz held the precious award in her hand for only a few minutes before she handed it right back to the agency. She could not keep it; it was a security risk. The medal would go into a vault at the agency, where it could sit in secrecy.

More valuable monetarily was Liz's promotion. She was finally made a GS-13, with a requisite bump in salary. It was more recognition than her younger self, who had struggled to gain respect during the Petticoat Panel, could hardly imagine. There was no one she could tell in her family, and certainly Pirro could not be informed, but her pride needed no outside validation. She knew she had deserved this moment, and the reward was sweet.

Liz finally receives the Intelligence Medal of Merit.
Credit: CIA/CREST

With her time off, Liz traveled to Iowa, where her family lived. She hadn't been able to visit in a long while, and her mood was "giddy" as she spent time with her parents, her brothers, her nephews, and her nieces. She seemed happy and relaxed, as if life had been extraordinarily good to her. Liz usually kept her feelings buttoned up tight, rarely letting her guard down, and so her family had never seen her like this. She was laughing and joking, a smile plastered on her face. The past few years had been extraordinarily difficult, full of danger, and to be home among those she loved felt like an extraordinary gift to Liz. The medal, wonderful as it was, came second to the joy she felt at this moment. She was alive.

.

In Washington, change was afoot. Ten years had passed since the Petticoat Panel, and yet outside the CIA, little effort had been put into

advancing women's labor laws in Washington. That was, until now. After assuming office, Kennedy established the Presidential Commission on the Status of Women in December 1961, with the aim of developing labor laws that would address pay equity for women.

The commission would comprise an impressive roster of women, including labor leader Esther Peterson and chair Eleanor Roosevelt. Yet among the group of intelligent, dedicated women who made up the multiple committees of the agency were a few members who were hiding a secret: they worked for the CIA, and they were bringing the lessons learned from the Petticoat Panel with them. One was a woman named Penelope Hartland-Thunberg, a noted international economist who had been working for the CIA since the 1950s. She would prove a fierce advocate for women in the decade ahead, joking in private that the "CIA got me into it!"

Like the Petticoat Panel, the commission gathered data and built coalitions among government agencies. Opposition swelled among business leaders, who claimed that women were more expensive to employ than men because of their absenteeism, high rates of turnover, and even their lavish need for separate restrooms. Undeterred, the group of women pressed on.

As the commission drafted the bill, protests in the business community grew louder. However, unlike Dulles, whose support of the Petticoat Panel wavered, Kennedy was committed to its success. When it became clear that a bill guaranteeing women equal pay would not pass on its own, his administration added it as an amendment to the Fair Labor Standards Act. It was signed into law on June 10, 1963, finally giving women the guarantee of "equal pay for equal work." Kennedy called it a "first step."

Unfortunately, the equal pay act had come too late for Addy, Liz, Mary, and Eloise. Their careers were established at the CIA despite the lack of workplace protections. Still, change was permeating the agency, and with it came a new generation of women. Recruitment into the agency had once been overwhelmingly male, but now the CIA was beginning to reach out to a younger generation of women.

In the early 1960s, one of the young people on the CIA's payroll was Gloria Steinem. "The CIA was the only one with enough guts and foresight to see that youth and student affairs were important," claimed Steinem. For a sliver of time, the priorities of the CIA and those of Steinem were perfectly aligned. In the early 1960s, Steinem was director of the Independent Research Service, ostensibly an organization committed to sending young people to European festivals that celebrated freedom, peace, and democracy. The truth was more complicated.

As part of heightened Cold War tensions, the Soviet Union, in the late 1950s and early '60s, was sponsoring celebrations in neutral countries, such as Finland and Austria. With names such as the "World Youth Festival" or the "Youth Festival for Peace and Friendship," these gatherings presented a front of harmony, democracy, and liberalism. In reality, they were manipulated as a way to distribute communist propaganda and weaken American interests.

In response, the CIA sent hundreds of college students and young people as delegations from the United States. Just as the Soviets hid their presence behind shell groups, the agency operated similarly, secretly funding organizations such as the Independent Research Service and the National Student Association. Young Americans like Steinem were sent to these festivals—some of whom were aware of their status in a covert operation and many of whom were not—distributed their own pro-democracy pamphlets, and wrote detailed reports on the people they met and the ideas being advocated.

"In my experience," Steinem would later say of her work with the CIA, "the agency was completely different from its image; it was liberal, nonviolent, and honorable."

.

The problem with the cargo manifests, at least as far as Addy could see, were the blank spaces. There was no palm oil listed, nor tractors, plows, or seeders. Ships kept arriving in Havana, but what they carried was

mysteriously left off the shipping documents. Addy's group was not intimately involved in the direction of the Cuban operations, but expertise in covert communications was critical to the CIA's planning. Addy was working closely with the NSA's signal intelligence team to gather intelligence inside Cuba. She did not like what she was seeing or hearing.

In the small town of Mariel, just west of Havana, Addy and the NSA were covertly listening in as ships were secretly unloaded. They heard whispers of Soviet tanks but could find no evidence of them. Unloading the ships was done in the dead of night, with black canvas stretched across the area, flights grounded, and a well-armed security detail. Sheets of metal were placed around the weaponry to deflect infrared photography, while tractors and harvesters were parked on the top deck to avert suspicion. Addy could guess what serious weaponry was being hidden from their prying eyes, but she could not confirm it. In the space of one month in 1962, Addy noted fifty-seven deliveries from the Soviet Union to Cuba transported with shipping manifests she was certain were fabricated or missing information. They had to get a better look.

The Corona satellites had possibly glimpsed Dragon Lady killers that summer, but despite the risks, the CIA decided to move ahead with U-2 spy planes over the island. The danger of not knowing what was down there was potentially even more precarious than another downed plane. On August 29, 1962, a Dragon Lady flew over Cuba and confirmed what the blurry Corona images had not been able to verify: nine surface-to-air missiles were now present on the island. By September 15, Addy and the NSA verified that a spoon rest radar was now functional on the island. The large radar antenna was mounted on a truck, and its operation meant that the SAMs could now detect and take down aircraft flying above.

While Addy was uncovering weapons hidden across the island, Soviet MiG fighter planes were flying in plain sight. MiG-19s frequently patrolled the island, challenging American aircraft at the border of their

airspace. In the wake of the Bay of Pigs, the island nation had become perilous to would-be invaders.

One of the officers Addy collaborated with at the NSA was a woman named Juanita Moody. Like Addy, Moody had begun her career as a cryptanalyst during World War II. Much of the intelligence Moody was gathering was obtained from the USS *Oxford*, a ship stationed off the Cuban coast that was intercepting radio communications. It was clear from the transmissions that weapons were pouring into Cuba, but despite the agency's efforts, they could not confirm exactly what the Soviets were shipping a mere ninety miles off the Florida coast.

If intelligence once flowed in steadily like a river to Addy's group, it had now risen to a tidal wave. There was so much data coming in from a wide variety of sources. Not only were Juanita Moody and the NSA dumping what felt like wheelbarrows of reports on their laps, but all other communications coming from Cuba were unremitting. As head of covcom, Addy was part of a top secret group privy to intelligence in Cuba that was restricted under the cryptonym Psalm. The system was put in place in early October to control the dissemination of intelligence "relating to the delivery or presence in Cuba of offensive weapons."

The CIA was screening reports from Cubans leaving the island, tourists, diplomats, and even some seventeen thousand letters sent to the United States. Many reports and letters spoke of missiles the Soviets had sent to Cuba, yet for the CIA, it was impossible to tell which reports were real and which were fiction. Instead of trying to stop intelligence leaks from Cuba, Castro had cleverly gone in the opposite direction. The Cubans made the amount of intelligence so vast that it would have taken an army to properly analyze it. It was also convoluted by its source. For example, troops headed to Cuba from the USSR were told to ready themselves for an arctic mission and were "outfitted with skis, felt boots, fleece-lined parkas, and other winter equipment." Arriving in the Caribbean, the men were shocked to find themselves very overdressed in

the tropics. The truth was that the list of winter gear had never been intended for them but was instead used to mislead the Americans.

Despite this maelstrom of information, what Addy and the CIA lacked was an organized espionage operation in Cuba. There was no Liz or Mary, with their well-defined network of spies with intelligence that could be depended on. A lack of cultural aptitude defined the officers assigned to intelligence operations in Cuba, many of whom could not speak Spanish. Still, the data that the CIA and the NSA were collecting was enough to convince the National Security Council to take a colossal risk.

On October 14, 1962, they sent a Dragon Lady to Cuba. Everyone knew the odds were good that she, and her pilot, might not return. She made the trip as quickly as possible, taking 928 photographs in six hurried minutes before slipping back into American airspace unharmed. The dark canvas the Cubans used to hide their Soviet weaponry, along with the dirt and mud the Cubans had smeared for camouflage on top, made analysis difficult, but the CIA's national photographic interpretation center could make out the distinct outlines of ballistic missiles in the photographs. They grappled with the images for hours, aware that their analysis could be the difference between war and peace.

Even before the analysis was finished, the Pentagon was preparing for potential military action. "We can't do what the British and French did over at Suez," the secretary of defense opined, "say we'll take action and then do nothing over a long buildup." The events in Egypt were present in everyone's minds. The United States had sided against their allies back in 1956. Would the tables now be turned in their own hemisphere? Perhaps even more dangerous was the charisma of the Cuban leader. Following the Suez crisis, Nasser had become the darling of the Middle East, drawing in followers and sparking revolution across the region, all while collaborating with the Soviets. Would a similar wave of Fidelmania now sweep the Americas?

While Radio Moscow claimed that they were providing the Cuban people with only "machine tools, wheat, and agricultural machinery,"

and "some 7,000 tons of various fertilizers," the Dragon Lady had discovered the awful truth. In a memo marked "Top Secret—Psalm," the CIA reported their "relatively complete" interpretation of the U-2 spy plane's photographs. They had discovered a regiment of medium-range ballistic missiles at two launch sites in western Cuba. Each site contained eight missiles. East of Havana, the CIA had identified another contingent of missiles whose surroundings appeared "permanent." Two more sites were under construction.

"All of the offensive missile systems in Cuba are Soviet manned and controlled. We believe that offensive action by these systems would be commanded from the Soviet Union, but have not yet identified the communication link," read a report. Tactical nuclear weapons could now potentially reach multiple targets within the continental United States. This was the moment that Addy had long feared.

Addy watched the mountains of Cuban intelligence, from the missiles, to the transport trucks, to the launchers, move from the agency to the White House. She knew what data President Kennedy was assessing, but she had no idea how he would proceed. No one did.

On the precipice of nuclear war, the president was presented with three options by Secretary of Defense Robert McNamara. He could pursue a diplomatic solution, launch an air attack, or cut off Cuba from the Soviets by ordering a naval and air quarantine.

Instead of hiding the top secret work of Addy and her colleagues, Kennedy chose to announce the missiles to the world, presenting photographic evidence of the threat and announcing his quarantine of Cuba. However, before broadcasting his intentions publicly, he sent a private message to Khrushchev, writing, "I have not assumed that you or any other sane man would, in this nuclear age, deliberately plunge the world into war which it is crystal clear no country could win and which could only result in catastrophic consequences to the whole world."

In public, Kennedy's words were even more pointed. "It shall be the policy of this nation," the American president announced, "to regard

any nuclear missile launched from Cuba against any nation in the Western hemisphere as an attack by the Soviet Union on the United States, requiring a full retaliatory response upon the Soviet Union." The Cold War had never been hotter.

As tensions peaked on the world stage, there was a feeling among some at the CIA that an emphasis on espionage rather than on paramilitary operations might have prevented Kennedy's ultimatum to the Soviets. "We believe that the absence of more effective clandestine agent coverage," read a memo, "as an essential adjunct to other intelligence collection operations, contributed substantially to the inability of our government to recognize at an earlier date the danger of the Soviet move in Cuba. It would appear that over the years there has been a lack of foresight in the long-term planning for the installation of these agents."

The thirteen days of the Cuban Missile Crisis were acutely dangerous, and yet there was little Addy could do but watch the scenes unfold. "The Soviet Union must never allow circumstances in which the imperialists could carry out a nuclear first strike against it," Castro wrote in a letter to Khrushchev on October 26, urging nuclear war.

Instead of taking the bait, Khrushchev sent a telegram unusual for its emotional vulnerability. "Mr. President," the Soviet leader appealed to Kennedy, "we and you ought not now to pull on the ends of the rope in which you have tied the knot of war . . . Let us take measures to untie that knot."

The next day, however, a tragedy rattled this earnest appeal. Rudolf Anderson Jr., on his sixth overflight of Cuba piloting a Dragon Lady, approached an installation of dual-use missiles that were capable of delivering both conventional and nuclear warheads. They were pointing at the American naval base at Guantánamo Bay. Unlike thirteen days earlier, his flight was more than an hour in length, prompting two surface-to-air missile launches. The missiles hit their target, and Anderson was killed instantly. Robert F. Kennedy, the president's brother and the country's attorney general, expressed the moment poignantly in his memoir of the

crisis, writing, "There was the feeling that the noose was tightening on all of us, on Americans, on mankind, and that the bridges to escape were crumbling."

Some of the president's advisors called the downing of the Dragon Lady a "first shot." These military leaders urged airstrikes against Cuba, but Kennedy was uncertain. The moving telegram he had received a day earlier seemed to preclude Khrushchev's involvement in the aggression.

Fortunately, another letter came that day, following a conversation between Robert F. Kennedy and the Soviet ambassador, and this one proposed a negotiation that the president was willing to accept. "We are willing to remove from Cuba the means which you regard as offensive," Khrushchev wrote. "We are willing to carry this out and to make this pledge in the United Nations. Your representatives will make a declaration to the effect that the United States, for its part, considering the uneasiness and anxiety of the Soviet State, will remove its analogous means from Turkey." Swapping Soviet missiles in Cuba pointed at the United States for American missiles in Turkey pointed at the USSR struck a fair compromise. In the end, the stark tragedy of Anderson's death sparked an intense need for diplomatic negotiation, likely saving millions of lives.

.

"If you think we have fallen down a drain or disappeared into the wild blue yonder," Mary wrote to her mother in December 1962, "that is more or less correct, for that is the way we feel too." Mary and her husband had only been back in Washington a month, and already she was miserable. The workload was strenuous. Most nights, Mary eked out only a few hours of sleep, and on more than one occasion that month she never returned home at all.

Mary was now working in counterintelligence, directly under James Jesus Angleton. She was dealing with Soviet defectors who could shed light on operations inside the USSR. She had long worked with

American-controlled agents, and it was an odd transition to now be on the other side, rooting out Soviet agents from within the CIA. Still, working with Soviet defectors offered an opportunity to identify traitors and protect their interests.

Mary still hadn't found a place to live, frequent snowstorms dampened her spirits, and a lack of bookshelves presented a "chronic problem." Yet despite the mountain of difficulties that threatened to bury her, there was deep satisfaction to be found in her work. On December 1, 1962, Mary watched as the last nuclear warheads left Cuba. The anguish of the past few months lifted as the ships made their way out of the Western Hemisphere. While Kennedy would "speak of peace because of the new face of war," and Khrushchev talked of days "the world was poised on the brink of thermonuclear catastrophe," in reality the event caused both world leaders to build nuclear weapons even more zealously. Instead of doing away with the means of obliterating humanity, both countries were quietly arming themselves to the teeth.

HYDRA
1965–1972

A hot, dry wind ran through Baghdad in the summer of 1965. The Iraqis called it a shamal, a dusty breeze that blew from the north, lasting for days and sometimes covering the area in buckets of sand. In her fifteen years of living in the Middle East, Liz had become accustomed to the sandstorms. The volatile weather made a taxicab desirable, and so Liz hailed one instead of walking through the streets. She gave an address to the driver and leaned back in her seat, but she did not relax. She knew better than to let her guard down. She suddenly realized that they had taken a wrong turn. She told the driver they were going the wrong direction, but he did not respond. Instead, he sped the cab faster. Her heart began pounding. They were leaving the city now, on the outskirts of Baghdad, and dark thoughts raced through Liz's mind. She knew what could happen here and what violence she might be subjected to. Her identity as a CIA officer did not have to be known to endanger her life; being a woman was enough.

Suddenly, the driver stopped. They were in the middle of nowhere, with the shamal blowing over the Arabian desert. "What's happening?" she asked. There was no answer. "Where are we?" The driver remained silent. The doors were locked, and Liz waited inside the hot taxi, every second wondering if it were to be her last. Even if she were to escape from the vehicle, she had no idea where she would go. She wondered if

men were coming for her, and if she might be killed there, in that remote spot, where no one would ever find her body. The CIA had taught her to remain calm in this situation, and so Liz followed her training, keeping her voice composed as she spoke with the driver. Then, without saying a word or explaining his actions, the man started the cab back up. They drove back into Baghdad. As soon as she possibly could, she got out of the cab as if her life depended on it. Perhaps it did.

.

Counterintelligence by its very nature is a dive into paranoia. It requires an officer to suspect and investigate even those who appear above suspicion. Through the eyes of a counterintelligence officer, potential spies are lurking everywhere. For those officers working in the field, however, the obsession with finding moles can mean the difference between life and death.

In 1965, Liz received earth-shattering news: counterintelligence had discovered a turncoat at CIA headquarters. The man had released the names of officers working in the Near East theater to the Soviets—and her name was on the list. Her cover was blown. The region was home to Liz, and she did not want to leave. It wasn't just herself she was worried about; she would be abandoning the network in Iraq that had taken her years to build.

In Iraq, it seemed nothing ever stayed the same for long. After the Ba'ath revolution in 1963, the new government stayed in power a mere nine months. The effect on Baghdad was detrimental, particularly for a country that had once welcomed tourists from across the globe. Where Liz had once sat at sidewalk cafés, taking in the bustle of activity and crowds of sightseers, all was now quiet. The sweet, spicy smell of Iraqi tea lay wasted on the air.

Liz's desires were irrelevant. Now that her identity was known, she could no longer operate anywhere in the Middle East. Wherever she went, she would be followed, and whoever she was in contact with

would be immediately under suspicion. She knew there was no choice, but still she struggled. For a CIA officer, being pulled from their station was like being ripped apart from their family. One thing was certain: under no circumstances could she ever return to the place and people she loved.

Liz wondered where her next tour would take her. The anticipation ate away at her, as it would have for anyone. Those who worked with her expressed regret that she would not be made a chief of station, or COS, a prized position, but one she had proven herself eminently capable of. "If she were a man, she would have been made a COS," one colleague later opined. Still, the Near East theater was a location of prime importance, and Liz did not want to be shuffled off to some corner of the world where CIA operations were trifling and dispensable. She wanted her work to mean something.

Liz needn't have worried. Her skills were desperately needed by the agency in stations across the globe. She was heading to a country that was writhing in turmoil: India. Just a few years earlier, in 1962, a border dispute erupted between India and China in the Himalayan mountain range. The United States and its allies had refused to provide weapons to India, but the Soviets, given their recent split with China, were happy to provide the arms. Flowing into the country were the fighter aircraft with whom Liz was intimately familiar: the MiGs.

For Liz, there was little time to waste. Her spies would be transferred over to others and her office cleared. Now she just needed to pack up her things; say whatever hurried goodbyes she could manage; bundle up Blackie, her dog; and go. She was starting over. It was an odd feeling for the senior officer.

As she readied herself to leave Baghdad forever, her security guard stopped her. Ever since that fearful taxicab ride, having a guard stand watch outside her house had given her immeasurable reassurance as a woman living alone. She wasn't prepared, however, for what happened next. When the guard learned she was leaving the country, he professed

his undying love for her and begged Liz to marry him. She had become a woman who collected marriage proposals—and then rejected them. She was leaving Baghdad single.

Not many fifty-three-year-old women got the opportunity for a completely fresh start. She was heading to a different country armed with a new name and a different cover story, where she knew absolutely no one, to work for a boss she had never met. Ahead of her lay a mix of human intelligence sources, both friend and foe, that she would have to navigate if she wanted to keep her job and stay alive. Perhaps the most frightening prospect for Liz, however, was not the present uncertainty, but the future. She might not have known what was going to happen the next day, but she knew exactly what was planned for her seven years hence. When she turned sixty, the life she had built would come to an abrupt end. She would be forced into mandatory retirement. The pressure was on. She had only seven more years to make a difference in this world.

.

In Washington, antiwar protests had begun to swell. In 1965, twenty-five thousand protesters, most of them young college students, lined the National Mall in the March Against the Vietnam War. Eloise was forty-five, twice the age of most of the demonstrators, and dressed nothing like them, with her heels clicking on the pavement, pearls around her neck, and a pair of white gloves clutched in one hand. To the younger generation, she must have appeared hopelessly out of touch.

Even at the CIA, the newest generation of female officers felt they had little in common with Eloise. Among the seventy-five officers receiving CIA officer training in 1963, only six were women. At Camp Peary, also called "the Farm," across the highway from Colonial Williamsburg, the men and women were trained in how to penetrate an enemy border without getting caught. The instruction was grueling. In the 1960s, sections of the camp were divided to represent the nations of

Eastern Europe. The trainees slogged through the mud, desperate to remain unseen. They knew that if ensnared by the "enemy," they'd have to start the painful process all over again. Two of the women had dropped out after training, leaving four pioneers from their class.

The training camp was something that Eloise had no experience in. She had never crawled through the dirt at "the Farm" or practiced sleep deprivation as part of the training's interrogation course. These experiences would all belong to the next generation of women. Instead, because Eloise was promoted after being a secretary during World War II, the young generation of CIA officers "looked down" on her. They felt she had cheated by getting in by "the back door."

Even worse, the women knew little about the Iron Butterfly and her many achievements. They saw her as someone who was severe and demanding, with little context about the struggles that had come her way. Not one of the women knew a thing about the Petticoat Panel. They did not know that Eloise and a group of female officers had fought for recognition and pay equity within the organization. The beneficiaries of their work were unaware of the many sacrifices that had been made.

Disconnected from this history but wanting to better circumstances for women at the CIA, the newest women of the organization scheduled brown bag lunches where women from across the agency could air their struggles and grievances. Men came to the meetings, too, often saying that they felt more comfortable discussing the strains of family and work with the sisterhood than they did with their male colleagues.

"We found strength in ourselves," one of the foursome explained. "We were taught to fly low and not draw attention to ourselves on the outside, but here was a place where we didn't feel threatened to talk about our families."

These four new trailblazers decided to raise women up at the agency. They were young and full of optimistic hopes that the agency they would build would be far better than the one they had joined. Still, as they looked down on Eloise, what they could not perceive was that

this diminutive Southern lady had once done the same thing. Time and circumstances had hardened her, yet it was not so long before that she had lunched with three friends of her own—Liz, Mary, and Addy—and found similar solace among women.

Perhaps one of Eloise's worst crimes in the eyes of her younger colleagues was that she was "nothing but a bureaucrat." Her position on influential committees had conferred power, but it had also edged her further away from boots-on-the-ground operations. It bothered Eloise. She did not necessarily care what others thought of her, but the truth was that she deeply wished for a coveted position in operations. She wanted to be a station chief. She might have worn white gloves, but she was ready to take them off and get her hands dirty overseas again. Still, when the CIA offered this dream position to her, she turned it down. It was a cushy job that presented no challenges. She didn't want to be shuttled off to some CIA station in Bermuda, where she would merely push paper around.

There was plenty to do at headquarters. The protesters on the National Mall might have been surprised at how much they had in common with the middle-aged woman. Eloise's efforts were concentrated toward preventing war. The more Eloise discovered about the Soviet cruise missile program, the more convinced she became that they had to sound the alarm. Action had to be taken immediately. Leading the influential critical collections committee, Eloise prepared a report that she was certain would convince the head of the CIA, a man she had a long association with: Richard Helms.

Helms was sometimes her friend and occasionally her enemy. Eloise respected him and appreciated the value his office put on espionage operations, even if she could not always agree with his decisions or the value he placed on women in the agency. Eloise had been at the CIA long enough to see the old guard slowly disappear. Donovan was gone, Dulles was gone, and poor Frank Wisner, the mastermind of so many failed paramilitary operations, had recently died of suicide. While the

women held strong, Helms was one of the last male holdouts of his era. In Eloise's work, Helms found little to criticize. He took her report immediately to President Lyndon B. Johnson and the other lawmakers who could exert policy decisions based on her recommendations.

Helms was struggling as director of central intelligence. He found President Johnson increasingly volatile on the subject of Vietnam. While his predecessors had believed that the CIA should take a hand in shaping policy, Helms believed his role was "one of support." He wanted to give the president all the information he needed as free as possible of his own bias.

Shortly after becoming director of the CIA, he submitted a 250-page "politically explosive" report to the president chock-full of "tables, charts, and graphs." The document was delivered to the president in a sealed envelope with the warning: "The attached paper is sensitive, particularly if its *existence* were to leak." Its key finding was a single line: "Nothing happening to the Vietnamese Communists as of mid-1966 is bad enough to make them stop fighting." Helms was astounded when Johnson never mentioned the document to him, or even discussed the certainty of defeat with his director of central intelligence. Instead, he sent more combat troops overseas.

At headquarters, Vietnam divided the sentiments of its officers, predictably over generational lines. The intensity of antiwar sentiment ran deep among younger officers, but even among those more senior, opinions differed. "Within the Agency," wrote Helms, "there was also an increasingly skeptical view of the domino theory as applied to Southeast Asia." The domino theory was proposed by Eisenhower, who predicted that like a row of dominoes, if Vietnam fell to the communists, so would Burma, Laos, Thailand, Indonesia, and perhaps even Japan. Considering that the fall of Iraq had not led to the takedown of Jordan, Saudi Arabia, and Lebanon, as Dulles had declared it would in 1958, it was logical to many CIA officers that a loss in Vietnam would not necessarily mean that communism would swallow up the region.

What all the CIA officers agreed on, however, was that intelligence coming from the North Vietnamese government was nonexistent. Not one of their programs had managed to gain information on what was happening in the upper echelons of Ho Chi Minh's government. There was no Liz, with her network of spies. Without this on-the-ground intelligence, the CIA had no way of recommending to President Johnson what could bring the communist leader to the negotiating table. "Not the least of the operational and policy problems in Vietnam," admitted Helms, "was our national ignorance of Vietnamese history, society, and culture."

While Vietnam remained a touchy issue inside the West Wing, Eloise's report would receive a positive reception, particularly from her colleagues in the intelligence community. "The result of this working group was a highly acclaimed study on the anti-ship missile threat," wrote the director of naval intelligence, "which centered national attention and provided the supportive documentation for the subsequent assignment of the highest national priority to this problem . . . Miss Page, in her capacity as chairman of this special working group has performed a valuable service to the United States, the results of which will contribute directly to operational capabilities of U.S. Naval Fleet units for years to come."

.

Arguably the most important task at the CIA in the late 1960s was gathering intelligence on nuclear weaponry. No other work would impact more lives or promote peace more effectively. "Today, every inhabitant of this planet must contemplate the day when this planet may no longer be habitable," President Kennedy once said in a speech to the United Nations. "Every man, woman, and child lives under a nuclear sword of Damocles, hanging by the slenderest of threads, capable of being cut at any moment by accident or miscalculation or by madness. The weapons of war must be abolished before they abolish us."

In the months before his assassination, Kennedy recognized the

existential threat of nuclear war and began to build the structure that would shape future bans on nuclear weaponry. After twelve days of negotiations, the United States, Great Britain, and the USSR agreed to ban nuclear testing in the atmosphere, in space, and underwater in 1963. The limited test ban treaty was a promising start, but it yielded unintended consequences. While the three countries were not allowed to *test* weapons, there was no limit as to how many they could *make*. As their production was still cloaked in secrecy, the treaty ultimately led to a nuclear arms race. From the imminent danger of the Cuban Missile Crisis, both the United States and the Soviet Union dramatically increased their weaponry in just a few years.

In 1950, the United States had an estimated nuclear weapon stockpile of roughly three hundred; the USSR, with its later start, had just five weapons. By 1965, that number had skyrocketed, with the United States accumulating a stockpile of some 31,319 weapons and the USSR, although boasting of a larger number, had 6,129. The vast majority of that growth had occurred since 1961.

While the growing Soviet nuclear armament was kept secret, it was clear to Eloise, Addy, Mary, and Liz that the reports they were funneling into Washington had finally met their mark. Their intelligence on the multifaceted threats the United States was facing were being taken seriously. Eloise clarified the threat of cruise missiles, Addy revealed nuclear testing facilities and weaponry, Mary exposed the danger of bioweapons, and Liz disclosed the threats from emerging nuclear powers. Taken together, their work presented a formidable body of evidence that it wasn't merely nuclear weapons testing that needed more stringent limitations. If they wanted to end the Cold War, comprehensive peace talks needed to be negotiated predicated on the wealth of intelligence they had collected.

Each round of talks formed a foundation for the next. The nuclear nonproliferation treaty of 1968 brought together both nuclear and non-nuclear powers, preventing countries from obtaining nuclear weaponry.

Adelaide Hawkins receiving the CIA's Certificate of Distinction for outstanding accomplishments in the field of positive intelligence production, 1969.

Courtesy of the estate of Adelaide Hawkins

While India did not sign the treaty in 1968, Liz's intelligence gained from the country put emphasis on their refusal. The country's nuclear program would be closely watched by her network while diplomats would continue to work their persuasive powers.

The Strategic Arms Limitation Talks began that same year, a negotiation that would end the folly of unlimited nuclear weapon manufacture. It froze the production of submarine-launched ballistic missiles, a threat Eloise defined, and spread restrictions on new technologies and the need for both verification and deterrents of Soviet and American threats. A year later, in 1969, talks for the Biological Weapons Convention began, a treaty that would ban all biological and toxin weapons. Thanks to the intelligence collected by Ukrainian and American scientists, made possible by Eloise and Mary, both the Americans and the Soviets agreed

to the convention, which one expert called "a foundational element of our nation's security."

This sliver of time, nearing the end of their careers, would be the culmination of their life's work. No other intelligence they gathered in their long careers at the agency would save as many lives. It did not take force, or massive budgets, or even torture to obtain, only the persistent toil of a small group of officers.

The Cold War would die from a thousand assaults, from the decline of the Communist Party, economic hardship in the USSR, US president Ronald Reagan's leadership, Soviet president Mikhail Gorbachev's policies, and, without question, the work of CIA officers who quietly helped peace prevail. The women cared nothing for recognition, nor did they expect it.

"I did it because I believed in what I was doing," Eloise said. "I love my country." Yet in the back of Eloise's mind was the gnawing feeling that she wasn't done yet. There was one more assignment that she had long been waiting for, and the moment for its realization was nearly here. Unfortunately, a CIA officer would have to die for her to get it.

.

On December 23, 1975, Richard Welch was leaving a party with his family. Welch was the new CIA station chief in Athens, Greece, a position he'd held for five months. As he, his wife, and their three children returned from the American ambassador's annual Christmas party, Welch got out of the car to open the gate that locked their driveway. He noticed that the lights were out. This seemed odd, as the family had certainly left them on in the house and driveway before leaving. He heard his name, "Dick!," shouted from the shadows behind him and turned in surprise. There were three men, two standing by the car, and one right next to him, less than a hundred feet away. "Put your hands up," a man said in Greek, edging toward the station chief and raising a .45 caliber revolver in his hand. "What do you want?" Welch asked. The man made no reply but instead shot him three times in the chest.

The Cold War had absorbed the CIA's attention for so many decades, and in so many locations, that the intelligence agency was unprepared for the new, global nature of terrorist threats. No longer was the focus on the Soviets. Welch was killed by a terror organization named 17N, and they were just one in a vast network of terror organizations operating across the world.

17N was intent on overthrowing the Greek government and attacking the United States and United Kingdom. The group took its name from the events of November 17, 1973, when, following a student uprising, the Greek government sent a tank careening into Athens Polytechnic University, ultimately killing twenty-four people. The date would become a national holiday, remembered with schools and businesses closed in observance and the laying of wreaths at a monument built in honor of the victims. Yet 17N was uninterested in these memorials to the dead. Instead, they were taking brutal action, with a focus on the CIA. In their letter taking credit for Welch's assassination, they claimed he was killed because of "crimes committed by the C.I.A. against our people."

CIA operations in Greece were needed now more than ever—not a single arrest had been made in Welch's assassination—yet the agency struggled to identify a man courageous enough to take the lead in the region. The next station chief would be actively hunting down 17N terrorists across Europe and have a blazing target on his back. It turned out there wasn't a man capable of the job. Instead, it would be a woman.

In 1975, Eloise was the highest-ranking female officer in the CIA. Yet there was still one job she desperately wanted, and it was about to be offered to her. No woman had ever held the position of chief of station, in any country, before Eloise took the job at Athens. Here was the challenge she had long coveted: the ability to make a profound difference in intelligence operations on the ground.

Greece offered redemption for Eloise and her mistakes at the Brussels station immediately following World War II. Back in 1945, she had

been a hungry twenty-five-year-old ready to prove herself as an officer, but she had been blind to the complex interplay of identity and loyalty. She bribed spies without gaining anything in return and lacked understanding of the culture and motivations of Russian immigrants living in Belgium. The intervening thirty years had taught her so much, and she was about to prove it.

In the 1970s and '80s, Western Europe was the most active terrorist environment in the world. In addition to 17N, Eloise was tracking numerous groups and making contacts within the Red Army Faction (RAF) in Germany, Action Directe (AD) in France, and the Red Brigades (RB) in Italy. Her operations were all clandestine, with little direct support or even acknowledgment from Washington.

"If you want to know what the bad guys are doing under the covers, you may have to crawl in bed with them. If you uncover them and their mischief, you're a hero. But if somebody uncovers you before you uncover the bad guys, you've had it," explained a CIA officer who worked under Eloise in Greece in the 1970s. This was the predicament that had ensnared Eloise, Addy, Mary, and Liz since the beginning of their careers. Now, Eloise was back to where she had started: creating a network of spies across Western Europe.

Eloise's experience over the decades had taught her that manipulating human nature generated far more reliable intelligence than threats and physical violence. There were those who disagreed with her at the agency, men Eloise called "cowboys," who were more interested in exerting power than in gathering information. Two of these men were working for her in Athens, and Eloise was harsh when dealing with them. One of the men was particularly aggravating because of his disdain for "women's work." He would not, under any circumstances, touch a typewriter, believing the task to be beneath him. He insisted that a secretary write up all his reports. It was evidence of what Eloise already knew to be true: Women were better at espionage. They did not let their ego get in the way of the work.

Her career had taught her that it wasn't the flashy operations that gained the most useful results. Instead, it was the maneuvers that the cowboys described as tedious, the ones that operated with small budgets, little attention from headquarters, and no uniformed personnel. It required an officer to engage in tasks that yielded no personal glory, entailing perseverance but not, preferably, bloodshed.

The terrorists, Eloise knew, did not operate the same way. If her cover was blown, 17N would not hesitate to ambush and kill her. Eloise was not the master of disguise Liz had proven herself to be in the Middle East. She could not blend seamlessly into her surroundings. Yet she had the distinct advantage of being nothing like what her adversaries expected.

Eloise was fifty-five years old, not that she would ever admit it. When friends asked how old she was, she said, "A woman who tells you her age will tell you anything." The officer adept at keeping secrets gave nothing away. Her blond hair was thinned by age, but her eyes were as bright as ever. With her pumps, spotless white gloves, and strand of pearls, she appeared as a well-heeled tourist moving through the European capital. The facade was broken only when she stooped down to check the wiring under her car before she got in, in case of a car bomb, or by the lump on her hip. Eloise carried a gun with her wherever she went. It was heavy hanging on her side, but at least it provided a semblance of comfort.

.

The chatter coming through the Greek human intelligence operation was unusually quiet. It seemed the identities of the terrorists were practically unknown on the streets of Athens. This suggested a possible complication to Eloise: perhaps the terrorists were related. Secrets were always better kept in families. This could make the organization nearly impenetrable. If they were operating in a clandestine cell system, in small familiar groups known only to one another, penetration by CIA

spies would be nearly impossible, at least with the tools they currently had on hand.

Back in Washington, Addy was working on a new system that would aid their organization against terrorist cells across Europe. As she entered the door of the workspace, she was immediately faced with a massive coatrack. Although it was a mild day, she found her own heavy coat hanging on the stand and pulled it on. As she opened the door, the first thing she felt was the rush of freezing cold.

The enormous freezer Addy had stepped in was where the computers were kept. The systems were so massive and generated so much heat that they required the room they were kept in to be super cooled to frigid temperatures. The computer hiding in the cold was called Hydra. It was a counterintelligence database that could link global terrorism threats.

While computers were infiltrating government agencies in the late 1960s and early 1970s, Hydra was different in its scope and development. Addy worked closely with the NSA to include their intelligence, as well as that of foreign intelligence agencies. For security, they incorporated a tiered access system so that each stream of intelligence was sorted based on its level of secrecy, and access was limited by passcode. For a file on a single individual, for example, an officer with a top security clearance could read all known information on the target, while an officer with a lower clearance could access only basic information. By 1972, there were a thousand files on organizations and more than seven thousand on individuals. The system was, as one CIA memo bragged, "incredibly complex and sophisticated."

Under Addy's fingers, it wasn't just the organization of intelligence that was improving at the CIA. She was also altering its communication in bold ways. Intelligence could now be transmitted securely at lightning speed. As reports came in on terrorist cells across Europe, they could be disseminated and analyzed with unheard-of rapidity.

Together Addy and Eloise were creating an intelligence grid that

was far beyond the disorganized mess of spies they had once depended on in the 1940s. The system would grow, both in size and complexity, forming a critical component of the American response to global terrorism.

In the 1990s, their framework for tracking members of a clandestine cell system would become imperative as a young terrorist group named al-Qaeda emerged in the Middle East. The group, like the European terrorist organizations before it, operated in small, familial units to evade detection. Intelligence reports made in the field were gathered by the CIA's computers in Washington and delivered to a new group of six women at headquarters who were working together under the cryptonym Alec Station. Under their watchful eye, the group of CIA officers identified a new, dangerous threat to American security. His name was Osama bin Laden.

Each operation linked across the years, the mistakes as well as the successes, connecting the generations of work to one another. Without Jessica there would have been no Belladonna; without Belladonna there could have been no Aerodynamic; without Aerodynamic there could have been no Hydra; and without Hydra there would have been no Alec Station. Ultimately it was Eloise, Addy, Mary, and Liz who were the stem that connected the blossoming, modern CIA to its roots.

In the distance Eloise could see the future the CIA was rushing toward. "Terrorism is not a short-term problem," wrote Eloise in 1985, near the end of her career. "The Intelligence Community will be faced with significant challenges in combatting international terrorism in the future." The threat of the Soviets, her life's work, was fading slowly into the haze of antiquity, while the menace of terrorism was emerging as a potent force that would shape American intelligence by new and untested means.

The growing threat of terrorism required a new generation of officers, capable of contributing novel perspectives to their work. "We need a workforce as diverse as the world we cover," former CIA director John

Brennan said in 2015. "CIA has come a long way in broadening the demographic of its senior ranks, but we still have significant work to do."

Today, roughly half of all CIA officers are women, working in locations spread out across the globe. They lead lives that the trailblazers of the agency could have only dreamed of, obtaining coveted field positions despite the "hazards" the male CIA administrators of 1953 once warned of: partners, marriages, and children. "Although it took decades for full fruition," reads a 2003 agency report, "the seeds of today's diversity were first nurtured by this 1953 panel."

Women are prominent in the agency. After Gina Haspel was appointed as the first woman to lead the CIA in 2018, she brought with her an unprecedented number of female officers into key positions within the agency. For the first time, women were promoted to lead the top three departments, or directorates, of the CIA: operations, analysis, and science and technology. In all, 43 percent of officers promoted to senior positions are now women. However, the breakthrough that many waited for came in 2021, when Avril Haines was confirmed as director of national intelligence, the highest position within the intelligence community. Her appointment was undeniably the promise of the Petticoat Panel fulfilled.

In Haines's personality there are echoes of the women who preceded her. She has been described as possessing an "inner steel." "She's very unassuming and extraordinarily modest," explains Kathryn Ruemmler, her former supervisor. "But that can be mistaken for weak. She has fortitude and a real ability to push back."

The iron butterflies of the agency left a road map for Haines and her contemporaries to follow. Eloise, Addy, Liz, and Mary submerged their egos, put off their own needs and desires, and immersed themselves in the cultures around them. Yet most important, they wielded intelligence as a weapon for peace. When the calcium suddenly left Germany, our allies invaded Egypt, a revolution shook our understanding of the Middle East, submarines targeted our cities, and aerial photography

revealed the destructive force to end humanity, their guiding hands in quiet, unheralded actions prevented war. Their work lives on in moments that will likely never be recorded, in stories that may never be told, and in the careers of men and women who might not even know their names. They dwell in the shadows of the Wise Gals, standing like a human shield, protecting us in the shade of their intelligence.

STATE SECRETS

In late September 2001, Eloise stood outside the exterior door through which she usually entered the CIA headquarters. The lanyard around her neck held her ID card, which also functioned as a key to the door. Yet no matter how many times she flipped its surface against the plastic key reader, it flashed red. She had lost her clearance.

Although no one had explained it to her, Eloise understood the situation. The country and the intelligence community were still reeling

Eloise Page's CIA badge that did not work following 9/11.
Credit: CIA/CREST

from the attacks of September 11. She knew that enacting new standards to restrict access to the building made sense. Technically, she had retired in 1987, although her elevated position within the CIA had earned her a lifetime pass into headquarters. In 1997, she was given the Trailblazer Award, which "recognizes CIA officers who by their actions, example, innovations, or initiative take the CIA in important new directions and help shape the agency." The recognition was supposed to come with unrestricted access to CIA headquarters for life.

Eloise could hardly believe that the agency she helped found after World War II, the one she had spent decades devoting herself to, would consider her a security risk. How could no one have told her? Eloise turned away from the door. It seemed she wouldn't be going in today. In fact, it was possible she would never be able to enter CIA headquarters again.

Fortunately, Eloise's former coworkers did not take the news passively. Immediately her colleagues protested her loss of security clearance, even going so far as to camp out in the director's office until they gave it back to her. The moment was significant, highlighting the role the first generation of CIA women played in so many lives at the agency and the devotion of the many agents they had hired and trained. Institutions are inherently disloyal—they rapidly forget a person's worth—but people remember.

Eloise did not forget the man who had trained her in espionage. Nearing the end of her career, she lobbied the director of the CIA to place a statue of William Donovan on the grounds. She had power to exert: Eloise was the number three employee at the CIA, working right under the director. When the memorial to Donovan was approved, she worked with the sculptor personally, wanting to ensure it captured the spirit of the man who founded American intelligence. With his hand on his belt, Donovan stands next to a single star, honoring the lives of OSS officers lost during World War II.

As an expert on global terrorism, Eloise taught terrorism classes at the National Defense University after retirement. She also served on the

A statue of William Donovan stands in the CIA headquarters.
Credit: Photographs in the Carol M. Highsmith Archive, LOC, Prints
and Photographs Division

altar guild at Christ Church in Georgetown. Embracing a path that she chose not to pursue, the woman who never married became central to wedding planning at the church. She crafted every aspect of the ritual for her brides, from the wedding march down to the flowers. It was often said she ruled the ceremonies with an iron fist, putting forth exacting standards that others found intimidating, but which she knew from her years at the CIA produced results.

The brides were terrified, but the weddings were flawless.

The Iron Butterfly passed away in 2002. She was buried in her Ferragamo heels, her gloves, and her jewelry, but without her watch. Her days of scrutinizing the passage of time, and inevitably running late, were over.

.

Liz returned to Washington in 1967 after her mother died. She was worried for her aging father, and so she flew him out from the Midwest to

Eloise Page acting as a wedding planner in the 1990s.
Courtesy of the estate of Eloise Page

live with her in the nation's capital, believing it was a daughter's duty to look after him. For a woman who prized her work overseas, the move to the placid world of headquarters was challenging. She found refuge at the bottom of a bottle. She had always loved to drink socially and had spent many an hour drinking whiskey with her male colleagues at the CIA station in Baghdad, an activity that won her the begrudging respect of the men she worked alongside. Now, however, she was drinking more, starting earlier in the day, and hiding her alcoholism from those around her. Sometimes she would slip a shot of hard liquor into a glass of milk with the hopes that her young nieces wouldn't notice.

Despite her deteriorating state, she kept tight control over her behavior at work, even becoming a mentor to the young officers she worked with at the CIA. She helped them break into the world of espionage, teaching them techniques, customs, and how to make connections. "She taught me everything but my name," one officer testified to her guidance.

When forced into mandatory retirement at age sixty, however, everything seemed to fall apart for Liz.

"We're not made for life after the agency," one officer who worked with her overseas said. "We've never prepared for it." Liz still had her friends and her family, but she was missing the part of her life that had given it deeper meaning. For Liz, separated from her colleagues and her work, the experience was reminiscent of Iraq in 1958, when she had stayed behind during the revolution. The isolation pressed in on her, and her drinking worsened.

Liz kept up to date on current events, colored by her own partiality. She read *The Washington Post* daily, but her reaction to the newspaper was based on their reporting of the CIA. She frequently canceled her subscription and then later resubscribed, depending on how they portrayed the agency at any given time. Before her death in 1989, at the age of seventy-six, she remained loyal to the Middle East and was fiercely pro-Iraq in her views. She explained to one young officer that working in intelligence was akin to "babysitting": You had to be responsible for the agents you recruited. You needed to know about their lives and personally be invested in their fate. The next generation at the agency, however, would not experience life in the Middle East in the same way.

If Liz could have witnessed how CIA operations changed in the years after her service in Iraq, she would have been shocked. The relationships she had fostered in her years working in Syria, Iraq, and India were replaced in the post-9/11 environment with black sites, where intelligence was gathered by torture.

In August 2002, "enhanced interrogation techniques" on Abu Zubaydah were overwhelming a group of CIA officers. The high-value target was water-boarded eighty-three times and subjected to sleep deprivation, forced nudity, starvation, and physical assault. "It is visually and psychologically very uncomfortable," one report read. "Several on the team profoundly affected . . . some to the point of tears and choking up." By August 9, "'two perhaps three [personnel] likely to elect transfer' away from the detention site if the decision is made to continue with the

CIA's enhanced interrogation techniques." Whether any valuable intelligence was gained from the torture of the prisoner would be a source of contentious debate. No definitive answer exists, as the tapes from Zubaydah's interrogation were destroyed by the CIA in 2005.

While the torture inflicted on Zubaydah was previously illegal under international law, a series of documents known as the "torture memos" were written by the US Department of Justice to provide a complex legal argument as to why the Geneva Conventions did not apply to detainees from the War on Terror. Not everyone in the George W. Bush administration, however, agreed with the expanded use of enhanced interrogation techniques. Secretary of State Colin Powell would argue against the "torture memos," saying it would "reverse over a century of U.S. policy and practice in supporting the Geneva Conventions and undermine the protections of the laws of war for our troops" and "has a high cost in terms of negative international reaction, with immediate adverse consequences for our conduct of foreign policy."

Powell was accurate in his assessment on the consequences for foreign policy. In the wake of 9/11, the work of CIA officers could not have been more different than that of their predecessors. In 1992, budget cuts at the agency, brought on by the post–Cold War environment, had resulted in the reduction of officers in the clandestine service. Once again, the roles of espionage, intelligence, counterintelligence, and covert action were being undermined at the agency, and nowhere was the result more obvious than in the Middle East. Where Liz had once immersed herself in the culture and customs of a region she loved wholeheartedly, future officers would not approach their posts overseas with the same passion. Some at the CIA would fault a declining cultural intelligence at the agency. "We don't speak the language enough, we don't understand the culture enough," said Stanley McChrystal, the US Army general who served as commander of US and NATO forces in Afghanistan. "We haven't taken the time to not be blind, deaf, and dumb in areas of the world that matter to us."

.

"Why bother to live in a country if you're not going to experience it?" Mary once asked in a letter home from Germany. She and Greg worked out of European CIA stations until 1969 before returning to Washington permanently. Greg retired from the CIA, but Mary kept on going until her mandatory retirement in 1971. One of her last performance reports asserted, "Subject is one of the unfortunately passing breed who are in the CIA because they believe in what it is doing rather than what it is paying them." It was certainly a far cry from the complaints about her "inborn (perhaps feminine) tendency to resist direction" two decades earlier.

In their later years, Mary and Greg traveled the world, finally freed from the restrictions of the CIA. They roamed from Hawaii, to Singapore, to Thailand, to Sri Lanka, to India, savoring the food, immersing themselves in the culture, and always eager to find a bookstore. Yet memories of her struggles within the CIA, and specifically the Petticoat

Mary and Greg Hutchison, 1980s.

Credit: The State Historical Society of Missouri, manuscript collection

Panel, remained. "It was very difficult," Mary reflected in an interview in 2002, "as it is even in today's world, for a woman to get into a position where she really commands. No matter how capable she is, she will not be able to because she is female. Say what you like, it is still just a man's world and it is going to keep on being so for a good long time." Mary died on March 4, 2007.

.

"Throughout the years," read a CIA recommendation of Addy in 1973, "she has always had the ability to work with and supervise men of equal ability without the slightest trace of resentment. She became a recognized expert in certain fields of analysis, both within CIA and at NSA, established a professional status at NSA where she is highly regarded as an accomplished authority."

In 1973, Addy received the Career Intelligence Medal from the CIA. She, like Mary and Liz, was rapidly approaching mandatory retirement age, and her days at the agency were numbered. In her last years at the CIA, the high school graduate brought "the latest computer techniques" to the agency, greatly improving efficiency. She also served on a panel on career service of women. The group worked, much like the Petticoat Panel before it, to advance opportunities for women and increase equity within the agency.

Addy never remarried. After retirement, she lived with her mother in an apartment in Arlington, Virginia, acting as her caretaker. The role of looking after her aging mother was arduous, especially as her mother could be combative and difficult, yet Addy stayed with her. Financially, she struggled. "Never having enough money had been my life," she said. Still, she would have sacrificed anything for the woman who raised her and had helped keep her family together in those tough, early years as a single mother.

The Career Intelligence Medal was just one in a long string of awards

and commendations that Addy received over the years for her work on different operations at the agency. Her children, unaware that she worked for the CIA, had little idea the accolades that Addy piled up during her more than three decades working for American intelligence.

Addy's son Don learned of her career only after her death. It was a surprise to him, especially as he'd once done a brief internship at the CIA. He'd had no idea that his mom worked for the agency. Suddenly, many of the conversations that he'd had with her came into focus. "I found out there were a lot of intelligent people in the world," Addy once told her son, as she contrasted her humble beginnings in West Virginia with her career in Washington, "and no one ever told me that." Addy passed away on July 10, 2008.

.

In a small funeral in 1989, the body of Elizabeth Sudmeier was laid to rest. There was no husband to mourn her passing or children to carry on her memories. Like most officers, Liz's accomplishments remained anonymous long after she passed away. Besides her hard-won Intelligence Medal of Merit, there were few other awards or commendations that graced her years of retirement. As the years passed quietly, and she sunk deeper into misery and alcoholism, there was no reason for Liz to believe her work would be remembered by the agency. Certainly, she expected that no one outside the CIA would ever hear her name.

Among the attendees at Liz's funeral were four younger women who never met her. Although not her children, they were, in a way, her descendants. They had recently learned of Liz through an obituary passed around at the agency, and they were struck by the parallels in their lives. Here was a woman who had fought for American interests, risked her life for her country, made operational blunders, waded in ethical predicaments, and fought the gender inequity of her own institution, all while paving the way for the next generation. Yet some impediments remain

unchanged. Officers working overseas must still submit a resignation letter if entering into a close relationship with a foreign national.

The women who came to the funeral on that mild spring day were officers who, like Liz, had experienced both the struggles and the solace of being a woman in the agency. They hung back quietly during the service, careful not to intrude on the notice of family or friends. They did not want to bother anyone. Standing by the grave site, they said their goodbyes to the woman they had never known. Then, one by one, the four nameless women disappeared.

.

On July 24, 1943, a letter was sent to Jane Burrell. "This is to inform you that your headquarters have been changed from Washington, D.C. to London, England, effective upon arrival," it read. "This transfer is not for your convenience, but in the best interests of the Government." With

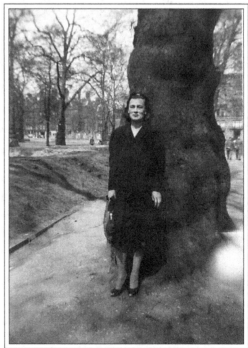

Jane Burrell in London.
Courtesy of the estate of Jane Wallis Burrell

those words, the young woman started down a path that ultimately led to her death in a plane crash in 1948. Jane was returning to Paris from CIA operational work in Brussels when she was killed. Yet in the moments in between, the United States of America was rendered a service that would stretch out across the decades, molding the very nature of American espionage.

Jane Burrell was never included on the CIA's memorial wall. No names are carved into the cold slab that stands within the entryway to the CIA headquarters. Instead, 137 small stars, each just two and a quarter inches in diameter, are engraved on its smooth surface. Each star represents a CIA officer who lost their life while serving their country. Eleven stars on the wall represent women. Jane, the first CIA officer to die in service to her country, is unjustly absent.

It might be thought that only those CIA officers who died in "action" are qualified, but further examination shows this not to be true. Of the 137 stars on the CIA's memorial wall, forty-five died accidentally. The vast majority of these accidents are plane crashes like Jane's; however, other accidents are also represented. There are agents who perished in car crashes and those who died during surgeries, such as a gallbladder operation gone wrong.

Of the many men and women who died in a plane crash while serving the CIA, many were flying in commercial aircraft like Jane was. One officer, Chiyoki Ikeda, was flying on Northwest Airlines flight 710 in 1960, over Cannelton, Indiana, when the plane suffered a mechanical failure and crashed, killing all sixty-three people on board. What unites all these men and women is not how they died but how they lived. They put service to their country ahead of their own interests.

A portion of that cold stone lies smooth where it should be carved.

ACKNOWLEDGMENTS

It's agonizing to write a book where those who have contributed the most cannot be properly thanked. I learned of these women through an individual who prefers her name not to be known. I am forever grateful for her rich life and work during World War II. Thank you for our interview days despite Boston's rain and snow.

This book would not be possible without the cooperation of numerous CIA officers who generously shared details of their careers and personal memories, often downplaying their own contributions in order to shine the spotlight directly on the women they worked with. Although I cannot share all their names, I am incredibly grateful for the gift of their interviews and their service to our country.

I am also fortunate to have conducted interviews with friends, family, and colleagues who shared their memories, photographs, and archival material. These generous individuals include Andrea Aven, whose own considerable research was instrumental, Anne Randolph, Don Hawkins, Richard Sudmeier, Margaret Webb, Kevin Callahan, Jim Hughes and the Association of Former Intelligence Officers, Carl Pletzke and the SIGNA Society, Elizabeth Sudmeier Stevenson, Michael Sudmeier, Ray and Ellen Mitchell, Rev. Stuart Kenworthy, Judi Thompson, Susan Dawkins, Paul Redmond, and Susan McCloud, among others.

Not a word of this book would have been possible without the librarians and archivists who tirelessly assisted my requests from afar during a global

pandemic. I'm indebted to Tatyana Shinn and the State Historical Society of Missouri, as well as Lauren Theodore and Suzanne Isaacs at the National Archives and Records Administration, Meg Melvin at the National Gallery of Art, and Darby Lynn at the Monuments Men Foundation for the Preservation of Art, as well as numerous others. I am incredibly grateful to the authors who shared unpublished interviews and tidbits with me, particularly the brilliant Ronald Kessler.

I'm fortunate to work with the editor of my dreams, Michelle Howry, who brought her expertise and passion to the project. I can't imagine writing this book without her. I'm grateful to the entire Putnam team, particularly the wonderful Ashley Di Dio. Thank you to my agent and friend, Laurie Abkemeier, to whom this book is dedicated.

For my bubble family: Sarah, Ross, John, Lila, and Anna Schuchard, my bestie Darcie Jarrett Tuite, Mark Tuite, Anna Seltzer, Lisa and Luther Ward, Mike Tubianosa, Jenny Ourada, Rosemary and J. T. Oldham. For my Met Hill family: Rachael and Gerry Coakley, Susie and Ben Bird, Elizabeth Keane, Sean Cashman, and Sarah Elliott. For my Ventucky crew: Elizabeth Shaw, Emlyn Jones, Amy Cantor, Scott Ambruster, Jennifer and Payson Thompson, Tim Flanagan, J. A. and Joline MacFarland. For my dear little Turkeys: Erika Hilden, Erica Olenski, Samantha Wilson, Ashlee Mikels, Mande Norman, Kimberly Kohler, Clare Rice, Becky Brown, Stacey Williams, Holly Button, Michelle Danley, Kiersti Pilon, Karlyn Goodman, Callie Slama, Andrea Alexander, Shelly McGill, Lisa Brincks Funari, Jessica Sakaske, Kristin Rascon, and Rosie Forbes. For my best bike buddy, Mark Lindsay. For the teachers: Ms. Brockmeyer, Ms. Chavez, Ms. Hiserman, and Ms. Evans. For my family: Joyce Boone, Claire McCleery, Rose Grundgeiger, Shane, Frannie, Ruby, Harrison, and Andrew Vesely, Scott Holt, and Shea Holt. For those I miss desperately: Kenneth and Ruby Holt, Eva Grundgeiger, Jerry McCleery, and my sweet Hannah Holt.

For those who make it all worthwhile: Larkin, Eleanor, Philippa, and Winnie.

NOTES

ABBREVIATIONS

AHC Adelaide Hawkins Collection, privately held

AN Archives Nationales (France)

CIA/CREST Records of the Central Intelligence Agency available under the CIA Records Search Tool, including documents declassified by the CIA and those obtained through the Freedom of Information Act

DDE Dwight D. Eisenhower Presidential Library

EPC Eloise Page Collection, privately held

ESC Elizabeth Sudmeier Collection, privately held

HST Harry S. Truman Presidential Library

HI Hoover Institution

JBC Jane Burrell Collection, privately held

JFK John F. Kennedy Presidential Library

LOC Library of Congress

MIPT National Memorial Institute for the Prevention of Terrorism

MMF Monuments Men Foundation

NARA National Archives and Records Administration

NSA Records of the National Security Agency

OSS Records of the Office of Strategic Services

SHSMO The State Historical Society of Missouri

TNA The National Archives of the United Kingdom

NOVEMBER 1953

1 **Eloise Page:** Background information on Eloise Page obtained from EPC and author interviews with friends, colleagues, and family members.

2 **While the group was officially named:** Transcripts from the Petticoat Panel obtained from CIA/CREST.

2 **Although 40 percent:** Statistics on women in the CIA workforce obtained from "Report of the Committee on Professional Women in the Overt Offices," declassified October 30, 2014, CIA/CREST.

3 **"Oh, I had the goods on Donovan":** "Divine Secrets of the RYBAT Sisterhood: Four Senior Women of the Directorate of Operations Discuss Their Careers," declassified October 30, 2014, CIA/CREST, confirmed by author interview with [redacted], April 12, 2018.

3 **Everyone loved the lively Elizabeth Sudmeier:** Background information on Elizabeth Sudmeier obtained from ESC and author interviews with friends, colleagues, and family members.

3 **Then there was Mary Hutchison:** Background information on Mary Hutchison obtained from SHSMO and author interviews with friends, colleagues, and family members.

4 **the chairwoman of their group:** Background information on Adelaide Hawkins obtained from AHC and author interviews with friends, colleagues, and family members.

5 **"I think it is important":** Transcript of steering group, "Agenda for the CIA Career Service Board," November 23, 1953, declassified October 30, 2013, CIA/CREST.

CHAPTER 1: JESSICA, 1934–1944

9 **The name:** *Carl Eitel:* Message dated December 20, 1943, containing the name of Eitel, KV-2, TNA.

9 **Carl Eitel had other names:** Carl Eitel's history and itinerary detailed in multiple interviews and documents, which can be found in KV-2, TNA, and 11AR, AN.

10 **soon the sheet of paper appeared blank:** More information on Abwehr's use of invisible ink can be found in Kristie Macrakis, *Prisoners, Lovers, & Spies: The Story of Invisible Ink from Herodotus to al-Qaeda* (New Haven, CT: Yale University Press, 2014).

12 **Britain's premier cryptanalysis operation:** Details on the operation at Bletchley Park can be found in Sinclair McKay, *The Secrets of Bletchley Park: The WWII Codebreaking Centre and the Men and Women Who Worked There* (London: Aurum Press, 2010).

13 **It was winter:** Background information on Adelaide Hawkins obtained from interviews with friends and family members and from Pauline E. Parker, ed., *Women of the Homefront: World War II Recollections of 55 Americans* (Jefferson, NC: McFarland & Company, 2002).

14 **"It's awfully warm in here":** Adelaide Hawkins interview with Barbara Matusow, July 29, 2003, LOC.

16 **"Why, you young people":** Ibid.

16 **"And a good thing I wasn't sitting down":** Ibid.

16 **"Anyone could do it":** Quoted in Richard Dunlop, *Donovan: America's Master Spy* (New York: Skyhorse, 2014).

17 **the prestigious Croix de Guerre:** Donovan's refusal of the Croix de Guerre: ibid.

17 **With little value placed on social pedigree:** Origins of the OSS and the dearth of American intelligence following the Black Chamber discussed in John Whiteclay Chamber II, *OSS Training in the National Parks and Service Abroad in World War II* (Washington, D.C.: U.S. National Park Service, 2008).

17 **"a Ph.D. who can win a bar fight":** Eric Olson, "The New U.S. Military Recruit: 'A Ph.D. Who Could Win a Bar Fight,'" *The Wall Street Journal*, December 8, 2015.

17 **"I know my own mind":** Background information on Eloise Page, including the quotes in this paragraph, obtained from interviews with friends, colleagues, and family members.

18 **a pivotal role:** Eloise's role in Operation Torch is described in Gordon Thomas and Greg Lewis, *Shadow Warriors of WWII: The Daring Women of the OSS and SOE* (Chicago: Chicago Review Press, 2017).

19 **the elite group of counterintelligence agents:** The relationship between X-2 and British intelligence is described in Robert Cowden, "OSS Double-Agent Operations in World War II," *Studies in Intelligence* 58, no. 2 (June 2014): 35–45.

19 **Jane Wallis never expected:** Background information on Jane Burrell, including the quote "witty and pretty," obtained from interviews with friends and family members.

20 **The female labor force grew:** Statistics on the growth of the female labor force in 1945 can be found in Susan M. Hartmann, *The Home Front and Beyond: American Women in the 1940s* (Boston, MA: Twayne Publishers, 1982).

20–21 **joining the OSS as a junior clerk:** Jane Burrell's salary obtained from OSS Personnel Files, RG226, Entry 224, Box 95, NARA.

21 **Men in her position:** Average salaries for members of the OSS were sent in a series of budgetary memos dated from 1943 to 1945, declassified October 1, 2013, CIA/CREST.

21 **"Possibly some of you possess a photograph":** Jennifer Davis Heaps, "Clio's Spies: The National Archives and the Office of Strategic Services in World War II," *Prologue* (Fall 1998), NARA.

24 **a key part of a sensitive operation:** Operation Double Cross is described in Ben Macintyre, *Double Cross: The True Story of the D-Day Spies* (London: Bloomsbury, 2012).

24 **"Who is John Eikins?":** Jane Burrell's meeting with Carl Eitel and quotes from his interrogation documented in RG226, NARA; KV-2, TNA; and 11AR, AN.

NOTES

24 **Eitel revealed the name:** Juan Frutos's history is detailed in multiple interviews and documents, which can be found in KV-2, TNA.

26 **A quarter of all espionage agents in France were killed:** Cameron Carlomagno, "Women in a Man's War: The Employment of Female Agents in the Special Operations Executive, 1940–1946" (master's thesis, Chapman University, 2019).

26 **possession of a wireless radio:** ibid.

26 **he hid both radio sets:** Juan Frutos's fears in June 1944 and his difficulties with British intelligence are documented in interrogations from KV-2, TNA, and Cowden, "OSS Double-Agent Operations in World War II."

27 **"If such [a] story is not proved, he should be executed":** Report, 1945, KV-2, TNA.

28 **this ruse had a fatal flaw:** The use of inflatable equipment is described in Megan Garber, "Ghost Army: The Inflatable Tanks That Fooled Hitler," *The Atlantic*, May 22, 2013.

28 **to flood Abwehr with misinformation:** Juan Frutos's role in Operation Jessica and his work in 1944–1945 are described in KV-2, TNA.

29 **"[x] might have had a decisive influence on the whole German U-boat campaign in American and British waters":** Ibid.

30 **"He appears to be three different men":** Ibid.

30 **"A sad end for a double agent":** Ibid.

30 **It concerned a meeting:** The meeting on August 10, 1944, is documented in Ian Kershaw, *The End: The Defiance and Destruction of Hitler's Germany, 1944–1945* (New York: Penguin Books, 2011).

CHAPTER 2: SAFEHAVEN, 1944–1945

32 *He's impossible:* Ronald Kessler, *The CIA at War: Inside the Secret Campaign Against Terror* (New York: St. Martin's Griffin, 2016).

32 **"Is the dictation done?":** Ibid.

33 **As early as 1943:** Donovan's involvement in the Nuremburg trials described in Richard Dunlop, *Donovan: America's Master Spy* (New York: Skyhorse, 2014).

34 **"I'm moving to Brussels":** Author interview with Ann Randolph, May 28, 2020.

34 **"Isn't that a strange profession?":** Ibid.

35 **the leader of the Russian community:** A history of Jurij Vojcehovskij can be found in Wim Coudenys, "Russian Collaboration in Belgium during World War II: The Case of Jurij L. Vojcehovskij," *Cahiers du monde russe* 43, no. 2 (April 2002): 479–514.

35 **"A miracle happened":** Ibid.

35 **Adelaide had spent her entire adult life:** Personal history of Adelaide Hawkins obtained through author interviews with friends, colleagues, and family members.

36 "Have they ever been to a picnic before?": Ibid.

38 "awful, horrible creatures": Ibid.

38 "Do you like crossword puzzles?": Ibid.

39 the majority of American codebreaking: The majority of American codebreaking took place in navy and army facilities, as discussed in Robert Louis Benson, "A History of U.S. Communications Intelligence during World War II: Policy and Administration," National Security Agency, Center for Cryptologic History, Series IV, no. 8 (1997).

39 employed hundreds of cryptologists: Diversity among American codebreakers discussed in Jeannette Williams, "The Invisible Cryptologists: African-Americans, WWII to 1956," National Security Agency, Center for Cryptologic History, Series V, no. 5 (2001).

39 Addy had been taught: More information on the Friedmans can be found in Jason Fagone, *The Woman Who Smashed Codes: A True Story of Love, Spies, and the Unlikely Heroine Who Outwitted America's Enemies* (New York: HarperCollins, 2017).

40 British propaganda film: *London Can Take It!* was a short propaganda film distributed to American audiences in November 1940.

41 glistened in opulence: The pristine condition of Brussels following World War II is described in Jean-Michel Veranneman, *Belgium in the Second World War* (Barnsley, England: Pen and Sword Books, 2014).

41 Of the approximately fifty thousand Jews: Ibid.

41 she had been promoted: Eloise spoke of her position in Brussels in several interviews. The reference to her opening the first postwar station in Brussels is also referred to in Eloise Page's bibliographic sketch, declassified March 30, 2020, CIA/CREST.

42 numerous reports from the Belgian police: Ibid.

43 a mushroom cloud formed: More information on early atomic tests found in Richard Rhodes, *The Making of the Atomic Bomb* (New York, NY: Simon & Schuster, 1986).

43 in a meeting in Potsdam: President Truman's expectations at the Potsdam conference in 1944 are documented in his diary entries between July 16–30, 1945, available from HST.

43 "A complex weapon": George Orwell, *The Collected Essays, Journalism, and Letters of George Orwell* (New York, NY: Harcourt, 1968).

CHAPTER 3: WERWOLF, 1945

44 "I am so savage": Lorraine Boissoneault, "The Nazi Werewolves Who Terrorized Allied Soldiers at the End of WWII," *Smithsonian Magazine*, October 30, 2018.

44 Operation Werwolf: More information on Operation Werwolf can be found in Eric Kurlander, *Hitler's Monsters: A Supernatural History of the Third Reich* (New Haven, CT: Yale University Press, 2017).

NOTES

44 **"Every friendly German civilian":** Stephen G. Fritz, *Endkampf: Soldiers, Civilians, and The Death of the Third Reich* (Lexington: The University Press of Kentucky, 2004).

45 **"Upon the German collapse":** Author redacted, "RSHA Financial Operations," declassified 2007, CIA/CREST.

45 **Arriving in Munich:** Jane's arrival in Munich on May 17, 1945, obtained from JBC.

46 **"For a small man":** Ibid.

47 **"Death is most likely to occur":** Ibid.

47 **Alongside Jane:** Background on the Ostrich can be found in author redacted, "An SD Agent of Rare Importance," declassified 2007, CIA/CREST.

48 **a rare opportunity:** Agent School West is described in Stuart Smith, *Otto Skorzeny: The Devil's Disciple* (London: Bloomsbury, 2018).

48 **"I was particularly interested":** Ibid.

49 **"agent of rare importance":** Author redacted, "An SD Agent of Rare Importance."

49 **"Shoot him at sight":** Ibid.

49 **"We have her":** Memo dated June 29, 1946, NARA.

50 **Operation Safehaven:** Overview of Operation Safehaven can be found in Donald P. Steury, "The OSS and Project SAFEHAVEN," *Studies in Intelligence* 9 (Summer 2000).

50 **running a large counterfeit operation:** More information on Project Bernhard can be found in Theodore P. Salvas and Kenneth D. Alford, *Nazi Millionaires: The Allied Search for Hidden SS Gold* (Havertown, PA: Casemate, 2002).

50 **Bernhard Krueger:** Further details on Krueger's role in the counterfeiting operation can be found in Lawrence Malkin, *Krueger's Men: The Secret Nazi Counterfeit Plot and the Prisoners of Block 19* (New York: Little, Brown, 2006).

52 **his real name was Herbert Berthold:** Records and interrogation on Herbert Berthold can be found in OSS Records, RG 226, Boxes 19 and 20, Paris-X-2-0P-3, Box 47, WASH-X-2-PTS-15, NARA.

52 **Addy Hawkins could feel the pressure:** Background information on Adelaide Hawkins obtained from author interviews with friends and family members.

54 **"We may be close":** June 15, 1945, RG226, NARA.

55 **he described the incident:** Report on Bela Tar, March 16, 1945, RG263, NARA.

55 **One of the men she interrogated:** Spitz's history with the OSS is documented in multiple primary documents held in CIA/CREST, NARA, and AR, as well as described in Kevin C. Ruffner, "On the Trail of Nazi Counterfeiters," declassified September 10, 2014, CIA/CREST.

56 **"uncivilized and ruthless combatants":** Kermit G. Stewart, "Russian Methods of Interrogating Captured Personnel World War II," declassified June 2, 2000, CIA/CREST.

56 **"In the hands of the Soviets":** Ibid.

56 **"If you make life for certain prisoners fairly easy, they will relax":** Quote from Rudolph Pins, a former Nazi interrogator, in Laura Strickler, "Secret WWII Camp Interrogators Say Torture Wasn't Needed," *CBS News*, December 9, 2014. Transcripts of interrogations and training in psychological techniques given to OSS officers can be found in RG226, NARA.

56 **"I go on trips for them":** Spitz interrogations can be found in RG226, May 16–28, 1945, NARA.

56 **"I'm Jewish":** Ibid.

56 **he filled his castle:** Operation at Schloss Labers described in author redacted, "RSHA Financial Operations," declassified 2007, CIA/CREST.

58 **"Soon you'll be liberated":** Malkin, *Krueger's Men*.

60 **Jane ran the gold:** Jane counted the treasure as described in a memo dated July 19, 1945, RG226, NARA.

60 **It may have been dumped:** Details of the dumping of counterfeit bills in the Enns River can be found in a report by George J. McNally, January 24, 1946, RG226, entry 155, boxes 2–3, NARA.

61 **found himself at odds:** Donovan's friction with Robert H. Jackson is documented in their correspondence from November 1945, HST.

62 **"You are walking on the edge of the grave":** Richard Dunlop, *Donovan: America's Master Spy* (New York: Skyhorse, 2014).

62 **"It so happens that I have the responsibility":** Ibid.

62 **there was a deep philosophical difference:** Donovan's convictions on Nuremberg are described in ibid.

62 **"I believe you are wrong":** Eugene C. Gerhart, *America's Advocate: Robert H. Jackson* (Indianapolis, IN: Bobbs-Merrill, 1958).

63 **"American Gestapo":** Amy B. Zegart, *Flawed by Design: The Evolution of the CIA, JCS, and NSC* (Palo Alto, CA: Stanford University Press, 2000).

63 **"We have come to the end":** Corey Ford, *Donovan of OSS* (New York: Little, Brown, 1970).

CHAPTER 4: RUSTY, 1946

67 **Mary Hutchison was squirming:** Background information on Mary Hutchison obtained from author interviews with friends and family members, as well as CA5861, SHSMO.

67 **"He doesn't seem to *like* me":** Letter, April 23, 1946, CA5861, SHSMO.

NOTES

67 **Helms was part shadow:** More information on Richard Helms can be found in Richard Helms and William Hood, *A Look over My Shoulder: A Life in the Central Intelligence Agency* (New York: Random House, 2003).

67 **"a different kind of intelligence service":** Harry S. Truman, *The Memoirs of Harry S. Truman: A Reader's Edition*, ed. Raymond H. Geselbracht (Columbia: University of Missouri Press, 2019).

68 **a secretarial job:** Helms's offer of a secretarial position and Mary's response of "That's a waste of my abilities," author redacted, "The Petticoat Panel: A 1953 Study of the Role of Women in the CIA Career Service," declassified October 30, 2013, CIA/CREST.

69 **"There is a general feeling":** "Challenging the Status Quo: Elizabeth Sudmeier's Historic Legacy," Central Intelligence Agency, June 26, 2015, https://www.cia.gov/stories/story/challenging-the-status-quo-elizabeth-sudmeiers-historic-legacy.

70 **formally decreed in a mocking tone:** Truman's presentation on January 26, 1946, including the quote "By virtue of the authority . . ." described in Margaret Truman, *Harry S. Truman* (New York: HarperCollins, 1972).

70 **"Intelligence work is held":** Author redacted, "William J. Donovan," declassified October 22, 2002, CIA/CREST.

71 **calling it "phony":** Ibid.

71 **there were only eight:** Shrinking numbers of OSS agents detailed in a memo dated March 14, 1946, CIA/CREST.

71 **They separated:** Details of Jane's divorce obtained from author interviews and JBC.

72 **The coded directives:** Weekly summary reports from the station in Brussels, Belgium, January to December 1946, RG226, NARA.

72 **"For two weeks":** Douglas Waller, *Disciples: The World War II Missions of the CIA Directors Who Fought for Wild Bill Donovan* (New York: Simon & Schuster, 2015).

72 **A new plan was emerging:** Transcripts concerning Operation Unthinkable, including the quote "impose upon Russia . . ." in report, May 22, 1945, CAB120/691, TNA.

73 **"an iron curtain":** Winston Churchill, speech at Westminster College, Fulton, MO, March 5, 1946.

74 **One man came in:** Weekly summary reports from the station in Brussels, Belgium, January to December 1946, RG226, NARA.

74 **"without genuine agent resources":** Author redacted, "Paper Mills and Fabrication," March 1952, CIA/CREST.

74 **One young woman came in:** Weekly summary reports from the station in Brussels, Belgium, January to December 1946, RG226, NARA.

74 **"The Soviet government":** Ibid.

NOTES

74 "subject found to be corrupt": Report, August 7, 1946, RG226, NARA.

75 Eloise called the situation "vexing": Author interview with [redacted], April 12, 2018.

75 "We're floundering": Ibid.

75 James Jesus Angleton: More information on James Jesus Angleton can be found in Jefferson Morley, *The Ghost: The Secret Life of CIA Spymaster James Jesus Angleton* (New York: St. Martin's Press, 2017).

75 Allen Dulles: More information on Allen Dulles can be found in his memoir, *The Craft of Intelligence: America's Legendary Spy Master on the Fundamentals of Intelligence Gathering for a Free World* (Guilford, CT: The Lyons Press, 2006).

75 "fine spies": Brent Durbin, "Addressing 'This Woeful Imbalance': Efforts to Improve Women's Representation at CIA, 1947–2013," Government: Faculty Publications, Smith College, Northampton, MA, October 30, 2013.

75 "For months": Michael S. Goodman, "The Foundations of Anglo-American Intelligence Sharing," *Studies in Intelligence* 59, no. 2 (June 2015): 1–12.

76 "I am completely opposed": Richard Dunlop, *Donovan: America's Master Spy* (New York: Skyhorse, 2014).

76 "would reveal to the Americans": Michael S. Goodman, *The Official History of the Joint Intelligence Committee, Volume I: From the Approach of the Second World War to the Suez Crisis* (Abingdon, UK: Routledge, 2014).

77 a secret project: More information on Project Venona can be found in Herbert Romerstein and Eric Breindel, *The Venona Secrets: The Definitive Exposé of Soviet Espionage in America* (Washington, D.C.: Regnery, 2014).

77 the newly re-formed CIG: The number of officers in the CIG in "Memorandum from the Fortier Committee to the Director of Central Intelligence," March 14, 1946, CIA/CREST.

78 "the needed communications organization": Memo, 1946, RG226, NARA.

78 "rescue Western civilization": John R. Boker Jr., "Report of Initial Contacts with General Gehlen's Organization," May 1, 1952, CIA/CREST.

79 Gehlen and his men: History of the Gehlen organization can be found in Kevin Ruffner, ed., "Forging an Intelligence Partnership: CIA and the Origins of the BND, 1949–56," 2006, declassified 2007, CIA/CREST; Author redacted, "America's Seeing Eye Dog on a Leash," declassified 2007, CIA/CREST.

79 "resurrect his Abwehr": author redacted, "America's Seeing Eye Dog on a Leash," declassified 2007, CIA/CREST.

80 "rather grandiose and vague": Ibid.

80 the group had grown: The size of Gehlen's organization described in ibid.

80 **the man who had arrested:** Role of Karl Josef Silberbauer described in Peter-Ferdinand Koch, *Enttarnt: Doppelagenten: Namen, Fakten, Beweise* (Salzburg, Austria: Ecowin, 2011).

81 **"be given complete control":** Author redacted, "America's Seeing Eye Dog on a Leash."

81 **"It seems a shame":** Ibid.

81 **"One of the greatest assets":** Ibid.

82 **a lethal poison:** The death of Donovan's granddaughter is described in Dunlop, *Donovan: America's Master Spy.*

CHAPTER 5: BELLADONNA, 1946

83 **In a small room:** Background information on Mary Hutchison obtained from author interviews with friends and family members, as well as CA5861, SHSMO.

83 **The man's real name:** Mary Hutchison's work with Zsolt Aradi is described in author redacted, "Long Experience in the Anti-Soviet Game," declassified 2007, CIA/CREST.

84 **Aradi was spying on church officials:** Zsolt Aradi's history with American intelligence is described in Kevin Ruffner, "Cold War Allies: The Origins of CIA's Relationships with Ukrainian Nationalists," declassified 2004/2006, CIA/CREST.

84 **a Hungarian bishop:** Vilmos Apor's history can be found in Máté Hajba, "Vilmos Apor, a Man Who Chose the Harder Road," Foundation for Economic Education Stories, December 21, 2017, https://fee.org/articles/vilmos-apor-a-man-who-chose -the-harder-road.

85 **"amounted to a strong desire":** Author redacted, "Long Experience in the Anti-Soviet Game."

85 **"The German Intelligence Service background":** Ibid.

85 **"influential Vatican circles":** Ibid.

86 **Mary's interviews with Aradi:** Mary's interviews at the end of 1946 are documented in an Operation Belladonna memo, distributed December 27, 1946, declassified 2007, CIA/CREST.

86 **Mary and Gregory:** Origins of the Hutchisons' relationship and marriage obtained from CA5861, SHSMO.

87 **"Did you ever try to pull a dress down":** Letter dated July 14, 1934, CA5861, SHSMO.

88 **"determined and able men":** Operation Belladonna memo, distributed December 27, 1946, declassified 2007, CIA/CREST.

88 **"the wife of":** Author redacted, "Long Experience in the Anti-Soviet Game."

89 **another fiercely intelligent woman:** Background information on Elizabeth Sudmeier obtained from author interviews with friends, colleagues, and family members.

90 **"It's beyond the pale":** Author interview with Richard Sudmeier, August 10, 2020.

91 **570 women were chosen:** Katy Endruschat Goebel, *Women for Victory: American Servicewomen in World War II* (Atglen, PA: Schiffer, 2011).

91 **"receive all the ranks":** Ibid.

91 **"I believe in the future":** Claus-M. Naske and Herman E. Slotnick, *Alaska: A History of the 49th State* (Norman: University of Oklahoma Press, 1997).

91 **overwhelming its small number of residents:** A history of the Battle of Attu is described in Mary Breu, *Last Letters from Attu: The True Story of Etta Jones, Alaska Pioneer and Japanese P.O.W.* (Berkeley, CA: West Margin Press, 2013).

92 **"famed as the most attractive":** Meghan McClory, *Their War, Too: The Women's Army Corps and Ladd Field* (Fairbanks, AK: Center for Environmental Management of Military Lands, 2018).

92 **"Hey, the WAC shack's on fire!":** Alexandra Wallace and Desiree Valaderes, *The War Remembered: Life at Ladd Field during World War II* (Fort Wainwright, AK: Center for Environmental Management of Military Lands, 2019).

94 **Liz was hired:** Liz was hired in March 1947, according to "Challenging the Status Quo: Elizabeth Sudmeier's Historic Legacy," Central Intelligence Agency, June 26, 2015, https://www.cia.gov/stories/story/challenging-the-status-quo-elizabeth -sudmeiers-historic-legacy.

94 **70 percent of women:** Susan M. Hartmann, *The Home Front and Beyond: American Women in the 1940s* (Boston, MA: Twayne Publishers, 1982).

95 **Kaj Munk was a Lutheran pastor:** Background on Kaj Munk can be found in John J. Michalczyk, ed., *Resisters, Rescuers, and Refugees: Historical and Ethical Issues* (New York: Sheed & Ward, 1997).

95 **"abstain from any":** Søren Dosenrode, ed., *Christianity and Resistance in the 20th Century: From Kaj Munk and Dietrich Bonhoeffer to Desmond Tutu* (Leiden, Netherlands: Brill, 2008).

95 **There are people:** Munk's sermons published in Kaj Munk, *By the Rivers of Babylon: The Wartime Sermons of Kaj Munk* (New York: New Nordic Press, 2013).

95 **"I must go to Copenhagen":** Dosenrode, *Christianity and Resistance in the 20th Century*.

96 **"national martyr-hero":** Dispatch, January 7, 1949, CIA/CREST.

96 **"unsavory acts":** Ibid.

CHAPTER 6: TRIDENT, 1947

97 **Jane had wispy brown hair:** Background information on Jane Burrell obtained from interviews with friends and family members as well as JBC.

99 **"thwart those enemy elements":** Letter, December 31, 1934, translation by Dr. Sarah Schuchard, JBC.

100 **George Spitz appeared to come through the war unscathed:** Spitz's history is described in Kevin C. Ruffner, "On the Trail of Nazi Counterfeiters," declassified September 10, 2014, CIA/CREST.

100 **"gambled his fortune":** Ibid.

101 **"Spies do not":** Richard Helms and William Hood, *A Look over My Shoulder: A Life in the Central Intelligence Agency* (New York: Random House, 2003).

102 **"Spitz is one":** George Spitz interrogation, October 28, 1947, RG260, NARA.

102 **"opportunist who made":** Ruffner, "On the Trail of Nazi Counterfeiters."

102 **"The organization feels":** Author redacted, "An SD Agent of Rare Importance," declassified 2007, CIA/CREST.

102 **The Danish became "insistent":** Ibid.

102 **"Although this man":** Ibid.

103 **"unfavorable publicity":** Ibid.

103 **"As happens so frequently":** Letter, July 26, 1946, declassified 2008, CIA/CREST.

104 **Macushla, Esmeralda, or Mary-girl:** Letters, CA5861, SHSMO.

104 **"I'll work harder":** Diary entry, July 22, 1933, CA5861, SHSMO.

105 **"being next":** Letters, 1941 and 1942, CA5861, SHSMO.

105 **"I can't quite picture":** Letter, September 21, 1943, CA5861, SHSMO.

106 **"some of its best":** Report, October 31, 1957, declassified 2006, CIA/CREST.

106 **Aradi as a "homosexual":** Transcript of a phone conversation describing the allegation in Aradi's file, February 24, 1958, declassified 2006, CIA/CREST.

106 **a national quota system:** More information on the immigration quota system during World War II can be found in Roger Daniels, "Immigration Policy in a Time of War: The United States, 1939–1945," *Journal of American Ethnic History* 25, no. 2/3 (2006): 107–16.

106 **"In all candor":** Letter from Richard Helms, November 25, 1946, declassified 2006, CIA/CREST.

107 **only 5 percent of Americans:** H. R. Diner, *We Remember with Reverence and Love: American Jews and the Myth of Silence After the Holocaust, 1945–1962* (New York: NYU Press, 2010).

107 **Aradi realized his cover had been blown:** Letter, February 18, 1947, CIA/CREST.

107 **communist-socialist party was gaining a toehold:** James E. Miller, "Taking Off the Gloves: The United States and the Italian Elections of 1948," *Diplomatic History* 7, no. 1 (1983): 35–55.

108 **"I've been thinking of you":** Letter, February 27, 1947, CA5861, SHSMO.

NOTES

108 **Mary was working on Operation Trident:** Operation Trident emerging as an offshoot of Belladonna, and a description of the operation, can be found in Operation Trident, Progress Report, January 21, 1947, CIA/CREST.

109 **Although he had never mentioned it to Jane:** Schwend's history recounted in author redacted, "RSHA Financial Operations," declassified 2007, CIA/CREST.

109 **AMC were bills:** Walter Rundell, *Military Money: A Fiscal History of the U.S. Army Overseas in World War II* (College Station: Texas A&M University Press, 2000).

110 **He hoarded these riches:** Flush's treachery described in author redacted, "RSHA Financial Operations."

111 **"always remember the Americans":** Ibid.

111 **always wearing heels:** Personal information on Eloise obtained from author interviews with friends, colleagues, and family members.

112 **"past records":** Report from Samuel Brossard, May 5, 1947, CIA/CREST.

112 **"It's going to get us in trouble":** Author interview with [redacted], July 18, 2019.

CHAPTER 7: OPERA, 1947–1948

114 **Before Air Force One:** Truman signs National Security Act aboard the Douglas VC-54C as described in David McCullough, *Truman* (New York: Simon & Schuster, 1992).

115 **"We now have a separate Air Force":** Ibid.

116 **"quiet intelligence arm":** John Hollister Hedley, "Truman's Trial and Error with the CIA," *Christian Science Monitor*, September 22, 1995.

116 **"I, Adelaide Hawkins":** Affidavit, July 28, 1947, CIA/CREST.

118 **"I'm just a West Virginia girl":** Author interview with [redacted], July 31, 2019.

118 **"I'd like to have a divorce":** Adelaide Hawkins interview with Barbara Matusow, July 29, 2003, LOC.

120 **building on the research:** History of the microdot camera can be found in John Hannavy, ed., *Encyclopedia of Nineteenth-Century Photography* (Abingdon, UK: Routledge, 2008).

120 **The microfilm technique:** Goldberg's history can be found in Michael Buckland, *Emanuel Goldberg and His Knowledge Machine: Information, Invention, and Political Forces* (Westport, CT: Libraries Unlimited, 2006).

124 **It had started with a letter:** Letter to Jane Burrell, November 24, 1947, JBC.

125 **were known as the Monuments Men:** More information on the Monuments Men can be found in Robert M. Edsel with Bret Witter, *The Monuments Men: Allied Heroes, Nazi Thieves, and the Greatest Treasure Hunt in History* (New York: Center Street, 2009).

126 **Joachem Stach:** Joachem Stach's investigation of George Spitz described in his report on October 28, 1947, RG226, NARA.

126 **Spitz's name:** Hoffmann's accusations against George Spitz described in author redacted, "RSHA Financial Operations," declassified 2007, CIA/CREST.

127 **"so heavy that":** Report, December 1, 1947, RG226, NARA.

127 **Stach postulated:** Background information on Joachem Stach obtained from MMF.

127 **a Belgian woman:** Inchler's accusations in ibid.

127 **Further inquiries:** Spitz's association with Göring, and his pass signed by Hitler, documented in a report from December 1, 1947, RG226, NARA.

127 **"I'm a Jew!":** Ibid.

128 **"Why, when he has been so helpful":** Report, October 28, 1947, RG226, NARA.

128 **"Request for Information":** Letter, December 1, 1947, RG226, NARA.

128 **She wrote a letter:** Jane's letter to Spitz, 1947, RG226, NARA.

129 **the first CIA officer:** Jane is listed as being "on official travel when the accident occurred" in a Department of State document, 1948, JBC.

130 **all the promise:** Jane's death reported in "The Mystery of Jane Wallis Burrell: The First CIA Officer to Die in the Agency's Service," March 30, 2012, CIA/CREST.

130 **"The organization was":** Letter, February 17, 1948, JBC.

CHAPTER 8: VERMONT, 1949

133 **"At the prearranged hour":** Henry S. Lowenhaupt, "Chasing Bitterfeld Calcium," July 2, 1996, CIA/CREST.

133 **Office of Reports and Estimates believed a Soviet atomic weapon was still years away:** Ibid.

133 **One of them:** Author interview with [redacted], August 12, 2019.

134 **September 3, 1949:** The events of September 3, 1949, are chronicled in Doyle Northrup and Donald Rock, "The Detection of Joe 1," *Studies in Intelligence* (Fall 1966), CIA/CREST.

134 **"the capability of the USSR":** This quote persisted until the summer of 1949, as reported in Donald P. Steury, "How the CIA Missed Stalin's Bomb," *Studies in Intelligence* 49, no. 1 (2005), CIA/CREST.

135 **The plane that touched down:** History of the WB-29s can be found in Robert A. Mann, *The B-29 Superfortress: A Comprehensive Registry of the Planes and Their Missions* (Jefferson, NC: McFarland & Company, 2015).

136 **of charged subatomic particles:** More information on Geiger counters can be found in Anwar Kamal, *Particle Physics* (Berlin: Springer-Verlag Berlin Heidelberg, 2014).

137 **Eloise returned to CIA headquarters:** Eloise Page's history obtained from author interviews with friends, colleagues, and family members.

139 **"She gets into your dreams":** Author interview with [redacted], August 12, 2019.

139 **1 to 2 percent uranium:** Steury, "How the CIA Missed Stalin's Bomb."

140 **In the Y-12 plant in Oak Ridge, Tennessee:** The calutron is described in William E. Parkins, "The Uranium Bomb, the Calutron, and the Space-Charge Problem," *Physics Today* 58, no. 5 (2005).

141 **One of them was Elizabeth Bentley:** Elizabeth Bentley's story is told in Kathryn Olmsted, *Red Spy Queen: A Biography of Elizabeth Bentley* (Chapel Hill, NC: University of North Carolina Press, 2003).

142 **the US military collected German scientists:** Annie Jacobsen, *Operation Paperclip: The Secret Intelligence Program That Brought Nazi Scientists to America* (New York: Little, Brown, 2014).

142 **Thirty tons of metallic calcium:** Lowenhaupt, "Chasing Bitterfeld Calcium."

143 **1,360 tons of calcium:** Ibid.

143 **American "clumsiness":** Ibid.

144 **purity of over 90 percent:** Ibid.

144 **code-named Operation Spanner:** Details of Operation Spanner: Ibid.

145 **To settle this:** Author interview with [redacted], August 12, 2019.

146 **a clear timetable:** Northrup and Rock, "The Detection of Joe 1."

147 **Truman wrestled with the data:** Gregg Herken, "'A Most Deadly Illusion': The Atomic Secret and American Nuclear Weapons Policy, 1945–1950," *Pacific Historical Review* 49, no. 1 (1980): 51–76.

148 **"I believe the American people":** Statement by President Truman in response to the first Soviet nuclear test, September 23, 1949, HST.

CHAPTER 9: KUBARK, 1950

150 **"I'm trying to build":** Author redacted, "The Junior Officer Training Program, 1950–1966," declassified July 12, 2001, CIA/CREST.

150 **seventeen people:** Ibid.

151 **propped open the side door:** Elizabeth's entrance into Junior Officer Training described in "Challenging the Status Quo: Elizabeth Sudmeier's Historic Legacy," Central Intelligence Agency, June 26, 2015, https://www.cia.gov/stories/story/challenging-the-status-quo-elizabeth-sudmeiers-historic-legacy. Personal details obtained from author interviews with friends, family, and colleagues.

151 **innocent citizens in the gulag:** More information on activities of the USSR following World War II can be found in Anne Applebaum, *Gulag: A History* (New York: Doubleday, 2003).

151 **Truman signed:** The Women's Armed Services Integration Act was signed into law on June 12, 1948. Text of the act and executive order 9981 available from HST.

152 **"selected as a member":** Author redacted, "The Junior Officer Training Program, 1950–1966."

152 **"a guy with brains":** Ibid.

152 **"Soviet in nature":** Kermit G. Stewart, "Russian Methods of Interrogating Captured Personnel World War II," declassified March 4, 2014, CIA/CREST.

153 **practiced a technique:** Dead drops and other espionage techniques described in Robert Wallace and H. Keith Melton, with Henry Robert Schlesinger, *Spycraft: The Secret History of the CIA's Spytechs, from Communism to Al-Qaeda* (New York: Plume, 2009).

154 **barely even made a start:** Soviet influence in the Middle East in the 1950s described in Rami Ginat, "Soviet Policy Towards the Arab World, 1945–48," *Middle Eastern Studies* 32, no. 4 (1996): 321–35.

155 **"I'm not sure":** Author interview with [redacted], February 3, 2020.

156 **fewer than twelve:** Author redacted, "The Junior Officer Training Program, 1950–1966."

CHAPTER 10: LOSS, 1951

157 **"Tokyo's a sprawling":** Letter, May 5, 1951, CA5861, SHSMO.

157 **"clean, cool seclusion":** Ibid.

157 **"quite as dirty":** Ibid.

158 **"Mr. Murdoch simply":** Ibid.

159 **"In considering the merits":** Author redacted, "The Petticoat Panel: A 1953 Study of the Role of Women in the CIA Career Service," declassified October 30, 2013, CIA/CREST.

159 **"The Hungarians have":** Letter from *Time-Life* magazine, June 17, 1948, CIA/CREST.

159 **Mary reported deficiencies:** Matvieyko's history with the CIA described in author redacted, "Long Experience in the Anti-Soviet Game," declassified 2007, CIA/CREST.

160 **citing his "ineptitude":** Ibid.

160 **"to collect and publish":** "Who We Are," The Asiatic Society of Japan, http://www .asjapan.org/about.html.

161 **the CIA found an ally:** The CIA's support of the Japanese liberal democratic party in the 1950s is described in Tim Weiner, "CIA Spent Millions to Support Japanese Right in 50's and 60's," *The New York Times*, October 9, 1994.

161 **"A shadow has fallen"**: Winston Churchill, speech, March 5, 1946, FO 371/51624, TNA.

161 **She typed**: Mary's reports containing "puppet regime," "invasion," and "Korea" in weekly summaries from summer to fall 1950, CIA/CREST.

162 **two hundred thousand Chinese troops**: P. K. Rose, "Two Strategic Intelligence Mistakes in Korea, 1950," *Studies in Intelligence*, 2001, CIA/CREST.

162 **Mary was livid**: Author interview with [redacted], April 25, 2020.

162 **"a weapon of aggressive war"**: W. W. Kulski, "Soviet Comments on International Law and International Relations," *The American Journal of International Law* 47, no. 1 (1953): 125–34.

162 **Mary's reports proved prescient**: Rose, "Two Strategic Intelligence Mistakes in Korea, 1950."

162 **"If we let Korea down"**: Jeffrey W. Taliaferro, *Balancing Risks: Great Power Intervention in the Periphery* (Ithaca, NY: Cornell University Press, 2004).

163 **"goose egg"**: Matthew Bunker Ridgway and Harold H. Martin, *Soldier: The Memoirs of Matthew B. Ridgway, as Told to Harold H. Martin* (New York: Harper, 1956).

163 **"We have a curtain"**: John P. Finnegan, "The Evolution of US Army Intelligence Operations in the Korean War," *Studies in Intelligence* 55, no. 2 (2011): 57–70.

164 **"Of course, the bookshops are the best"**: Letter, August 1951, CA5861, SHSMO.

164 **"I'll be damned"**: Johanna Neuman, "Southern Lady, with Accent on Spy Career," *Los Angeles Times*, October 26, 2002.

167 **"acutely conscious"**: George F. Kennan, *The Kennan Diaries*, ed. Frank Costigliola (New York: W. W. Norton, 2014).

168 **They called it *the thing***: A history of *the thing* can be found in Benjamin B. Fischer, "Leon Theremin—CIA Nemesis," declassified December 28, 2010, CIA/CREST.

168 **Addy first held it**: Addy's reaction to *the thing*: Author interview with [redacted], July 31, 2019.

169 **Eloise read Addy's reports**: Eloise's reaction to *the thing*: Ibid.

CHAPTER 11: AQUATONE, 1952

171 **She stayed only a minute**: Liz's work in Baghdad described in author interviews with her colleagues and "Challenging the Status Quo: Elizabeth Sudmeier's Historic Legacy," Central Intelligence Agency, June 26, 2015, https://www.cia.gov/stories/story/challenging-the-status-quo-elizabeth-sudmeiers-historic-legacy.

172 **The architecture and culture**: Baghdad's architecture is discussed in Sandy Isenstadt and Kishwar Rizvi, ed., *Modernism and the Middle East: Architecture and Politics in the Twentieth Century* (Seattle: University of Washington Press, 2011).

172 **The river Tigris:** Videos of Baghdad taken in 1954 available from British Pathé, "Ageless Iraq Reel 1," 1954, https://www.britishpathe.com/video/ageless-iraq-reel-1/query /ageless+iraq.

174 **"Women can't blend into their surroundings":** Author interview with [redacted], August 23, 2020.

174 **Fewer than twenty Black officers:** Milo Jones and Philippe Silberzahn, *Constructing Cassandra: Reframing Intelligence Failure at the CIA, 1947–2001* (Palo Alto, CA: Stanford University Press, 2013).

174 **One of his recruits:** Ralph Bunche's career is described in Brian Urquhart, *Ralph Bunche: An American Odyssey* (New York: W. W. Norton, 1998).

175 **"Anglo-American imperialists":** Karol Sorby, "The 1952 Uprising in Iraq and Regent's Role in Its Crushing," *Asian and African Studies* 12, no. 2 (2003): 166–93.

177 **"pensive nature":** Author interview with [redacted], August 23, 2020.

177 **The engraved letters and numbers:** Addy's role in designing the communications compact: Author interview with [redacted], July 31, 2019.

178 **"We are prioritizing reconnaissance":** Ibid.

178 **the CIA was pursuing Operation Aquatone:** "Project Aquatone: Operational Concept," February 5, 1958, declassified 01/24/2000, CIA/CREST.

179 **downed another American plane:** Airplanes shot down by the Soviets in the early 1950s described in Paul Glenshaw, "Secret Casualties of the Cold War," *Air & Space Magazine*, December 2017.

180 **"And since you know":** William Shakespeare, *The Plays and Poems of William Shakespeare* (Lausanne, Switzerland: University of Lausanne, 1833).

181 **"General Salary" range:** Mary's salary reported in author redacted, "The Petticoat Panel: A 1953 Study of the Role of Women in the CIA Career Service," declassified October 30, 2013, CIA/CREST.

181 **"She has an inborn":** Ibid.

181 **"Incredible as it may seem":** Letter, CA5861, SHSMO.

CHAPTER 12: PETTICOAT, 1953

182 **A long life was not assured:** Background information on Elizabeth Sudmeier obtained from author interviews with friends, colleagues, and family members.

183 **Arthur Callahan was her station chief:** Arthur Callahan's career summarized in T. Rees Shapiro, "Arthur E. Callahan, CIA Officer, Dies at 92," *The Washington Post,* May 10, 2012.

184 **He was more than just a dear friend:** Liz's relationship with Callahan obtained by author interviews with the Callahan family.

185 **The women peppered Dulles with questions:** "The Petticoat Panel: CIA's First Study—in 1953—on the Role of Women in Intelligence," March 8. 2021, CIA/CREST.

186 **"I think women":** Ibid.

186 **"This place is a real man's world":** "Eleanor L. Dulles of State Dept. Dies at 101," *The New York Times*, November 4, 1996.

186 **officially called the Committee on Professional Women:** More information on the Petticoat Panel can be found in author redacted, "The Petticoat Panel: A 1953 Study of the Role of Women in the CIA Career Service," declassified October 30, 2013, CIA/CREST.

186 **Addy surveyed the room:** Meeting minutes, "Careers for Women Task Force," July 31, 1953, CIA/CREST.

187 **"considerable responsibility":** Personnel evaluation report, May 1952, declassified October 30, 2013, CIA/CREST.

187 **"[Addy] has achieved":** Ibid.

187 **She was determined:** Background information on Adelaide Hawkins obtained from author interviews with friends, colleagues, and family members.

188 **"Oh, I'll just keep at":** Author interview with [redacted], July 31, 2019.

190 *This is going to be an uphill battle:* The feelings of Eloise during the panel obtained from author interview with [redacted] and "From Typist to Trailblazer: The Evolving View of Women in the CIA's Workforce," June 15, 2014, CIA/CREST.

190 **It had been built:** A description of L-building can be found in Douglas Sefton with Ron Frenesse and Michael Tallent, "National Register of Historic Places Registration Form" for E Street Complex (Office of Strategic Services and Central Intelligence Agency Headquarters), National Park Service, November 10, 2013.

190 **"Without air conditioning":** Ibid.

191 **"We don't have the data":** Author redacted, "The Petticoat Panel: A 1953 Study of the Role of Women in the CIA Career Service."

191 **"It seems to me":** Transcript of steering group, "CIA Career Service Board," August 10, 1953, CIA/CREST.

192 **When she was a child:** "Lay minister" and background on Eloise's faith obtained from author interviews with her friends and family members.

193 **21 percent:** Report of the committee on professional women in the overt services, declassified October 30, 2013, CIA/CREST.

193 **a dramatic 55 percent:** Richard E. Schumann, "Compensation from World War II Through the Great Society," Bureau of Labor Statistics, *Compensation and Working Conditions*, Fall 2001.

194 **average annual salary:** Report of the committee on professional women in the overt services.

194 **7 percent of operatives in the field:** Ibid.

194 **"stepping-stones":** Author interview with [redacted], August 12, 2019.

194 **long catalog of complaints:** Report of the committee on professional women in the overt services.

195 **"a damned pig sty":** Andrew Friedman, *Covert Capital: Landscapes of Denial and the Making of U.S. Empire in the Suburbs of Northern Virginia* (Berkeley: University of California Press, 2013).

195 **"I played it for everything it was worth.":** "Divine Secrets of the RYBAT Sisterhood: Four Senior Women of the Directorate of Operations Discuss Their Careers," declassified October 30, 2014, CIA/CREST, confirmed by author interview with [redacted], April 12, 2018.

196 **"How do you make":** Transcript of the steering group, "CIA Career Service Board," November 23, 1953, CIA/CREST.

196 **"I want you to be sure":** Richard Helms and William Hood, *A Look over My Shoulder: A Life in the Central Intelligence Agency* (New York: Random House, 2003).

197 **"theft of secrets":** Ibid.

197 **"a bunch of old washerwomen":** Evan Thomas, *The Very Best Men: The Daring Early Years of the CIA* (New York: Simon & Schuster, 2006).

197 **"No aspect of CIA operations":** Helms and Hood, *A Look over My Shoulder.*

197 **"forces or groups distinct":** U.S. Special Operations Forces, *United States Special Operations Forces Posture Statement, 2003–2004: Transforming the Force at the Forefront of the War on Terrorism,* 2003.

198 **Among their many missteps:** MKUltra and the death of Olson discussed in Joseph B. Treaster, "Ex–C.I.A. Aide Says Scientist Who Died Knew about Experiments with LSD," *The New York Times,* July 18, 1975.

198 **"It is probably offensive":** Report of the committee on professional women in the overt services.

198 **"The questioning of":** Poem by Mary Hutchison, October 1953, CA5861, SHSMO.

199 **"I'm trying to behave":** Letter, August 1953, CA5861, SHSMO.

199 **"You have good taste":** Letter, September 10, 1959, CA5861, SHSMO.

200 **"The chief thing":** Diary, September 1953, CA5861, SHSMO.

200 **"subject's presence":** Author redacted, "The Petticoat Panel: A 1953 study of the Role of Women in the CIA Career Service," declassified October 30, 2013, CIA/CREST.

200 **While women represented 39 percent:** Report of the committee on professional women in the overt services.

201 **"take a different job":** Ibid.

NOTES

201 **"Some of the statements"**: Converation that follows can be found in the tran-
script of the steering group, "CIA Career Service Board," November 23, 1953, CIA/
CREST.

CHAPTER 13: FARMER, 1954

207 **Liz was coming home to a familiar world**: Background information on Elizabeth
Sudmeier obtained from author interviews with friends, colleagues, and family
members.

209 **Liz had transformed the tailor shop**: The nature of Liz's spy network in Iraq de-
scribed in author interviews with [redacted], 2019 and 2020, with details confirmed by
Elizabeth Sudmeier and family members of Arthur Callahan in author interviews,
and "Challenging the Status Quo: Elizabeth Sudmeier's Historic Legacy," Central
Intelligence Agency, June 26, 2015, https://www.cia.gov/stories/story/challenging-the
-status-quo-elizabeth-sudmeiers-historic-legacy. The name of Liz's contact in Bagh-
dad is withheld, but all accompanying details are accurate.

210 **"Men—foreign men"**: "Divine Secrets of the RYBAT Sisterhood: Four Senior Women
of the Directorate of Operations Discuss Their Careers," declassified October 30, 2014,
CIA/CREST.

211 **"Apprehension by the security authorities"**: "Challenging the Status Quo: Elizabeth
Sudmeier's Historic Legacy."

212 **The plane was incredibly light**: Technical details on the Farmer obtained from the
manuals Liz obtained and reported in "Characteristics and Performance Handbook:
USSR Aircraft," declassified August 1, 2013, CIA/CREST.

CHAPTER 14: MUSKETEER, 1956

214 **"Subject's sex and family"**: Personnel report for Adelaide Hawkins, 1956, CIA/
CREST.

214 **"It's finally happened"**: Author interview with [redacted], July 31, 2019.

215 **"This is going to be the best thing for you"**: Author interview with Don Hawkins,
June 2, 2020.

215 **In London, Addy received a file**: More information on Operation Musketeer can be
found in Ricky-Dale Calhoun, "The Art of Strategic Counterintelligence. The Mus-
keteer's Cloak: Strategic Deception during the Suez Crisis of 1956," *Studies in Intel-
ligence* 51, no. 2 (2007), CIA/CREST.

NOTES

215 **"We shall defend":** Tony Rea and John Wright, *The Arab-Israeli Conflict* (Oxford, UK: Oxford University Press, 1997).

216 **"Sounds suspiciously like":** "The Suez Crisis: A Brief CONMINT History," 1988, declassified January 15, 2013, NSA.

216 **$80 and $200 million:** Calhoun, "The Art of Strategic Counterintelligence."

216 **The agency's answer was a slick, new plane:** History of the Dragon Lady recounted in Gregory W. Pedlow and Donald E. Welzenbach, *The Central Intelligence Agency and Overhead Reconnaissance: The U-2 and Oxcart Programs, 1954–1974* (New York: Skyhorse, 2016).

218 **"feudal barons":** Brent Durbin, "Addressing 'This Woeful Imbalance': Efforts to Improve Women's Representation at CIA, 1947–2013," Government: Faculty Publications, Smith College, Northampton, MA, October 30, 2013.

218 **"capitalist tendencies of the West":** Lora Soroka, *Archives of the Communist Party and Soviet State: Fond 89: Communist Party of the Soviet Union on Trial* (Stanford, CA: Hoover Institution Press, 2001).

220 **they would "break Nasser":** Correspondence between Eisenhower and Eden, Whitman file, July 31, 1956, DDE.

220 **"You boys must be":** Joseph S. Nye Jr., *Nuclear Ethics* (New York: Free Press, 1988).

220 **"All wars are stupid":** *Hearings on H.R. 3678, Before the Subcommittee of the Committee of Appropriations*, 80th Cong. (1947).

221 **"we were cut off":** "The Suez Crisis: A Brief CONMINT History."

221 **"on a scale":** Ibid.

222 **"I'm positive the Israelis":** Michael Beschloss, *Mayday: Eisenhower, Khrushchev, and the U-2 Affair* (New York: Harper and Row, 1988).

222 **"a complete surprise":** Ibid.

223 **"I feel I must urgently":** Correspondence between Eisenhower, Eden, and French prime minister Guy Mollet, Dulles Papers, October 30, 1956, DDE.

223 **Soviets ruthlessly attacked:** Victor Sebestyen, *Twelve Days: The Story of the 1956 Hungarian Revolution* (New York: Vintage, 2007).

224 **"barbaric":** Ibid.

224 **positioning themselves as allies:** Messages from the Soviet Union and their replies published in *Keesing's Record of World Events*, volume X, November 1956.

CHAPTER 15: NSG5520, 1957

225 **"This is easy":** Letter, January 20, 1957, CA5861, SHSMO.

225 **"Well, you don't have anything":** Ibid.

226 **"the prospect of colored"**: Ibid.

226 **"It is one of the duties"**: Julian Huxley, *From an Antique Land* (Boston, MA: Beacon Press, 1966).

227 **"a highest priority"**: Report, "Soviet Capabilities and Probable Programs in Guided Missiles," October 5, 1954, declassified March 23, 2004, CIA/CREST.

227 **"intense interest"**: Memo, CIA support for Earth satellite program, October 10, 1955, CIA/CREST.

228 **While the army's Jet Propulsion Laboratory:** History of American rocketry and the wrangling over America's satellite described in Nathalia Holt, *Rise of the Rocket Girls: The Women Who Propelled Us, from Missiles to the Moon to Mars* (New York: Little, Brown, 2016).

228 **It took the spy planes:** The Dragon Lady's flights over Tyuratam described in Dino A. Brugioni, "The Tyuratam Enigma," *Air Force Magazine*, March 1, 1984.

229 **"into any part of the world"**: Avrahm G. Mezerik, "The Technological Revolution: Reshapes Planets and People," *Great Decisions* 132 (1958): 5–29.

229 **radar cross-section:** Eugene F. Knott, John F. Shaeffer, and Michael T. Tuley, *Radar Cross Section*, 2nd ed. (Raleigh, NC: SciTech, 1993).

231 **"I know everything there is to know"**: Author interview with [redacted], August 12, 2019; and Ronald Kessler, unpublished interviews with Eloise Page, 2002.

234 **"You really ought to put this out"**: Amy Ryan and Gary Keeley, "Sputnik and US Intelligence: The Warning Record," *Studies in Intelligence* 61, no. 3 (2017).

234 **other news would shock the attendees:** The cocktail party at the Soviet embassy described in George H. Ludwig, *Opening Space Research: Dreams, Technology, and Scientific Discovery* (New York: Wiley, 2013).

234 **"What have they said"**: Holt, *Rise of the Rocket Girls*.

235 **"Crates of champagne!"**: Ryan and Keeley, "Sputnik and U.S. Intelligence."

236 **"full-scale national emergency"**: Transcript of news conference held over WMAL-TV (Washington), November 17, 1957, CIA/CREST.

236 **"In view of the unfavorable"**: Ryan and Keeley, "Sputnik and U.S. Intelligence."

236–7 **If Eisenhower had let the Jet Propulsion Laboratory:** Holt, *Rise of the Rocket Girls*.

237 **"We are primarily concerned"**: Roger D. Launius, John M. Logsdon, and Robert W. Smith, ed., *Reconsidering Sputnik: Forty Years Since the Soviet Satellite* (London: Routledge, 2000).

237 **called it a "grapefruit"**: Eric Betz, "Vanguard 1: Earth's Oldest Artificial Satellite That's Still in Orbit," *Discover*, July 9, 2020.

237 **"in receiving aid"**: Rebecca Maksel, "In the Museum: Second, but Still Up," *Air & Space Magazine*, May 2008.

237 **The group would launch:** More information on Explorer 1 can be found in Holt, *Rise of the Rocket Girls.*

238 **code name City 40:** City 40 is discussed in Samira Goetschel, "'The Graveyard of the Earth': Inside City 40, Russia's Deadly Nuclear Secret," *The Guardian,* July 20, 2016.

239 **"The reports locate":** Report, September 18, 1951, CIA/CREST.

239 **"Cloud cover":** Photographic Intelligence Report, Tyuratam Missile Research Center, declassified 2003, CIA/CREST.

CHAPTER 16: BLUEBAT, 1958

241 **They knew what this song meant:** Description of the 1958 Iraqi revolution can be found in Elizabeth Bishop, "The Local and the Global: The Iraqi Revolution of 1958 between Western and Soviet Modernities," *Ab Imperio* 4 (2011): 172–202.

242 **"Roosevelt's erection":** David D. Kirkpatrick, *Into the Hands of the Soldiers: Freedom and Chaos in the Middle East* (New York: Penguin Books, 2019).

242 **"staunchly anti-Communist":** Jack O'Connell with Vernon Loeb, *King's Counsel: A Memoir of War, Espionage, and Diplomacy in the Middle East* (New York: W. W. Norton, 2011).

243 **quickly warned the king:** Jack O'Connell's history, and the meeting between King Hussein and the chief of the Iraqi army, recounted in ibid.

244 **"that important political events":** Ibid.

245 **"Noble people of Iraq":** Sara Pursley, *Familiar Futures: Time, Selfhood, and Sovereignty in Iraq* (Palo Alto, CA: Stanford University Press, 2019).

245 **believing the Egyptian president's role:** Activities of the CIA station during the 1958 Iraqi revolution obtained from author interviews with [redacted], 2019 and 2020.

246 **"[Women] were much better":** Brent Durbin, "Addressing 'This Woeful Imbalance': Efforts to Improve Women's Representation at CIA, 1947–2013," Government: Faculty Publications, Smith College, Northampton, MA, October 30, 2013, declassified October 30, 2013.

247 **"we have a call from Lebanon":** Memorandum of a telephone conversation, Dulles Papers, White House Telephone Conversations, DDE.

247 **"We always felt":** Ibid.

247 **"We must act":** Ibid.

248 **bikinis were prohibited:** Alissa J. Rubin, "From Bikinis to Burkinis, Regulating What Women Wear," *The New York Times,* August 27, 2016.

248 **"long and confusing day":** Major Brian A. Jaquith, "Operation Blue Bat, 1958: Framing Activities in Crisis Response," School of Advanced Military Studies, US Army Command and General Staff College, Fort Leavenworth, KS, 2019.

NOTES

248–9 **instead found only a relaxed beach scene:** A review of Operation Bluebat can be found in Bruce Riedel, "Beirut 1958: America's Origin Story in the United States," Brookings Institution, October 29, 2019.

249 **"Yesterday was a day":** Statement by President Eisenhower, July 15, 1958, DDE.

249 **"What we now see":** Ibid.

250 **"I did not favor the idea":** Major General David W. Gray, "The U.S. Intervention in Lebanon, 1958: A Commander's Reminiscence," US Army Command and General Staff College, Fort Leavenworth, KS, August 1984.

250 **"was couched in the rudest":** Dwight D. Eisenhower, *Waging Peace, 1956–1961: The White Years* (New York: Doubleday, 1965).

CHAPTER 17: AERODYNAMIC, 1959

251 **"In one way":** Letter, November 5, 1958, CA5861, SHSMO.

251 **"I have gone to work in a new section":** Letter, November 12, 1958, CA5861, SHSMO.

252 **"well worthwhile":** Ibid.

252 **Arriving in Frankfurt:** Top secret memo contents: Project outline for Aerodynamic, March 23, 1958, CIA/CREST.

253 **"the largest paramilitary":** William M. Leary, "CIA Air Operations in Laos, 1955–1974," *Studies in Intelligence* 43, no. 3 (1999), CIA/CREST.

253 **$500 million:** Jean-Pierre Lehmann, "A Look Back at the CIA's Dirty War in Laos," *Forbes*, March 1, 2017.

253 **"Let me make this clear":** Richard Helms and William Hood, *A Look over My Shoulder: A Life in the Central Intelligence Agency* (New York: Random House, 2003).

254 **"unsteady ally":** Project outline for Aerodynamic.

254 **"political warfare":** Ibid.

254 **They were given the code names:** Ibid.

256 **"fumbling in the dark":** Allen Dulles Briefing, *Executive Sessions of the Senate Foreign Relations Committee*, volume X, July 22, 1958.

257 **as Eisenhower's "aggression":** Major Brian A. Jaquith, "Operation Blue Bat, 1958: Framing Activities in Crisis Response," School of Advanced Military Studies, US Army Command and General Staff College, Fort Leavenworth, KS, 2019.

257 **"out of date and unreliable":** Ibid.

258 **The Red Army was marching:** Evan Thomas, "Spymaster General: The Adventures of 'Wild Bill' Donovan and the 'Oh So Social' O.S.S.," *Vanity Fair*, March 3, 2011.

259 **"the last hero":** Ibid.

259 **"The man more responsible":** Ibid.

260 **also called saxitoxin:** Patricia Ann Tester, et al., "Saxitoxin and the Cold War," Proceedings of the 18th International Conference on Harmful Algae, 2018.

CHAPTER 18: MUDLARK, 1960

263 **Operation Grand Slam began:** More information on Operation Grand Slam can be found in Gregory W. Pedlow and Donald E. Welzenbach, *The Central Intelligence Agency and Overhead Reconnaissance: The U-2 and Oxcart Programs, 1954–1974* (New York: Skyhorse, 2016).

264 **Japanese newspapers reported:** Krzysztof Dabrowski, *Hunt for the U-2: Interceptions of Lockheed U-2 Reconnaissance Aircraft Over the USSR, Cuba and People's Republic of China, 1959–1968* (Warwick, England: Helion, 2020).

265 **he began to design a "plan for greater Baghdad.":** Frank Lloyd Wright's plans for Baghdad discussed in Adam Cohen, "Frank Lloyd Wright 'Builds' Baghdad...," *Wall Street Journal*, April 20, 2003.

266 **so-called House of Wisdom:** Jonathan Lyons, *The House of Wisdom: How the Arabs Transformed Western Civilization* (London: Bloomsbury, 2011).

267 **"the most dangerous spot in the world":** Memo, June 4, 1961, JFK.

267 **uncovered the Soviet's newest fighter jet:** Liz obtained the plans for the MiG-21 according to author interviews with her colleagues and "Challenging the Status Quo: Elizabeth Sudmeier's Historic Legacy," Central Intelligence Agency, June 26, 2015, https://www.cia.gov/stories/story/challenging-the-status-quo-elizabeth-sudmeiers -historic-legacy.

268 **spotted the plane killers:** Dabrowski, *Hunt for the U-2*.

268 **brand-new Su-9:** Ibid.

268–9 **"to destroy the target":** Ibid.

269 **"the greatest threat to the U-2":** Pedlow and Welzenbach, *The Central Intelligence Agency and Overhead Reconnaissance*.

270 **The CIA called it:** Details on Operation Mudlark can be found in ibid.

270 **She was a high-level liaison:** Addy's role in Operation Mudlark obtained through author interviews with her colleagues, 2019–2020.

271 **Dragon Lady painted boldly in NASA colors:** Pedlow and Welzenbach, *The Central Intelligence Agency and Overhead Reconnaissance*.

271 **"She can make an intelligent":** Author redacted, "The Petticoat Panel: A 1953 Study of the Role of Women in the CIA Career Service," declassified October 30, 2013, CIA/ CREST.

272 **"Germany looks best":** Letter, December 14, 1959, CA5861, SHSMO.

272 **It felt like a personal failure:** Struggles with Operation Aerodynamic described in report, December 9, 1959, CIA/CREST.

273 **Anthrax had been used by Germany:** History of the weaponization of anthrax can be found in G. W. Christopher et al., "Biological Warfare: A Historical Perspective," *Journal of the American Medical Association* 278, no. 5 (1997): 412–17.

273 **forty million Ukrainians:** Richard Breitman and Norman J. W. Goda, *Hitler's Shadow: Nazi War Criminals, U.S. Intelligence, and the Cold War* (Ann Arbor: University of Michigan Press, 2010).

273 **"We must change our tactics":** Ibid.

273 **"Some form of nationalist feeling":** Ibid.

274 **"We said that the aircraft":** Quincy Wright, "Legal Aspects of the U-2 Incident," *The American Journal of International Law* 54, no. 4 (1960): 836–54.

274 **all evidence of the plane's reconnaissance:** The downing of the U-2 plane in 1960 is described in Monte Reel, *A Brotherhood of Spies: The U-2 and the CIA's Secret War* (New York: Doubleday, 2018).

276 **a very different tale:** Matthew M. Aid, *The Secret Sentry: The Untold History of the National Security Agency* (New York: Bloomsbury Publishing, 2009).

276 **"Comrades, I must tell":** Giles Whittell, *Bridge of Spies* (London: Simon & Schuster UK, 2011).

276 **"It is either peaceful":** *The Department of State Bulletin* XLII, no. 109 (June 6, 1960): 904–05.

277 **a passive covert listening device:** *The thing* is a passive covert listening device as described in Robert Wallace and H. Keith Melton, with Henry Robert Schlesinger, *Spycraft: The Secret History of the CIA's Spytechs, from Communism to Al-Qaeda* (New York: Plume, 2009).

277 **"greatest asset":** Memo, August 2, 1955, CIA/CREST.

278 **"dominated operations planning":** Ibid.

278 **The operation was called Corona:** Details of Operation Corona can be found in Kevin C. Ruffner, "Corona: America's First Satellite Program," 1995, CIA/CREST.

CHAPTER 19: LINCOLN, 1961

280 **Never in the history of American intelligence:** Controversy over Liz's nomination described in author interviews with her colleagues and "Challenging the Status Quo: Elizabeth Sudmeier's Historic Legacy," Central Intelligence Agency, June 26, 2015, https://www.cia.gov/stories/story/challenging-the-status-quo-elizabeth-sudmeiers -historic-legacy.

NOTES

281 **"Fidel Castro is the best thing"**: Tony Perrottet, *Cuba Libre!: Che, Fidel, and the Improbable Revolution That Changed World History* (New York: Blue Rider Press, 2019).

282 **"eight jet minutes"**: Martin J. Sherwin, *Gambling with Armageddon: Nuclear Roulette from Hiroshima to the Cuban Missile Crisis* (New York: Knopf, 2020).

282 **"common sense"**: Author interview with [redacted], August 12, 2019.

282 **"a little busy"**: Letter, March 15, 1961, CA5861, SHSMO.

282 **"unachievable"**: Jack P. Pfeiffer, "Official History of the Bay of Pigs Operation," Vol. III, December 1979, CIA/CREST.

283 **the 5412 committee**: The 5412 committee is explained in Jim Rasenberger, *The Brilliant Disaster: JFK, Castro, and America's Doomed Invasion of Cuba's Bay of Pigs* (New York: Scribner, 2011).

283 **"whether the situation did not have the appearance"**: Ibid.

283 **"It is expected that these operations"**: Memo, January 4, 1961, CIA/CREST.

283 **"lacked access to high-level military sources"**: Michael Warner, "Lessons Unlearned: The CIA's Internal Probe of the Bay of Pigs Affair," *Studies in Intelligence* (1998), CIA/CREST.

283 **"Who, me?"**: Pfeiffer, "Official History of the Bay of Pigs Operation."

284 **"Not one American"**: Ibid.

284 **"Since our invasion force is very small"**: Ibid.

285 **"I have nothing left to fight with"**: Warner, "Lessons Unlearned: The CIA's Internal Probe of the Bay of Pigs Affair."

285 **It was called Operation Lincoln**: Operation Lincoln is described in Robert Vandaveer, "Operation Lincoln," *Studies in Intelligence* 7, no. 1 (1963): 69–73, CIA/CREST.

285 **the foundation the agency had been built upon**: Eloise's role in Operation Lincoln obtained from author interviews with her colleagues; however, no supporting documentation from the CIA was made available.

287 **"Toward the end of February"**: Brian Kannard, *Steinbeck: Citizen Spy* (Nashville: Grave Distractions Publications, 2013).

288 **"Victory has a hundred fathers"**: News conference, April 21, 1961, JFK.

288 **"What the hell do they want?"**: Richard Reeves, "Saved by the Cold War," *The New York Times*, April 25, 2009.

288 **new paramilitary operations**: More information on Operation Mongoose can be found in Max Boot, "Operation Mongoose: The Story of America's Efforts to Overthrow Castro," *The Atlantic,* January 5, 2018.

288 **Florence Thorne and Margaret Scattergood**: Jessica Contrera and Gillian Brockwell, "In 1933, Two Rebellious Women Bought a Home in Virginia's Woods. Then the CIA Moved In," *The Washington Post*, February 14, 2020.

289 **the world's most powerful thermonuclear weapon:** Tsar Bomba is described in Stephen Dowling, "The Monster Atomic Bomb That Was Too Big to Use," *BBC*, August 16, 2017.

CHAPTER 20: PSALM, 1962

291 **There was a flurry of activity:** Dinner is described in letter, CA5861, SHSMO.

291 **"machine guns":** Ibid.

291 **"Algeria is French and will remain so.":** More information on the Algerian war can be found in Alistair Horne, *A Savage War of Peace: Algeria 1954–1962* (New York: New York Review Books, 1977).

292 **"a rather simple old man":** Memo, September 4, 1959, CIA/CREST.

292 **"one of the most effective":** Richard Breitman and Norman J. W. Goda, *Hitler's Shadow: Nazi War Criminals, U.S. Intelligence, and the Cold War* (Ann Arbor: University of Michigan Press, 2010).

292 **"Ukrainian inventions in the field":** Aerodynamic project approval, September 29, 1958, CIA/CREST.

292–3 **Mary met with the agents clandestinely:** Mary's work with the Aecassowaries documented in contact reports from 1962, and author interviews with her colleagues, CIA/CREST.

293 **"longing to stay":** Letter, 1961, CA5861, SHSMO.

294 **"monumental struggle":** "Challenging the Status Quo: Elizabeth Sudmeier's Historic Legacy," Central Intelligence Agency, June 26, 2015, https://www.cia.gov/stories/story/challenging-the-status-quo-elizabeth-sudmeiers-historic-legacy.

294 **"does the work of a man":** Author interview with Kevin Callahan, August 26, 2020.

295 **her mood was "giddy":** Author interviews with the family of Elizabeth Sudmeier, 2020.

296 **Presidential Commission on the Status of Women:** Record 400, Box 001-005, 1961–1963, JFK.

296 **"CIA got me into it!":** Letter to Richard Helms, November 28, 1966, CIA/CREST.

296 **"first step":** Remarks, June 10, 1963, JFK.

297 **"The CIA was the only one":** Robert G. Kaiser, "Work of CIA with Youths at Festivals Defended," *The Washington Post*, February 16, 1967.

297 **CIA sent hundreds of college students:** Louis Menand, "A Friend of the Devil: Inside a Famous Cold War Deception," *The New Yorker*, March 16, 2015.

297 **"In my experience":** Markos Kounalakis, "The Feminist Was a Spook," *Chicago Tribune*, October 25, 2015.

NOTES

298 **The Corona satellites:** Corona satellite surveillance of Cuba discussed in Joseph W. Caddell Jr., "Corona over Cuba: The Missile Crisis and the Early Limitations of Satellite Imagery Intelligence," *Intelligence and National Security* 31, no. 3 (2016): 416–38.

299 **One of the officers:** Juanita Moody's involvement with the Cuban Missile Crisis is discussed in David Wolman, "The Once-Classified Tale of Juanita Moody," *Smithsonian Magazine*, March 2021.

299 **"relating to the delivery":** Psalm community coordination, declassified May 5, 2018, CIA/CREST.

299 **"outfitted with skis":** James H. Hansen, "Soviet Deception in the Cuban Missile Crisis," *Studies in Intelligence* 46, no. 1 (2002), CIA/CREST.

300 **928 photographs:** Ibid.

300 **"We can't do what the British and French did":** Transcript of the meetings of the Joint Chiefs of Staff, October–November 1962, CIA/CREST.

300 **"machine tools, wheat, and agricultural machinery":** Hansen, "Soviet Deception in the Cuban Missile Crisis."

301 **"All of the offensive missile systems in Cuba":** "Joint Evaluation of Soviet Missile Threat in Cuba," October 19, 1962, CIA/CREST.

301 **"I have not assumed that you":** Ibid.

301 **"It shall be the policy":** Address, JFKWHA-142-001, October 22, 1962, JFK.

302 **"We believe that the absence":** Kenneth Michael Absher, "Mind-sets and Missiles: A First-hand Account of the Cuban Missile Crisis," Strategic Studies Institute, US Army War College, September 1, 2009.

302 **"The Soviet Union must never":** Letter, Castro to Khrushchev, October 26, 1962, JFK.

302 **"Mr. President":** Telegram, Khrushchev to Kennedy, October 26, 1962, JFK.

302 **dual-use missiles:** David G. Coleman, "The Missiles of November, December, January, February . . . : The Problem of Acceptable Risk in the Cuban Missile Crisis," *Journal of Cold War Studies* 9, no. 3 (2007): 5–48.

303 **"There was the feeling":** Robert F. Kennedy, *Thirteen Days: A Memoir of the Cuban Missile Crisis* (New York: W. W. Norton, 1968).

303 **"first shot":** Rick Hampson, "Cuban Missile Crisis, Really Touch-and-Go?," *USA Today*, October 14, 2012.

303 **"We are willing":** Letter from Khrushchev to Kennedy, October 27, 1962, JFK.

303 **"If you think we have":** Letter, December 10, 1962, CA5861, SHSMO.

304 **"chronic problem":** Ibid.

304 **"speak of peace"**: Commencement address at American University, June 10, 1963, JFK.

304 **"the world was poised"**: December 1962, FO 371/171934, TNA.

CHAPTER 21: HYDRA, 1965–1972

305 **Suddenly, the driver stopped:** Liz's harrowing taxi ride obtained from author interview with [redacted], August 23, 2020. Although no documentation exists of this specific incident, because it was confirmed with a member of Liz's family during an author interview, I feel confident including this account.

306 **Her cover was blown:** Liz's cover blown in Iraq described in multiple sources: Author interview with [redacted], August 23, 2020; author interviews with Kevin Callahan, 2020; author interview with Jim Hughes, October 6, 2020; and also confirmed by author interviews with Liz's family members and friends.

307 **"If she were a man":** author interview with Jim Hughes, October 6, 2020.

307 **a border dispute erupted:** M. Taylor Fravel, *Active Defense: China's Military Strategy Since 1949* (Princeton, NJ: Princeton University Press, 2020).

308 **begged Liz to marry him:** Author interview with [redacted], August 23, 2020, confirmed by author interviews with family members and friends.

308 **She was heading to a different country:** Liz Sudmeier's work in India was described in multiple author interviews with her colleagues, family members, and friends. Although no supporting documentation from the CIA has been released on her work in the country, I feel confident including this portion of her career due to corroboration among sources.

308 **twenty-five thousand protesters:** Charles DeBenedetti with Charles Chatfield, *An American Ordeal: The Antiwar Movement of the Vietnam Era* (Syracuse, NY: Syracuse University Press, 1990).

308 **At Camp Peary:** Description of CIA officer training in 1963 described in author interviews with Sue McCloud, 2021.

309 **"looked down":** Ibid.

310 **"nothing but a bureaucrat":** Ibid.

311 **"one of support":** Richard Helms and William Hood, *A Look over My Shoulder: A Life in the Central Intelligence Agency* (New York: Random House, 2003).

311 **"politically explosive":** Ibid.

311 **"Within the Agency":** Ibid.

312 **"Not the least of the operational":** Ibid.

312 "The result of this working group": DCI briefing, November 17, 1967, CIA/CREST.

312 "Today, every inhabitant of this planet": General address to the United Nations, New York, NY, September 25, 1961, JFK.

313 ban nuclear testing in the atmosphere, in space, and underwater in 1963: Benjamin P. Greene, *Eisenhower, Science Advice, and the Nuclear Test Ban Debate, 1945–1963* (Palo Alto, CA: Stanford University Press, 2007).

313 31,319 weapons: Robert S. Norris and Hans M. Kristensen, "Global Nuclear Weapons Inventories, 1945–2010," *Bulletin of the Atomic Scientists* 66, no. 4 (2010): 77–83.

315 "a foundational element of our nation's security": Daniel M. Gerstein, *National Security and Arms Control in the Age of Biotechnology: The Biological and Toxin Weapons Convention* (Lanham, MD: Rowman & Littlefield, 2013).

315 "I did it because I believed in what I was doing": Ronald Kessler, unpublished interviews with Eloise Page, 2002.

315 The man made no reply: Welch's death described in Steven V. Roberts, "One Year Later, the Murder of the C.I.A.'s Chief Officer in Athens Remains a Mystery Without Solid Clues," *The New York Times*, December 26, 1976.

316 a terror organization named 17N: More information on 17N can be found in Miltiadis Fakitsas, *The Rise and the Fall of Terrorist Organizations in Post-Dictatorial Greece: The Role and the Lessons for the Intelligence Services* (thesis, US Naval Postgraduate School, Monterey, CA, June 2003).

316 "crimes committed by the C.I.A. against our people": Roberts, "One Year Later, the Murder of the C.I.A.'s Chief Officer in Athens Remains a Mystery Without Solid Clues."

317 Western Europe was the most active terrorist environment: "Patterns of Global Terrorism," US Department of State, 1989, MIPT.

317 Red Army Faction (RAF) in Germany, Action Directe (AD) in France, and the Red Brigades (RB) in Italy: Ibid.

317 "If you want to know what the bad guys": John Maury, "The Greek Coup: A Case of CIA Intervention? No, Says Our Man in Athens," *The Washington Post*, May 1, 1977.

317 men Eloise called "cowboys": Ronald Kessler, unpublished interviews with Eloise Page, 2002.

317 "women's work": Author interview with [redacted], April 12, 2018.

318 clandestine cell system: Derek Jones, "Understanding the Form, Function, and Logic of Clandestine Insurgent and Terrorist Networks: The First Step in Effective Counternetwork Operations," Joint Special Operations University, MacDill Air Force Base, Tampa, FL, 2012.

319 The enormous freezer: The freezer nature of their computing space described in Adelaide Hawkins interview with Barbara Matusow, July 29, 2003, LOC.

319 was called Hydra: Jens Wegener, "Order and Chaos: The CIA's HYDRA Database and the Dawn of the Information Age," *Journal of Intelligence History* 19, no. 1 (2020): 1–15.

319 "incredibly complex and sophisticated": Ford Rowan, *Technospies: The Secret Network That Spies on You—and You* (New York: G. P. Putnam's Sons, 1978).

320 Alec Station: Robert Windrem, "Hunting Osama Bin Laden Was Women's Work," *NBC News*, November 14, 2003; and Joana Cook, *A Woman's Place: US Counterterrorism Since 9/11* (Oxford, UK: Oxford University Press, 2020).

320 "Terrorism is not a short-term problem": Eloise Page, "Critical Intelligence Problems Committee: The Terrorism Intelligence Challenge," March 1985, CIA/CREST.

320 "We need a workforce": Maya Rhodan, "The CIA's Latest Mission: Improving Diversity," *Time*, April 20, 2015.

321 half of all CIA officers are women: Robert Windrem, "Sisterhood of Spies: Women Crack the Code at the CIA," *NBC News*, November 14, 2013.

321 despite the "hazards": Transcript of steering group, "CIA Career Service Board," November 23, 1953, CIA/CREST.

321 Women are prominent: More information on Gina Haspel can be found in Tessa Berenson, "Who Is Gina Haspel, President Trump's Pick for CIA Director?," *Time*, March 13, 2018.

321 women were promoted to lead the top three departments: Emma Newburger, "Women Head the Top Three CIA Directorates for the First Time in History," *CNBC*, January 16, 2019.

321 43 percent of officers promoted to senior positions are now women: Ibid.

321 the breakthrough that many waited for: Avril Haines is profiled in Daniel Klaidman, "Avril Haines, The Least Likely Spy," *Newsweek*, June 26, 2013.

321 "inner steel": Ibid.

321 "She's very unassuming": Ibid.

EPILOGUE: STATE SECRETS

323 She had lost her clearance: Johanna Neuman, "Southern Lady, with Accent on Spy Career," *Los Angeles Times*, October 26, 2002.

324 "recognizes CIA officers who by their actions": "A CIA Trailblazer: Eloise Page," March 30, 2002, CIA/CREST.

326 "She taught me everything but my name": Author interview with [redacted], October 18, 2020.

327 "We're not made for life after the agency": Author interviews with [redacted], 2019 and 2020.

327 akin to "babysitting": Ibid.

327 "enhanced interrogation techniques": Senate Select Committee on Intelligence, *The Senate Intelligence Committee Report on Torture: Committee Study of the Central Intelligence Agency's Detention and Interrogation Program* (New York: Melville House, 2014).

327 "It is visually and psychologically very uncomfortable": Ibid.

328 known as the "torture memos": Staff writers, "Complete Coverage: A Guide to the Memos on Torture," *The New York Times*, 2005.

328 "reverse over a century of U.S. policy": Memo from Colin Powell, January 25, 2002, NSA.

328 "We don't speak the language enough": *Manhunt: The Inside Story of the Hunt for Bin Laden*, directed by Greg Barker, aired January 20, 2013, on HBO.

329 "Why bother to live in a country": Letter, May 3, 1972, CA5861, SHSMO.

329 "Subject is one of the unfortunately passing breed": Author redacted, "The Petticoat Panel: A 1953 Study of the Role of Women in the CIA Career Service," declassified October 30, 2013, CIA/CREST.

329 "Inborn (perhaps feminine) tendency": Ibid.

330 "It was very difficult": Ibid.

330 "Throughout the years": Recommendation for honor or merit award, July 5, 1973, CIA/CREST.

330 "Never having enough money had been my life": Author interview with Don Hawkins, June 2, 2020.

331 "I found out there were a lot of intelligent people": Ibid.

332 "This is to inform you": Letter, July 24, 1943, JBC.

INDEX

Note: Italicized page numbers indicate material in photographs or illustrations.

INDEX

INDEX

INDEX

INDEX

Organization of Ukrainian Nationalists (OUN), 160, 254–55, 272
Orwell, George, 43
USS *Oxford*, 299

Page, Eloise
 and Allied counterintelligence operations, 159
 and Angleton, 138–39
 as Athens station chief, 316–18
 and Bissell, 282
 and Burrell's legacy at CIA, 130
 at CIA headquarters, *232*
 contacts in scientific community, 148
 and covert vs. clandestine operations, 115–16
 death, 325
 and Donovan's decline and death, 259
 and Donovan's leadership at CIA, 174
 and Dragon Lady missions, 268, 277
 and Dulles, 221–22
 education and language skills, 32–34, 111–12, 137–38, 190
 and espionage/covert ops divide at CIA, 253
 and estimates of Soviet nuclear capabilities, 133–34, 142, 143–48
 France posting, 218–19
 and gender inequities in American intelligence, 1–5, 36, 149, 190, 296
 and generational shifts at CIA, 308–10
 and Helms, 310–11
 and hunt for looted arts and valuables, 63
 intelligence operations in Brussels, 40–43
 legacy at CIA, 319–21
 and lethal toxins, 275
 life after CIA, *323*, 323–24, *326*
 motivations for intelligence work, 218–19
 and Nazi sheltering of money after war, 30
 nickname, 104, 309
 and nuclear nonproliferation efforts, 313–15
 and Operation Aquatone, 178–80
 and Operation Lincoln, 285–88
 and Operation Musketeer, 219–24
 and Operation Rusty, 81
 and origins of OSS, 17–19
 and Petticoat Panel, 185, 187, 189–91, 193–98
 portraits of, *xvii*, *18*
 and postwar intelligence environment, 64
 professionalism, 112
 promotions, 164–65, 259–60
 recruitment of assets, 112–13
 religious life, 192–93
 role in Brussels, 71–76
 and Soviet listening devices, 169
 and Soviet nuclear accidents, 240
 and Soviet weapons programs, 169, 220, 227–34, 272–73, 312
 and Sputnik launch, 234–38
 and spycraft, 153
 Trailblazer Award, 324
 and X-2 program, 54
Page, Lillian, 138
Page, Randolph Rosewell, 137–38
Pakistan, 263, 278
paramilitary operations, 197, 253, 283–85, 288, 291–93, 302, 310
Paris, France, 96–100, 293
Paris nuclear negotiations, 264–65, 276–77
Partisans of Peace, 175
Peabody Conservatory of Music, 33
Pearl Harbor, 68, 91
Peasant Dance (Rubens), 127
Period Piece (Raverat), 199
personnel reports, 180–81, 214, 271
Peterson, Esther, 296
Petticoat Panel. *See* Committee on Professional Women
photography. *See* cameras and photography
Pictorial Records Section (of OSS), 21
Pirro (Sudmeier's love interest), 182–85, 208, 246, 293, 294
Pius XII, Pope, 84
plane accidents, 129–30, 333
playback double agents, 254, 256
plutonium enrichment, 140–41, 146–48, 239
poisons, 12, 260, 314
Poland, 72–73
potassium cyanide, 47, 82
POW camps, 78
Powell, Colin, 328
Powers, Francis Gary, 265, 270, 274–76, 279
Presidential Commission on the Status of Women, 296
Project Belladonna, 85, 88, 108, 320
Project Bernhard (Operation Bernhard), 50, 58, 110
Project Venona, 77
propaganda, 44–45, 175, 235, 255, 273, 297
psychological warfare and training, 56, 227, 252
Purple (Japanese cipher machine), 77

INDEX

INDEX

INDEX

Printed in the United States
by Baker & Taylor Publisher Services